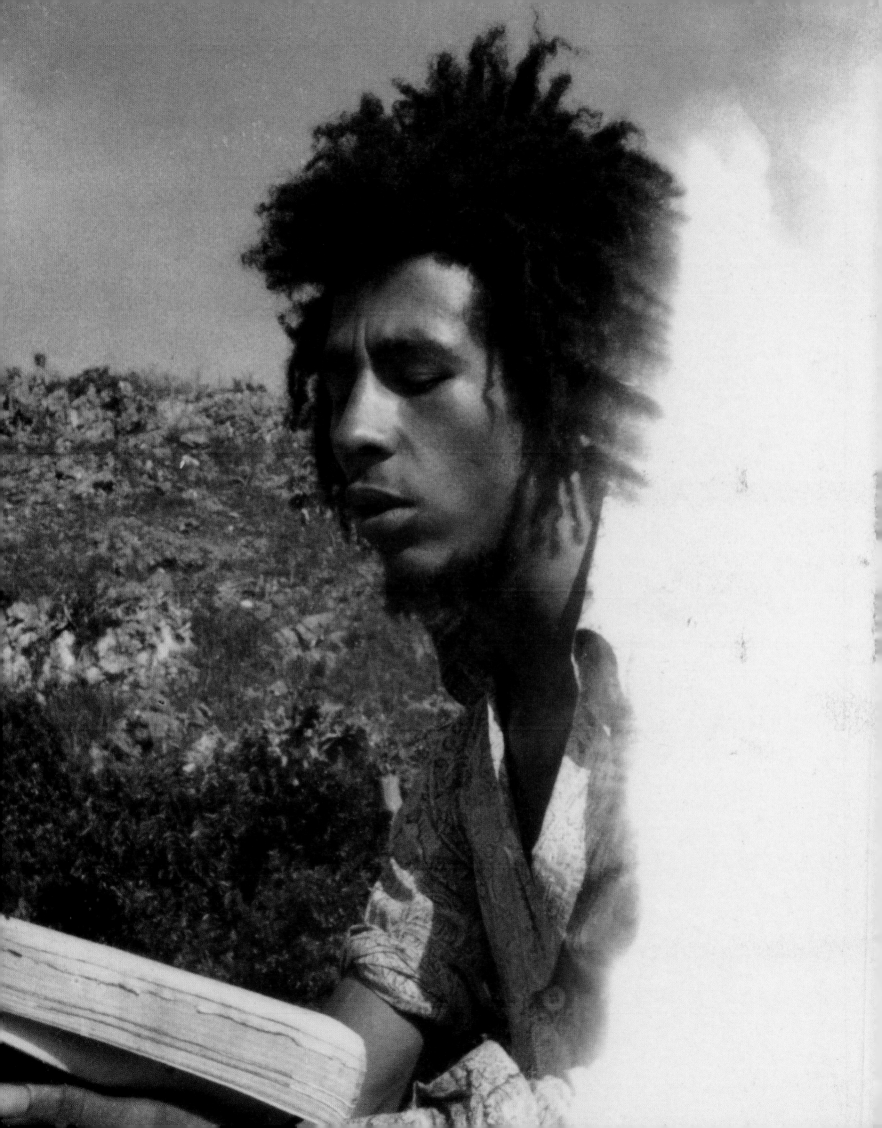

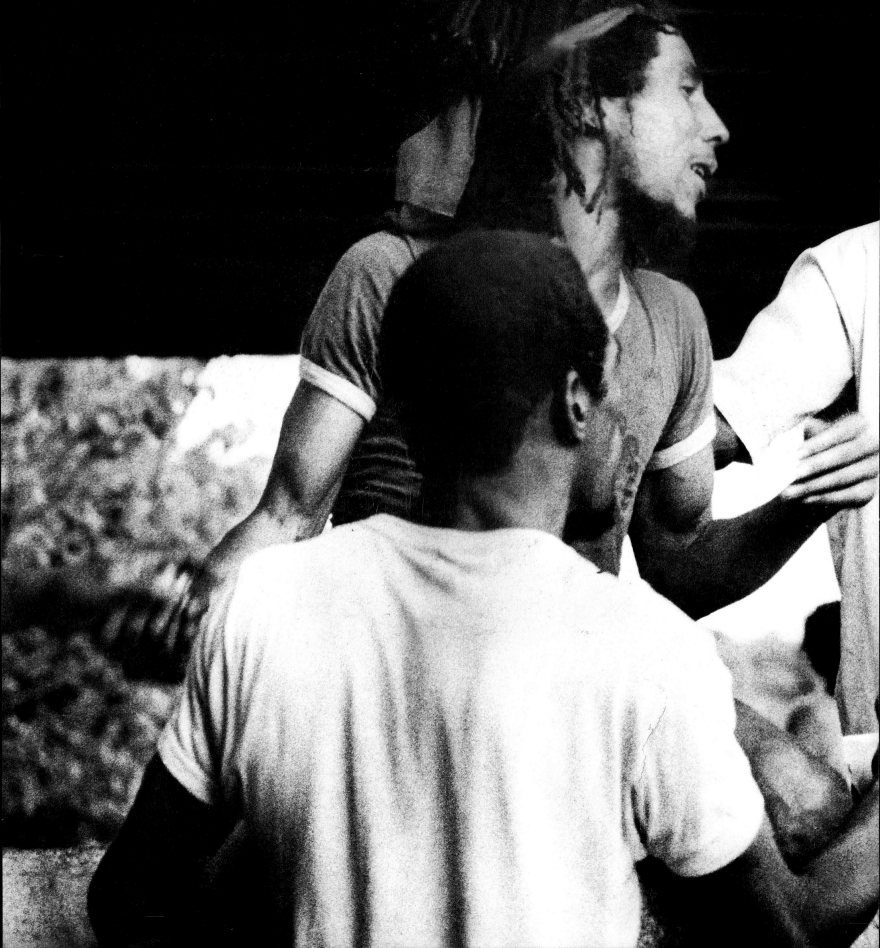

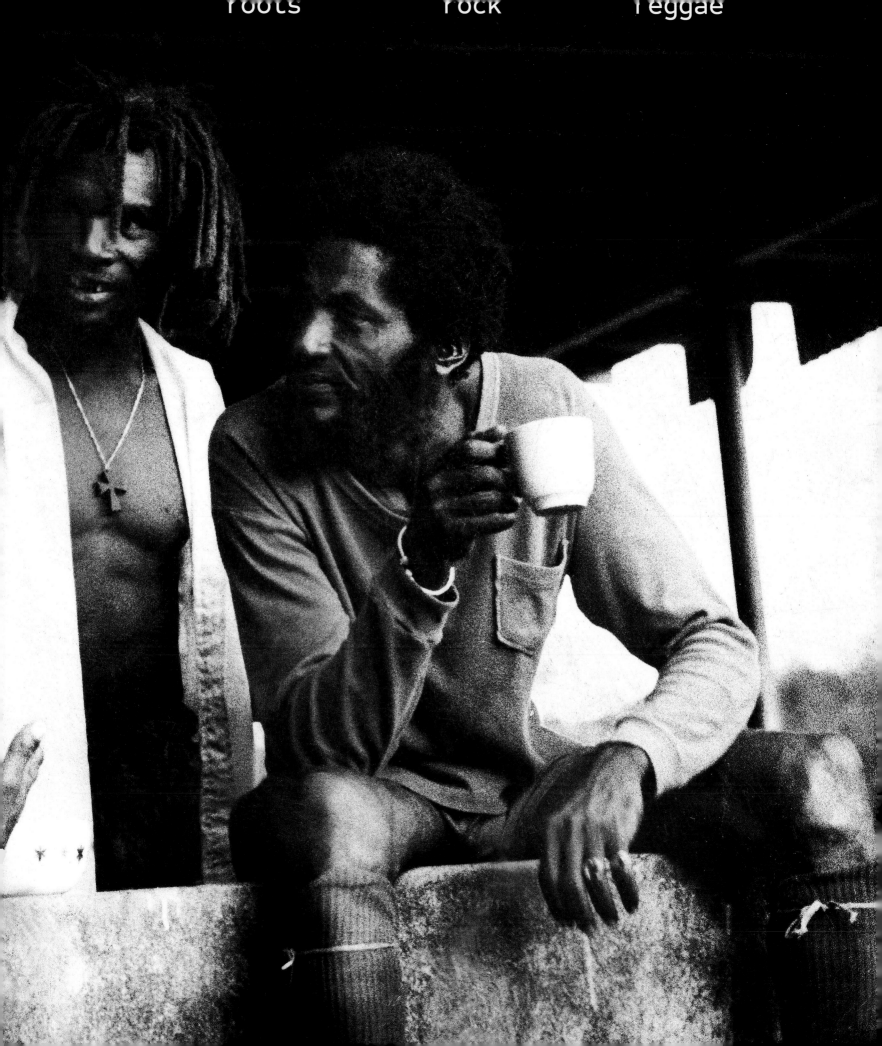

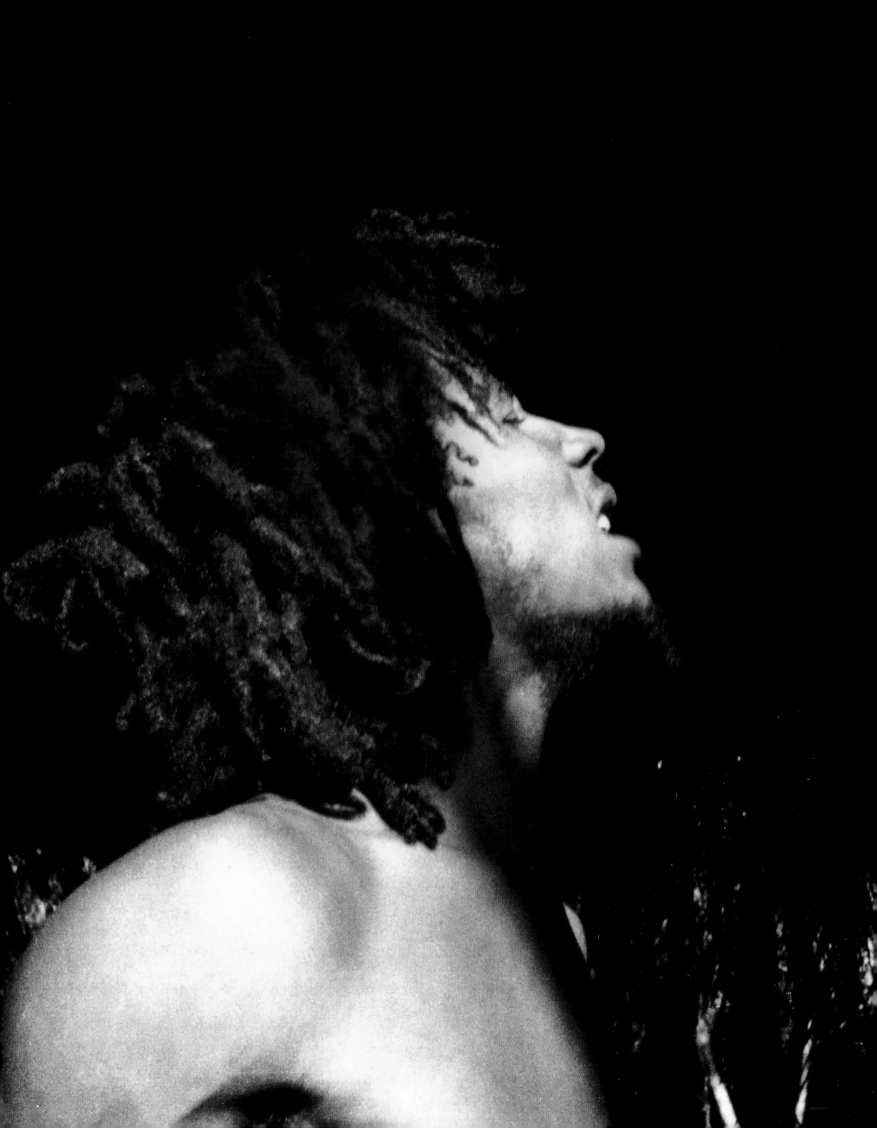

Hit Me With Music

Travels with Bob Marley, Peter Tosh, Joe Higgs...

Lee Jaffe

RIZZOLI
NEW YORK

New York · Paris · London · Milan

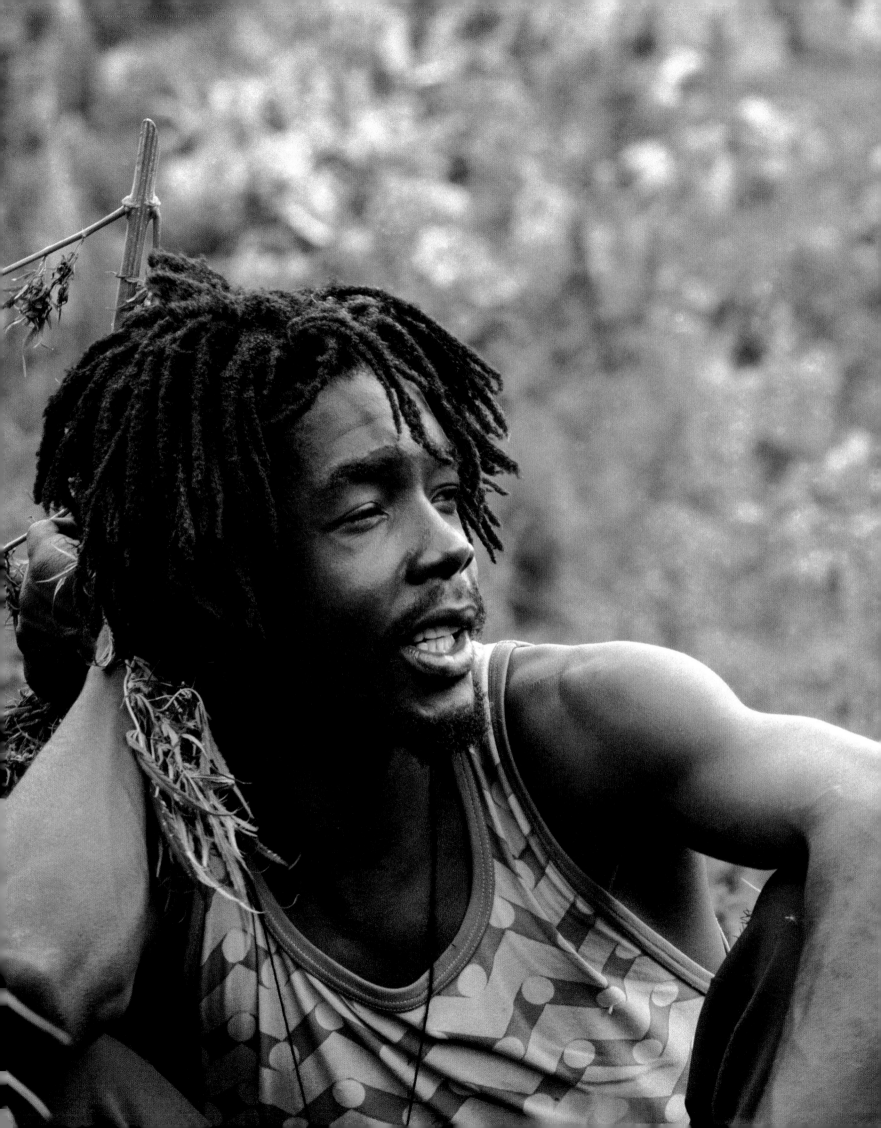

CONTENTS

Previous Pages:

Bob Marley reading a Bible.

Bob and Wailers percussionist
Seeco Patterson with friends.

Bob connecting with nature.

Left: Peter Tosh, relaxing in rural Jamaica.

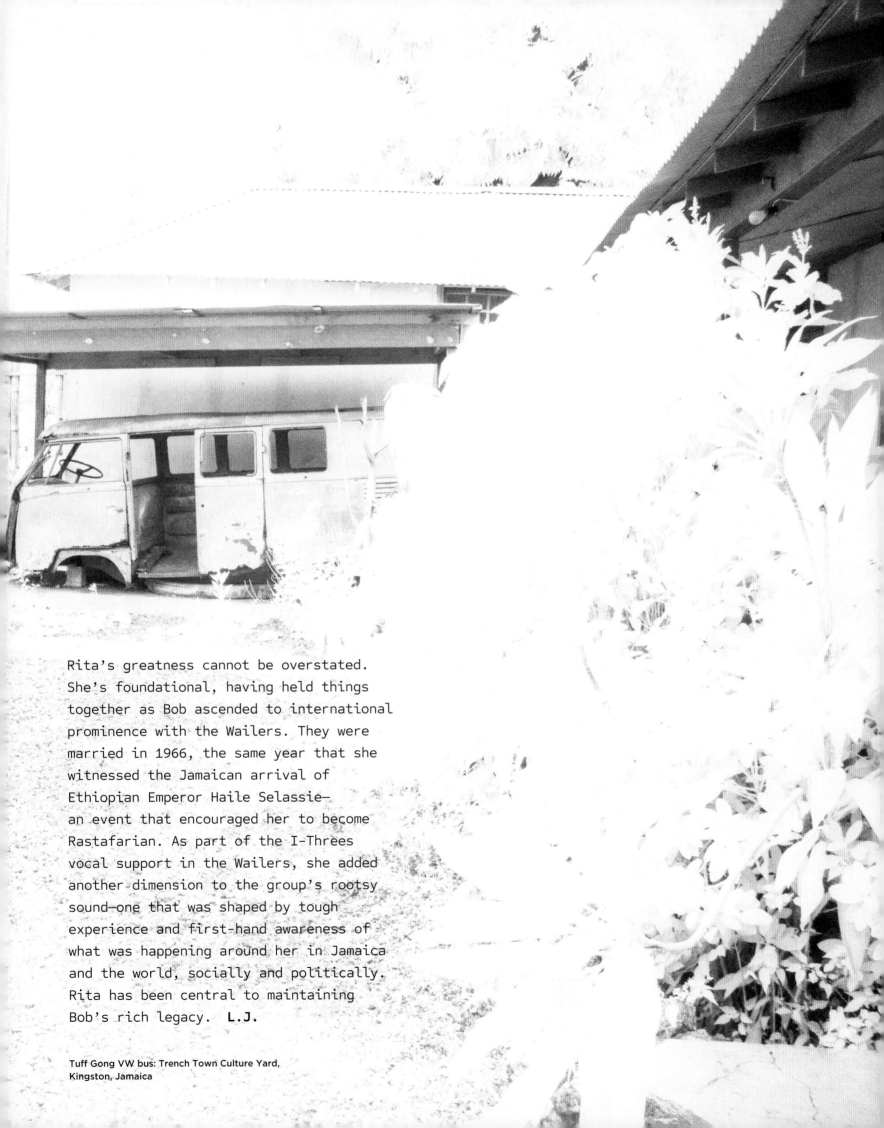

Rita's greatness cannot be overstated.
She's foundational, having held things
together as Bob ascended to international
prominence with the Wailers. They were
married in 1966, the same year that she
witnessed the Jamaican arrival of
Ethiopian Emperor Haile Selassie—
an event that encouraged her to become
Rastafarian. As part of the I-Threes
vocal support in the Wailers, she added
another dimension to the group's rootsy
sound—one that was shaped by tough
experience and first-hand awareness of
what was happening around her in Jamaica
and the world, socially and politically.
Rita has been central to maintaining
Bob's rich legacy. **L.J.**

**Tuff Gong VW bus: Trench Town Culture Yard,
Kingston, Jamaica**

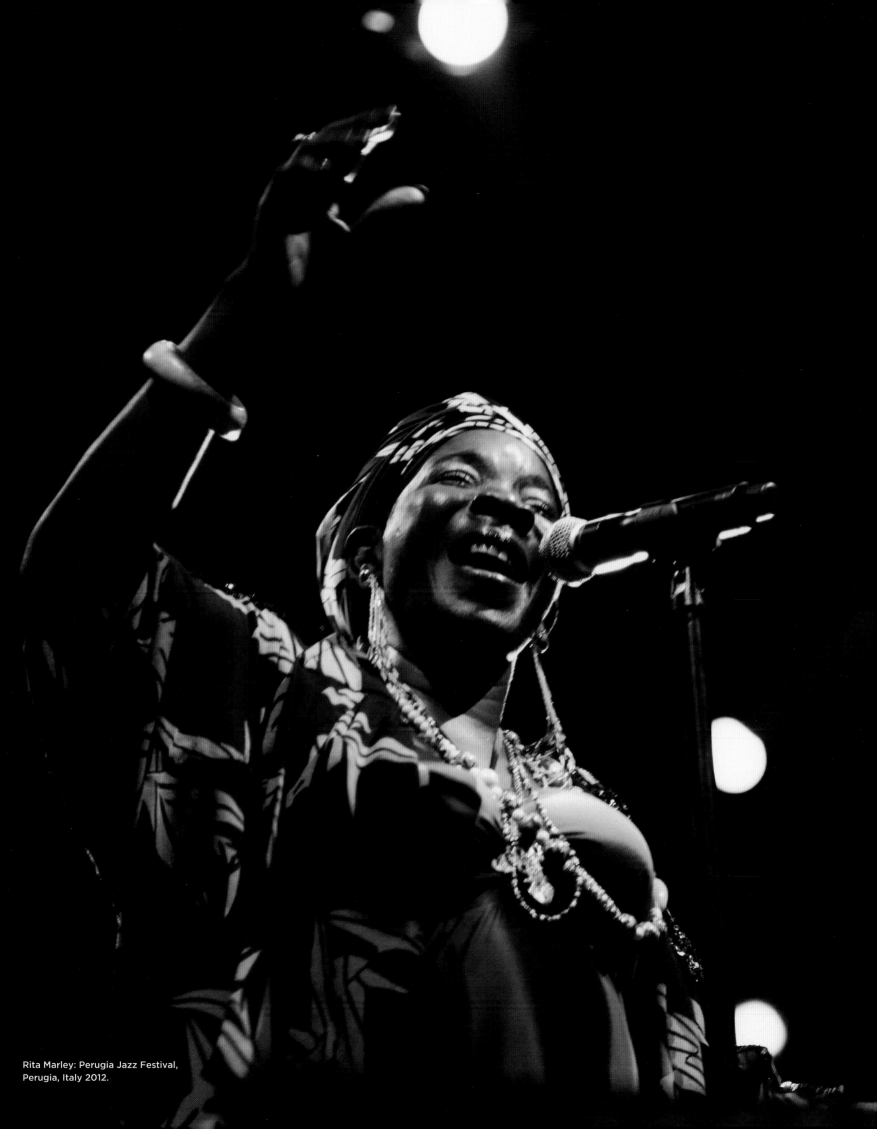

Rita Marley: Perugia Jazz Festival,
Perugia, Italy 2012.

Chris Blackwell

I recently asked Lee Jaffe if he knew, at the time when he met Bob Marley in 1973, that he would become an international icon with enormous musical and cultural impact. The movie, *Bob Marley: One Love*, produced by Bob's children Cedella and Ziggy and their mom Rita, had just been released, and I wanted to know what he thought. After all, he knew Bob much better than I did, having lived with him in his house on 56 Hope Road for three years, just prior to the movie's timeline of 1976-1978. He told me he loved every frame of the film—that he was transported in time.
He told me that he knew—with "1000% certainty"—upon meeting Bob and listening to the still-unreleased album, *Catch a Fire*, that the music would resound globally and have a vast cultural impact. He said the movie made him reflect on the incredible accomplishments of Bob's wife, Rita Marley, and Bob's children in keeping his message of One Love alive over the decades since his passing.

When the Wailers recorded *Catch a Fire* for my label, Island Records, in 1972, I felt that they would get somewhere if they had the image and energy of a Black rock act. Despite the skepticism of my colleagues, the gamble paid off, taking Jamaican music into an exciting future. Although we all realized we were onto something good, within a few years Bob Marley and the Wailers was an enormous international act, surviving the breakup of the original group.
But maybe Lee sensed something more than I did. He visualized how reggae would become the new center of global youth counterculture, while also opening doors for many other acts, and for Jamaica. Parts of that vision are documented in this fabulous book's photos, capturing the flavor of a unique time on the island and in popular music. In *Hit Me With Music: Roots Rock Reggae*, every shot—in its own way—expresses the heart and soul of the music and culture. Play some reggae and catch your own fire while you read the stories and view the photos that transport you in time.

Oracabessa, Jamaica, 2024.

Chris Blackwell, founder of Island Records, on a DC-3 he rented to fly from Jamaica to Trinidad for Carnival, March, 1973.

Lee is not only incredibly talented, but also a
person of great integrity. He was with the group
when the Wailers' international reggae revolution
began in the seventies, witnessing how the music
changed the world.

He approaches his art with authenticity and
dedication, always striving to create work that
is meaningful and impactful.

Cedella Marley

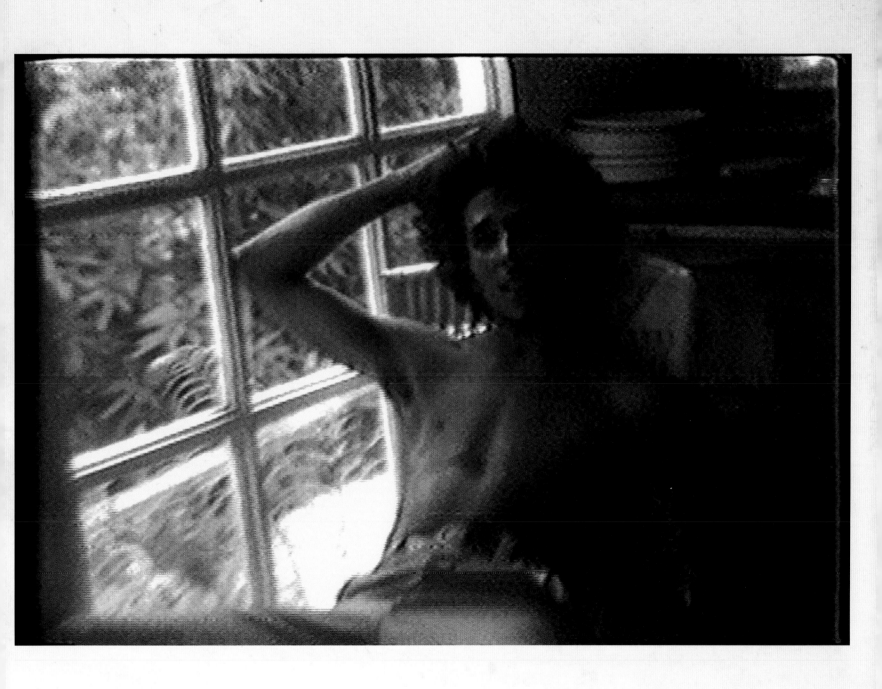

Bob Marley captured in a
Lee Jaffe video still, Jamaica, 1973.

London & New York

I met Island Records founder Chris Blackwell in the fall of 1972. I traveled to convince a young, London-based Jamaican film star, Esther Anderson, to act in my picture—which was to be my first feature—for free! She had starred in the soon-to-be-released Hollywood studio movie, *A Warm December*, opposite Sidney Poitier. I had assembled a cast of young, happening French actors including Zouzou (*Chloe in the Afternoon*, 1972), Jean-Pierre Kalfon (*Weekend*, 1967), Pierre Clémenti (*The Conformist*, 1970)—just released from prison in Italy for possession of hashish—and an unknown Maria Schneider, who had starred opposite Marlon Brando in the soon-to-be-released *Last Tango in Paris*. My idea was to

make a movie of our planned trek to the Andes in search of a hallucinogenic root used by the Incas.

When I arrived in London from Paris, I phoned Esther. I was focused on my mission to round out the cast with a Hollywood star. She said, "Be at my flat at seven o'clock tonight. We're going to the movies." She was bossy in a Joan Crawford kind of way, and she wasn't asking. It was an order and I was to humbly obey.

She lived in a small but posh flat in Cheney Row in the very upscale Chelsea. The place was sumptuously embellished with expensive-feeling North African carpets and pillows flaunting a disregard for nationalistic boundaries. Esther was even more exquisitely gorgeous

in person than on the screen, with her piercing dark eyes, long, straight black hair and a warm, ebullient, coffee-toned aura that belied her rising, establishment stardom.

Elegantly and eclectically adorned in an earthy way that rose above being categorized as "privileged class," she intoned through her dress and manner a release from the bonds of colonialism in a Far Eastern way that accented her Indian ancestry (her great-grandparents having arrived in Jamaica as indentured servants after England "abolished" slavery in 1839). She said, "My friends made this movie and we are going to the premiere."

What threw me was that it wasn't a limo that picked us up; rather, Chris Blackwell himself was driving. Seated next to him was the movie's director, Perry Henzell, and they weren't in a Rolls Royce or Jaguar. It was a 1969 Firebird convertible, which, of course, had the steering wheel on the wrong side in England. It was outside the realm of pretension and a minor shock compared to what was in store for me that evening.

Until then, I knew Chris only by reputation. He had a larger-than-life aura. He was in a pantheon of music moguls that included Ahmet Ertegun, founder of Atlantic Records (the premier R&B record label); Clive Davis, who ran Columbia Records; Bill Graham, who owned the Fillmore East and West and managed the Grateful Dead and Santana; and Albert Grossman, who managed Bob Dylan and Janis Joplin. For me, Chris had an even greater mystique than any of them; his label, Island Records, represented a dedication to allowing art to flourish in the domain of popular culture.

Indeed, Island was having huge commercial success with Traffic—an eclectic band established in 1967 that combined elements of jazz and West African music with poetic lyrics and psychedelic rock—as well as with singer-songwriter Cat Stevens, who was selling millions of albums. Island's other hit acts included rock groups such as Jethro Tull, Free, Uriah Heep, and Roxy Music. But for me, what separated Island Records from all other labels in the pop music realm was that it was also releasing amazing music that seemingly had little chance of wide commercial success, yet still treated the artists producing this music with the same respect as its biggest pop stars. Island's varied roster also included acts like the experimental electronic group, White Noise, idiosyncratic guitarist, John Martyn, enigmatic singer-songwriter, Sandy Denny, and the shapeshifting Brian Eno whose solo debut was released in 1973.

We were headed to Brixton, London's West Indian neighborhood. This was new to me. I was naive to the extent that I didn't even know a place like that existed in London.

For all intents and purposes this was a premiere; however, I learned several decades later in 2004 when an ailing Perry Henzell gave a talk before a screening in Ocho Rios, Jamaica, that this was actually the third night the movie had played.

The first night, no one came. Perry explained that several months earlier another West Indian movie had been released (a first of its kind) and no one liked it; people just thought *The Harder They Come* would be like that. Perry recounted that the next morning he went to the Island office and mimeographed flyers (there were no Xerox machines yet)—and personally went all over Brixton handing them out and imploring people to come. That night the theater was about one quarter full.

When we arrived at the theater that third night—Chris, Perry, Esther, and me—there was a line around the block, sold out on word of mouth from the night before. The theater was electric with anticipation. I was possibly the only person of non-West-Indian origin in the audience, and from the opening scene on I was surrounded by cheering and laughter, and enthralled by the music and the stark introduction to Rasta culture.

Hearing the pre-release cassette of *Catch a Fire* in Jim Capaldi's New York hotel room months later in February 1973—in the physical presence of Bob Marley—really changed everything for me. I got out of the cab at 56th and 6th; it was February, and the sky was crystal-line with a dark winter sun bouncing off the filthy white remnants of week-old snow. I shivered. I knew my life was at a crossroads. I was 24 years old. I had a stellar cast and crew assembled. We were supposed to leave for Chile the next day to start filming what was to be my first feature—an unscripted search for a mystical hallucino-genic root in the southern Andes that the great sculptor Gordon Matta-Clark had told me about.

He had come across it on a recent trip to discover his ancestral roots—but the CIA had upset my plans. People were disappearing, including our Chilean co-producer. Soon, Salvador Allende was to be assassinated.

My world seemed then completely uncertain.But meeting Bob, and hearing that music for the first time instantly opened other doors. The flaming roots reggae of *Catch a Fire* led me in a new direction.

How I Met Bob

In 1972, like the rest of the world outside of the Jamaican diaspora, my first knowledge of reggae came from seeing the just-released movie, *The Harder They Come*. It was a movie that showed Jamaica beyond the stereotypical image of the straw-hatted banjo player with white patent leather shoes and a plastic smile, warbling mento tunes on the beach at north coast resorts. It served to introduce reggae—its dichotomy of irresistible dance rhythms juxtaposed against lyrics of social and political resistance and rebellion—and the revelation that something other than entertaining tourists was going on in this island whose ethnographic cultural mix was a microcosm portending a 21st-century world.

The cast was all "Black," but in reality, the movie revealed "Black" to be various shades of brown, and a class conflict intrinsically tied to shades of skin color. Its hero, Ivan, an aspiring singer played by Jimmy Cliff, rebels first against the big record company and its light-skinned owner—appropriately named "Mr. Hilton"—by not accepting an exploitative contract, resulting in the record company shelving his record. Then, working by running ganja from the country to the city, he refuses to make payoffs to the government higher-ups, precipitating a shoot-out with police. Police die, Ivan escapes, and as he continues to elude capture, his fame increases exponentially. Of course, the company releases his record and it immediately goes to #1.

In the final scene, Ivan is killed attempting to get on a boat to Cuba. But as I sat in the movie theater in Brixton, London's center of West Indian culture, I reveled in the excitement that this exquisitely crafted movie with its irresistible soundtrack was not only made, but that it would certainly find a vast audience of middle-class white kids like myself. I watched the film with its director Perry Henzell and producer, Island Records founder, Chris Blackwell—myself probably the only non-Jamaican in the crazily enthusiastic packed house that was alternately laughing uncontrollably and cheering wildly throughout. Little did I know that several months later, I would meet the lead singer of a group that Chris was producing for Island Records, and that I would get invited on a ten-day trip from Kingston to Trinidad for Carnival, and that this trip would turn into a lifetime.

I met Bob Marley in February of 1973 in New York, where he was visiting to buy equipment for his band, the Wailers. They had just finished their debut album for Island Records, *Catch a Fire*, and when I first heard it—even having been forewarned by *The Harder They Come*—I was totally overwhelmed. I had gone to see a friend, Jim Capaldi, who was the co-writer and drummer for the British rock group, Traffic. His group had just played two sold-out shows at the American Academy of Music, and sadly these were among their last gigs. For me, Traffic signified unquestionably that popular music could be powerful, popular, multicultural and high art. It was English poetry and African percussion, expertly performed by Rebop Kwaku Baah (d. 1983). It was the blues, and it was symphonic.

Bob—completely unknown to me—was in Jim's suite. Jim had a cassette of the unreleased *Catch a Fire*. He had a boombox and asked Bob to play it for me. With budding dreads, Bob seemed shy and reticent, yet his eyes were keen and radiant—as if nothing could get past them. Bob was sitting in a chair in the corner of the living room, his locks transitioning from an afro, and undeniably charismatic. As soon as I walked in, Jim said, "You have to hear this." He smiled at Bob who half-laughed, accepting the rock star's unabashed enthusiasm, but with the calm knowledge that though they may be in the same room, just a mile from the American Academy of Music, he would have to travel tens of thousands of hard winding miles to someday perform where Jim had just been an hour before. Jim then pressed play on the cassette deck. What I experienced in the next ninety seconds changed for me indelibly all that would follow. The mixture of sounds: rhythms upside down, so new to North American ears; Peter Tosh's guitar used as a percussion instrument; the hipness of the clavinet, which had just then burst on to the scene with Stevie Wonder's "Superstition"; the innovative Joe Higgs-taught harmonies informed by the whole of R&B history; and the interminable power of the poetic "Concrete Jungle," a voice that once and for eternity deconstructed the myth of the smiling, docile native, blissful in a tropical paradise, and the colonialist concept of the "noble savage," soon to be gently faded below the horizon like a Caribbean sunset.

The first lines were so unforgettable: "No sun will shine in my day to day / The high yellow moon won't come out to play… In this here concrete jungle / Where living is hardest."

My mind raced and heartbeat quickened. Poetic, spiritual, brazenly revolutionary…

First Week
with Gong
a.k.a. Bob Marley

New York City
February 10th, 1973

The ice crackled under my feet with every hesitant step. The wind strangled my breath. If I had known really what a Rastaman was, I would have thought this was no place for a dreadlocks. We were the cruel weather's toys hunched in our overcoats begging for mother nature's forgiveness, but we were on a mission—a mission, that for the years we sparred, was the interminable, relentless, and intractable search for the better "herb."

I pierced the night air with a high-pitched wail to let Bob know I was a "sufferer" too, and it was all he could do not to double over laughing as we picked up the pace along Central Park West, trying not to lose our balance on the slick sidewalk layered with the week-old remnants of a nasty frozen mix of city grime and snow. A flock of pigeons shuddered above us, clamoring through the spiraling exhaust of a honking yellow cab, the pale din of headlights bobbing. A ragged out-of-place beggar in this more or less upscale neighborhood, wheeling a shopping cart overflowing with all his worldly possessions, coughed among the newly floating flakes of snow glowing in the lamplight, teetering on the verge of madness, and disappeared from consciousness as we turned left down West 85th St. lined with four-storied brownstones, their intact facades reminiscent of the stately zeitgeist of the Gilded Age, but now chopped into single floor railroad apartments to where my friend Brew, a 24-year-old art school dropout—now a precocious maestro distributor of the better strains of Colombian golds and reds—kept a "stash house."

We bounded up the four flights of stairs, shivering to escape the dampness and frigid hawk that whips unrelentingly in mid-winter NYC. Arriving, we found ourselves at the entrance to this ethereal cathedral of cannabis. With a confident hint of a smile signaling my expectation that I might impress this towering decolonized revolutionary genius—and he, with the stoic, yet inquisitive air of, "Have I seen this movie before?"— I knocked. A pause, in front of the formidable wooden steel-ringed door and then the clicking sound of one, two, three, four locks successively disengaging, and Brew, with a proud old-buddy-made-good smile greeting us in fake patois, "Yes mon. Come forward mon." Brew stood 6 feet tall with impish, yet ultra-attentive blue-green eyes that made you feel nothing could slip past them, sporting the honed athletic build of the serious kung fu practitioner that he was.

Normally, only The Brew's small contingent of trusted jobbers was ever allowed entry to the hallowed abode. Occasionally, he would accept deliveries of crocus sacked bales wrapped in sealed plastic and ensconced in

The door Bob and I entered to meet Brew, the pioneering herb dealer.

innocuous cardboard boxes, that were in turn dispatched to the half dozen dealers scattered throughout the-city-that-never-sleeps. But I was a trusted exception.
I had met Brew through his older brother, The Fox, in the late 1960s. We were at a big public university of a 30,000-plus student body, located in what seemed to the citified as the middle of nowhere—the vast campus with its stately ivy-covered buildings was a vision of rarified academia. Yet it was surrounded by the "Happy Valley" of deer hunters and racist redneck state troopers with their over-starched steel gray uniforms and stiff straight-brimmed hats, proudly embracing the aura and legacy of the revered "law enforcement agency."
It began in 1823 as a ten-man vigilante squad of executioners "whose job was to seize and hold Texas for the white man."
As an undergrad at Penn State, I had double majored in Art and LSD (not particularly in that order) with a minor in Mescaline and Peyote. My studies led me to believe that I had a mystical responsibility to elevate the consciousness of the historically fraternized beer-guzzling student body by turning them on to various—what were then exotic—controlled substances.
On weekends, once or twice a month, I would check school bulletin boards offering rides—four to five hours from central Pennsylvania to New York, in exchange for splitting the gas—and would often stay with Brew at his parents' swanky Upper East Side door-manned, high-rise apartment with its leopard skin-patterned velvet couch and pristine view of the East River and 59th St. Bridge. His parents were living mostly in Florida, and we'd take advantage of the time at the vacated hutch and the roiling "sexual revolution," experimenting with the newest psychedelics, tripping and having sex with as many willing cute girls as possible. We did our first pot deals together. We'd scraped up enough money to buy a pound and then sell ounces and half ounces, the proceeds of which got us into concerts at the Fillmore East and clubs like The Scene and The Salvation. I'd carry back some bounty to State College and sell to what quickly became a growing intrigued student body, eager to get a taste of what the "counterculture" of the 1960s was all about.
When I dropped out of college before my senior year and went off to Brazil and then Paris, Brew had continued his life in the cannabis trade eventually convincing his brother—"The Fox"—to quit his lucrative job as a Wall Street headhunter to come help him turn his burgeoning pot dealing enterprise into a real business. Now we were together, escorting the new signee to the label of Traffic and Cat Stevens and Free—eager to impress this "third world" advocate of herbs and revolution.
Brew escorted us through a narrow foyer that opened to an expansive "living room" with a vaulted fourteen-foot ceiling. There was an expensive-looking Chinese rug covering the polished hardwood floor, and a posh black leather couch with deco chairs surrounding a blue-glass coffee table. Behind the couch, a florid art-nouveau armoire, its gaudy arms spread open wide revealing hand-crafted shelves supporting the most high-end McIntosh stereo gear, and against the opposite wall on either side of the working wood-burning ornate fireplace was a free-standing state-of-the-art Klipsch speaker system.
A few days before, I had given Brew an advance copy of the as-yet unreleased *Catch a Fire* album—the group's first on Island Records—and the first Wailers album to have an international release. Brew teed it up on his turntable.

No sun will shine in my day today
The high yellow moon won't come out to play
I said darkness has covered my light
(Darkness has covered my light)
And has changed my day into night, yeah
Where is the love to be found ?
Won't someone tell me ?
Cause life (Sweet life)
Must be somewhere to be found
(Has got to be, out there somewhere for me)
Instead of concrete jungle
(Jungle, jungle, jungle)
Where the living is hardest (Concrete jungle)
Concrete jungle (Concrete jungle,
** jungle, jungle)**
Man, you've got to do your best

Framed European film posters hung on the walls; *Blow Up*, *La Dolce Vita*, and an *Easy Rider* poster depicting Dennis Hopper and Peter Fonda on choppers.

Sitting on the reflective coffee table was a hand-carved, wooden box of Nepalese origin, with an ounce of Columbian sticky dark reddish buds and a pack of Big Bambu rolling papers. Brew lifted the silver-hinged case and ceremoniously offered Bob the meditative "weed" with the self-confidence of knowing he had the best smoke in the world.

Then, to Brew's astonishment, eyebrows raised, Bob licked five papers together and rolled the largest joint Brew had ever seen. Before lighting, Bob looked up and said with a wry, satisfied smile, "In Jamaica, we call dat a spliff mon." Not missing a beat, Brew, all business, said "I have something to show you."

We followed Brew to the rear of the apartment, to what would have been the master bedroom. The smooth sounds from the McIntosh amp enhancing the dichotomy between lilting rhythm and Bob's uncompromising lyrics trailed us, and Brew, who had memorized all the words, sang along surprisingly and thankfully not out of tune.

Every time I hear the crock of a whip my blood runs cold. I remember on a slave ship how they brutalized my very soul... Slave driver, the tables are turned... Slave driver ya gonna get burned...

It was awkward and bordered on embarrassing, yet was also an endearing acknowledgement of the monumentality of the work of this still-obscure artist that was so worth listening to over and over again.

The music faded behind us as we followed him to the rear of the apartment.

Brew, his short scruffy beard disguising his babyface features, switched on the light and sauntered to the far end, where iron security bars enclosed a window looking down four stories to a dimly lit frozen backyard garden. He pulled shut the plush, dark red velvet blackout curtains. A large, thick, garlanded wooden table with wheeled hand-carved lions' feet and a green, leather brass studded top, sat along the wall left of the window. There was a framed black and white photograph of Jimi Hendrix burning his guitar on stage at the Monterey

Pop Festival in 1967, and Brew lifted it and placed it preciously on the tabletop. On the opposite wall hung an eight-by-six-inch well-varnished, obsessively detailed photo-realist painting of a massive half-smiling guerilla in the mist.

The Gong—Bob was nicknamed as Tuff Gong as a youth in Trenchtown, Jamaica—gave me a suspicious sideways glance as Brew wheeled the heavy table to the center of the room and then partially lifted it to allow his hand to slip beneath the garrulous ape and the wall, reaching behind the ignominious likeness.

Slowly, the wall opposite began to rise Lazarus-like from the bottom up, revealing a stash of forty or so bales-up-on-bales, stacked one on top of each other in neat rows of three. They were sealed in thick, clear plastic wrap and labeled with black magic marker, grading them "A" or "AA," along with their weights in kilos ranging from 7.25, 6.4, 5.85. All of this enclosed the softly pressed, prodigious burlap-cloaked foliage.

Gong, half-squinting, squeezed his chin between his thumb and forefinger and nodded slightly, his nascently emerging dreadlocks foreshadowing an everlasting, boundaryless cultural phenomenon. I returned his mischievous gaze and then after a pause, like a pause between notes of an Aston "Familyman" Barrett bass line, he declared: "Bwoy ya na easy," igniting rollicking laughter while acknowledging that yeah, this was a plot twist he was not expecting.

Brew lifted one of the bales and hauled it onto the posh, formidable furnishing, revealing and transforming it, as was his wont, into an elegant, often-used industrial grade worktable. He pulled a mother-of-pearl inlaid ratchet knife from his pocket, and whipping it open cut two long slits into the plastic, peeled it back, and then cut into the thick burlap. He reached in, grabbing a loving fistful of the sweet and pungent herb,

and raised the flowers to his professionally well-educated nose. If they were giving PhDs in smuggler perfumery, I should have introduced Brew as "Doctor Brew." "Have a whiff mon," he said, lowering his well-accomplished nozzle to catch a whiff himself.

At that moment, my mind drifted and I found myself wandering in a TV commercial escorted on donkeys through a farm, high in the mountains of the Sierra Nevada de Santa Marta. An unseen angelic mestizo plucked a tiple, its strings tintinnabulating through the thick, dreamy tropic air. Each barebacked, past-their-prime *Equus asinus* (African wild ass) navigated craggily through the jungle terrain, snouts snorting and bobbing in the jingly-jangly heavenly afternoon. But instead of Juan Valdez cheerfully hawking the richness of Colombian coffee, he was espousing the redoubtable merits of Colombian marijuana.

"To the people of Colombia, South America, the sun is not just a fair-weather friend, amigo. All year long it keeps the mountain air as sweet as Spring. For these trees—the trees of Juan Valdez—it is the best climate in the world. The branches grow strong and full and fragrant with flowers."

Peasants plied lustrous green fields while others gathered cured stalks hanging upside down in a steamy post-deluge afternoon haze. I imagined hundreds with identical Juan Valdez hats and tiny scissors clipping the buds off the thick, tough, tacky branches, soft-pressing them into crocus sacks and piling them onto the mule and donkey-backs meandering down craggy hillsides to meet ancient generic trucks that were manned by grizzled drivers with bodyguards armed with unretired army surplus Kalashnikovs riding shotgun, waiting for the chance to deliver the sweet and pungent cargo to a trawler of undetermined origin, parked, Federales-protected, in the sea-glistening Caribbean harbor.

I snapped forward into reality…

Brew grabbed a Ziploc from the brass-handled table draw and lovingly—in acknowledgement of the arduous and dangerous journey the seasoned blooms had survived, evading remote mountain bandidos, modern day Pirates of the Caribbean, DEA Coast Guards and multiple state police and highway patrols on the trek northward from the Florida Keys to NYC—settled the handful of flowers into the sandwich bag and then pulled another handful, added it, then swooshed the bag closed. He grabbed a shiny-gray roll of duct tape from the open draw and tore off a strip to re-seal the bale, then lifted it and re-stacked it behind the fallacious wall. Brew turned around and stepped toward the smirking redheaded Silverback Congolese. He blurted a cheerful "hi," then meticulously—so as to "not disturb" the lulling, larger than life ape—reached again behind him/her and, with the miracle of modern gadgetry, made the wall opposite smoothly lower itself Mission Impossible-style, concealing once again the mind-expanding stash.

We returned to the drawing room, and Brew gifted the bag of "weed" as if to say, "Welcome to Gotham, Rastafari." Gong, with his gigantic spliff less than half spent, eyed in the corner of the room a guitar stand cradling a voluptuous pre-war jumbo Gibson SJ-200—its glorious brown spruce sunburst body with dark maple sides and back, a neck inset with mother-of-pearl crowns and flowery tortoise shell pickguard, and engraved and hand-painted with inlaid dots of yellow and light orange—forlorn in all its glory. I rolled one up for myself as Bob set his eyes on the splendid axe. He looked at Brew as if asking permission, and Brew nodded "Yes mon, give that one a try mon." Bob rested his spliff on the black Murano

glass ashtray as I lighted up my paltry joint in an attempt to assuage the awkwardness of the situation. After all, Brew never played a lick of guitar, and who knew how long it had been sitting there untouched. Brew went for the precious instrument and brought it to Gong. As I suspected, it was badly out of tune, and it wasn't lost on me that there had never been seen an instrument like that in the "Concrete Jungle" of West Kingston. I had a Hohner Marine Band D harmonica, and I pulled it out of my side jeans pocket: "Here's an A," I said to Bob, and sucked in on the second reed. Bob quickly ned and started in on a song that wasn't on the *Catch a Fire* album.

Lord I got to keep on moving
Lord I got to get on down
Lord I've got to keep on moving
Where I can't be found,
where I can't be found
Lord they coming after me
I've been accused of a killing
Lord knows I didn't do
For hanging me
they are willing yeah! yeah!
And that's why I've got to get on thru

The song had two chords and it was easy to follow the rhythm emanating from his right hand. We jammed— transported as I was to a totally new mystical space—for what seemed to me an eternity.

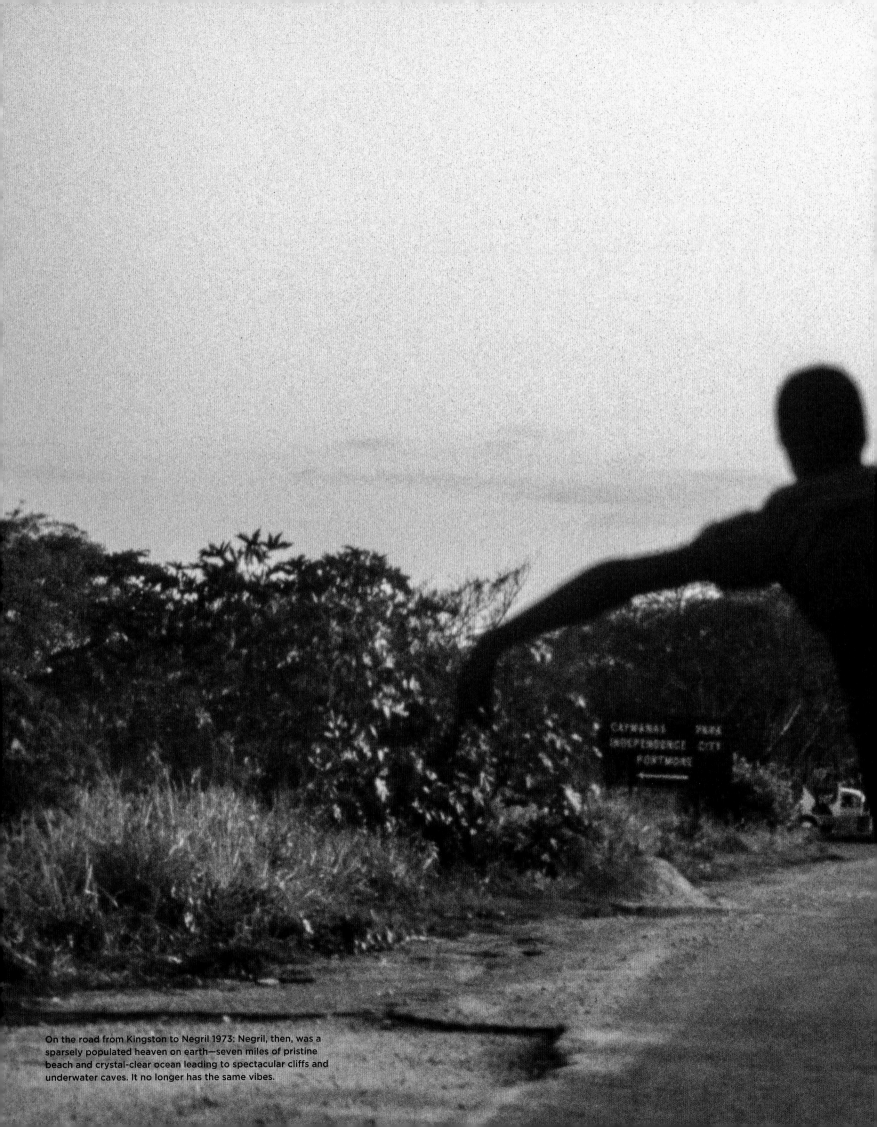

On the road from Kingston to Negril 1973: Negril, then, was a
sparsely populated heaven on earth—seven miles of pristine
beach and crystal-clear ocean leading to spectacular cliffs and
underwater caves. It no longer has the same vibes.

Nine Mile & Hope Road

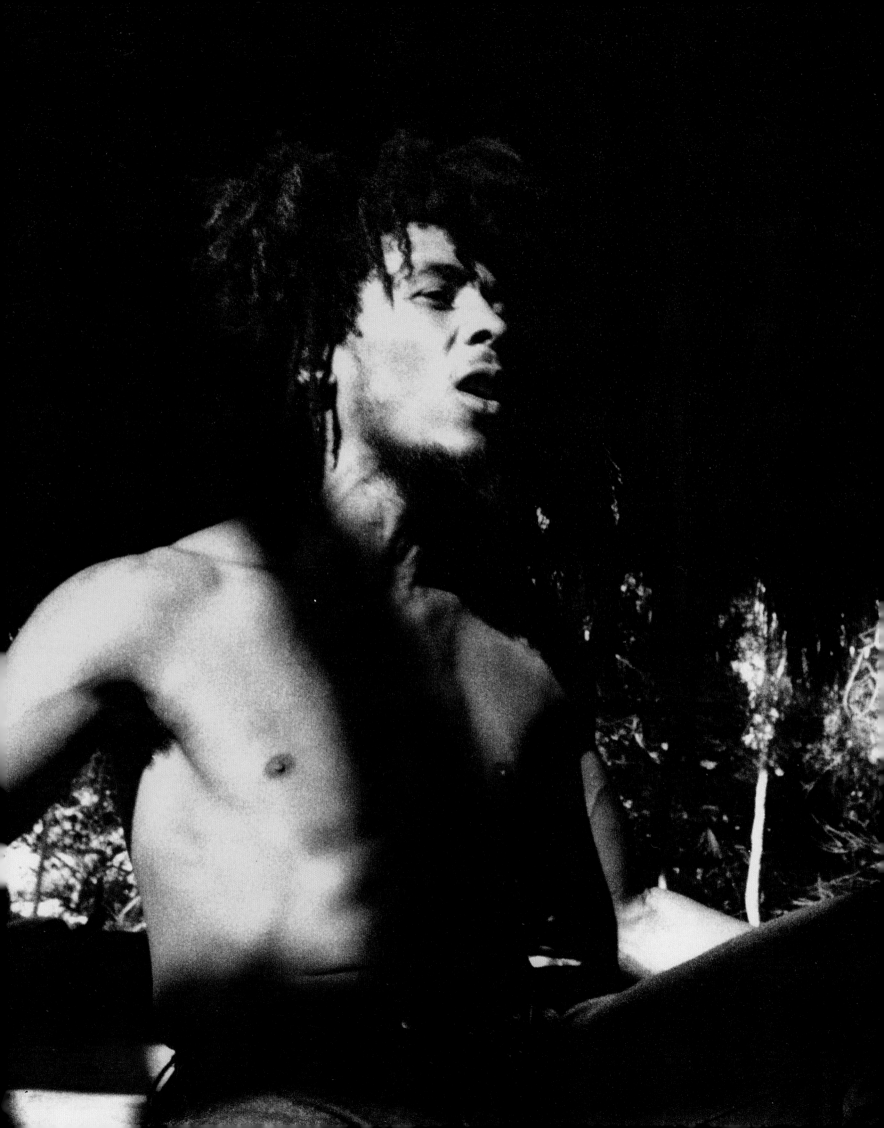

Nine Mile

Nine Mile was Bob Marley's rural birthplace
in St. Ann's Parish, and a refuge for him in
later years. Hope Road was in the city,
and #56 once represented colonial power.
The Wailers made it a symbolic cornerstone
of the reggae revolution.

He was a hero in Trench Town, Ghost Town, and "Concrete Jungle"—all the impoverished hardcore neighborhoods. When we'd drive out to the country, it seemed incredible how the people knew him, treating him like a son, or a brother, or a nephew. I could never tell—when people offered us their best herbs or *ital* food, or just their best wishes if they had nothing else to give—if they really knew him or were related, or just recognized him because he was in the Wailers and loved him for the joy and hope the music would always bring. We'd stop at the tiny roadside shops made of rusted zinc and wood, and they'd always have a jukebox with a few classic Wailers singles. I'd want to stop at every one of those shops because there just might be a Wailers record I hadn't known or heard. I can remember hearing "Trenchtown Rock" for the first time at one of these shacks at the side of a winding mountain road on a lazy golden late afternoon in Saint Ann's Parish. We were on our way to the tiny village, Nine Mile, where Bob was born, and upon punching in the tune on the ancient music machine, Bob's voice resounded and seemed to float through the lush green peaks and valleys around us: "Hit me with music… When it hits you feel no pain." No recording had ever moved me like that. I must have been shaking; I was so blown away. Bob had gone around to the back of the shop to look at some herb and roll a spliff. I just needed to hear that song over and over again, the scratchy vinyl 45 emanating from the ancient machine. Bob came around the front of the store, saw me, and said, "Wha happen to ya man???" I opened my mouth to try and say something, but it just stayed open with nothing coming out, and Bob joked, "Look like a duppy get ya mon," meaning I looked like a ghost had possessed me. Finally, I said "That's the greatest record I ever heard," and he threw his arm around my shoulder. He just started to laugh, and then we were both laughing, and he handed me his spliff, which he had just lit, and he said, "Take this spliff, Lee Jahfree—you need a good draw to scare dem duppy away."

Bob Marley at Little Bay, Westmoreland, Jamaica.

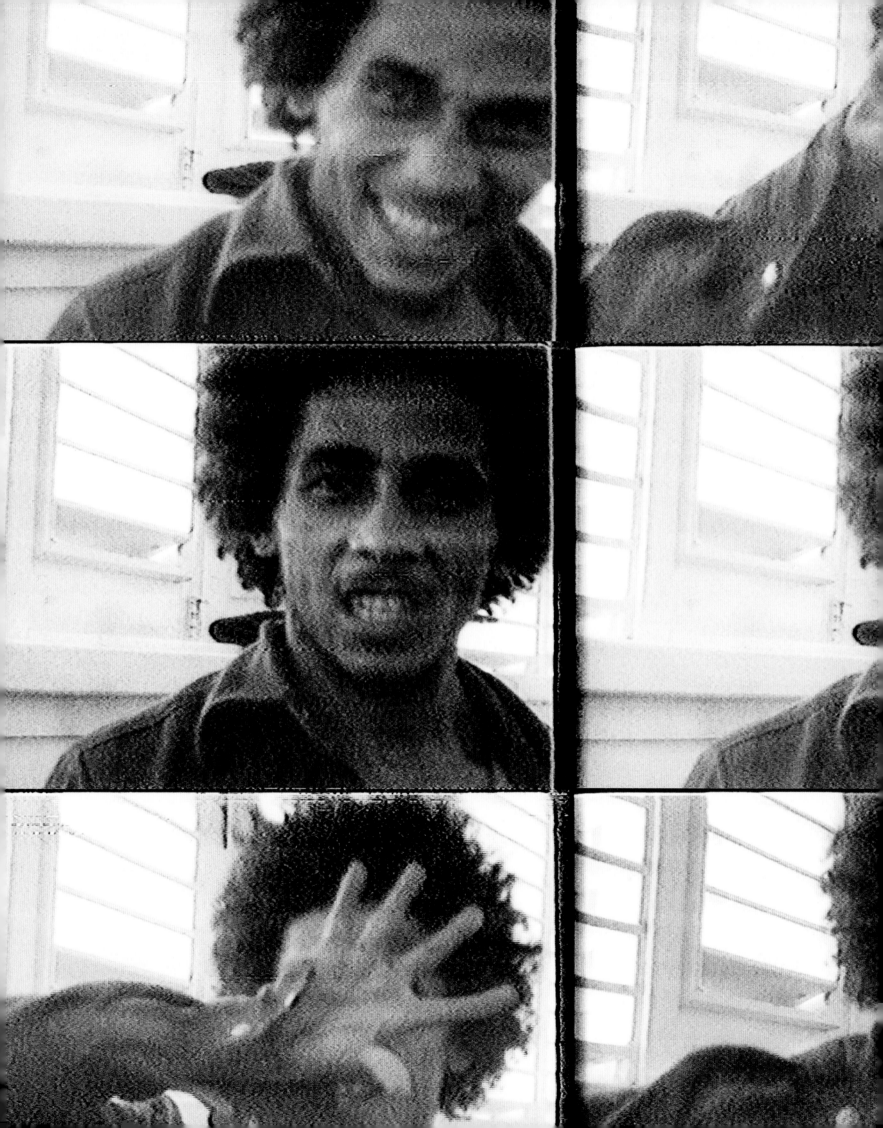

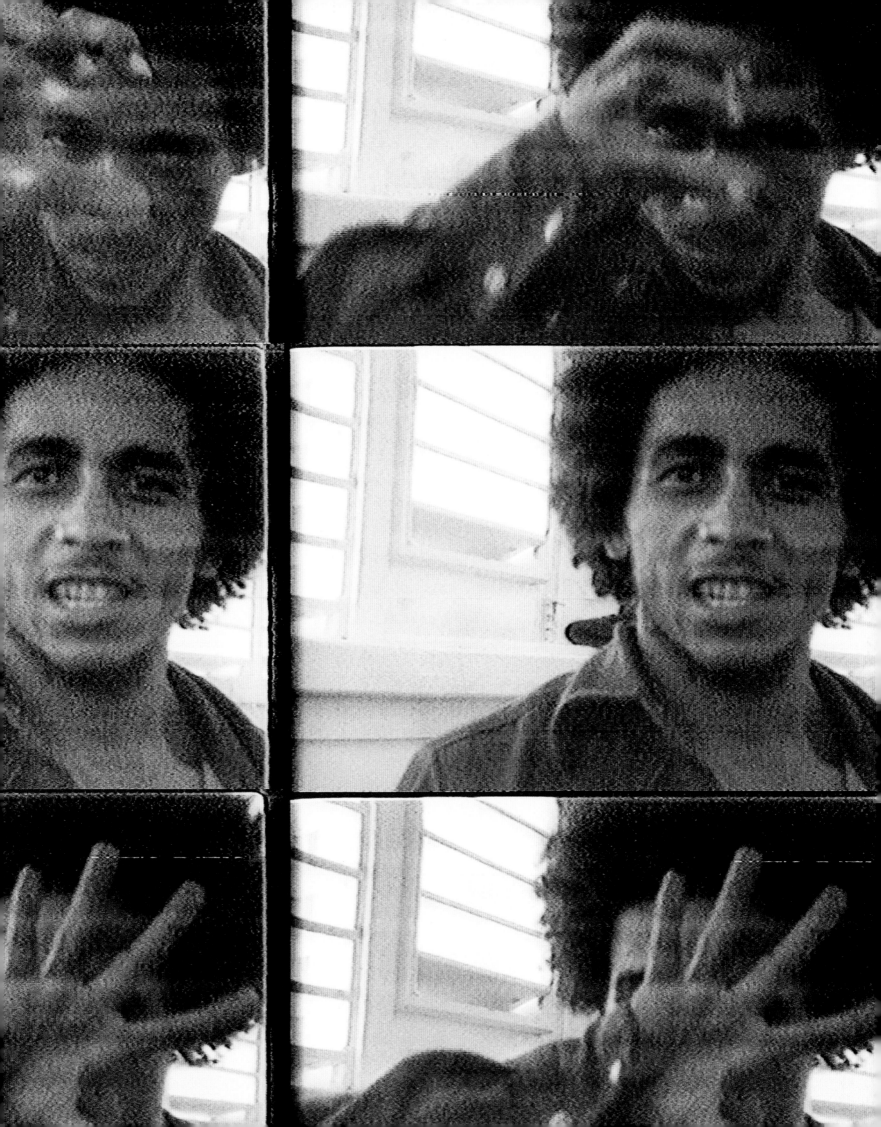

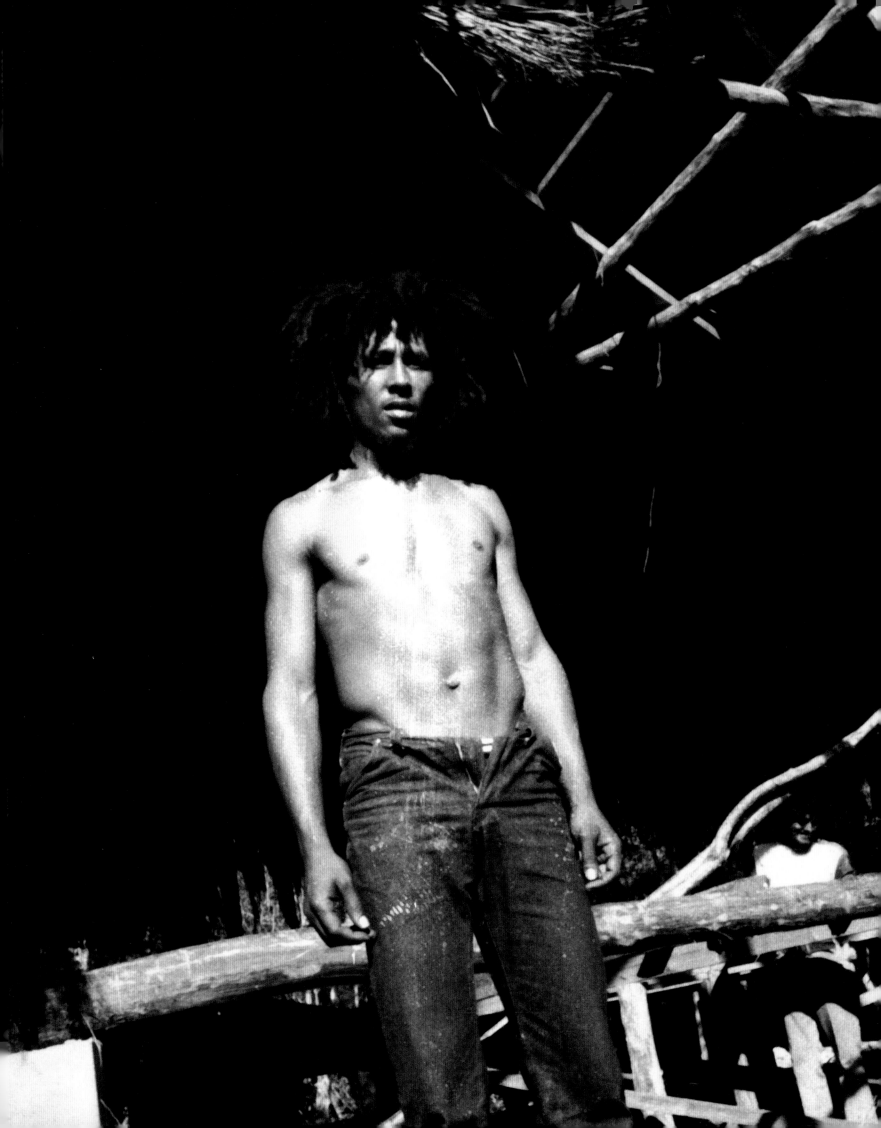

Hope Road

At 56 Hope Road, Kingston, Jamaica; when I first arrived in Jamaica, I settled into the two-story colonial great house. Chris Blackwell had bought it with the idea it could be an Island Records outpost. There were no remaining vestiges of ruling-class opulence, but there was an extra bedroom with a bed and clean sheets, which was comfortable enough. It had become the Wailers headquarters. At the end of the backyard, which was home to a majestic mango tree, was a small shack that had been the former slave quarters of the property, now transformed into a rehearsal room. In 1973, Rasta was not welcome in that uptown neighborhood which was just a five minute jog up the road from Jamaica House, the Prime Minister's residence.

The comings and goings of dreadlocked musicians represented a seismic cultural shift that would have global reverberations. When entering the compound for the first time, the sounds and power of Peter Tosh rehearsing the song "400 Years" with Familyman, Carlton Barrett, and "Wire" Lindo resounded through the yard. I had listened to this by now a hundred times from a cassette of the still-unreleased *Catch a Fire* album, but live in these surroundings, it shook me to my core…

Dickie Jobson, Chris's childhood friend who was managing the Wailers, had what was the first portable video camera—the Sony Portapak. It was a clunky box that hooked up to a reel-to-reel tape recorder, and I had some knowledge of it having used one in my conceptual art practice. I was excited to use it, knowing whatever I could record would have historical value.

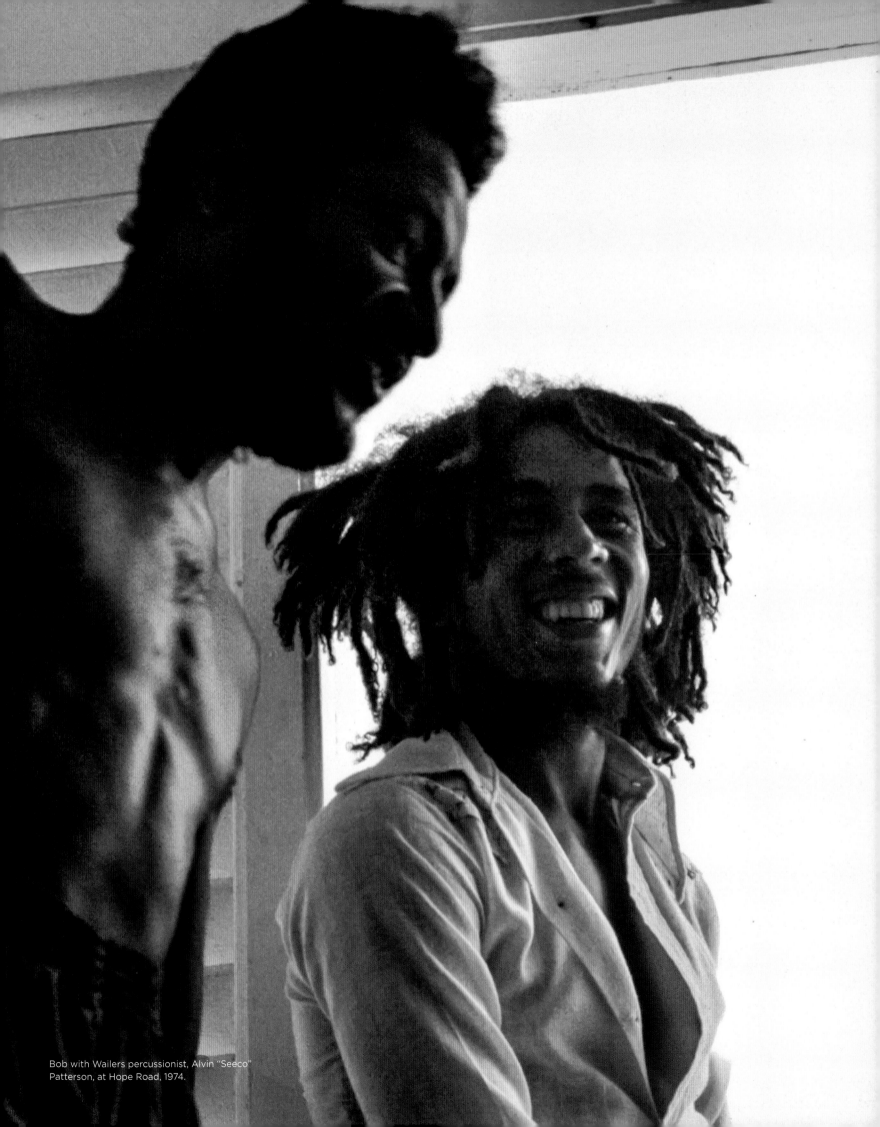

Bob with Wailers percussionist, Alvin "Seeco"
Patterson, at Hope Road, 1974.

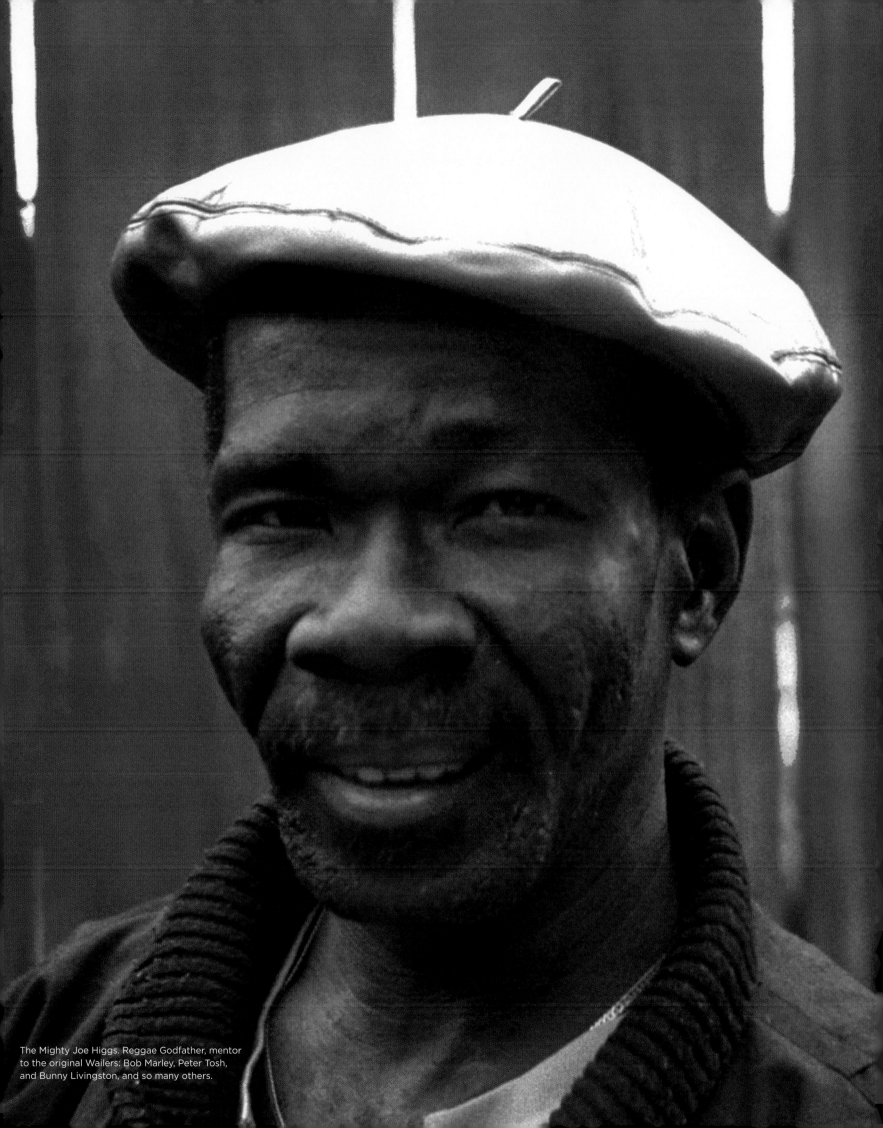

The Mighty Joe Higgs. Reggae Godfather, mentor
to the original Wailers: Bob Marley, Peter Tosh,
and Bunny Livingston, and so many others.

→4A →5 →5A →6 →6A →7

KODAK SAFETY FILM 5063 KODAK SAFETY FILM 5063 KOD

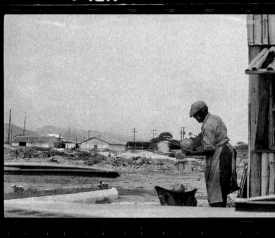

→10A →11 →11A →12 →12A →13

→19A →20 →20A E 6 6 9 →21A →22

SAFETY FILM 5063 KODAK SAFETY FILM 5063 KODAK SAFET

→28A →29 →29A →30 →30A →31

KODAK SAFETY FILM 5063 KODAK SAFETY FILM 5063

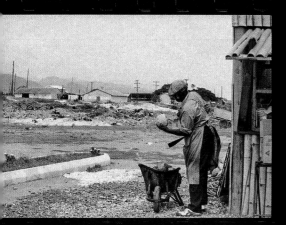
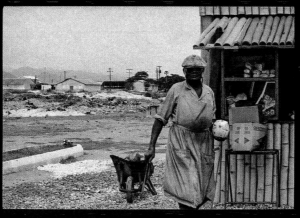

→22A →23 →23A →24 →24A →25

M 5063 KODAK SAFETY FILM 5063 KODAK SAFETY FILM 506

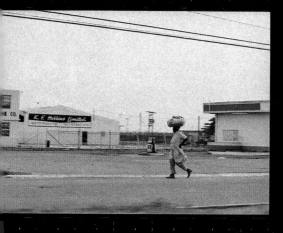

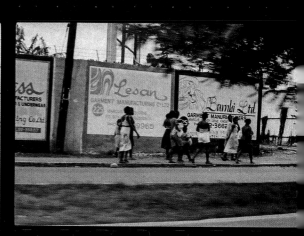

→16A →17 →17A KODAK SAFETY FILM 5063 →18A

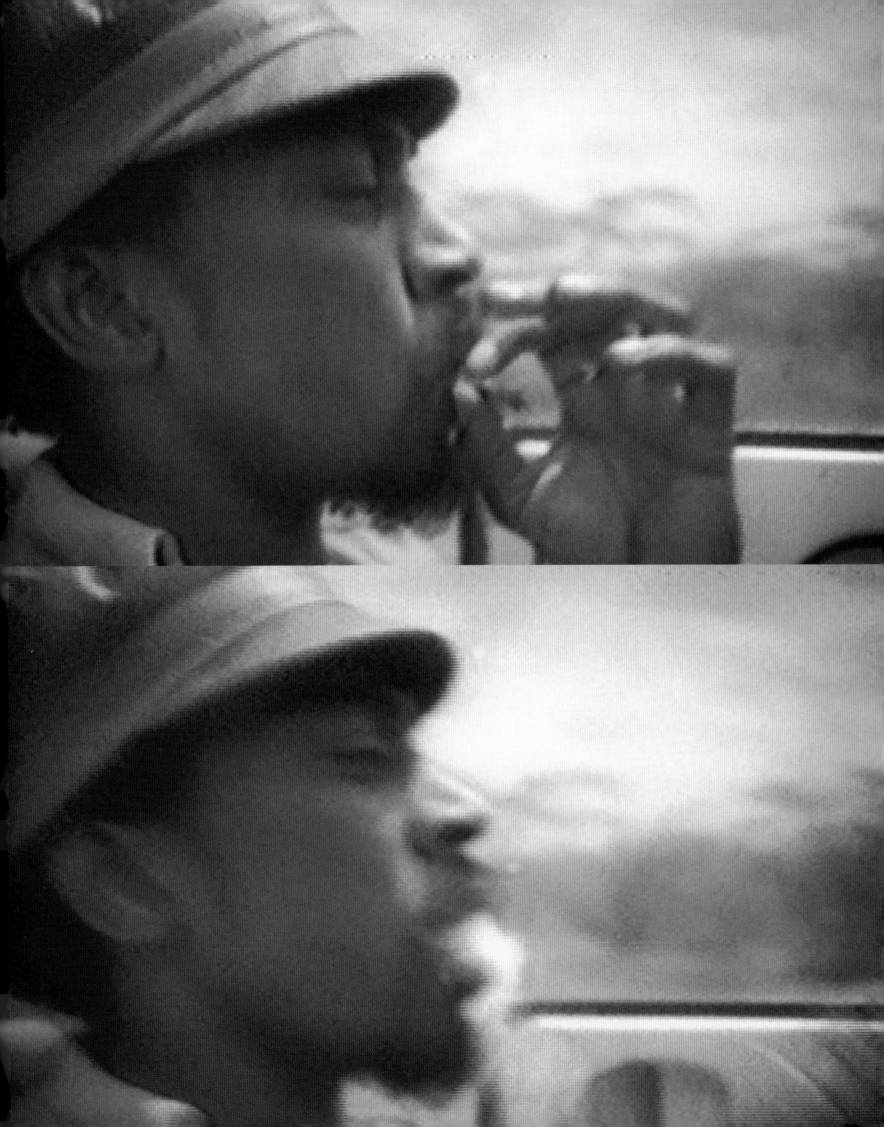

Bunny Wailer smoking a spliff on the road from Kingston
to Cane River Falls, 1973. Neville O'Riley Livingston, a.k.a.
Bunny Wailer, was, along with Peter Tosh and Bob Marley,
one of the three original Wailers.

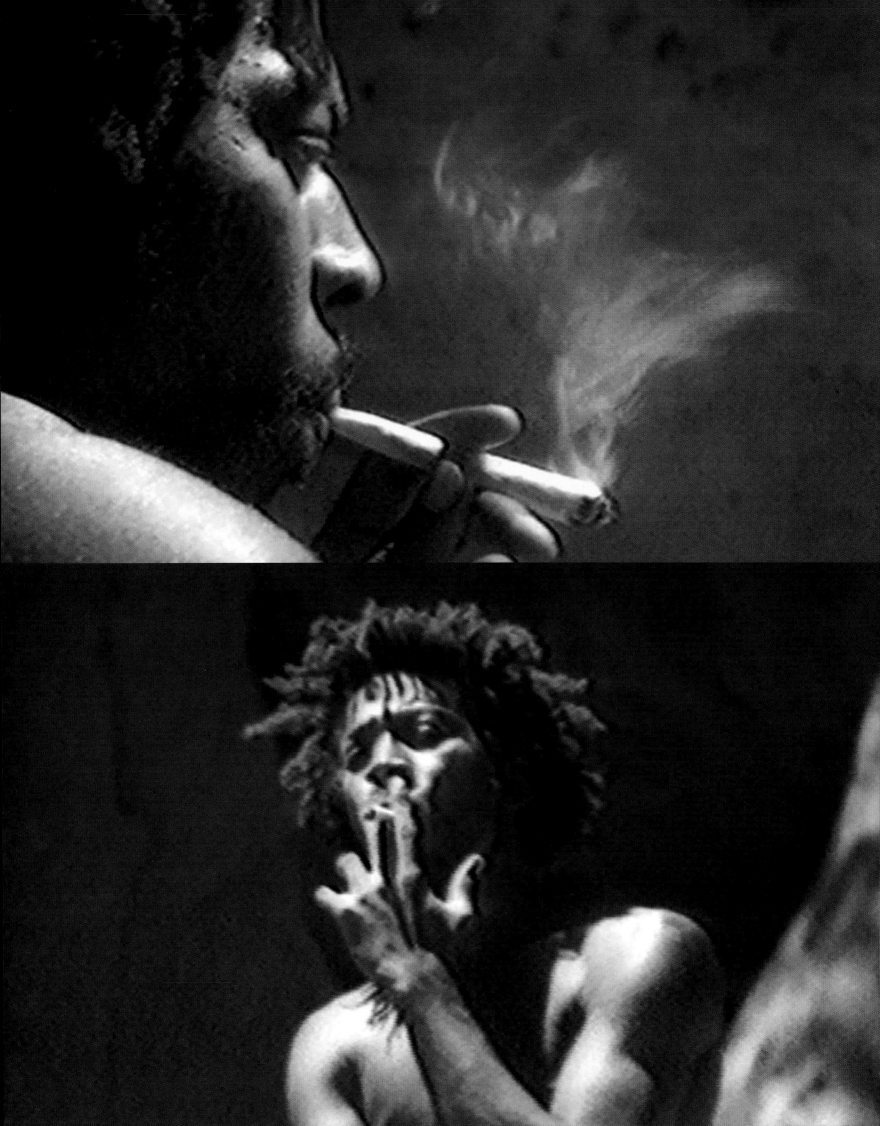

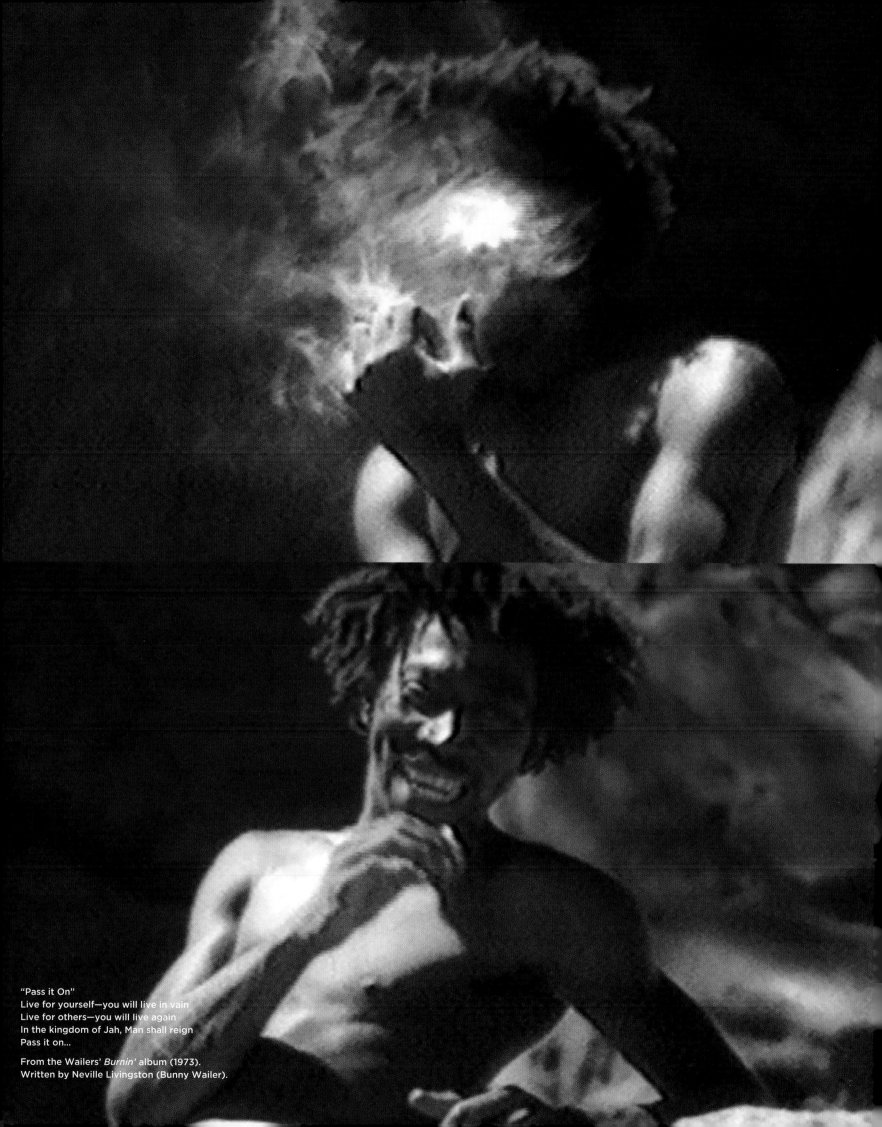

"Pass it On"
Live for yourself—you will live in vain
Live for others—you will live again
In the kingdom of Jah, Man shall reign
Pass it on...

From the Wailers' *Burnin'* album (1973).
Written by Neville Livingston (Bunny Wailer).

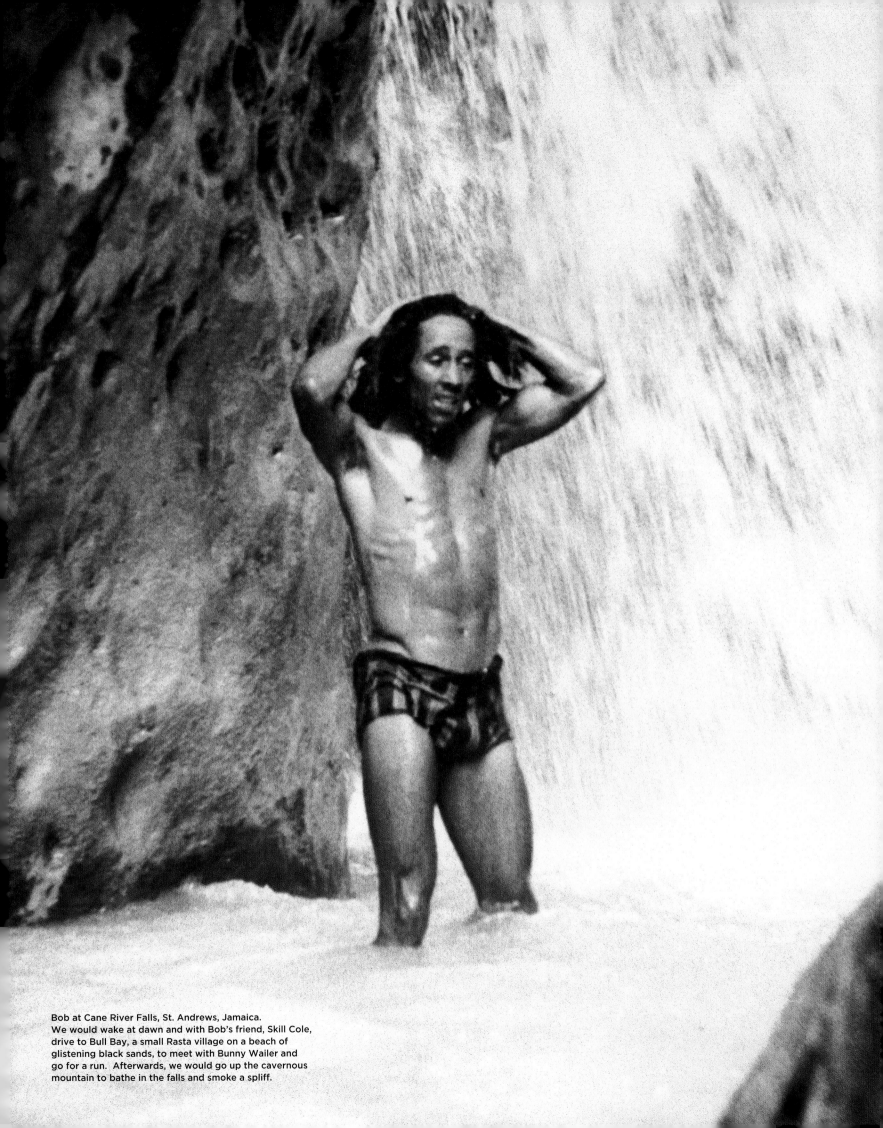

Bob at Cane River Falls, St. Andrews, Jamaica.
We would wake at dawn and with Bob's friend, Skill Cole,
drive to Bull Bay, a small Rasta village on a beach of
glistening black sands, to meet with Bunny Wailer and
go for a run. Afterwards, we would go up the cavernous
mountain to bathe in the falls and smoke a spliff.

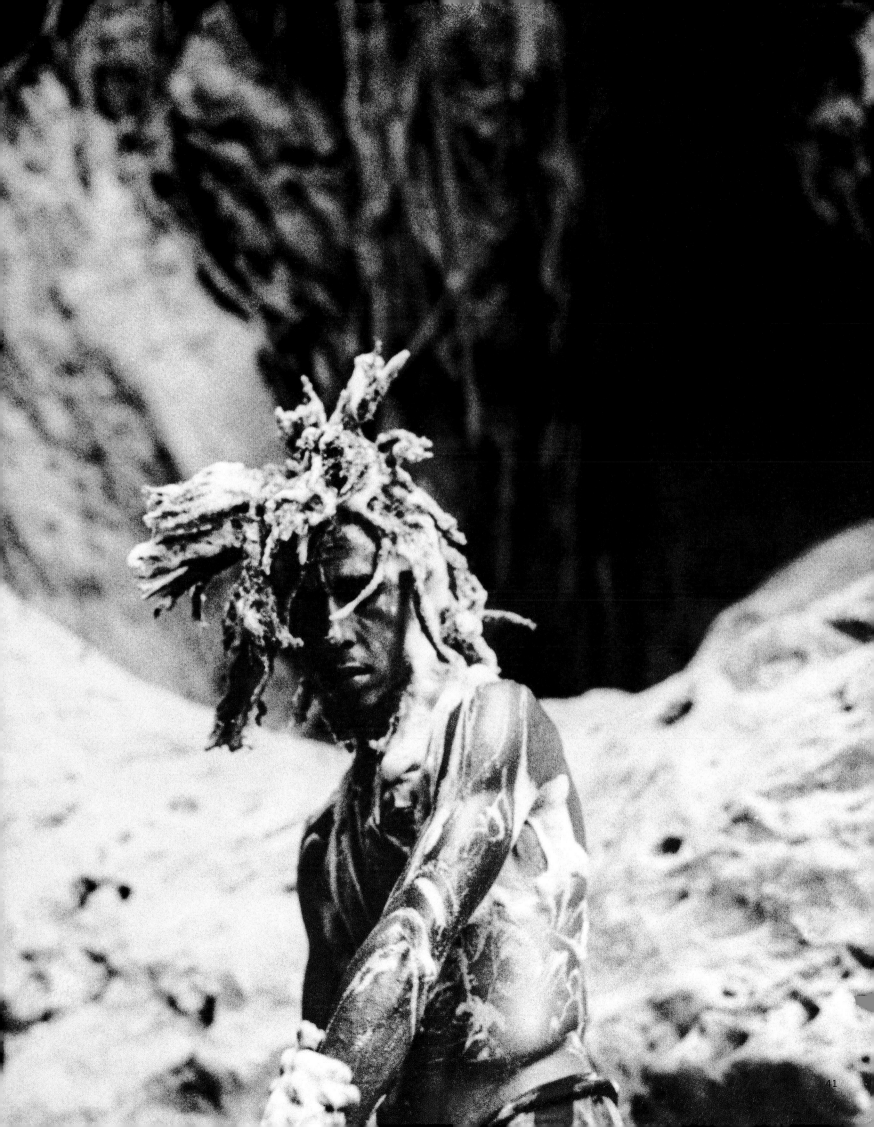

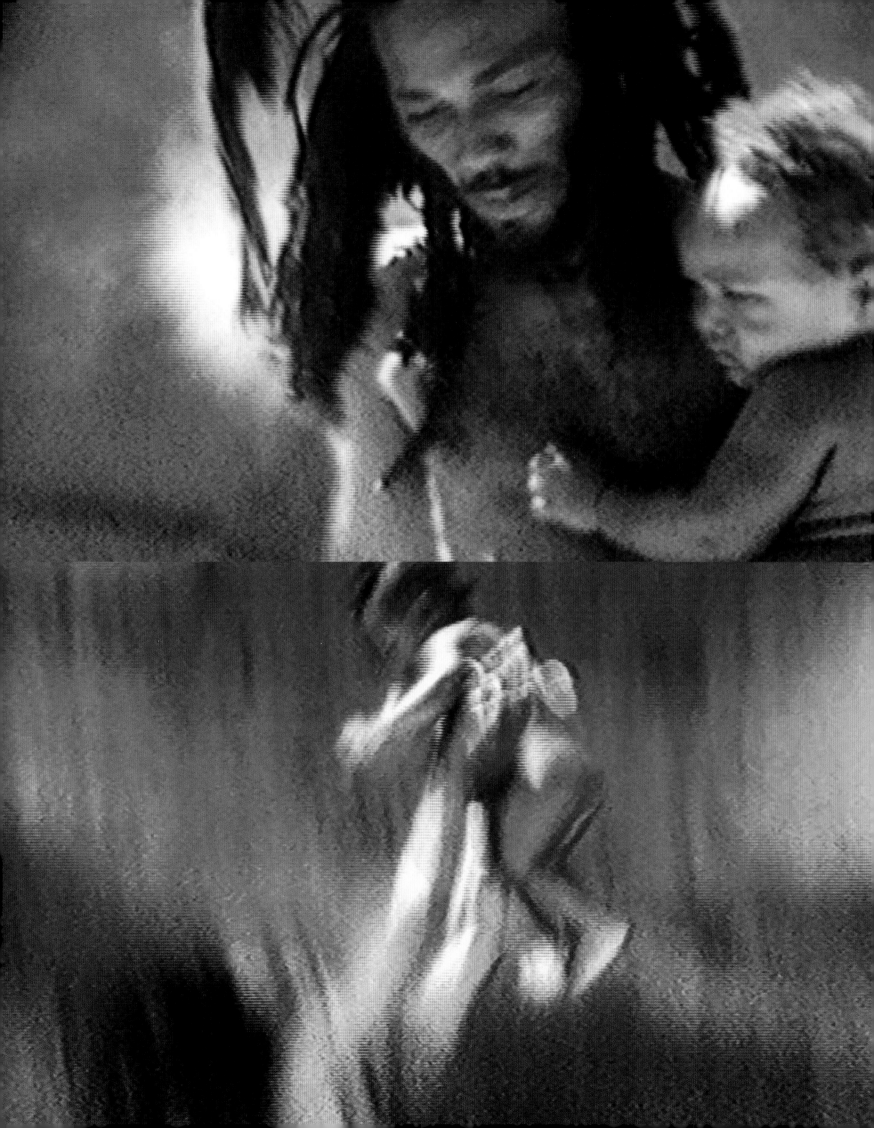

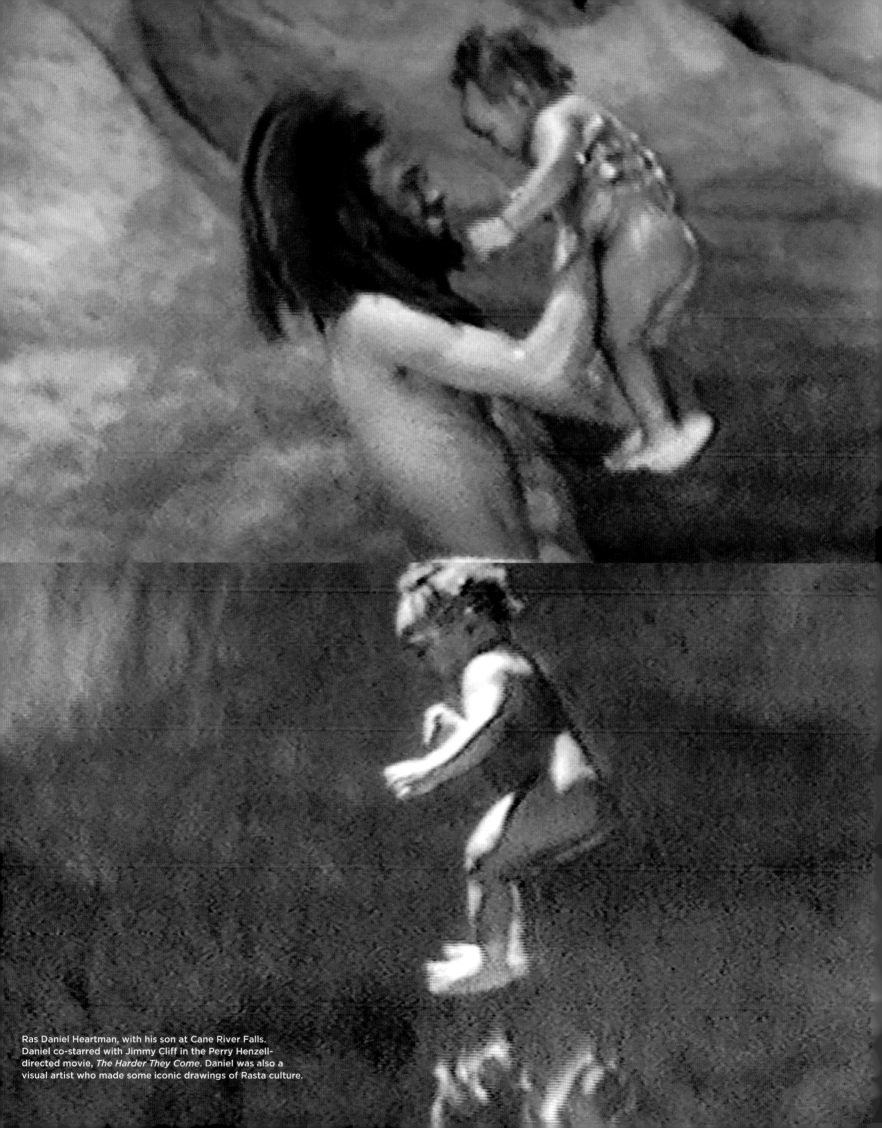

Ras Daniel Heartman, with his son at Cane River Falls.
Daniel co-starred with Jimmy Cliff in the Perry Henzell-
directed movie, *The Harder They Come*. Daniel was also a
visual artist who made some iconic drawings of Rasta culture.

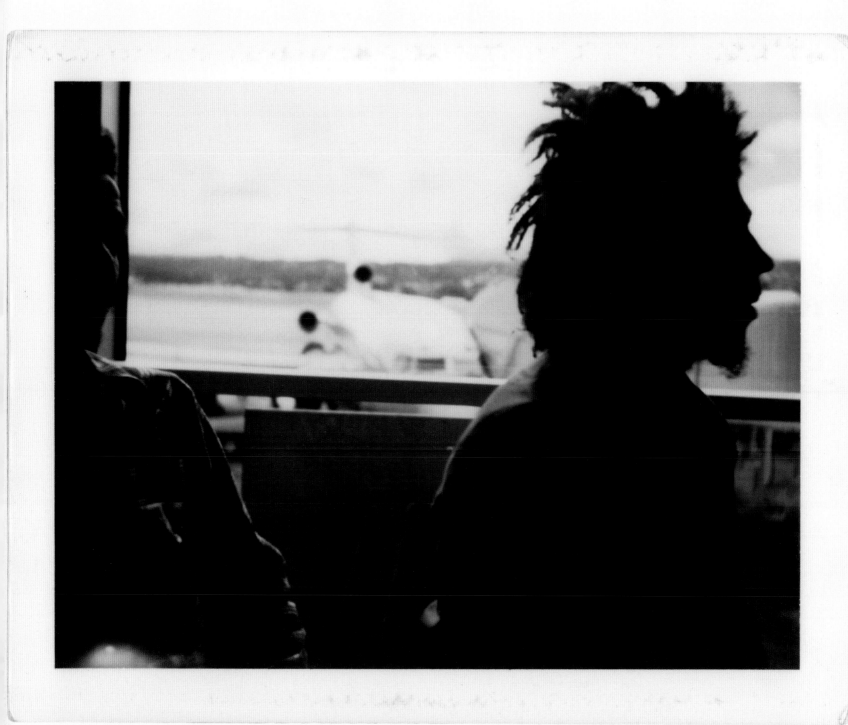

Left: Aston "Familyman" Barrett: Norman Manley Air-
port, Kingston, Jamaica, 1973, as the Wailers prepare
to hit North America.

Above: Carlton Barrett and Bob Marley.

Max's Kansas City

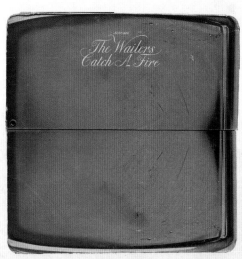

Designed in America, the original *Catch a Fire* sleeve package reflected rock album cover art. It was a major turning point for reggae album presentation.

On a cruel, early April afternoon, the sun was playing tricks—peering between dark ominous clouds. Intermittent snow flurries mixed with sleet were bouncing haphazardly off car windshields. I walked briskly from the Windsor Hotel on 6th Avenue and 58th St., descending a garbage-strewn staircase to grab the subway down to 14th St.

I had made an appointment with Sam Hood, who in the 1960s managed the Gaslight, a club in Greenwich Village where he booked an incredible array of talent: folk-styled American singer/songwriters including Tom Paxton, Bob Dylan, Carolyn Hester, Dave Van Ronk, Phil Ochs, Buffy Ste. Marie, Kris Kristofferson, and James Taylor, as well as comedians like Dick Gregory and Flip Wilson, among countless others. The irascible but kindhearted Sam was now the guardian of who got to play Max's Kansas City, the small iconic music venue above the restaurant opposite Union Square Park which was located between Park Avenue South and Broadway and between 14th St. and 17th St. In the late 19th century, the park had been designed by the landscape architect Frederick Law Olmstead and partner Calvert Vaux—the designers of New York's Central Park —based on the idea that the Union Square Plaza would be a place to facilitate democracy as an active and ongoing process.

And in the early 20th century it was, with protestors and union organizers—my paternal grandfather among them—calling for living wages and humane working conditions for factory workers.

Max's was first a restaurant, opened in 1965 by owner Mickey Ruskin. It became a place where the most cutting-edge visual artists of the time would hang out—Walter De Maria, Lawrence Weiner, Gordon Matta-Clark, Robert Rauschenberg, as well as writers William Burroughs, Allen Ginsberg, and many more. On the wall behind the bar was a 50"x75" Warhol, titled: *Most Wanted Men No. 11, John Joseph H., Jr*. One of a series of 13 which were simply copies of black and white mug shots silk screened on canvas.

For artists that were not making money, Mickey would trade meals for art. Around 1970, Mickey took a lease on the floor above to have live music, and an incredible array of musicians graced its tiny stage at a venue that could shoebox-in an audience of around sixty or seventy: Emmylou Harris and Gram Parsons, Bonnie Raitt, Tom Waits, The Velvet Underground, etc. Max's became a hangout for rock celebrity. David Bowie, Patti Smith, Alice Cooper, and Lou Reed were regulars, as well as Warhol and his "superstars" who toiled for him at "The Factory," just down the block on East 17th St.

I bounded up the cold damp cement stairs from the bowels of the city—the tumultuous sounds of the subway trains entering and leaving the station fading behind me, replaced by the cacophony of Manhattan traffic. I clutched a manila envelope stuffed with three copies of the *Catch a Fire* album whose cover opened like a Zippo lighter. Determined, I marched up to Max's.

The door was locked, but I could see staff scurrying to set up for dinner and I knocked on the window. A slim, strikingly good looking blond, 5'3" with crystal clear blue eyes, cracked open the glass door, suspiciously staring up at me: "Can I help you?" She led me to a creaky wooden staircase at the side of the bar and pointed: "There's a door behind the stage to Sam's office."

I tried to feel confident as I nervously made my way down the narrow loft toward the raised platform. I felt like the future of reggae music, Rasta culture, Jamaican history, and the liberation of the "third world" depended on the Wailers getting a gig at Max's (it didn't, ha!) and being introduced to NYC's media gatekeepers, who I was certain the Wailers could win over. I only needed to convince the Mississippi-born Sam Hood to give us the opportunity. The door to Sam's tiny office was open, and with a lilting southern drawl, he asked, "What ya got there young man?" He was only four or five years older than me, but was already a grizzled veteran of the rough and tumble New York City music biz. I pulled out a *Catch a Fire* album, tore off the cellophane wrap, and lifted up the cigarette lighter cover, trying to keep my hands from shaking while I pulled out the vinyl disc. Sam sat it on the silver Technics 1200G Grand Class turntable, and I tried to breathe normally through what seemed an interminable instrumental intro and then the first verse of "Concrete Jungle."

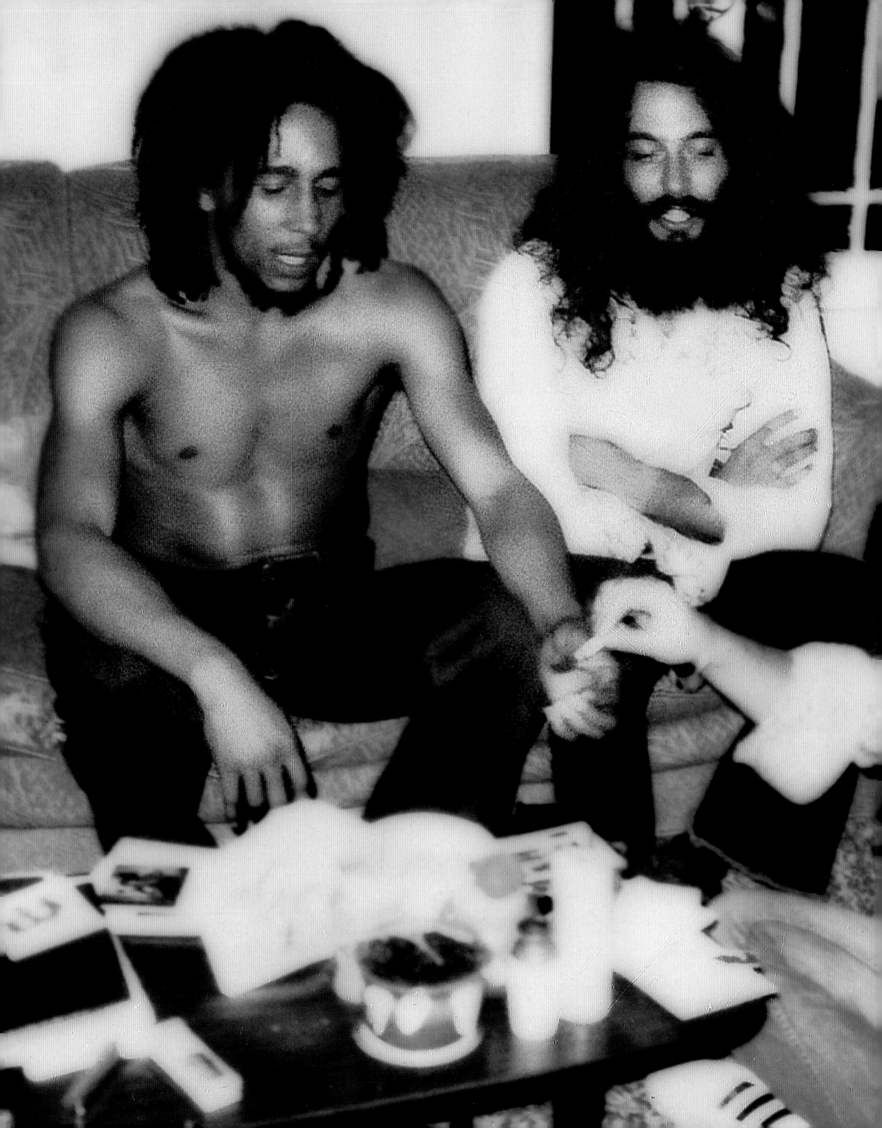

Receipt for our stay at the Chelsea Hotel, the
week the Wailers played at Max's Kansas City,
NYC: July 18th to July 24th, 1973.

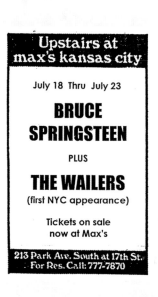

BRUCE SPRINGSTEEN THE WAILERS

Max's Kansas City, New York

Most devotees of Bruce Springsteen would have some difficulty imagining a virtually unknown band capable of neatly eclipsing Springsteen's formidable, growing charisma, but the Wailers did precisely that, blowing away any further speculation about the possible potency of reggae. Word-of-mouth pulled in some of the largest crowds at Max's this summer, repeating the band's somewhat less surprising success the week before in Boston.

Most reactions to Jamaican music to date have, for the larger marketplace, hinged on the efforts of established pop and rock performers to integrate elements of this joyful, sometimes surly, yet hypnotic reflection of our own r&b traditions and their various pop refractions. With the arrival of this Island recording act, forget those attempts for the moment. Some pop efforts have captured the languid textures and sense of instrumental economy central to this music, but the Wailers offer the real thing. Since their beginnings over a decade ago, they've helped pioneer the style, but their importance to their countrymen lies in their continued growth and its effect on the evolution of reggae.

They retain the raw vitality of "Kinky Reggae" while displaying a limber yet precise cutting edge that sets them apart from most rock bands within a few bars. This is fluid, rolling body music, projected with an overall sense of spareness and design framed by strutting, staccato guitar, punctuated by simple but sly bass throbs, buoyed by rich organ textures.

The focal point is Bob Marley, writer, rhythm guitarist and prime vocal power, a Rastafari whose political attitudes toward the powers that be in Jamaica are reflected, sometimes directly and often obliquely, in his material. The parallels between this music and the best contemporary black music here lies in its balance of sheer motion, energy that is irresistible yet restrained; and the range of evocative emotions, primal and more socially oriented, that are there for listeners willing to try to stop moving long enough to decipher Marley's rich intonations. SAM SUTHERLAND

**No sun will shine in my day today
The high yellow moon won't come out to play
Darkness has covered my light
And has changed my day into night
Where is the love to be found
In this here concrete jungle.**

Sam picked up the tonearm and went to the next track. Peter Tosh's percussive rhythm guitar, the lilting immaculate harmonies and,

Slave Driver, the table is turned / Catch a fire, you're gonna get burned.

Sam didn't wait for the chorus and went to the next track. Peter's lead vocal resounded:

**400 Years
400 years
(400 years, 400 years)
And, it's the same philosophy
I said it's 400 years
(400 years, 400 years)
And the people just can't see
Why do they fight against
these youth,
these youth of today...**

I was crushed as he lifted the tonearm again and it seemed the audition was over. He couldn't even bother to hear one song through to a second verse.

I was on an emotional rollercoaster that had landed rock bottom.

Then, Sam turned to look at me and with a wry smile: "I get it. That's the Drifters with raised consciousness. I'll put you guys on."

We got booked for a week, playing two shows a night and three on the weekend as an opening act for a must-see newly signed singer to Columbia Records who was being hailed by some as the new Bob Dylan, and it began a love affair with the media and the Wailers.

In his September review in *Billboard* magazine, writer Sam Sutherland said, "Most devotees of Bruce Springsteen would have some difficulty imagining a virtually unknown band capable of neatly eclipsing Springsteen's formidable, growing charisma, but the Wailers did precisely that…"

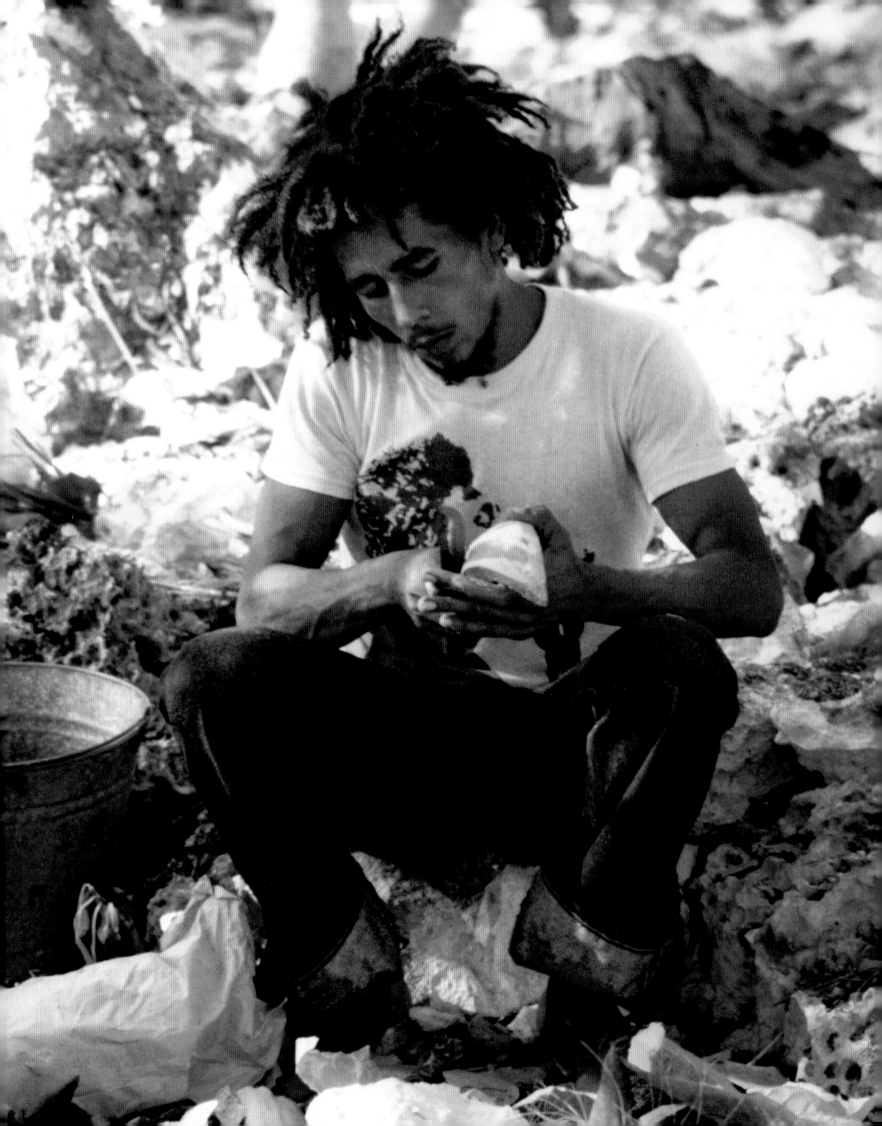

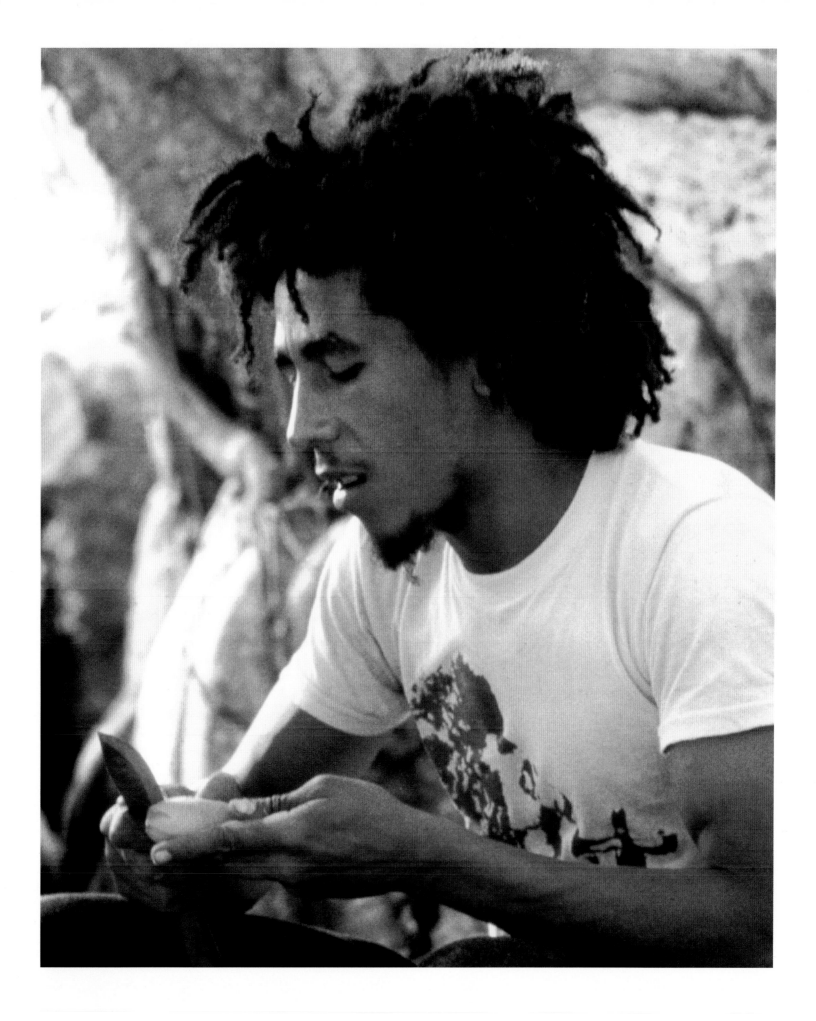

Bob cooking Ital food: Westmoreland, Jamaica. 1974. Rasta culture puts a great value on health and fitness. Ital cooking means organic and sustainable ingredients, and shuns the use of salt. It's influenced by the Book of Genesis: "Then God said, 'I give you every seed-bearing plant on the face of the whole earth and every tree that has fruit with seed in it. They will be yours for food'" (Genesis 1:29).

I Shot the Sheriff

At Hellshire Beach, about twenty minutes outside of Kingston, we were jamming—Bob with his Yamaha acoustic guitar and myself on harmonica. There were these two really huge girls dancing (in Jamaica, they would be laudatorily called "fatty boom booms"), when Bob came out with the line in a falsetto voice exclaiming, "I shot the sheriff." It was such a funny and ironic line as there is no such thing as a "sheriff" in Jamaica, but Jamaicans loved western movies, and it seemed the Carib Theatre at Halfway Tree in Kingston was interminably playing Sergio Leone pictures like *The Good The Bad and The Ugly*. And I just blurted out in a basso, "But you didn't get the deputy," and Bob just went with it and began to create a masterpiece. I was thrilled to be playing along. The beach wasn't very crowded, but Bob's voice was a magnet drawing the scattering of people towards the music, and suddenly there were maybe a dozen people just dancing to the sounds. I would stop playing intermittently to write down all the genius lyrics Bob was coming up with 'cause I wanted to make sure he wouldn't forget, and I was excited 'cause I knew it was a big song. And then I came up with a line, "all along in Trenchtown the jeeps go round and round," 'cause the police and military drove jeeps. I was thinking of the curfews that were being called in the West Kingston neighborhoods where the "sufferahs" lived; what it was like for the poor to live in a militarized zone and to have the basic freedom of walking in the street taken away. I thought about how it related to global politics and the U.S.' involvement in Southeast Asia, and the CIA pressure on the Caribbean and Latin America. I flashed back to being on the beach in Rio, in Ipanema a few years earlier, with a girlfriend who was a radical student leader. She pointed at a blonde crewcut guy with his wife and two pre-teenage daughters relaxing on a Sunday morning and hipped me to the fact that he was an American sent by Nixon to train torturers. I thought of what was taking place in Chile and the imminent assassination of the democratically elected president, Salvador Allende, and how the events there had resulted in my being in Jamaica. What a genius Bob was for coming out with the line, "I shot the sheriff," because though it was whimsical on the surface, it was also so poignant, so relevant to the global repression. Later he changed the line to, "All along in my hometown," and that was better, because it made the point that these violent interventions into everyday life in the shanty towns of Jamaica were intrinsically foreign-influenced. When I said, "but you didn't get the deputy," he went with it—not making less of his act, but rather as a humble, slightly self-deprecating admission, because what he was saying was, "Yeah, I got the nerve to shoot the sheriff, but I don't have it together by myself to get all his backup, and this is going to be a long tragic struggle that's going to need a lot of everyday heroes."

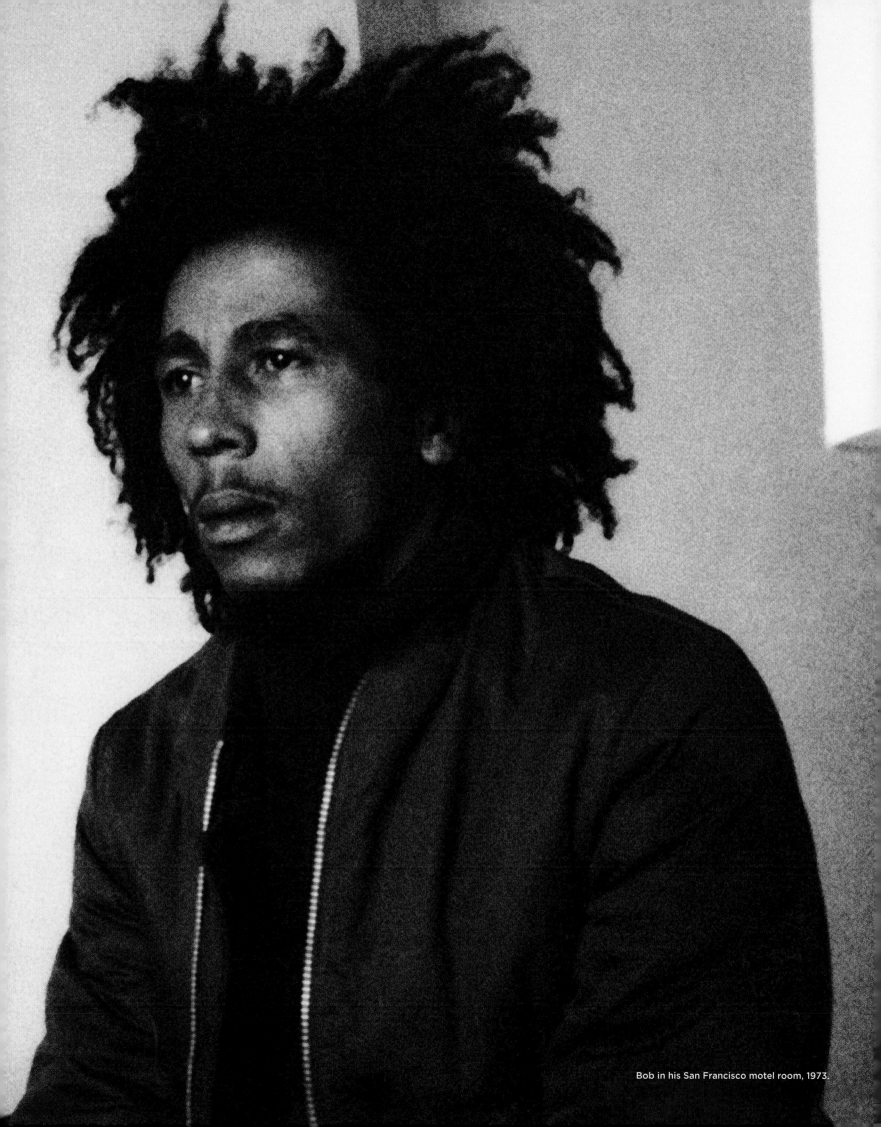

Bob in his San Francisco motel room, 1973.

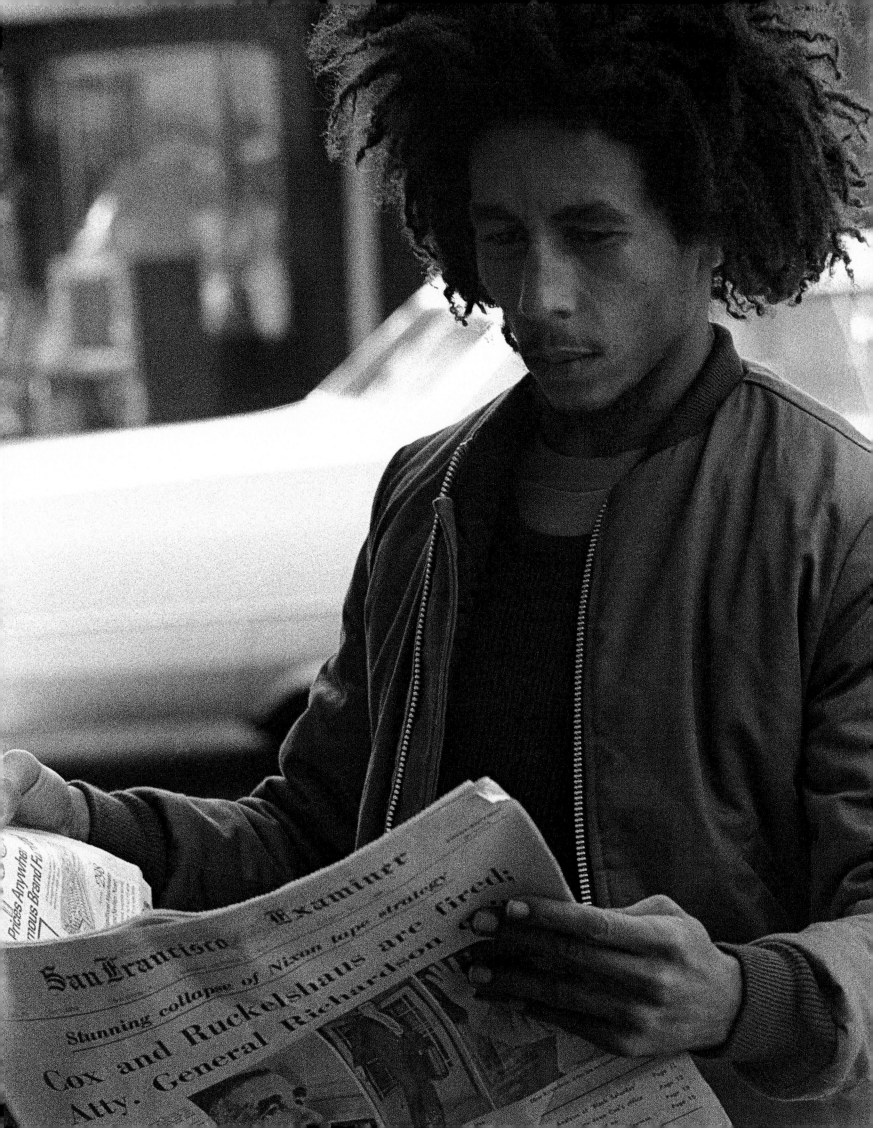

The Matrix

San Francisco, October 19th, 1973

The fog was a dense dark silver-blue, chilling the late October night, like Dragon's breath glowing through the street light haze. Rastas, dazzled by the strangeness of this new universe. In our motel parking lot, we crammed into the steel-gray Buick station wagon I had rented at the airport, and took a slow, deliberate, and what seemed interminable trek through the San Francisco cobblestoned streets. I was cautious and confident, the promoter having informed me they expected a sellout. Earlier in the afternoon, the sound check had gone well. A sympathetic and competent house engineer helmed an excellent sound system. The club—which had a capacity of 800—was called The Matrix.

I pulled around the rear of the venue to the backstage entrance, and we unfolded out. I grabbed Bob's guitar from the back of the wagon—I was honored to be entrusted with it, feeling like an essential part of a group whose power was ordained by Jah.

There was a worker: skinny, tall with curious pale blue eyes, early 20s and hippy length hair, waiting for us at the back entrance. He escorted us through a narrow hallway, walls stickered with posters with the likes of Moby Grape and Country Joe and the Fish, Big Brother and the Holding Company—lingering psychedelia just to let us know the context of where we were. We were led into a shabbily posh dressing room with a giant comfy couch and big wine-red velvet chairs, somewhat tattered with warn armrests and a massive wooden table harboring a throne of tropical fruits. Someone had taken care to make us feel wanted. People started emerging, kind strangers with gifts of various herbs to smoke, some awkward, others too familiar. Yet, everyone sensed the charged air of anticipation—feeling that this was more than just a new hot group they were coming to see.

Sweet and pungent clouds of enkindled ganja wafted through the dressing room while the club was beginning to fill up. I moved out front to check the engineer at the mixing board, which was three-quarters of the way back into the room and centered with the stage. Then, I scurried back through the crowd to help Bob write out a song list that he carefully dictated to me. Then, determined and focused, The Wailers filed onto the stage. The lights dimmed, and shouts from the mostly white crowd—"Rasta! Dreadlocks"!—filled the air. The Nyabinghi drums set a transcendental mood, followed by voices entering in perfect harmony:

**Hear the words of the Rastaman say /
'Babylon, your throne gone down, gone down /
Babylon, your throne gone down.'**

The crowd screamed as the chant finished and segued into full electric:

**Lively up yourself, and don't be no drag /
Lively up yourself 'cause reggae is another bag.**

I stood at the board, egging the engineer to pull up the bass. As the walls of the place began to throb with each new song, the crowd grew more and more ecstatic. Into the second encore, Bob danced frenziedly but still with more agility than I'd ever seen him display on the football field. Transitioning into a third encore with "Slave Driver," he made an unforgettable move—bending backward so far as to almost touch the stage floor behind him. I was startled yet amazed that he didn't fall but somehow miraculously sprang up. With his right arm swinging, his hand came down on a chord with perfect timing as he sang:

**Slave driver the table has turned,
slave driver you're gonna get burned...**

As we packed to leave the hotel the next morning, I ran out to get the newspaper, hoping for a review. *The San Francisco Examiner* had a headline for the entertainment section that read: "Apocalyptic: The Wailers at the Matrix."

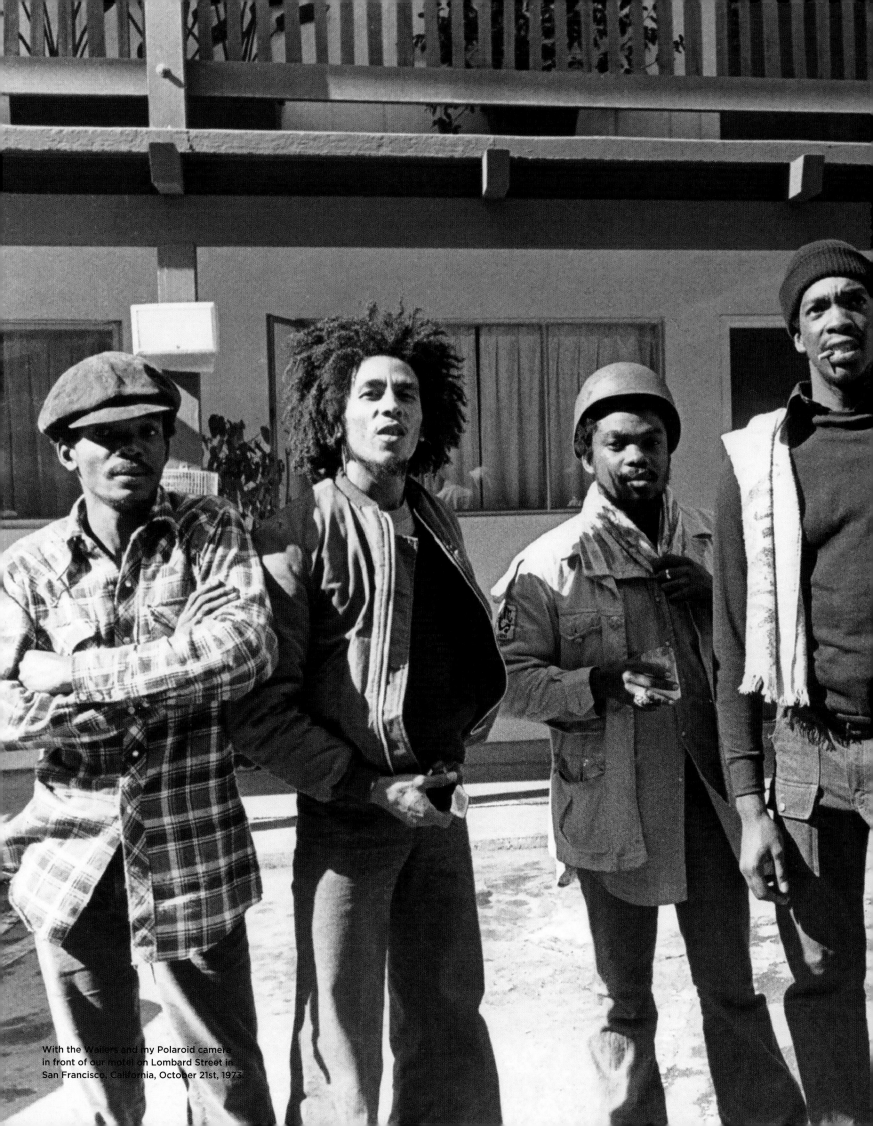

With the Wailers and my Polaroid camera in front of our motel on Lombard Street in San Francisco, California, October 21st, 1973.

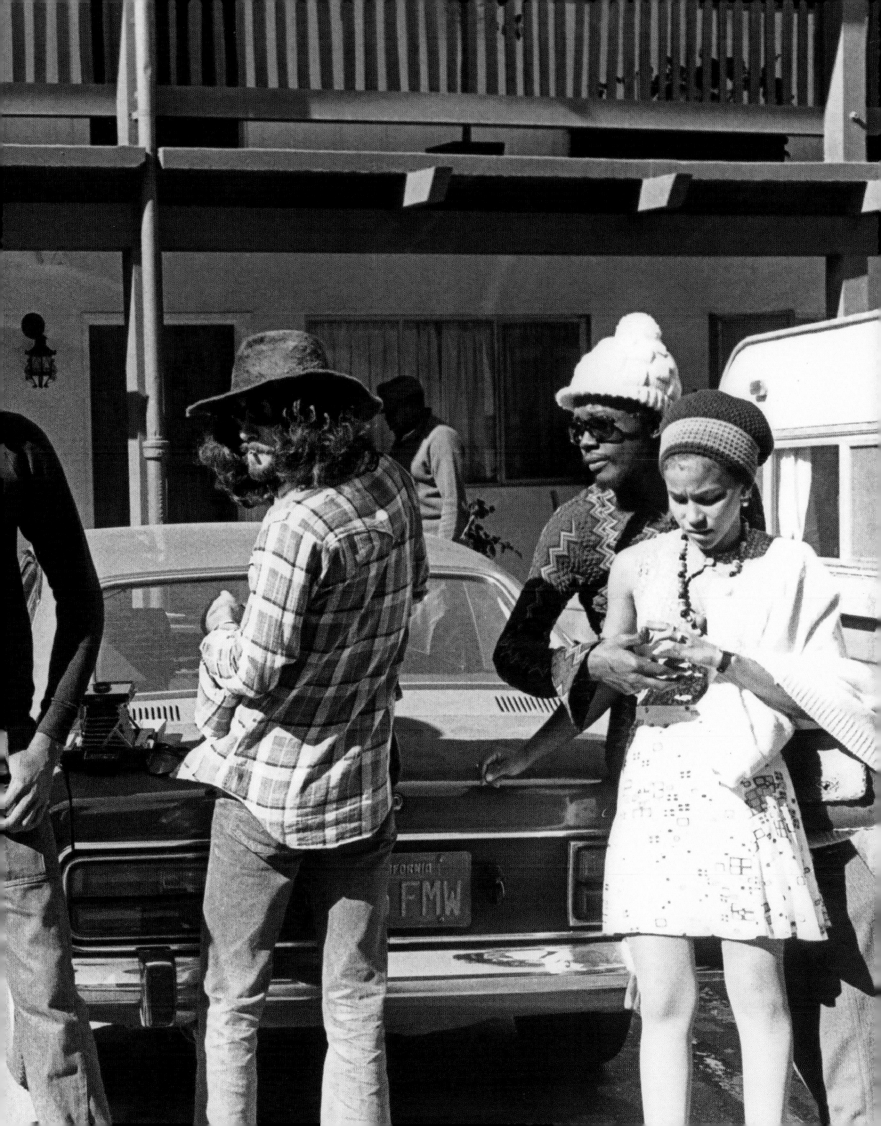

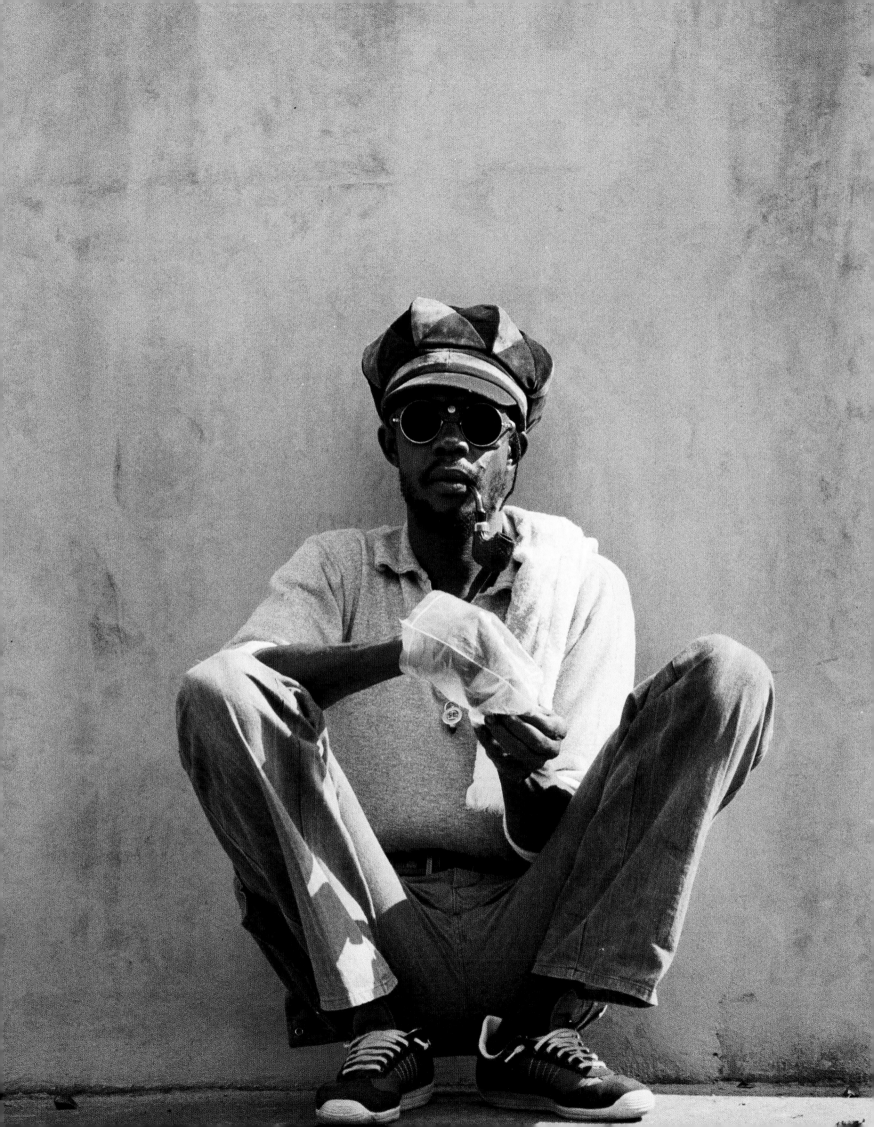

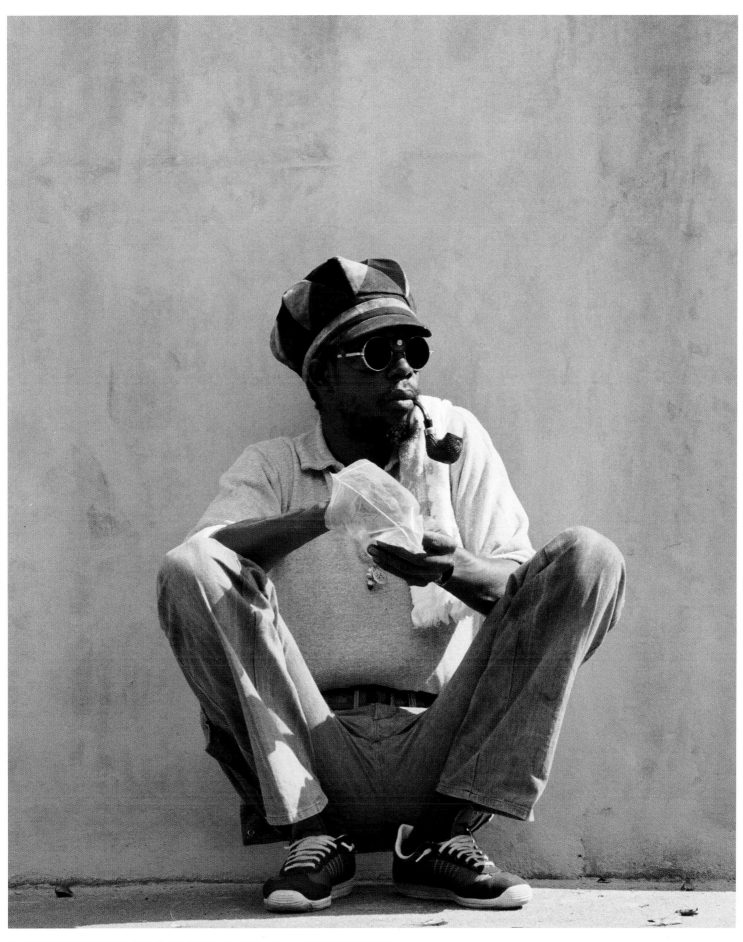

Peter Tosh defiantly preparing a bowl of herb
in front of our motel on Santa Monica Blvd.,
Hollywood, California, 1973.

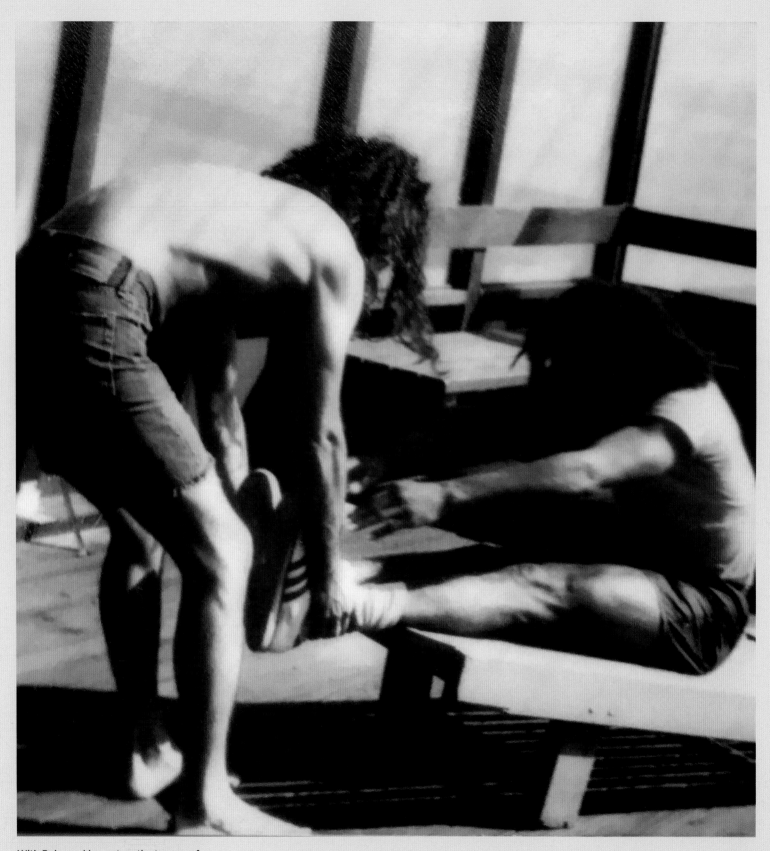

With Bob, working out on the terrace of
Denny Cordell's house in Malibu, California
overlooking the Pacific Ocean.

Following Pages: Stills from a video I co-directed
with Leon Russell at Capitol Records Studio,
Hollywood, California 1973.

Capitol Records Session

Leon was partners with record producer, Denny Cordell, in a label called Shelter Records which, like Island Records, was distributed in North America by Capitol Records. Shelter was producing great artists, among which were Freddie King, J.J. Cale, the Gap Band, and Tom Petty's first band, Mudcrutch. They also released the first Bob Marley and the Wailers American single—produced by Lee "Scratch" Perry—on their label in 1971, with the title "Duppy Conqueror," misprinted as "Doppy Conquer."

After our gigs in San Francisco, we were heading south to Los Angeles when Chris Blackwell suggested I get in touch with Denny. Bob and I drove out from our cheap motel in a smoggy Hollywood, past Santa Monica and the Palisades, and up along the Pacific Coast Highway to Denny's house. It was great to get a breath of fresh air.

Shelter had recently purchased a state-of-the-art mobile video recording truck, and we arranged to shoot a live studio performance of the Wailers. The truck was equipped with four cameras that Leon and I directed outside the Capitol studio on Sunset Blvd. We did all the effects live while shooting. I was thrilled to work with the genius Leon as I was such a great fan. What amazing opportunities the Wailers were affording me.

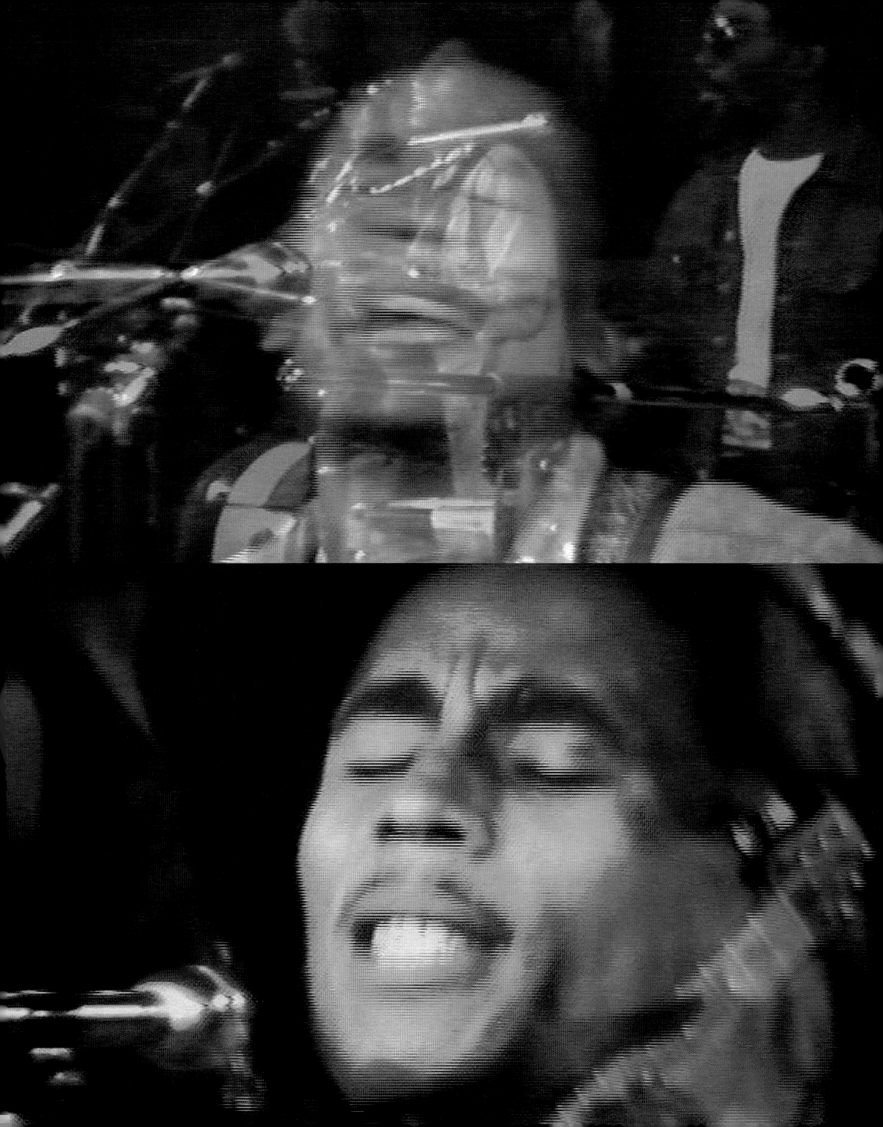

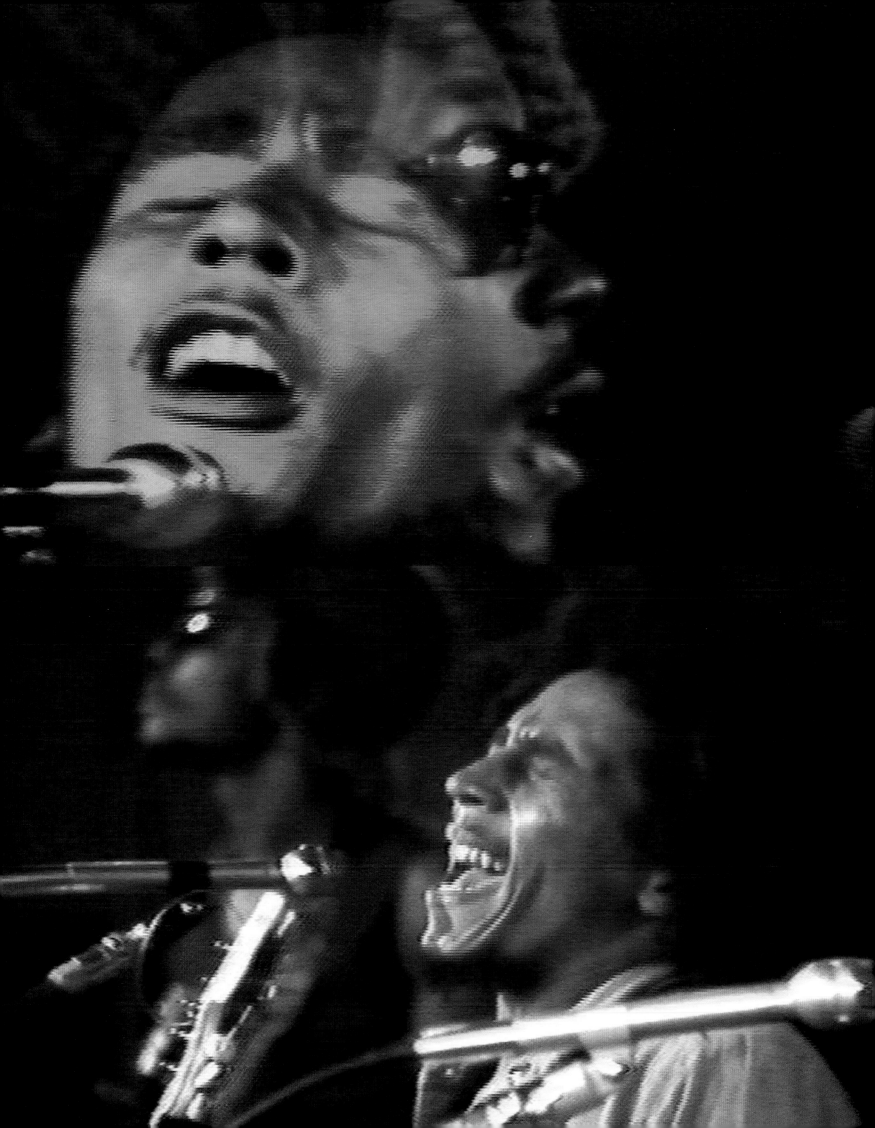

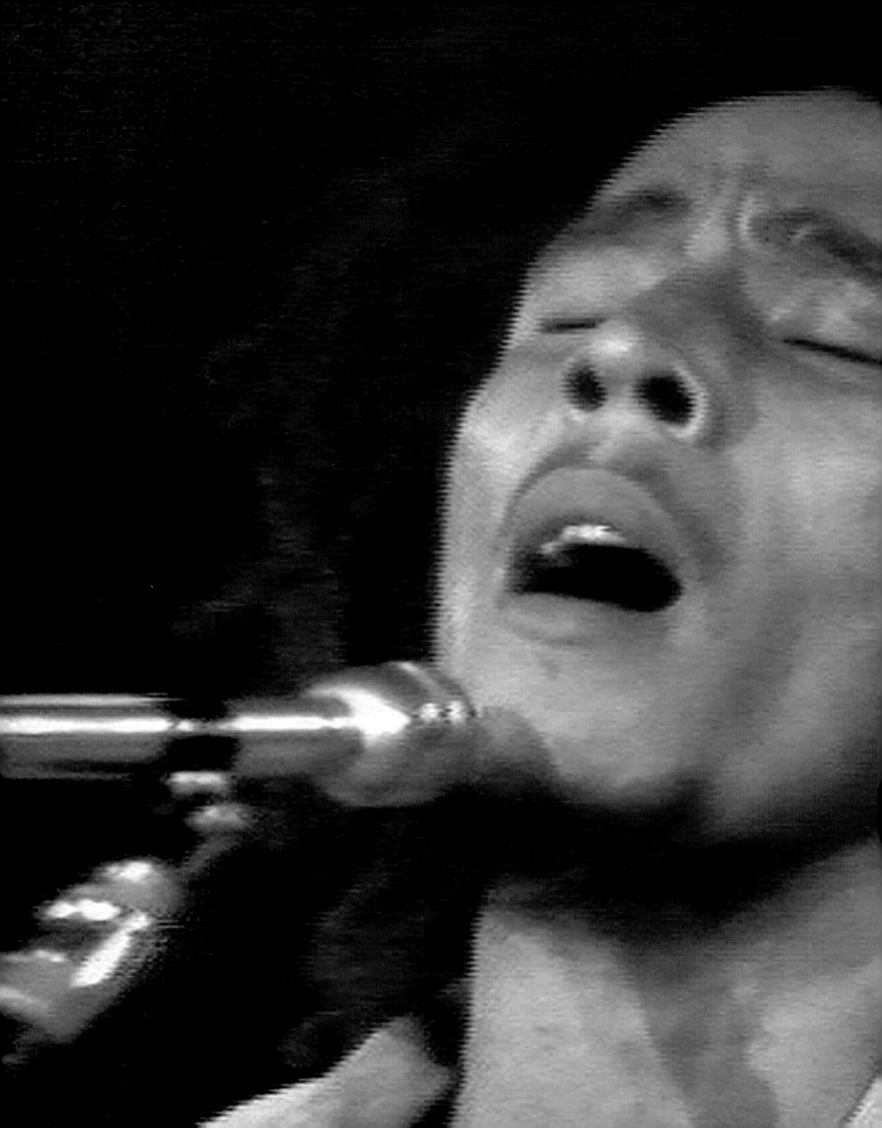

Harmonica on Rebel Music

I had the good fortune to play harmonica on the original recording of "Rebel Music: 3 O'Clock Roadblock." I remember Bob and I in the control room behind the mixing board at Harry J's Recording Studio, having trouble finding where precisely to start playing. I was crazy nervous. This was my big chance.

Then, Aston "Familyman" Barrett (d. 2024), the Wailers bass player, finally came and stood next to me and said, "When I tap you once"—and he tapped me on the shoulder— "you come in. When I tap you twice, you come out." The control room was filled with people as it often was when Bob was recording, including members of the Wailers, other musicians and hangers-on, and Take Life and Frowser, the infamous teenage bodyguards that Bob had assigned to me. Having a harmonica—a "mouth organ"—was a novelty in reggae music at the time. Bob had a big spliff, like some record producer tycoon, and he was beaming like he had just become the head of the biggest music company in the world.

People in the control room were pointing at me, nodding and cracking up laughing. I guessed it was OK, or Bob would have stopped me. Then I knew it was alright, because I turned to "Familyman," and he said, "That's really good mon, let's go listen." And I'm thinking about how, even though I had never played on a record before, there I was, recording an album with arguably— though few people knew it at the time—the greatest band in existence.

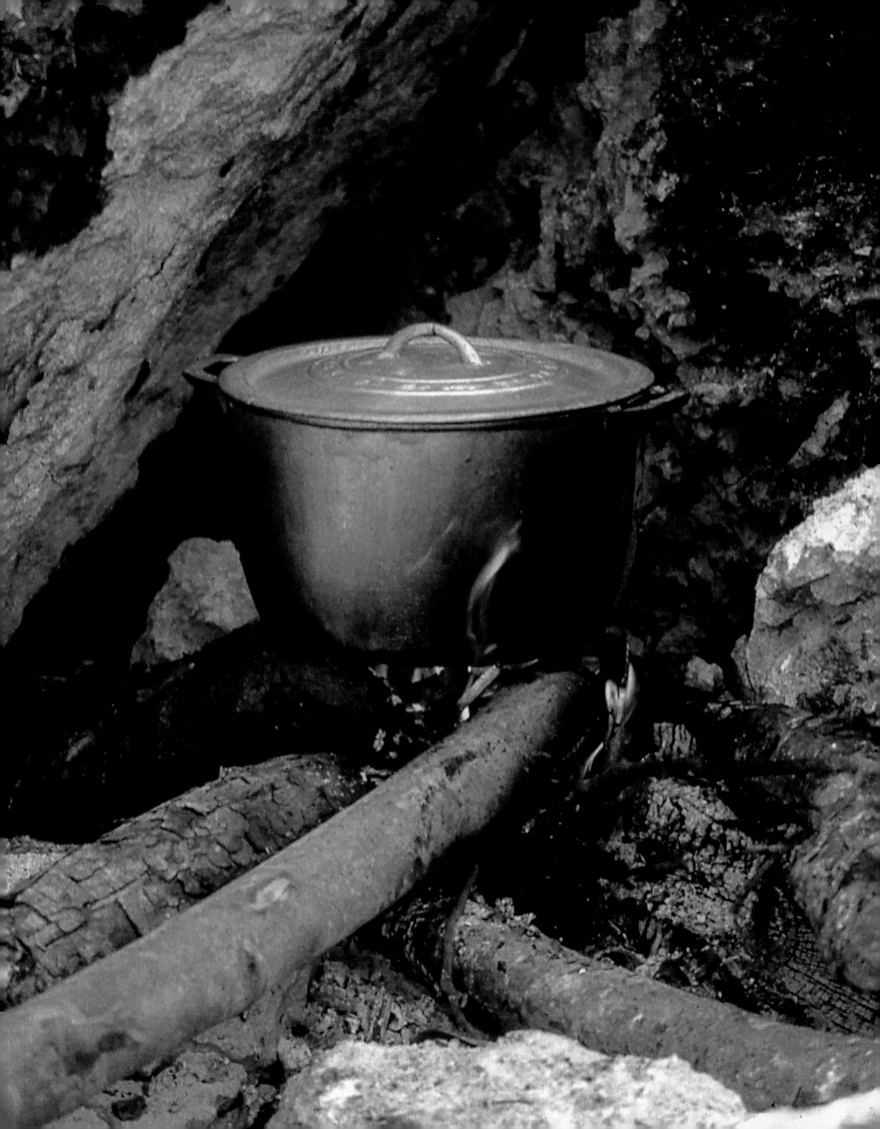

Rita Marley

In this becalmed zone the sea has a smooth surface, the palm-tree stirs gently in the breeze, the waves lap against the pebbles and raw materials are ceaselessly transported, justifying the presence of the settler: and all the while the native, bent double, more dead than alive, exists interminably in an unchanging dream.

Frantz Fanon

Bob drove a Mercury Capri—bronze colored, with steering on the right. It was a car made by Ford in Europe with sleek lines and a sporty look, but with an adequate back seat to pack a few kids, or "bredren," without much discomfort. Like everything about Bob, it signified style and difference. He drove immaculately: slowly, then quickly, then slow again, with confidence. He safely avoided the numerous potholes that, for the less cautious, could be devastating to vehicles made for the smoother roads of the U.K. and the U.S.—certainly not for the ravaged streets of "Concrete Jungle," "Back-a-Wall," "Lizard Town," and "Rema."

We had started driving from 56 Hope Road, just a few hundred yards up from King's House, where the British Governor General had long ruled, and not far from Jamaica House, where the Jamaican Prime Minister, Michael Manley—a confessed socialist at the time in 1974—resided. Manley—a friend of Cuba's Castro, champion of Rasta and the poor, bane of the CIA who had just aided in the assassination of the democratically elected Chilean President, Salvador Allende—defiantly stood up to the forces of the "imperialist" north who sought to destabilize his government.

Chris Blackwell, the Anglo-Jamaican founder of Island Records, had recently purchased the house on Hope Road— a former colonial great-house—and had lent it to Bob and the Wailers. Behind the main house was a shack, maybe fifteen by twenty feet, which had been the former slave quarters; the band transformed it into a small rehearsal studio. Since they had taken over the property, 56 Hope Road had become a haven for Rasta, for the "dreads"—a term coined by the uptown elite to signify their "dreadful" uncombed hair, yet also a moniker which was reclaimed by Rasta as a symbol of solidarity for those who rejected the neo-colonialist system and the legacy of the African slave trade. Bob had brought the Rastas uptown—a place previously out of bounds—and later, there'd be a price to pay for it.

We headed down toward Half Way Tree and Crossroads, past the hagglers and hustlers selling hot peanuts and sky juice—flavored ice in cone shaped paper cups—bright red, yellow, and green—and youths scrounging for change by washing car windshields at the stoplight.

Reggae blared from record shops amidst the cacophony of honking horns—cars, trucks, and aged taxis belching putrid exhaust into the veil of a hot tropical sun. We wove our way towards Trenchtown, the ghetto neighborhood where the original Wailers—Bob, Peter Tosh, and Bunny Livingston—first formed as a singing group, and where they were mentored and taught harmonies by the great Joe Higgs. It's also where Bob met his wife, Rita Anderson Marley, the biological mother of three of his children, adoptive mother of several of his others, singer in his band, and manager of their record label, Tuff Gong.

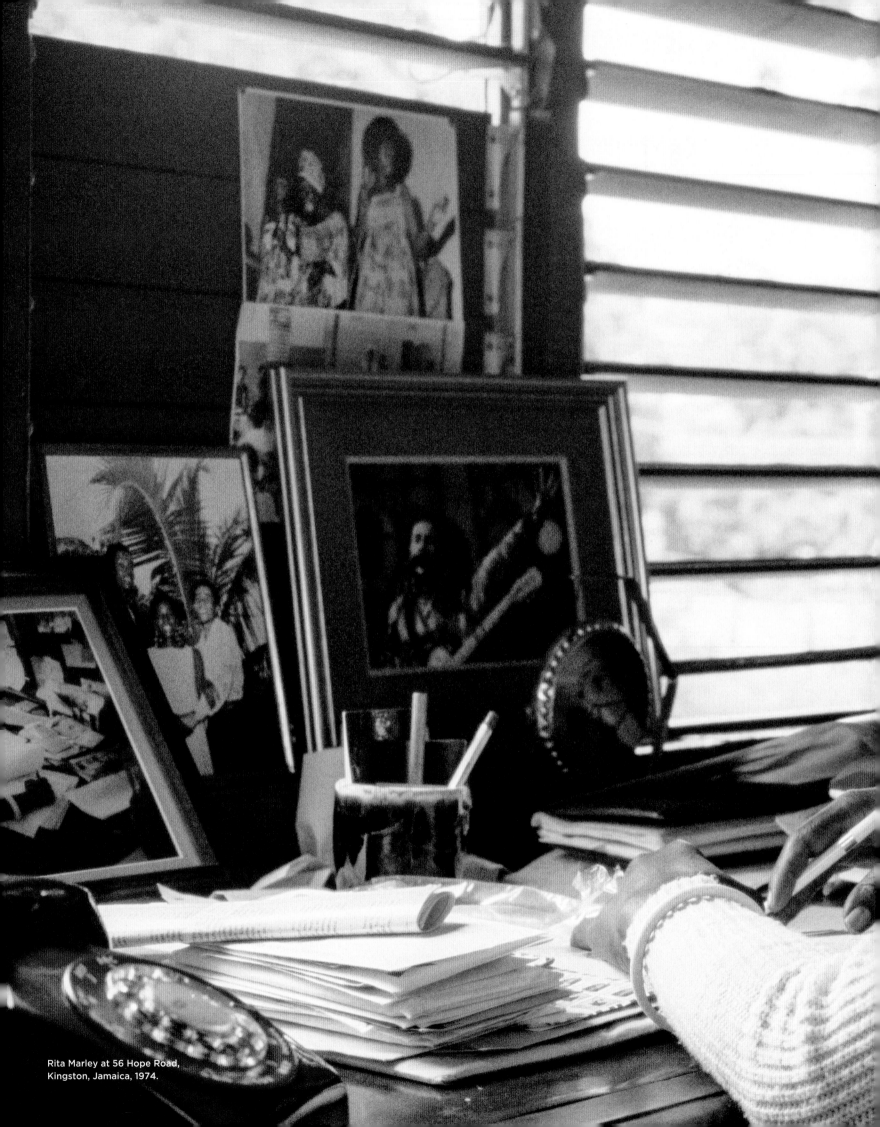

Rita Marley at 56 Hope Road,
Kingston, Jamaica, 1974.

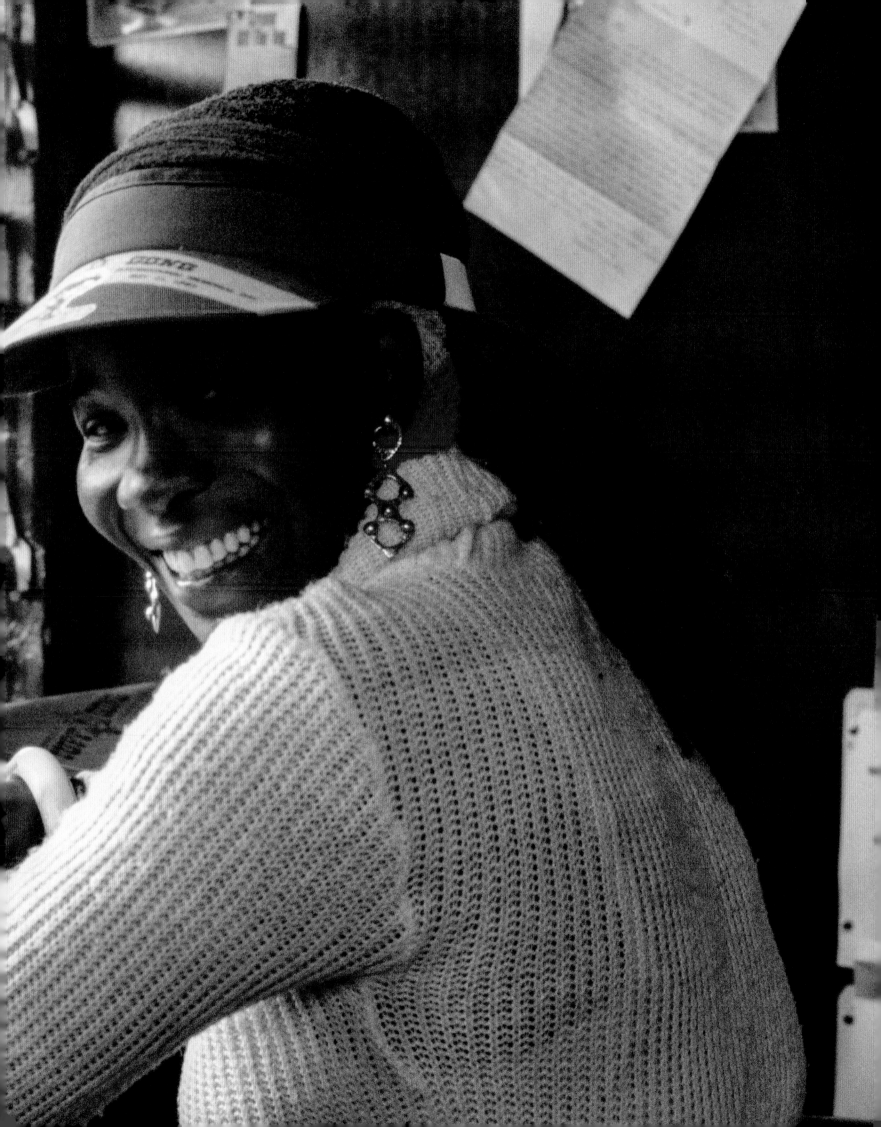

"Dread I," "Wha happen Skip," "Jah B," "Yes Rasta,"
"I I I": people of different ages greeted Bob as we
passed through the sullen, ramshackle streets. Bob's
fleeting presence was a glistening ray of aspiration as
several "John Crow" vultures glided slowly above. Wings
dark and flapping, they were jet black against a pale
blue midday sky, with beady eyes scouring below
for a fresh carcass to scavenge. Maga dogs, emaciated—
rib bones visible—scurried away to avoid our car as
goats meandered, wantonly oblivious to our passing,
foraging through detritus on the sides of the broken
West Kingston alleys.
We drove onto Spanish Town Road—its name a nod to
the legacy of genocide committed by the island's first
colonialists, and their obliteration of the Arawak and
Carib first nation people—past a giant smoldering
garbage dump, and into downtown Kingston to Parade, a
square that was once a parade ground for British
soldiers, and where once unruly African slaves were
publicly flogged and hanged. It was now the dilapidated
third world city center where music rang into the streets
from the prominent Randy's Record Store, above which was
Chin Randy's Recording Studio going non-stop. This was
one of the numerous facilities churning out sounds for
would-be vinyl 45s, intended to infiltrate the insatiable
island market where more music was released per capita
than in any country on earth.
Bob halted the car, and we got out to drink two jelly
coconuts from a well-worn wooden pushcart. The Jellyman—
stout, enthusiastic yet serious with a sense of certain-
ty and purpose" deftly chopped the tops off the coconuts
with his sharpened machete. A small crowd began to gather
around Bob looking to chat, or for advice, or seeking a
handout from the veritable voice of the people.
A shiny new Honda S90 motorcycle, gears winding down,
slid up to us through the parting crowd. A Dread with a
full head of locks stuffed beneath a knitted brown tam
maneuvered deftly up to us, his broad grin showing four
gold encrusted front teeth with emerald and rubies

inlaid. This was a sight completely novel to me. He
as called "Big Youth," and his records were dominating
the Jamaican charts, with several simultaneously in
the top 10.
When I first arrived in Jamaica some eighteen months
before, I was confronted with his voice and the sounds
of something so new, so innovative, that my mind was com-
pletely blown. People chatting on top of stripped-down
rhythm tracks were dominating the airwaves and dancehall,
bass lines pounding in the front of the mix and the
overall sound, highly synthesized and experimental. It
was Stockhausen you could not help but dance to. It was
concrete poetry, liberated from the page and transposed
into the ephemeral, yet weighted and visceral—sparse and
urgent. It was in English, but I could barely decipher a
word of it. It was popular music extricated from the
confinement of popular song structure. It was the
language of rhythm, of heartbeat and procreation.
It was simultaneously sexy and political. It was
foreshadowing what would be born a half dozen years
later; a ubiquitous, parallel genre of music and
lifestyle—Hip-Hop—invented in the Bronx by a Jamaican
immigrant, DJ Kool Herc (he lived in the Sedgwick
Projects, across the street from the tenement building
where I lived growing up). Big Youth had songs with
titles like "Screaming Target," "The Killer," and
"Honesty." He was the voice of the conscious "sufferah,"
and yet the ladies loved him still.
Bucky Marshall approached, appearing like a dark
apparition from out of nowhere—the diminutive
mercurial gang leader, his scraggy frame not more than
5'5" tall with a pronounced "telephone" scar down the
left side of his cheek from temple to chin. At any given
time, he appeared atop the list of Jamaica's "most
wanted," depending on which political party was in
power. He was of the PNP—the socialist side: "Jaff I a
mi bredren," he declared emphatically, lifting his arm
and draping it around my shoulder, a teardrop of sweat
dripping from his forehead in the sweltering noonday sun.

The night before, the Wailers had played at the Carib Theatre, a venue swelled to its 2000 standing room capacity, which on that night could have sold out thirty times over. Marvin Gaye had descended on Kingston with a seventy-piece orchestra to perform from his internationally acclaimed 1971 album, *What's Going On*, and the buzz in Kingston on the day of the show was electric. The promoter of the show came by Hope Road—unannounced—to see if the Wailers would do a short set to open for him. It had been several years since the Wailers had performed live in Jamaica. But now, as popular demand for them had heightened exponentially with the radio success of the single "Rebel Music (3 O'Clock Roadblock),"

3 o'clock roadblock – curfew
And I've got to throw away
Yes I've got to throw away
Yes I've got to throw away
My little herb stalk

coupled with the fact that Marvin Gaye's popularity had soared in Jamaica, due in large part to the socially conscious lyrics of *What's Going On*, so the Wailers acquiesced to the promoter's request.

I had a featured part on the "Roadblock" recording playing harmonica—or "mout' organ"—which was a novelty in reggae. I remember standing on the side of the stage, anxiously waiting for the last song of the six-song set when it would be my turn—a white dread with a red tam to appear from the wings. I was next to Bob's close friend, the international soccer player, Alan "Skill" Cole, and he nudged me onto the stage. "Your time Jaff I." It was a first for me, performing live, and I tried to put out of my mind stories I had heard of the notoriously demanding Jamaican audiences who would throw bottles at performers deemed with "nuttin' a gwan."

The stage lights glared blindingly for a moment, and I wished I had worn shades. I stared into the packed house and zoned out. Was this really happening? Was I actually going to be playing with the Wailers—live on stage at Carib Theatre in the heart of Kingston, Jamaica? There was a mic stand with a microphone waiting for me. Approaching it I, for a split second, froze—but there was no turning back. The I-Threes came on to sing background as they had on the record, and after Bob said a few things to the audience introducing the song, the band played the intro and my life changed. In a phantasmagorical moment, I was part of what I knew was the most important band in the world.

The next day, I'm in downtown with Bob, and the most notorious gunman in Jamaica is embracing me, announcing that I am in his protection "an' no one can do nuttin' to de I…"

Bob nodded to me, and I followed him to the car, and we drove around to the Tuff Gong record shop on the corner of King and Beeston Streets. Rita was there minding the shop—a proud independent hole-in-the-wall that said "We are taking control of our careers—of our lives."

Rita was at once a larger-than-life figure and a rootsy garrison girl. She was proud, yet humble, with fierce but delicate dark eyes that radiated an aura of one who could survive against all odds. Her deep, rich, warm cocoa complexion served to signify her West African heritage, and her dreadlocks, worn tied atop her head, a defiant crown of acknowledgment of an inherited legacy of resistance.

Rita told Bob she had the newly-printed record labels for the seven-inch vinyl single of "Rebel Music" (with its title instead printed simply as "Road Block"), which was quickly selling out and necessitating more to be pressed. Bob tossed the car keys about a foot in the air for me to catch them. It was his way of saying I had to be alert and ready in "dis here dread" times when being caught off guard could cost you your life. It was only two years later when gunman attacked Hope Road, and both Bob and Rita survived gunshot wounds—shots that, if they had landed an inch to one side, would have cost them their

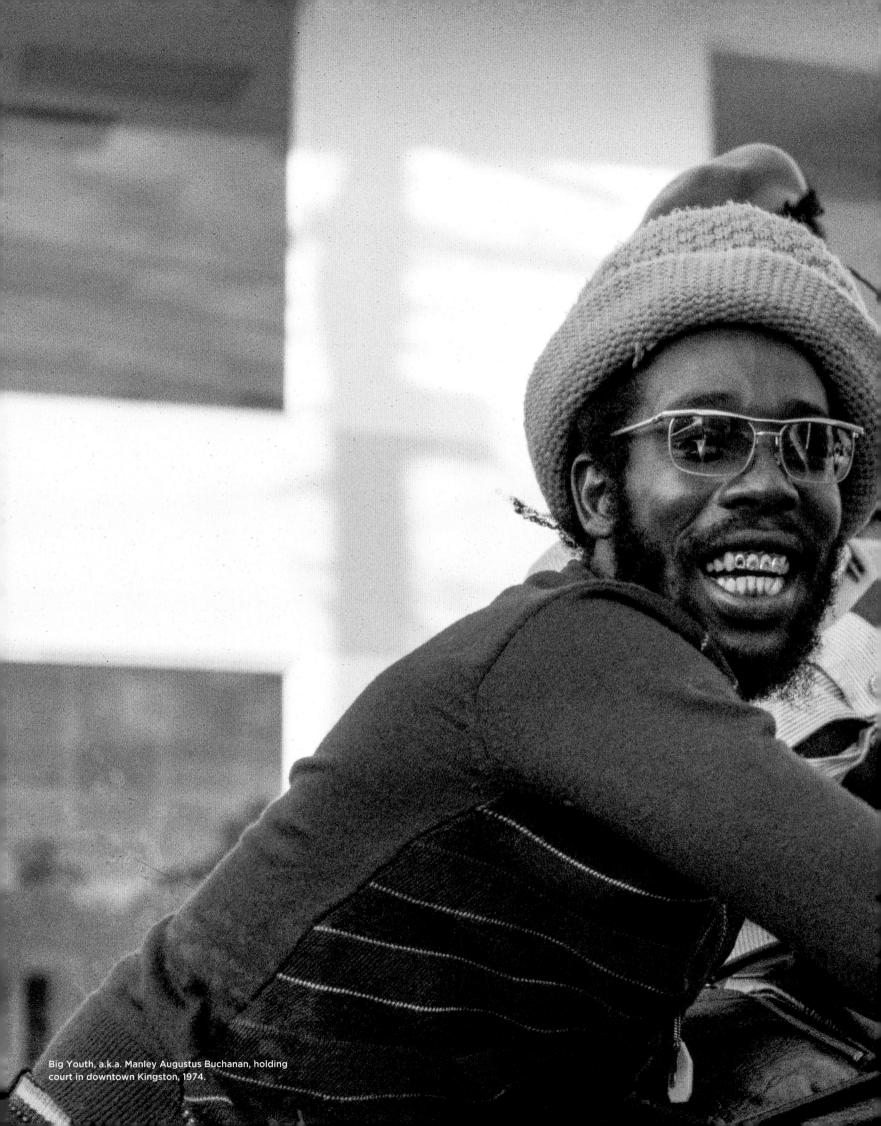

Big Youth, a.k.a. Manley Augustus Buchanan, holding
court in downtown Kingston, 1974.

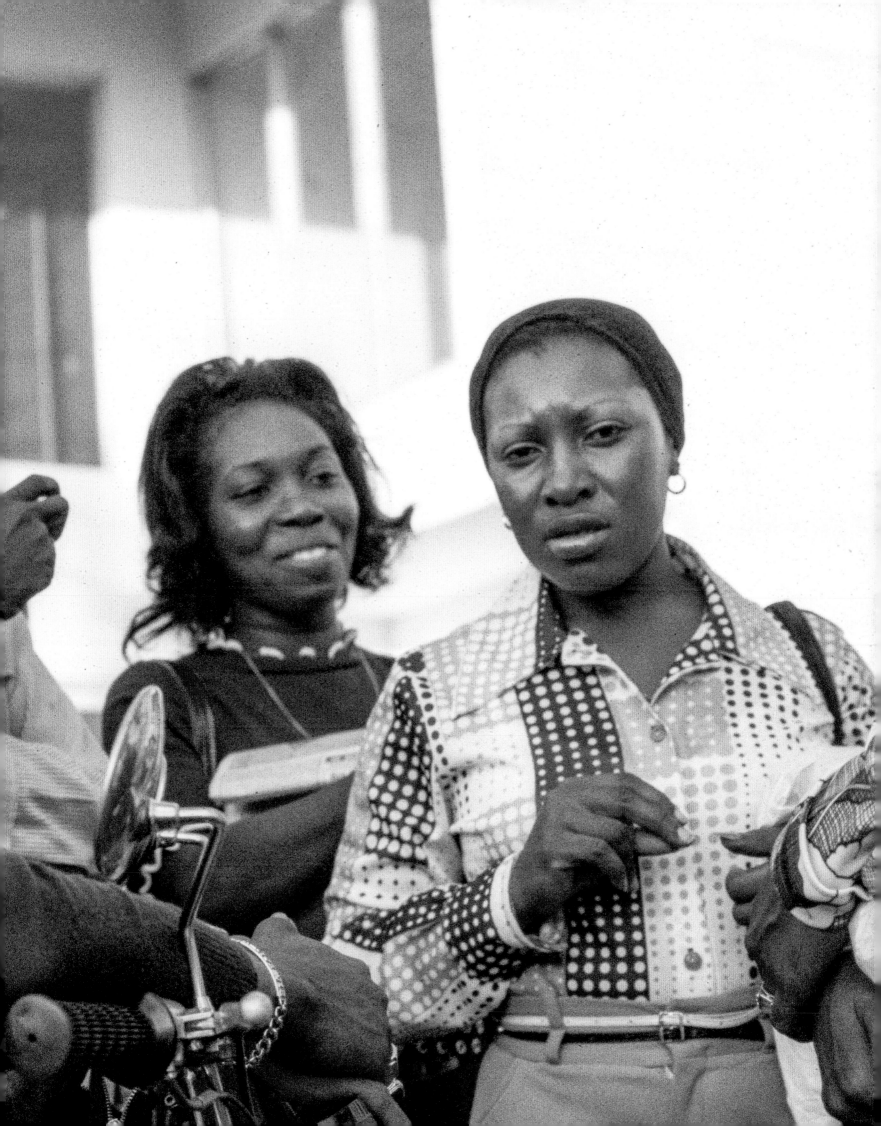

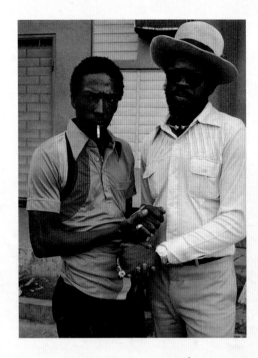

Bucky Marshall and rival JLP gang leader, Claudie Massop, making a short-lived truce in 1978. Massop died a year later in a shootout with police at a roadblock outside of Kingston, and Bucky was killed in a gunfight in a Brooklyn dancehall in 1980.

lives. Did it sink in that all of Bob's small but ironic notices—tests, rather—were readying me for the ever present danger that we were living in?

I had become quite adept at driving on the left side of the road, but needed Rita's directions. The Federal Records pressing plant was downtown near the Kingston harbor on Marcus Garvey Drive, and when we approached, the guard swung open the big iron gate, acknowledging that he recognized our car. The plant was hot and steamy and a kind of shock to me, as I had never actually seen how records were made. It smelled of molten plastic, and the sounds of pounding metal stamping out the vinyl were like the sound of an ancient steam engine beginning to pick up speed. Rita handed over the record labels, and once we were driving again to the record store, she explained that it was necessary to make the labels themselves, as to try and prevent the plant from pressing extra unaccounted for copies; a small, yet crucial example of the struggle for everyday survival.

"Yea mon," she said, "Ya know dem big record companies will thief ya if ya give dem a chance." I was thinking, wow, Rita's really on top of things, and was in awe of her. She organized the printing of the labels, the pressing of the records and took care of the record store—and she sang on the record!

When Bob had finished recording the basic tracks for what would become the *Natty Dread* album (1974), and began doing vocals at Harry J's Studio, not too far from Hope Road, I had suggested to him that Rita and her newly formed group with Marcia Griffiths and Judy Mowatt, "The I-Threes," do background vocals. Peter Tosh and Bunny Livingston had left Bob, and were contemplating doing solo albums; the album needed harmonies. I felt that, not only would female voices work musically, but that having three gorgeous, powerful women on stage, each great singers in their own right, would make the overall impression of the group bigger, more dynamic and more compelling. When I subtly mentioned it to Bob one day in the crowded, smoky control room of the studio, to my shock, he immediately turned to someone—not missing a beat—and said "go fa di I Trees dem." I knew it would work. It wasn't until years later, having previously been smug in the thought that I had come up with the brilliant idea, that I discovered that Rita had started her recording career as a teenager with Coxsone Dodd at Studio One, a full ten years prior, in 1964—right at the same time Bob was recording there—and had made many excellent records with her previous group, the Soulettes. Her recording career was inextricably tied with Bob's, and my great idea was not something novel at all; if Bob had not already planned to have Rita's group take Peter and Bunny's place, he would have thought of it soon enough. As I drove with Bob to Trenchtown, I was given the privilege to "lick a chalice"—a pipe with a large cone-shaped clay bowl—lovingly brimmed with finely cured herb attached to a hollowed coconut shell. The shell was filled with water to cool the heat of the smoke of the burning "ital" buds. The chalice—always passed to the left by Rasta custom—had a fifteen-inch rubber tube connected to the coconut shell and was puffed on in quick draws, causing the herb to burn louder and louder with each succeeding rhythmic draw, until one last long draw left smoke rising, billowing.

Later that early evening, we drove out to Bull Bay, near the sea, about twenty minutes outside of Kingston. The warm pastel colors of a Caribbean sunset made me feel

The Tuff Gong Record
Shop in Kingston.

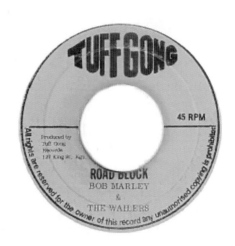

that I was where I was meant to be, contributing to a cultural movement whose importance was second to none (even if my perception of my own importance to it was greatly exaggerated).

Rita was building an extra room to be added to their house situated on a hill, near other like houses. It was about a quarter mile up from the black sand beach and small Rasta fishing village where I would run nearly every morning at dawn with Bob, Bunny and Skill. She arrived just after our run in a small, battered pick-up, and we immediately started to help her unload the bags of cement she had brought from "town." Rita was pregnant at the time, and the realization that she was physically renovating the house herself, and that she had also probably built the existing structure, overwhelmed me. There was a cacophony of sounds as the children— Sharon (the oldest, nine, who was adopted by Bob), and his and Rita's other children, Cedella (seven), Ziggy (their oldest son at six), and Stephen (who was two years old)—shared a joy in laughter and tears that perhaps only the sense of hard times could afford. I say sense, because although they lived in such overcrowded quarters while Rita and Bob struggled to make ends meet, they lived with a confidence that their mother would always

be there to protect them.

I crashed on the floor of the small veranda. In the morning, while the children got ready for school, Bob woke me with a bowl of porridge in hand that Rita had made for me. He picked up his acoustic guitar and began to play a lilting blues progression. I had an A key harmonica and began to play along. Bob began to sing,

Cold ground was my bed last night; rock was my pillow too...

I had to force myself to keep playing, suppressing the laughter welling inside me. His sense of irony was always a marvel to me. He sang,

I'm saying talkin' blues, talkin' blues / They say your feet is just too big for your shoes.

After Bob's passing, it was Rita who—regardless of who their mothers were—made sure that all Bob's children would share equally in Bob's legacy.

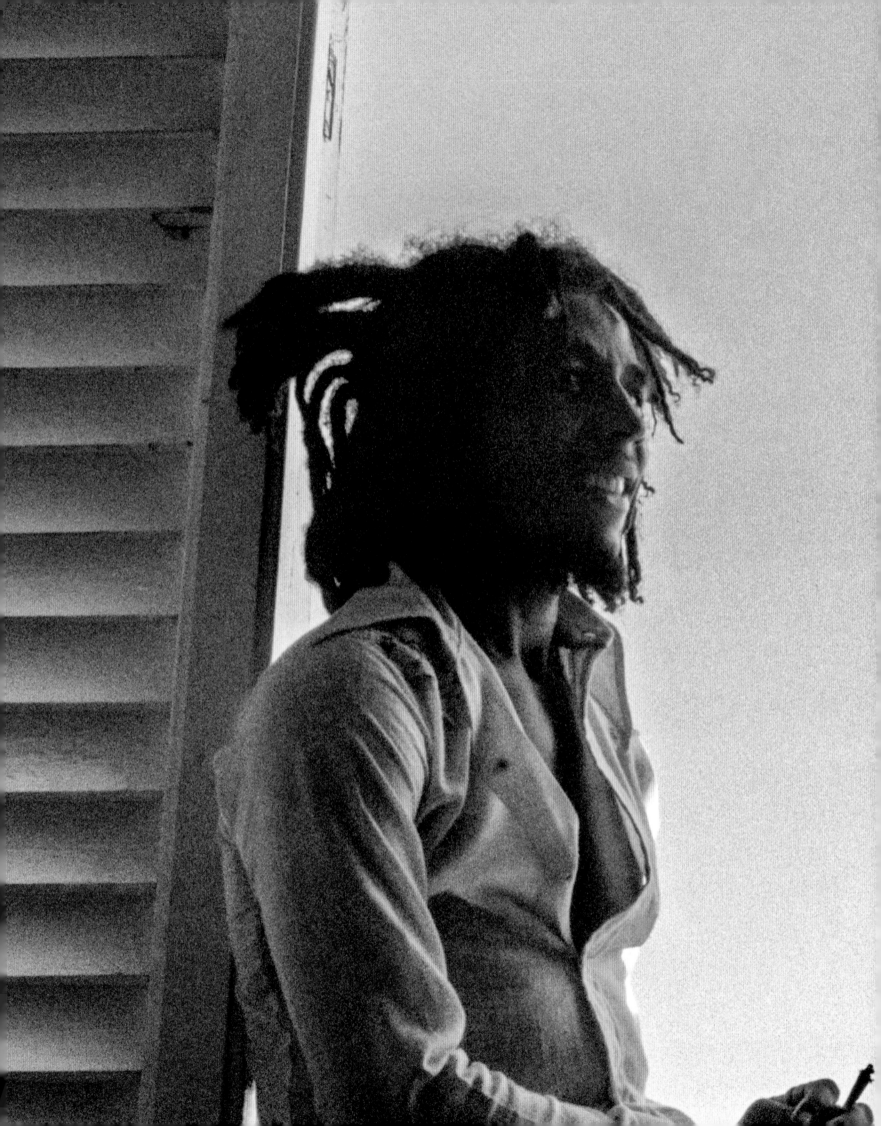

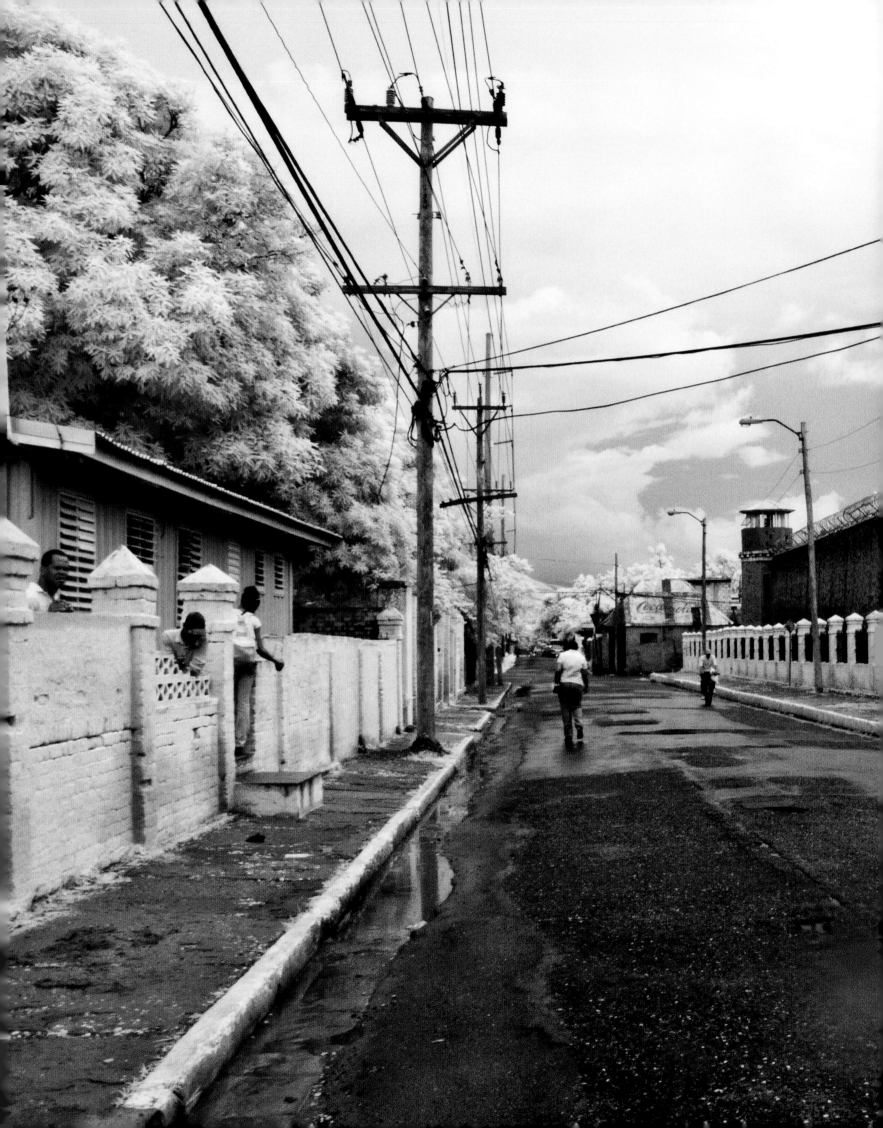

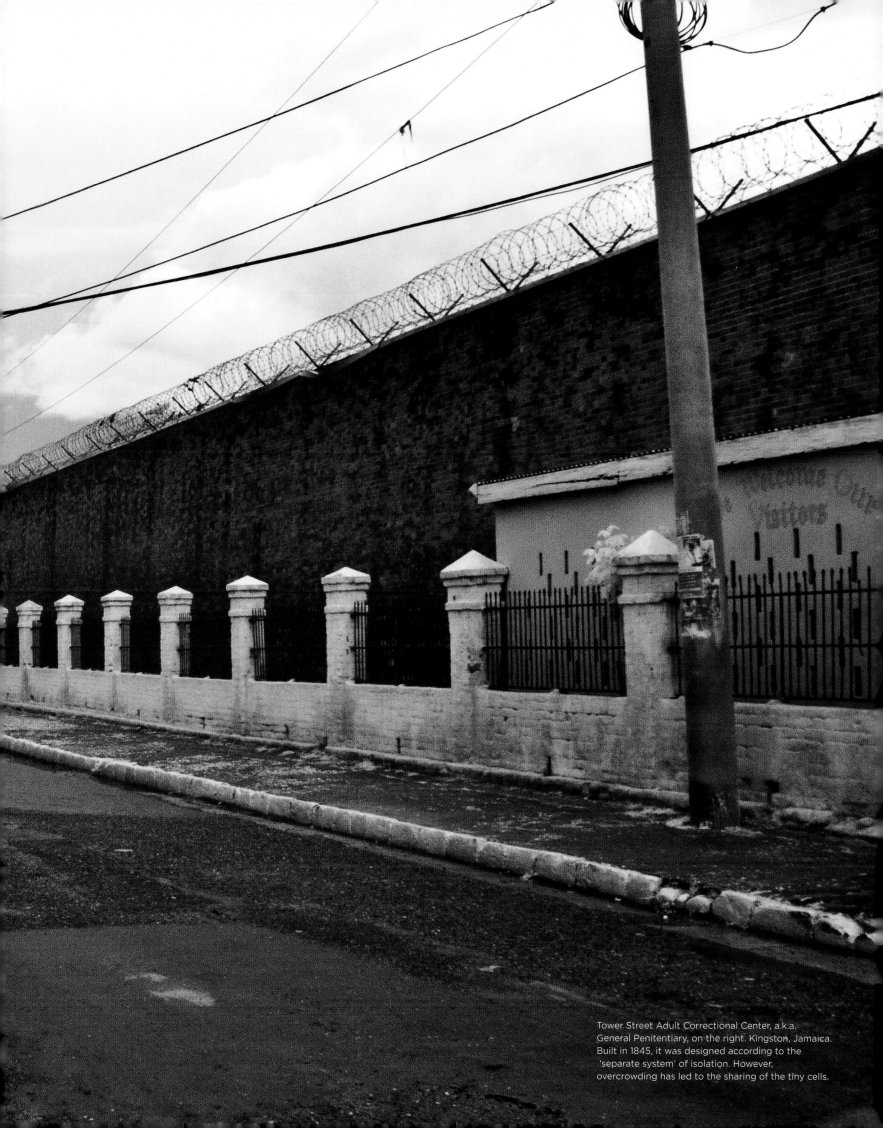

Tower Street Adult Correctional Center, a.k.a.
General Penitentiary, on the right. Kingston, Jamaica.
Built in 1845, it was designed according to the
'separate system' of isolation. However,
overcrowding has led to the sharing of the tiny cells.

Out Of Many,One People

As Jamaica prepared for its political independence in August 1962, the motto, "Out of Many, One People," had been adopted months earlier for inclusion on the national Coat of Arms, replacing a Latin inscription. Created in the days of ska, the motto certainly didn't specifically reference popular music, but it did symbolize reggae's unifying power, both within and beyond Jamaica in later years.

A young Ziggy Marley at Rita and Bob's house above the black sand beach of Bull Bay, the small fishing village where Bunny Wailer lived in St. Thomas, Jamaica.

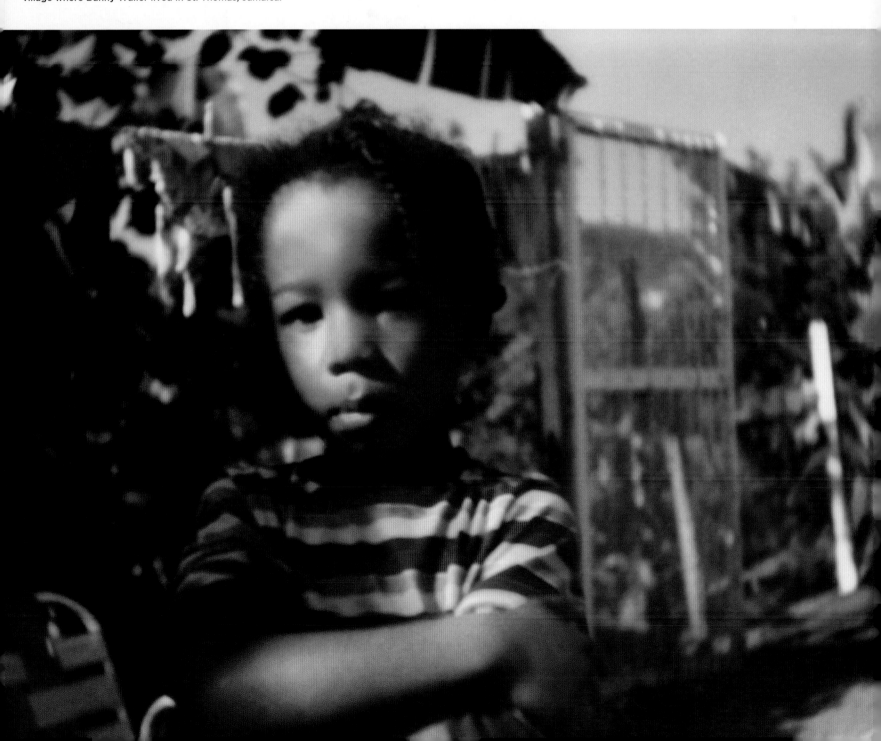

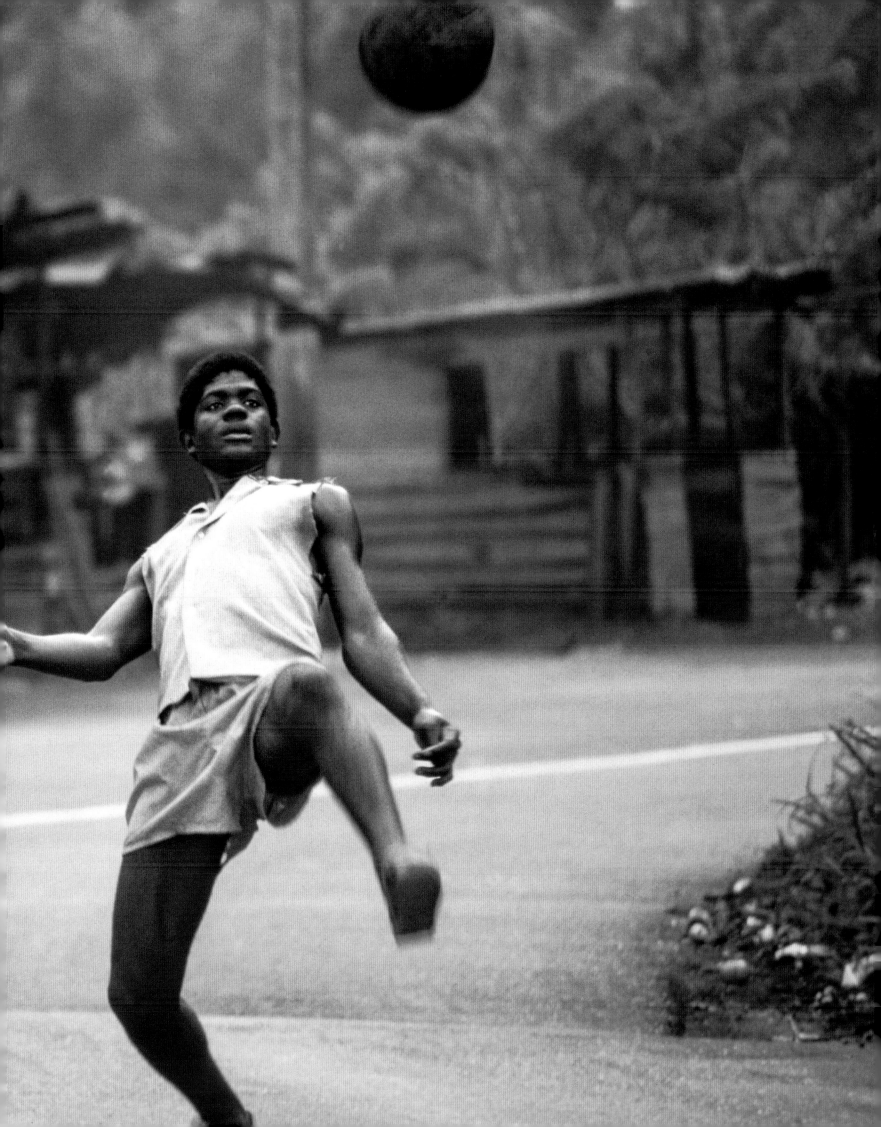

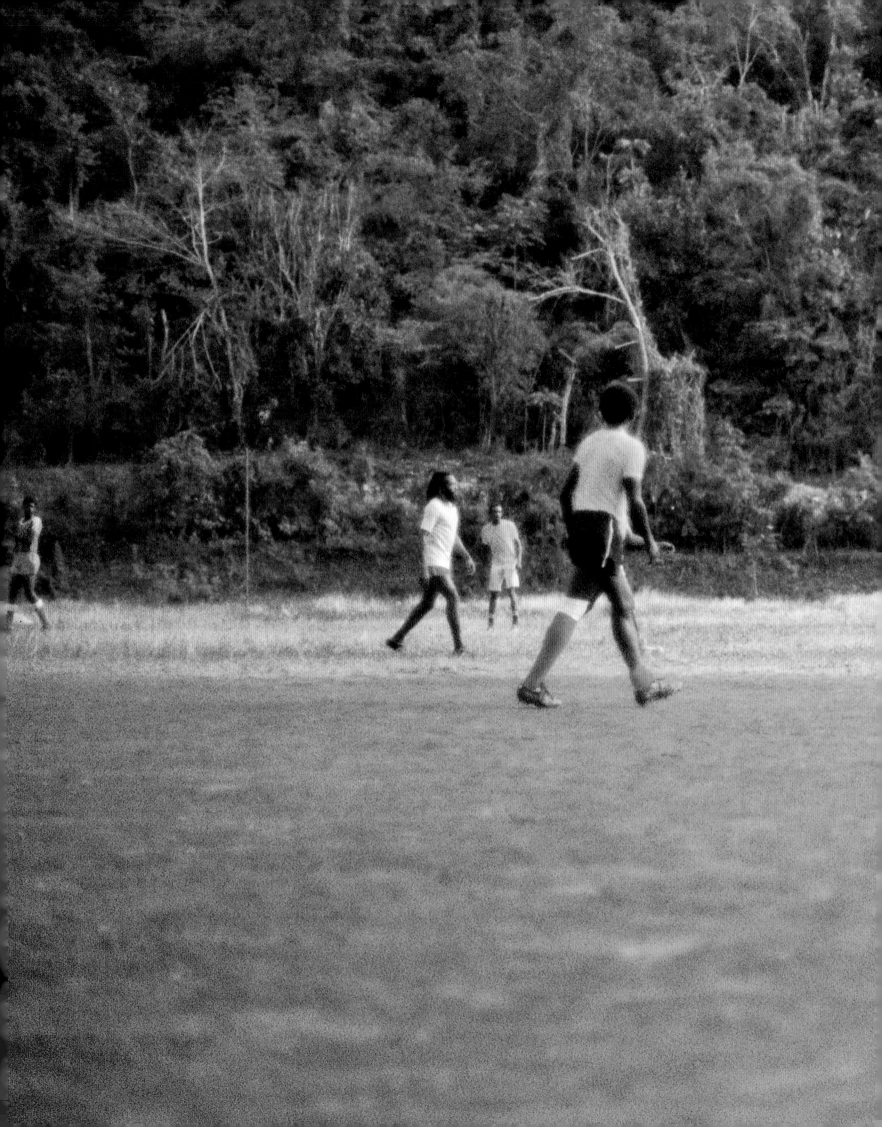

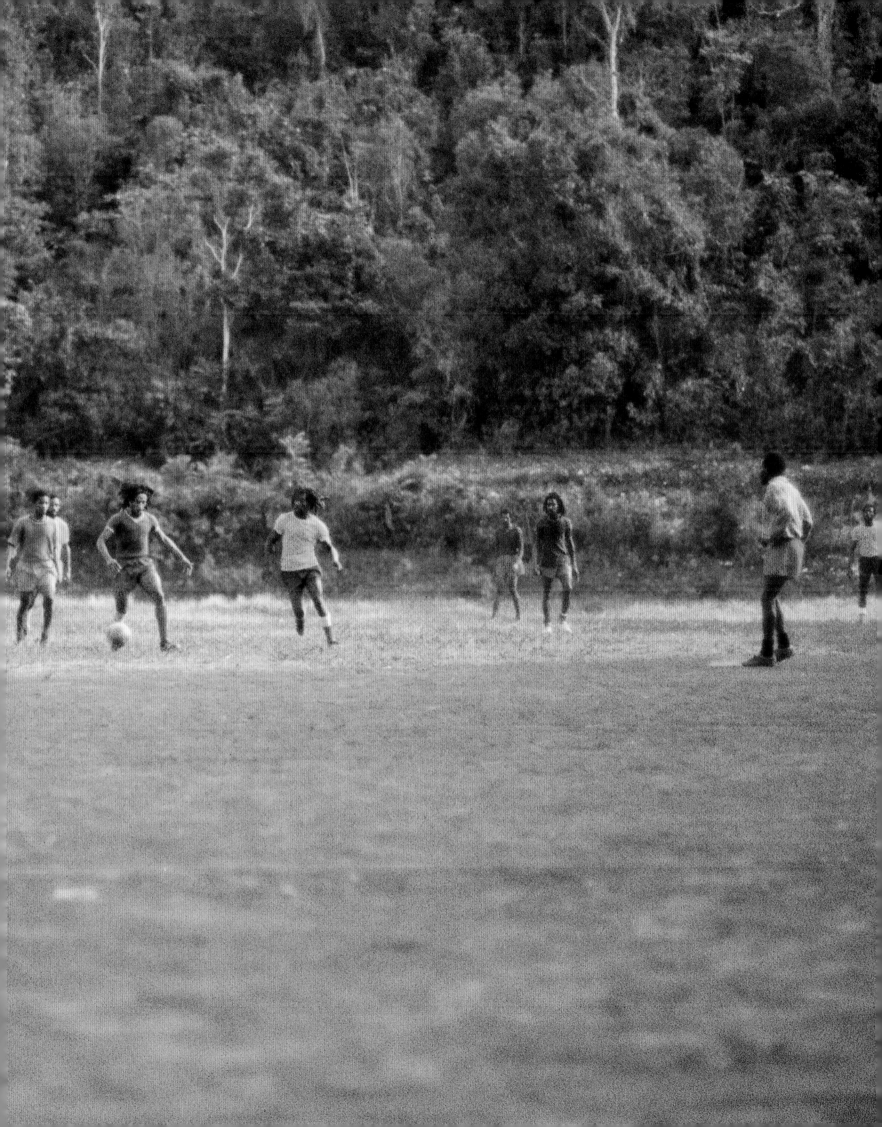

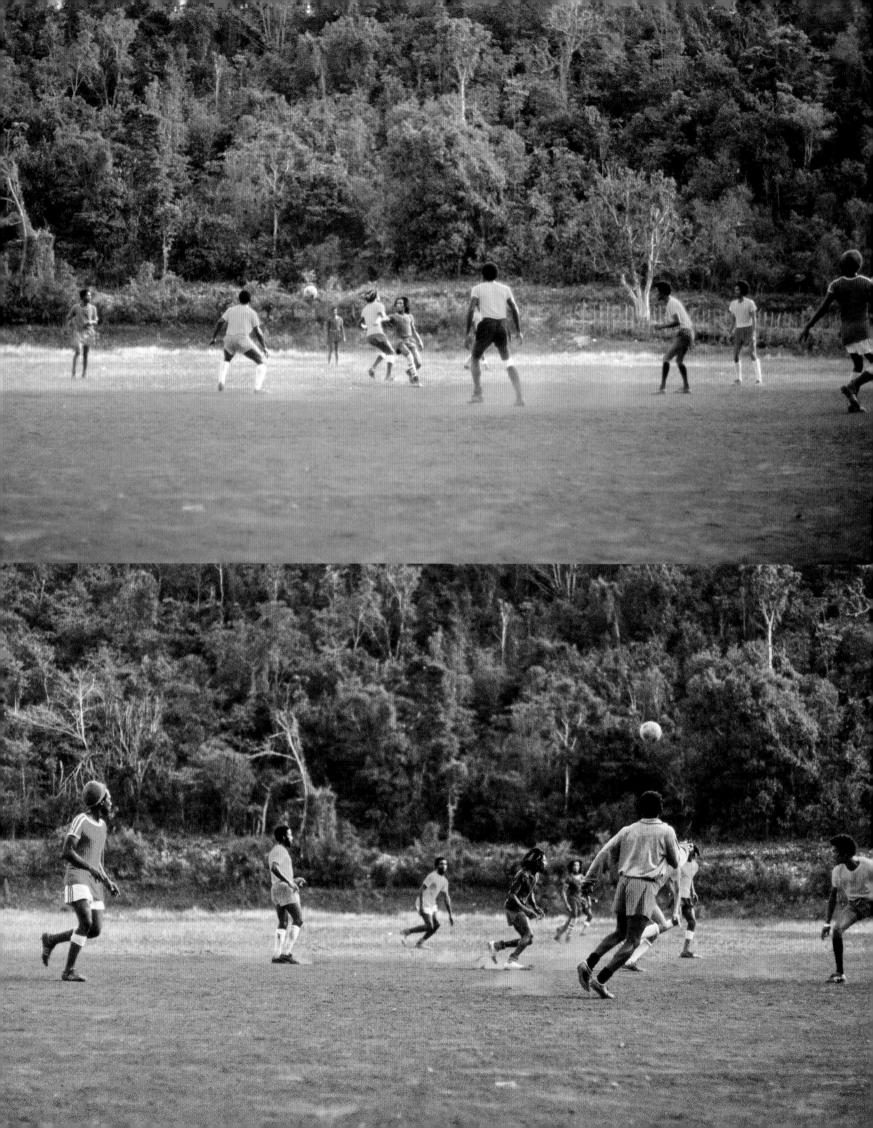

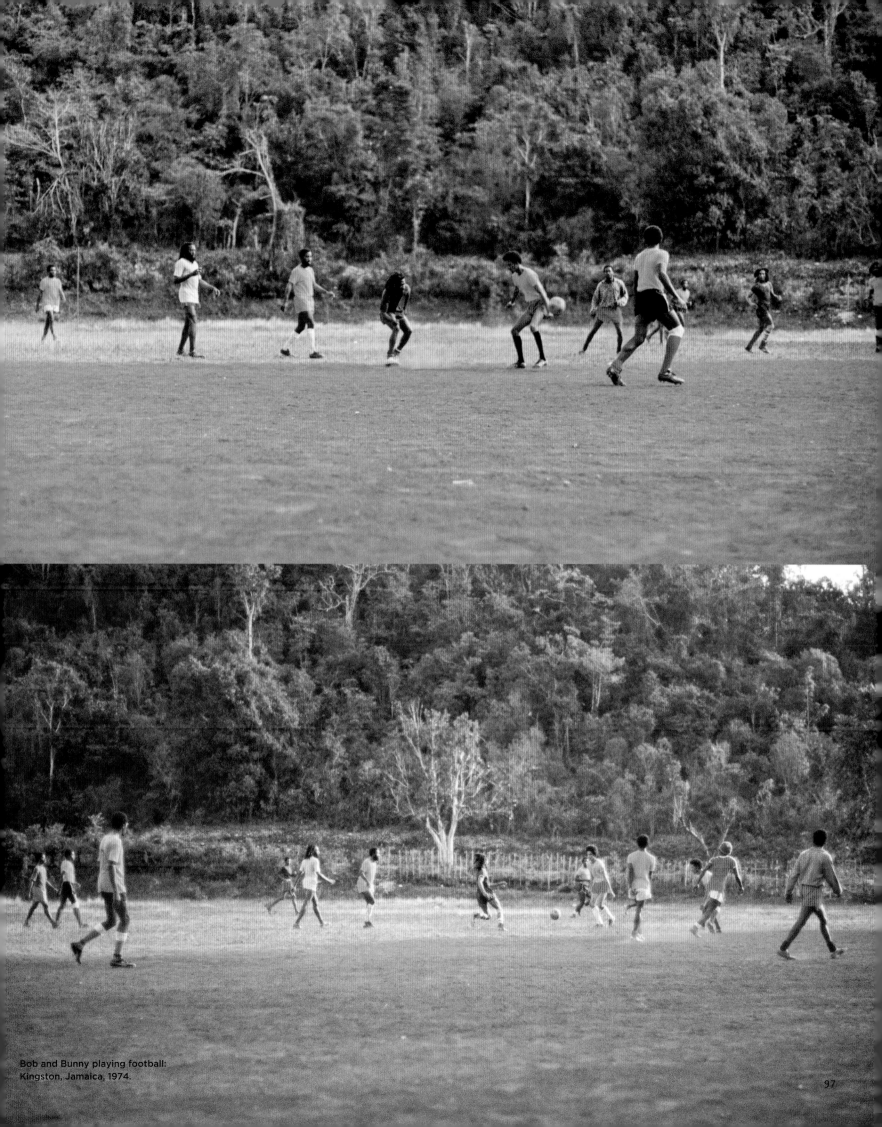

Bob and Bunny playing football:
Kingston, Jamaica, 1974.

Them Belly Full
(But We Hungry)

Them belly full but we hungry
A hungry mob is a angry mob
A rain a fall, but the dirt it tough
A pot a cook but the food no 'nough

Cost of livin' gets so high
Rich and poor, they start to cry
Now the weak must get strong
They say oh, what a tribulation.

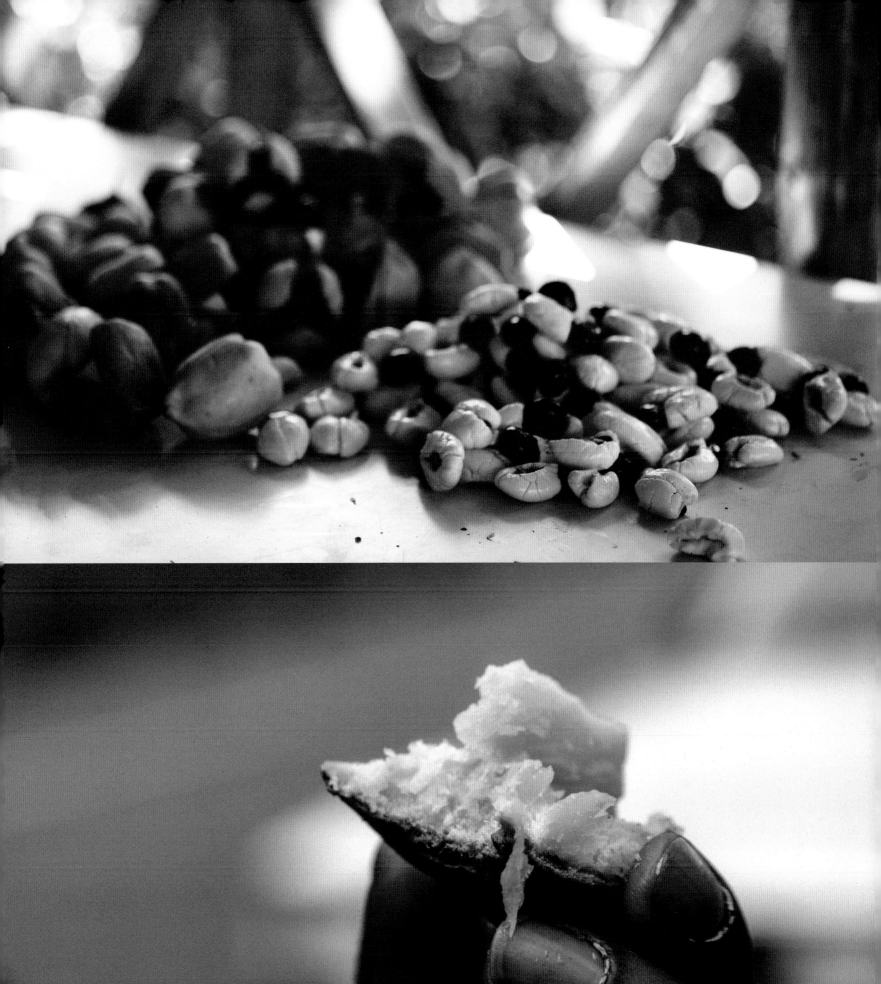

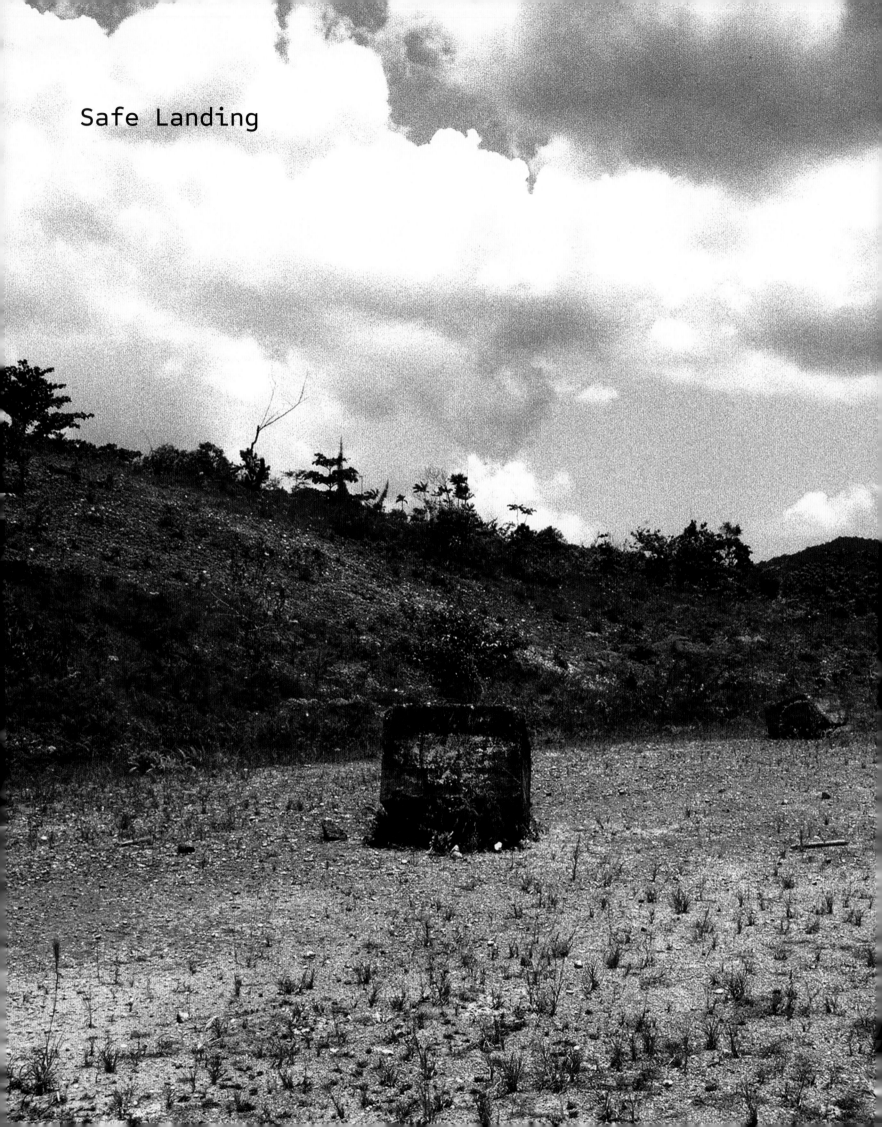

Safe Landing

In the predawn light just beginning to seep through the dark gray overcast, my fingers were clutched too tightly around the walkie-talkie. The forty-odd crocus sacks—their weights varying between fifteen and twenty pounds—had been unloaded from the Datsun 521 pick-up that had shuttled them from Blue Harbor to the coarse, gravelly airstrip that hugged the coast at Boscobel—a convenient 15-minute drive away. I waited, gazing to the heavens for Jah to deliver safe landing for our pilot, Sy.

Sy had inherited millions from a father who had amassed a fortune growing shade tobacco in the Connecticut River Valley. He initially employed child laborers, and then Black migrant college students who came to toil on summer breaks—among them a young Martin Luther King Jr. Sy, a calm, confidently skilled pilot, wasn't in it for the money—though the hefty payday would be sweet. He was in it for the thrill.

I waited anxiously with Peter and Sledger out on the strip, while Champs—who had helped with introducing us to the dozen or so farmers from whom we bought the sticky herb—and two fit young Dreads, McGyver and Blacka, hid in the thick bush, guarding the load. Sy was late, and the tension was palpable. Then the invisible hum of twin-engines broke through the clouds. I leaned into the gawky pre-cellular talkie: "Ground to 007, ground to 007." The sound of the engines grew louder, and there was excitement and relief to hear Sy's voice: "007 to ground." Then she appeared.

The lucky Lockheed Loadstar emerged through the cloud cover like a phantasmic thunderbird, settling down in a widescreen CinemaScope, slow-motion shot, transforming me into Bogie in the good-bye scene in *Casablanca*.

The Dreads began to haul the bales to the plane. I stood triumphant on the wing as Sledger helped McGyver and Blacka lift the cargo to me as I passed it on to a smiling Sy inside the bird.

Then the unspeakable happened; we heard another plane descending. As it approached—a black Cessna 172 Skyhawk with bold white letters painted on its side that read: JAMAICA DEFENCE FORCE—we collectively froze.

It landed and rolled up beside us. To our relief, it was just an Air Force pilot out for a Sunday morning joy ride with his gal. They smiled and waved, then flew away. "Legalize It" was alive to fight another day.

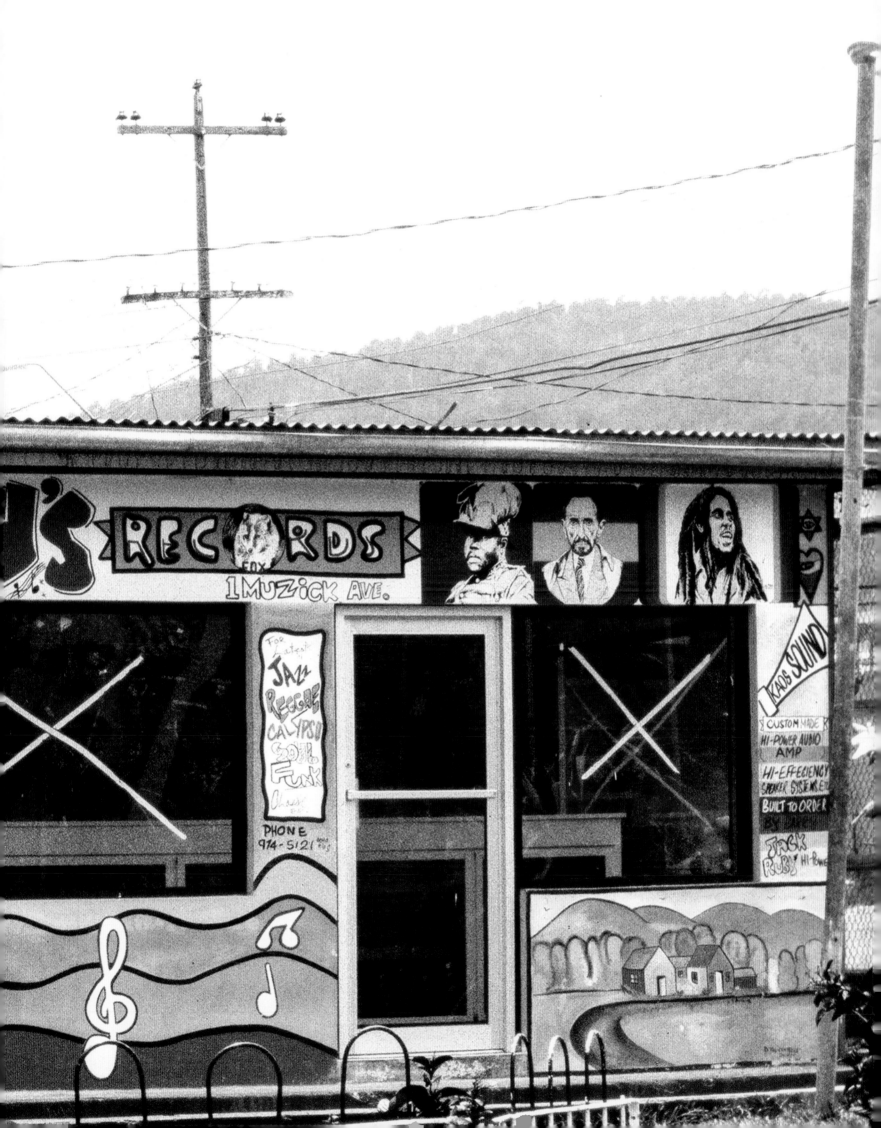

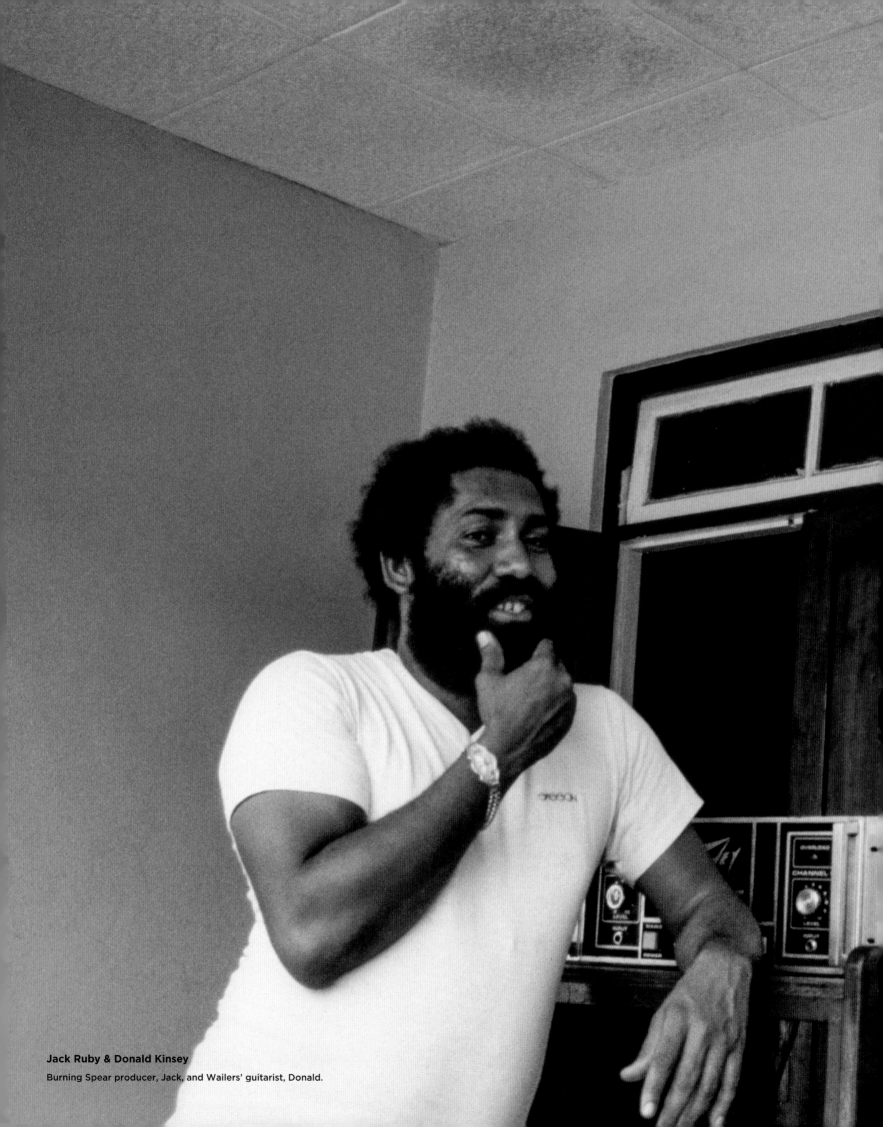

Jack Ruby & Donald Kinsey
Burning Spear producer, Jack, and Wailers' guitarist, Donald.

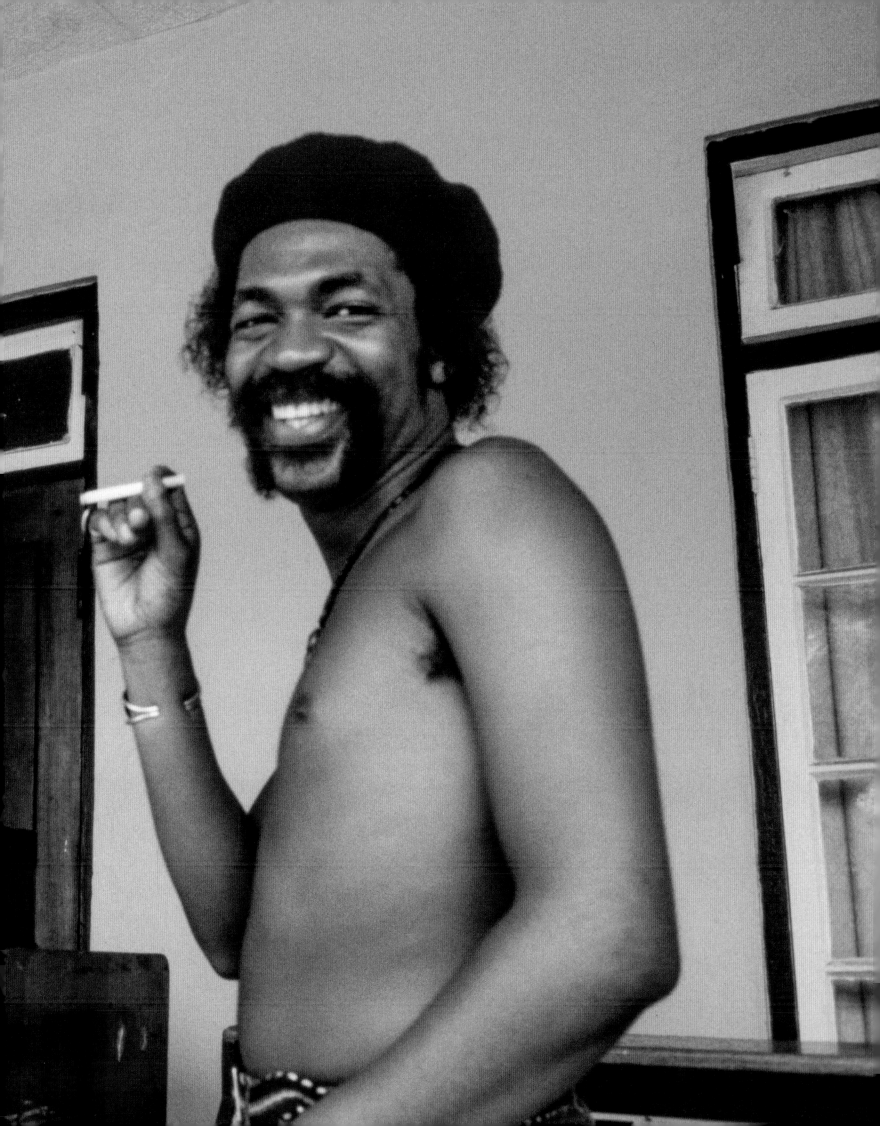

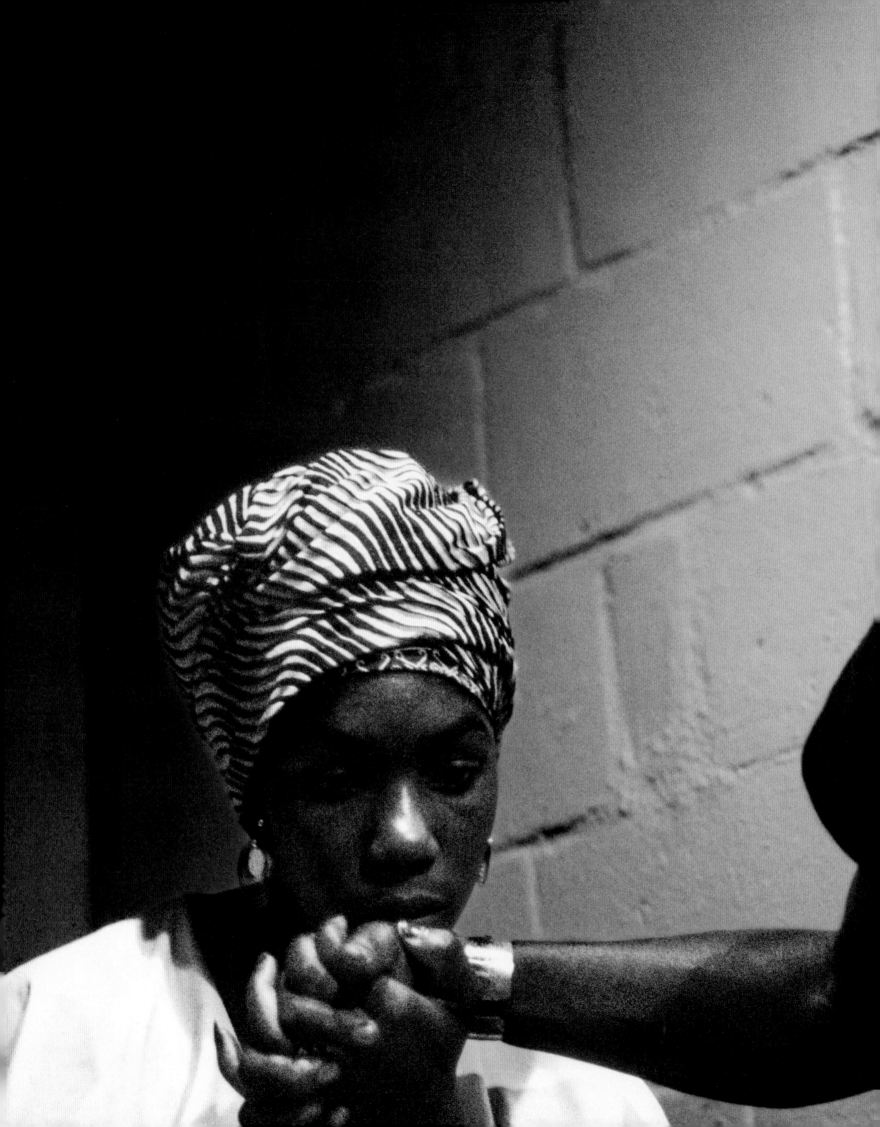

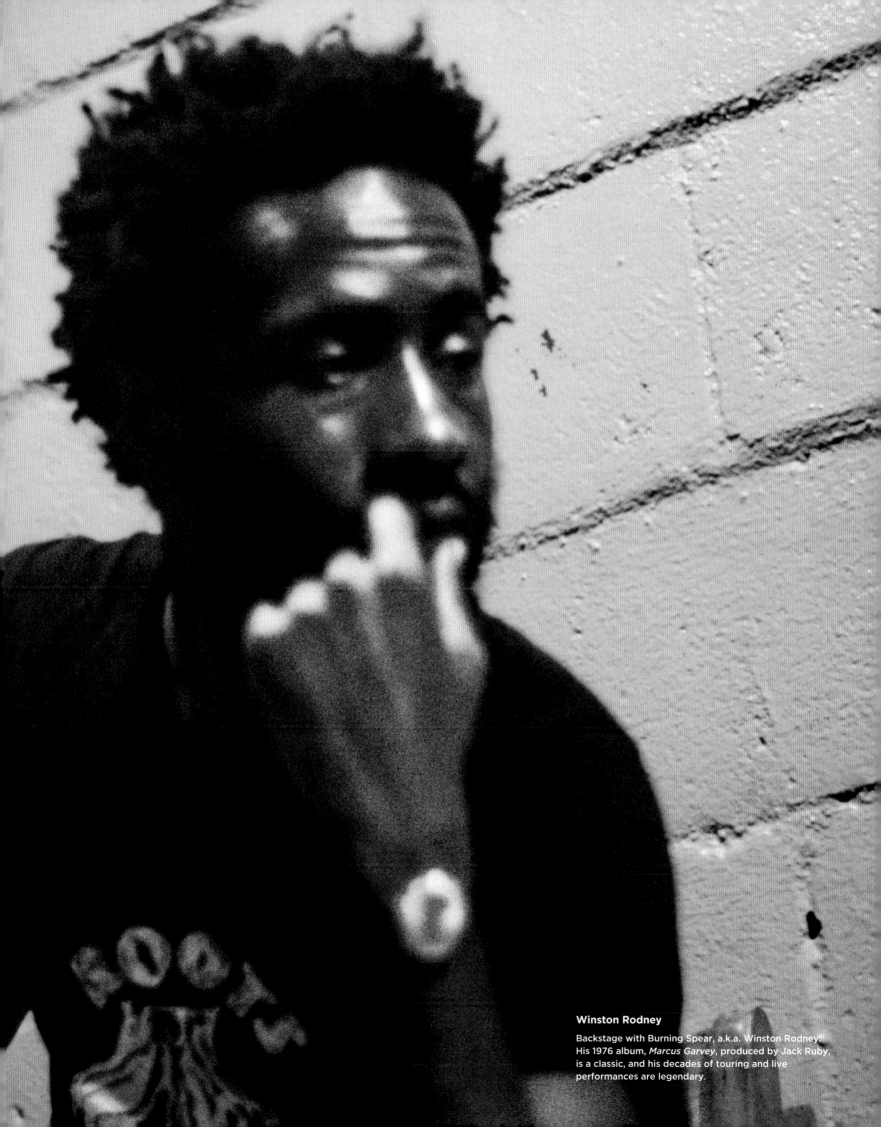

Winston Rodney

Backstage with Burning Spear, a.k.a. Winston Rodney.
His 1976 album, *Marcus Garvey*, produced by Jack Ruby,
is a classic, and his decades of touring and live
performances are legendary.

The poet, Black X, near Waterhouse, Kingston.

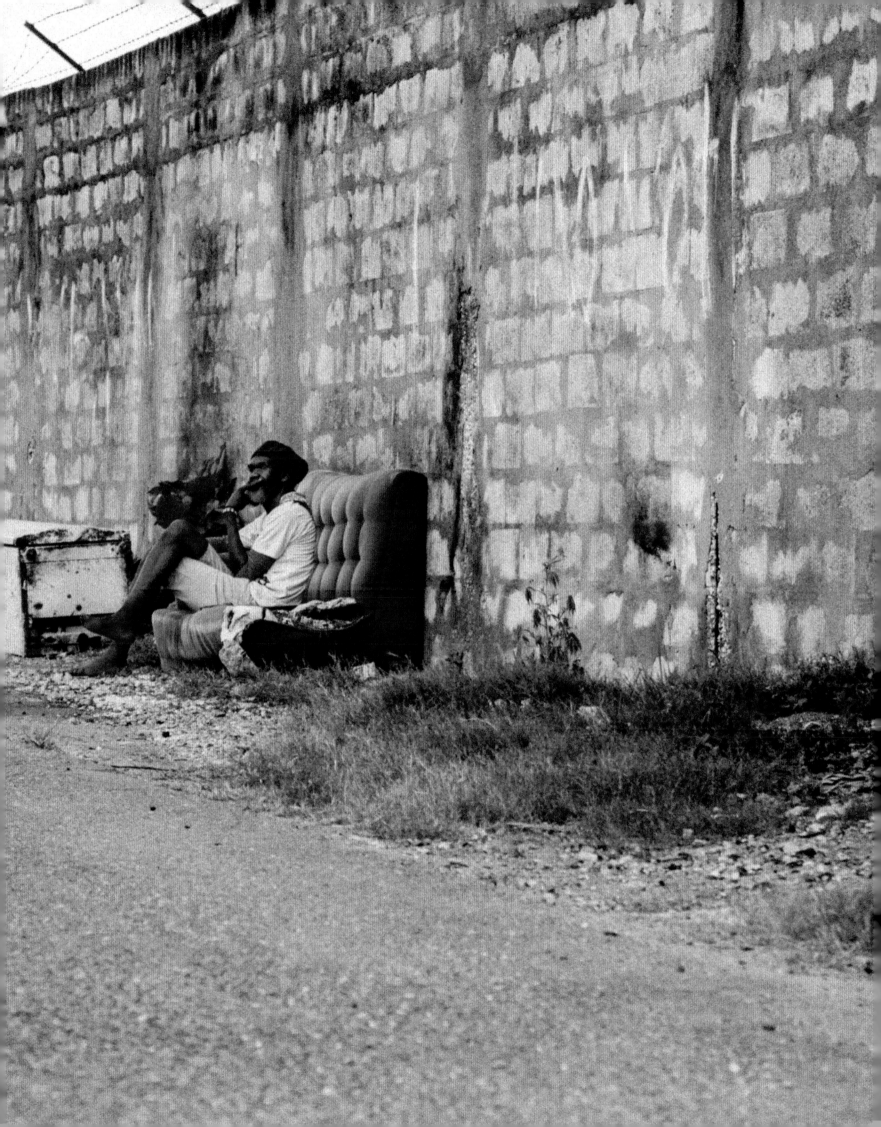

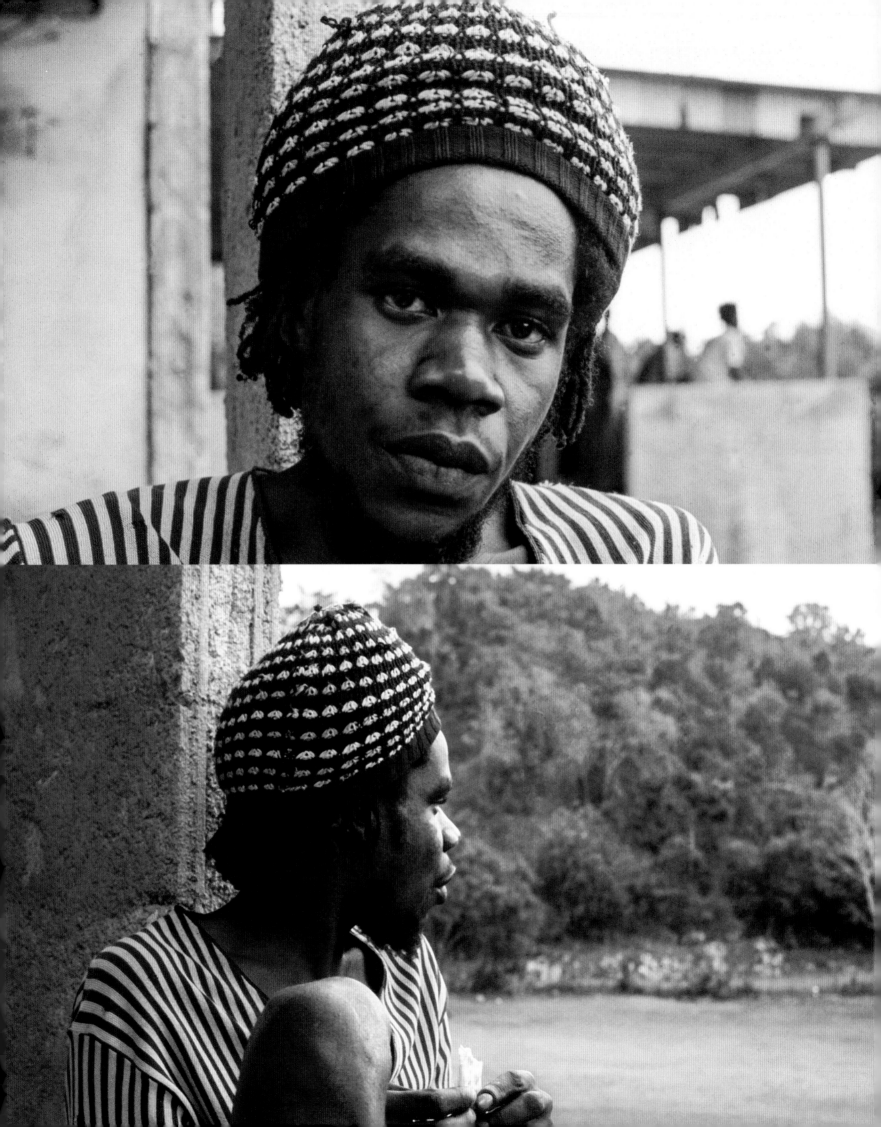

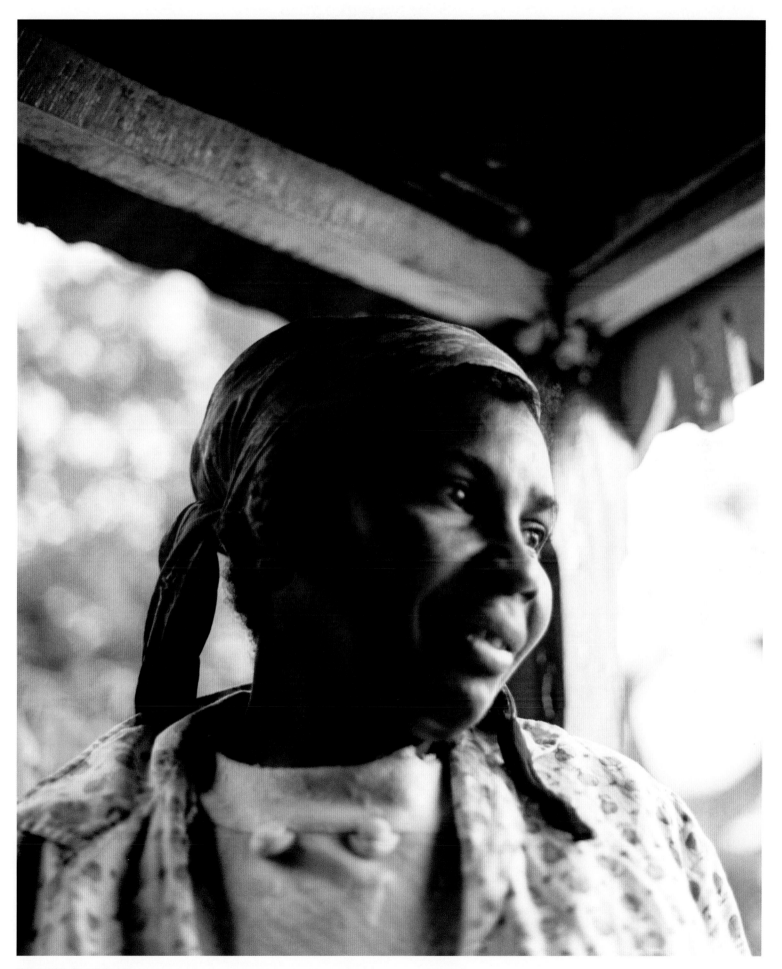

Hugh "Sledger" Peart

Bob's first cousin. They grew up together at the tiny
village of Nine Mile, high in the mountains of St. Ann's
Parish, Jamaica. Sledger's mom, Enid Malcolm (above),
and Bob's mom, Cedella, were sisters. Sledger was Bob's
constant companion during the times I lived at Hope Road.

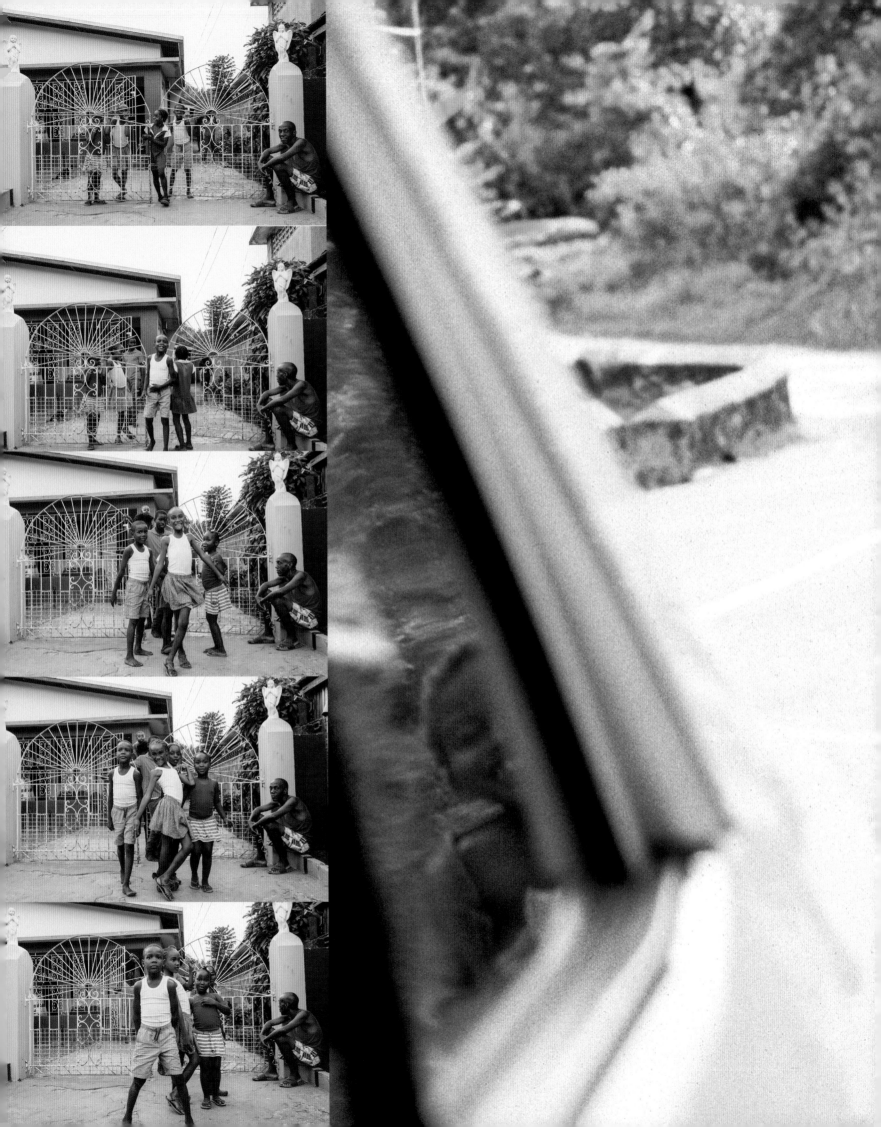

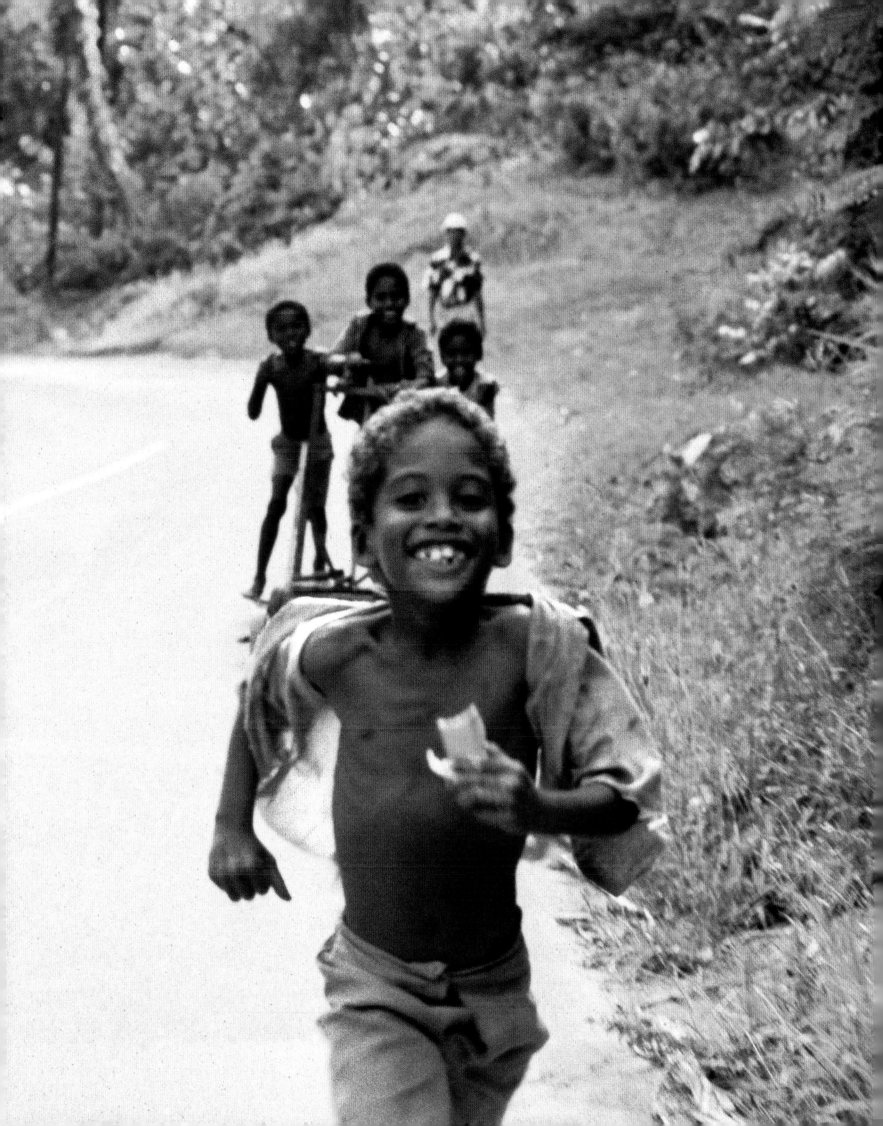

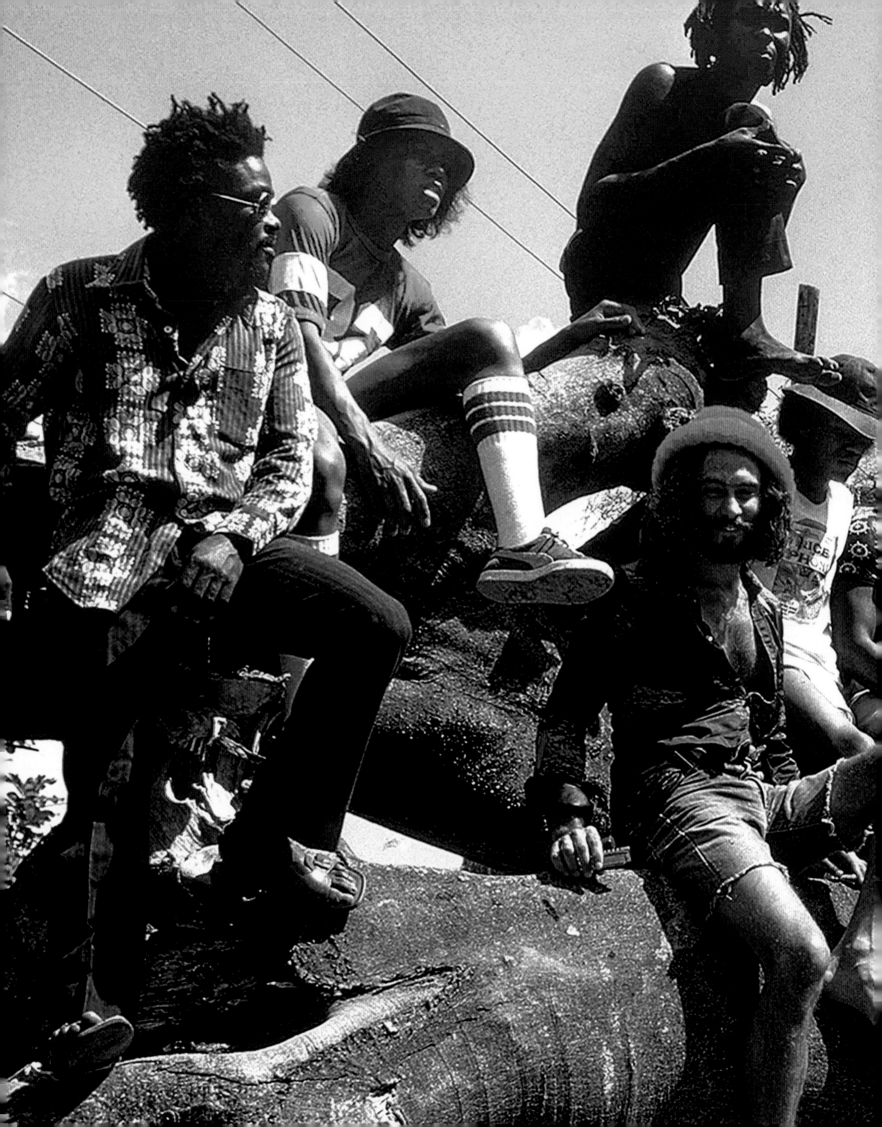

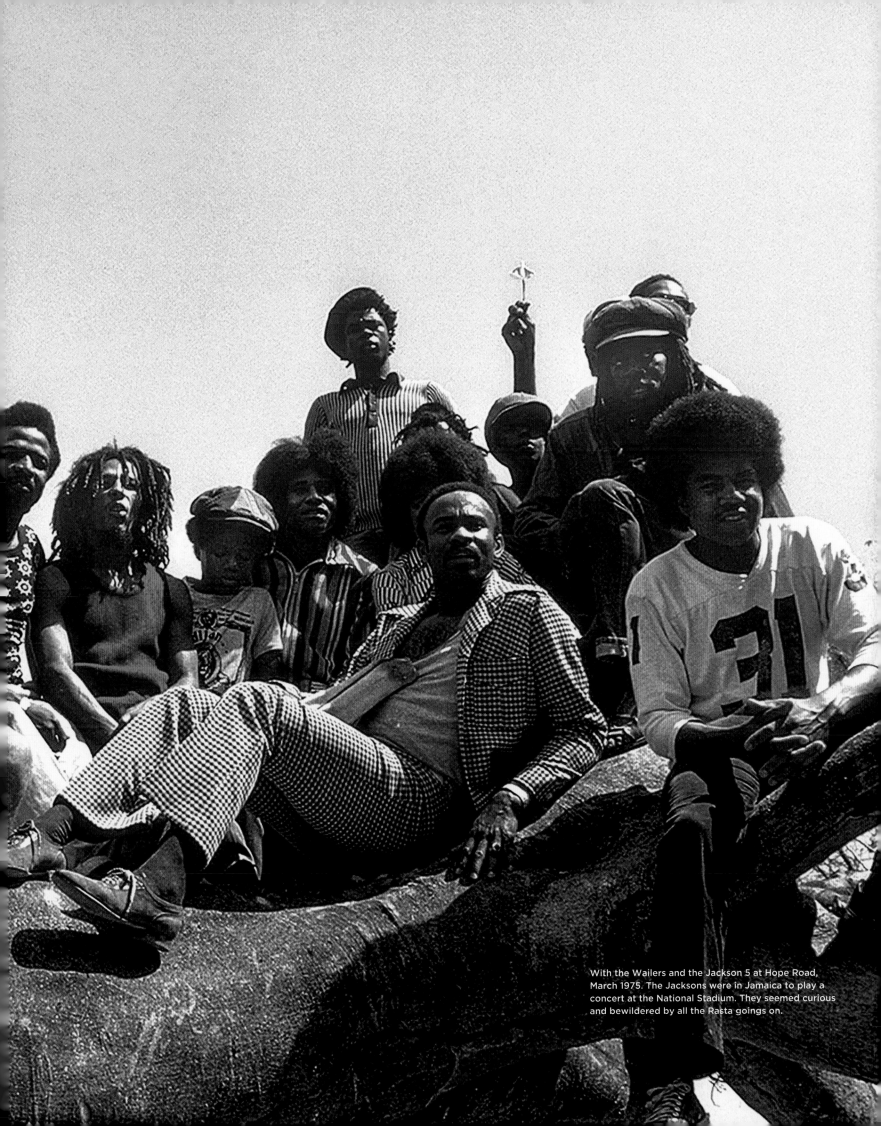

With the Wailers and the Jackson 5 at Hope Road, March 1975. The Jacksons were in Jamaica to play a concert at the National Stadium. They seemed curious and bewildered by all the Rasta goings on.

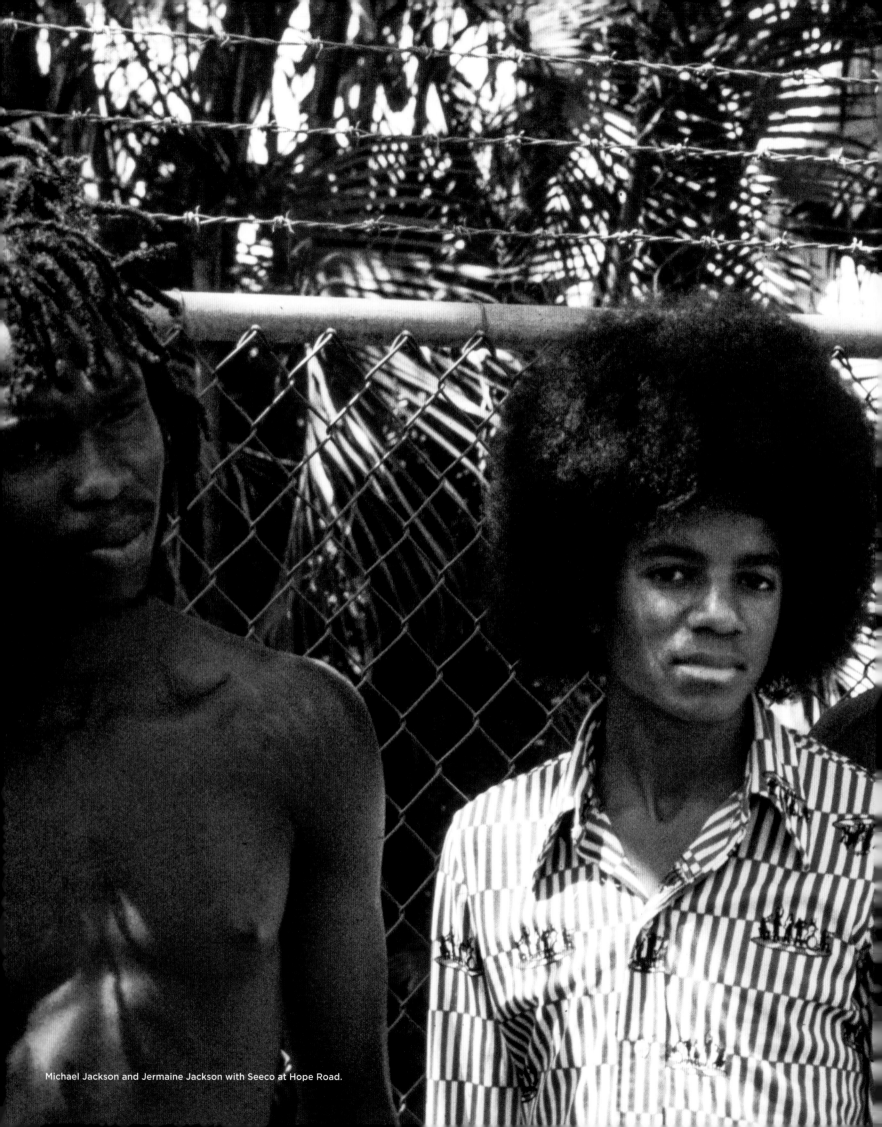

Michael Jackson and Jermaine Jackson with Seeco at Hope Road.

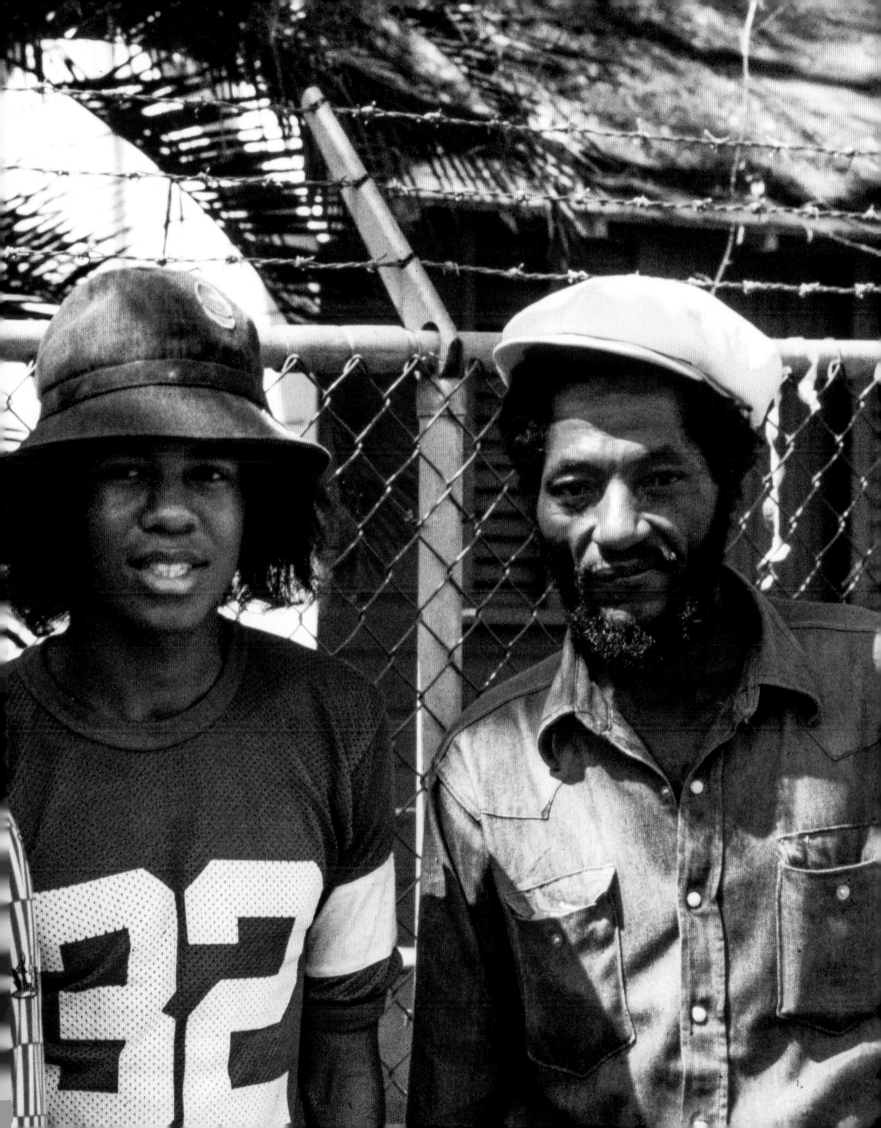

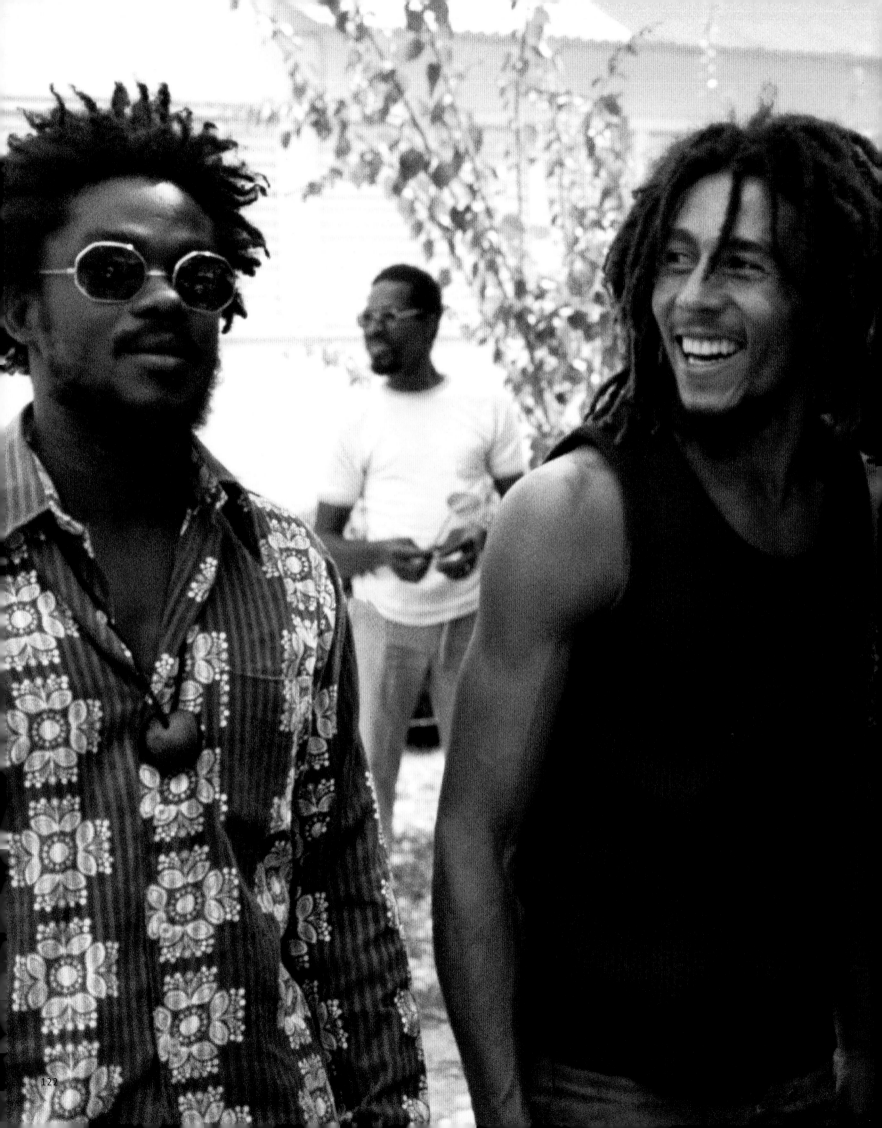

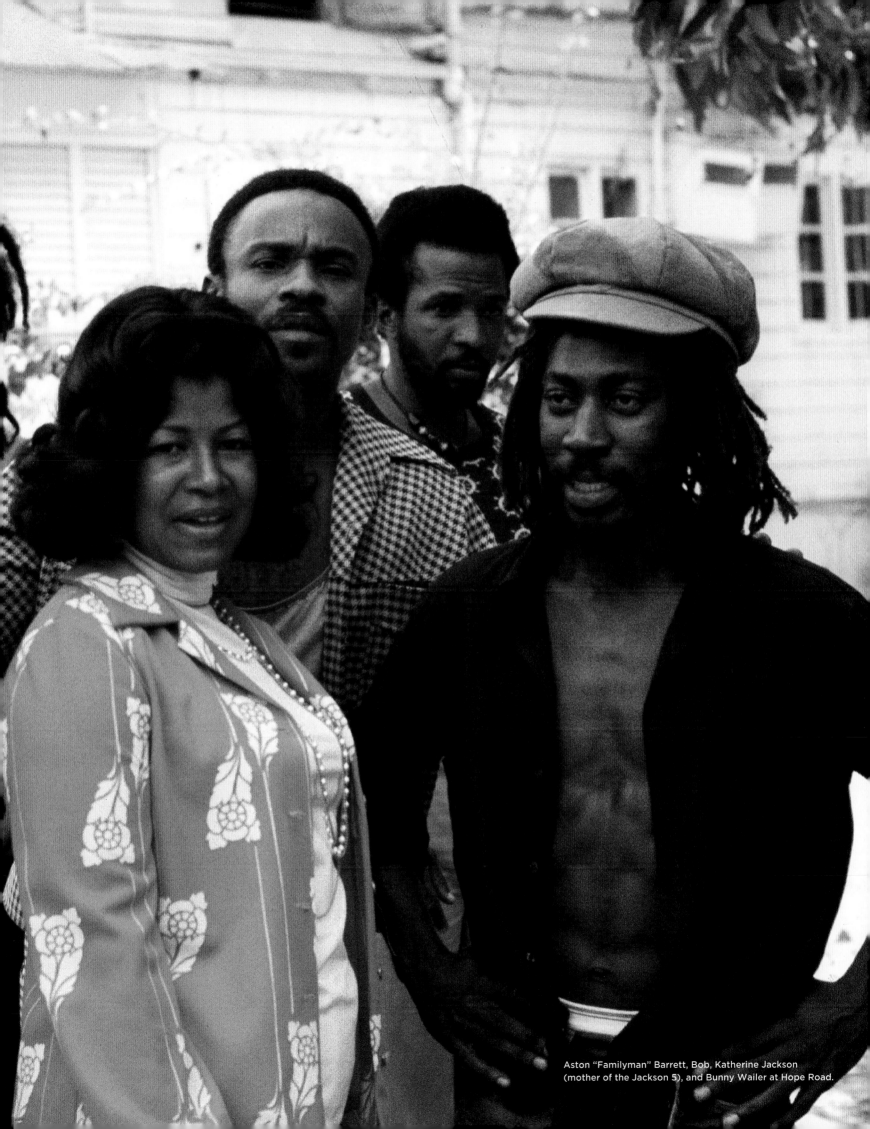

Aston "Familyman" Barrett, Bob, Katherine Jackson (mother of the Jackson 5), and Bunny Wailer at Hope Road.

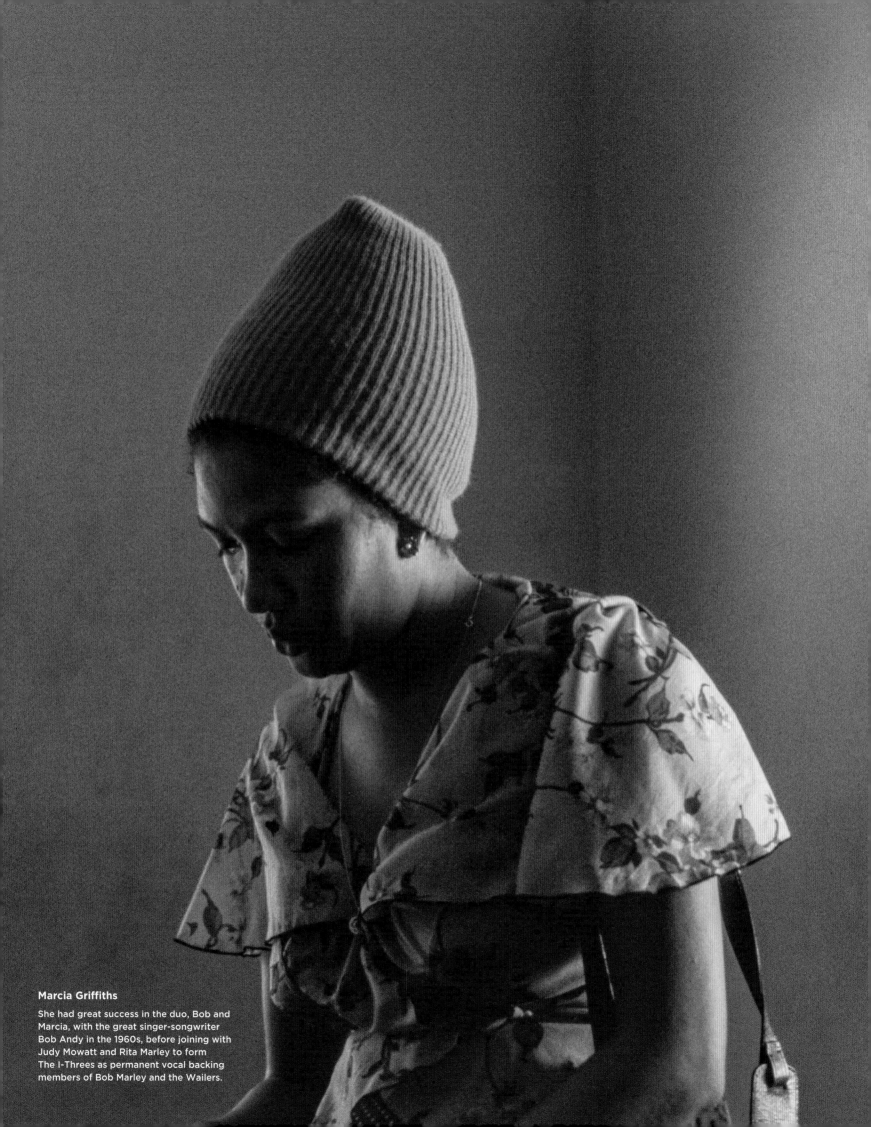

Marcia Griffiths

She had great success in the duo, Bob and
Marcia, with the great singer-songwriter
Bob Andy in the 1960s, before joining with
Judy Mowatt and Rita Marley to form
The I-Threes as permanent vocal backing
members of Bob Marley and the Wailers.

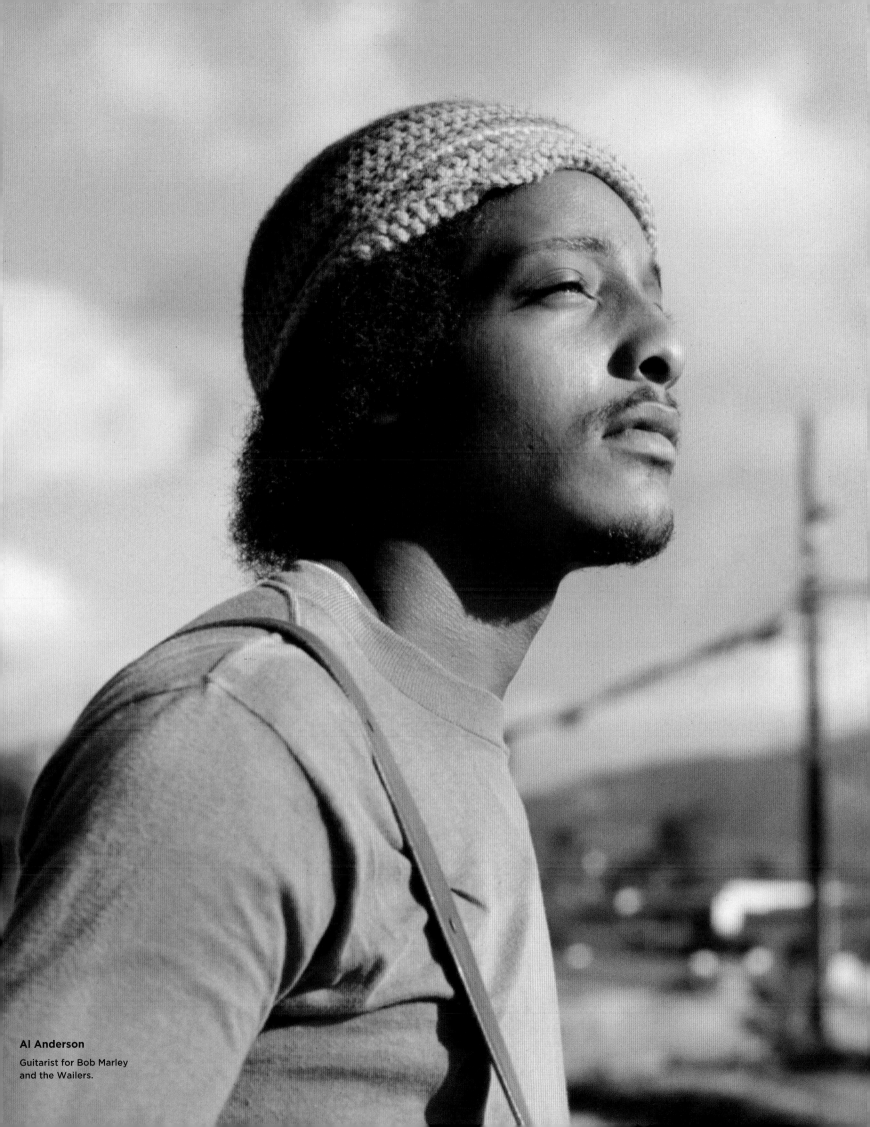

Al Anderson

Guitarist for Bob Marley
and the Wailers.

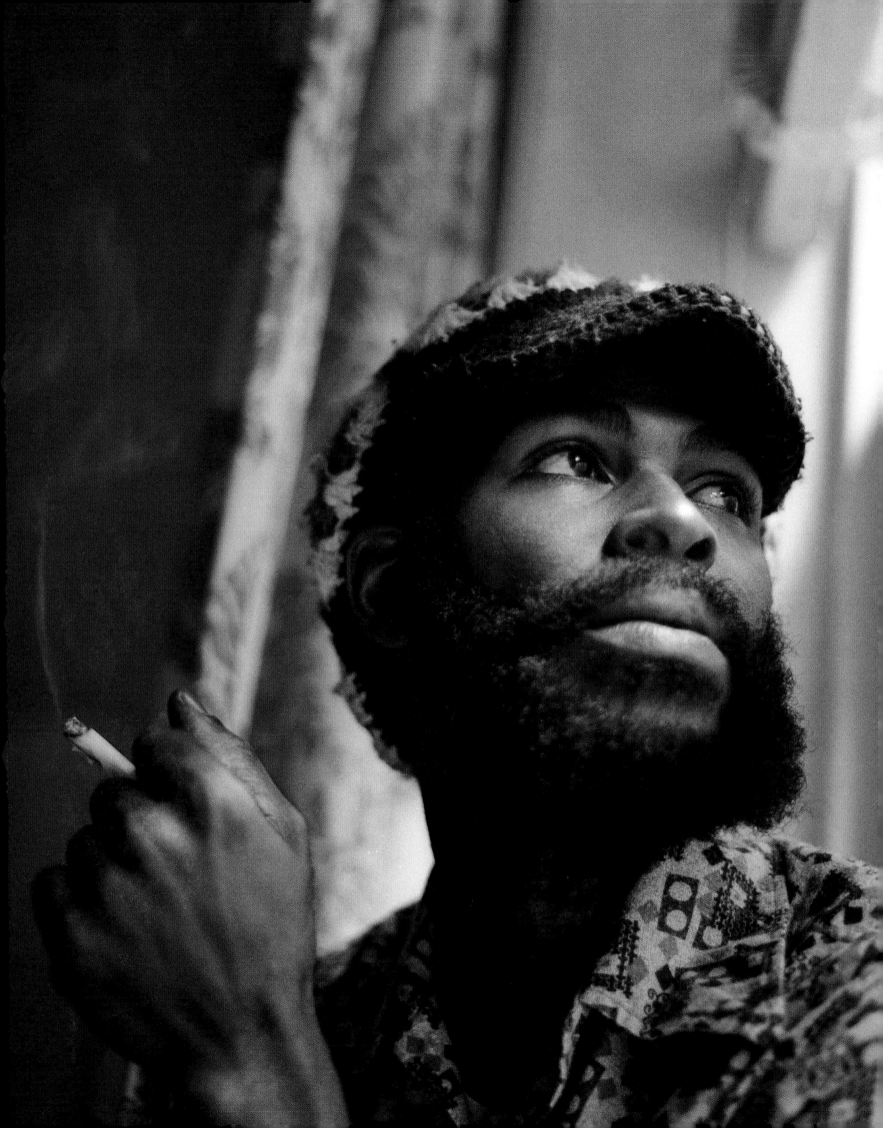

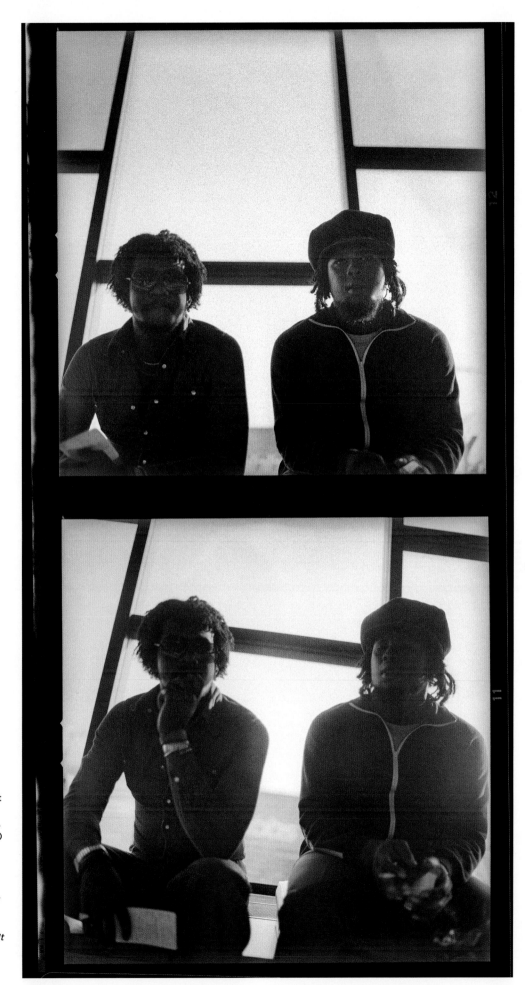

Left:
Karl Pitterson

Karl is a seminal figure in the history of Jamaican music. The importance of his work as a producer, engineer and musician cannot be overstated. He produced Steel Pulse's first two albums, *Handsworth Revolution* (1978) and *Tribute to the Martyrs* (1979), released by Island Records, both enduring classics. He launched the band's successful career, now five decades long. I had the great fortune to work with him on Peter Tosh's *Legalize It* album (1976) and Joe Higgs' *Blackman Know Yourself* (1990).

This page:
**Sly Dunbar &
Robbie Shakespeare**

Sly and Robbie at Norman Manley Airport, Kingston, Jamaica, about to embark on a U.S. tour with Peter's band, Word, Sound and Power, 1976.

Following page;
With Peter at the National Stadium, Kingston, Jamaica, 1974.

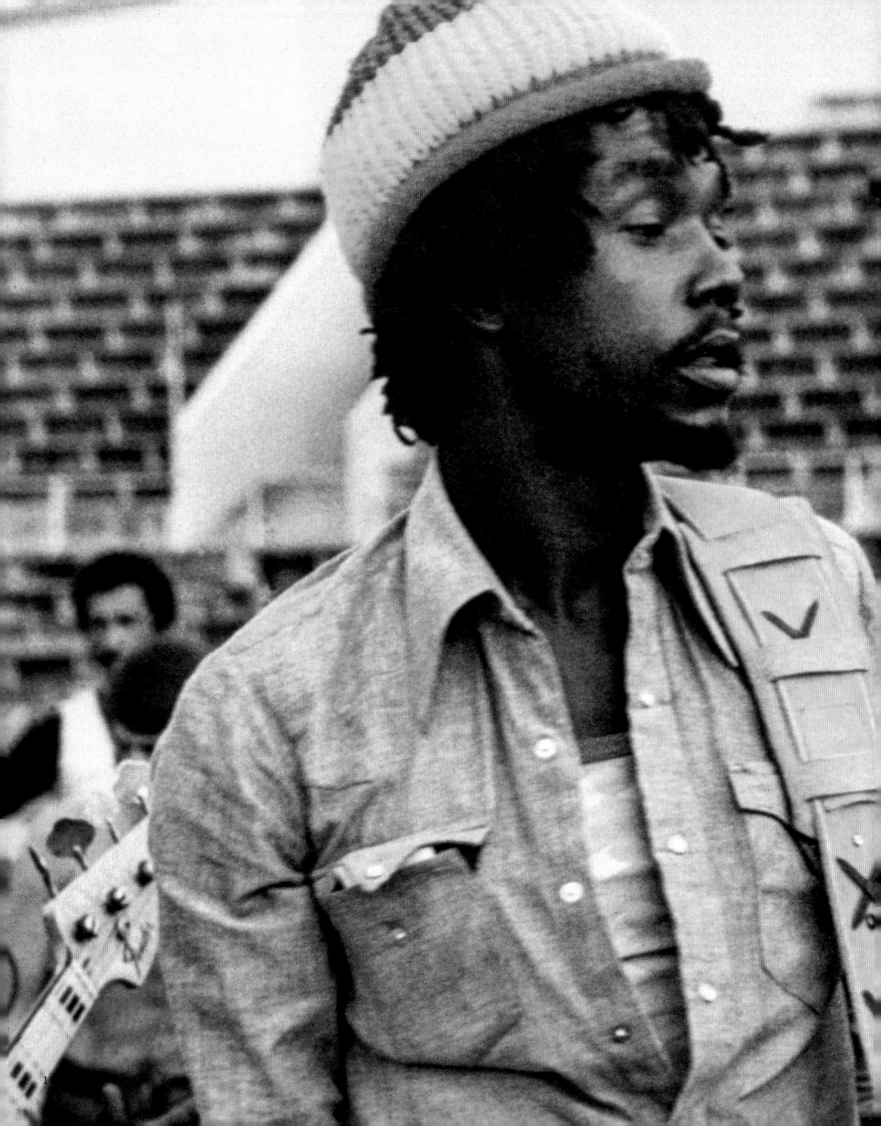

Jacob Miller at National Stadium Kingston, Jamaica

Jacob was the lead singer for the group, Inner Circle. He was a larger-than-life personality and was a generous soul who, except when he was driving, was someone you always wanted to be around. But he was a reckless driver. One time he had picked me up at the house on Hope Road to go to the studio to hear some music. After a few minutes, while stopped at a red light near Halfway Tree, I turned to him and said "Jacob, I'm going to walk." I didn't wait for him to respond. He and his group were destined for international stardom with a scheduled tour opening for Bob Marley and the Wailers, when sadly he died in a car crash in 1980.

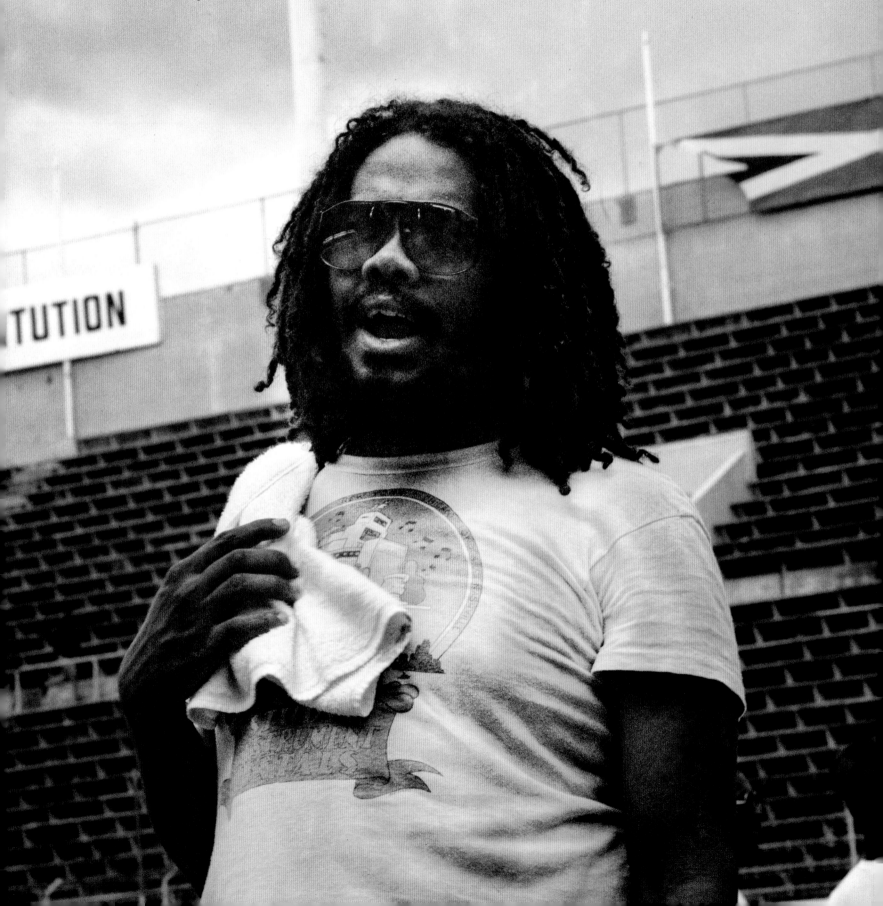

The Mighty Diamonds

Fitzroy "Bunny" Simpson, lead singer Donald "Tabby" Shaw, and Lloyd "Judge" Ferguson. Their seminal 1976 album, *Right Time*, was produced at Joseph Ho Kim's Channel One Recording Studio, with Sly Dunbar and Robbie Shakespeare supplying stellar backing. They issued more than forty albums, and in 2021 were honored the Order Of Distinction by the Jamaican government. One year later on March 29th 2022, Tabby was murdered in a drive-by shooting. Simpson died two days later from diabetes complications.

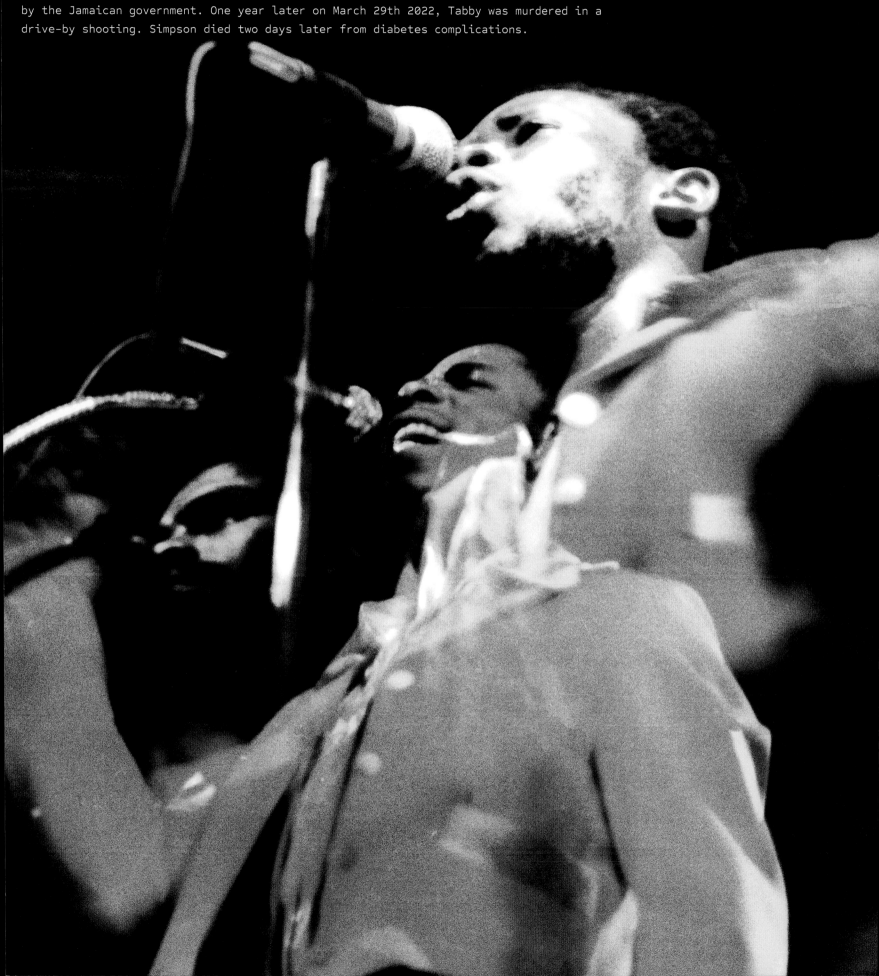

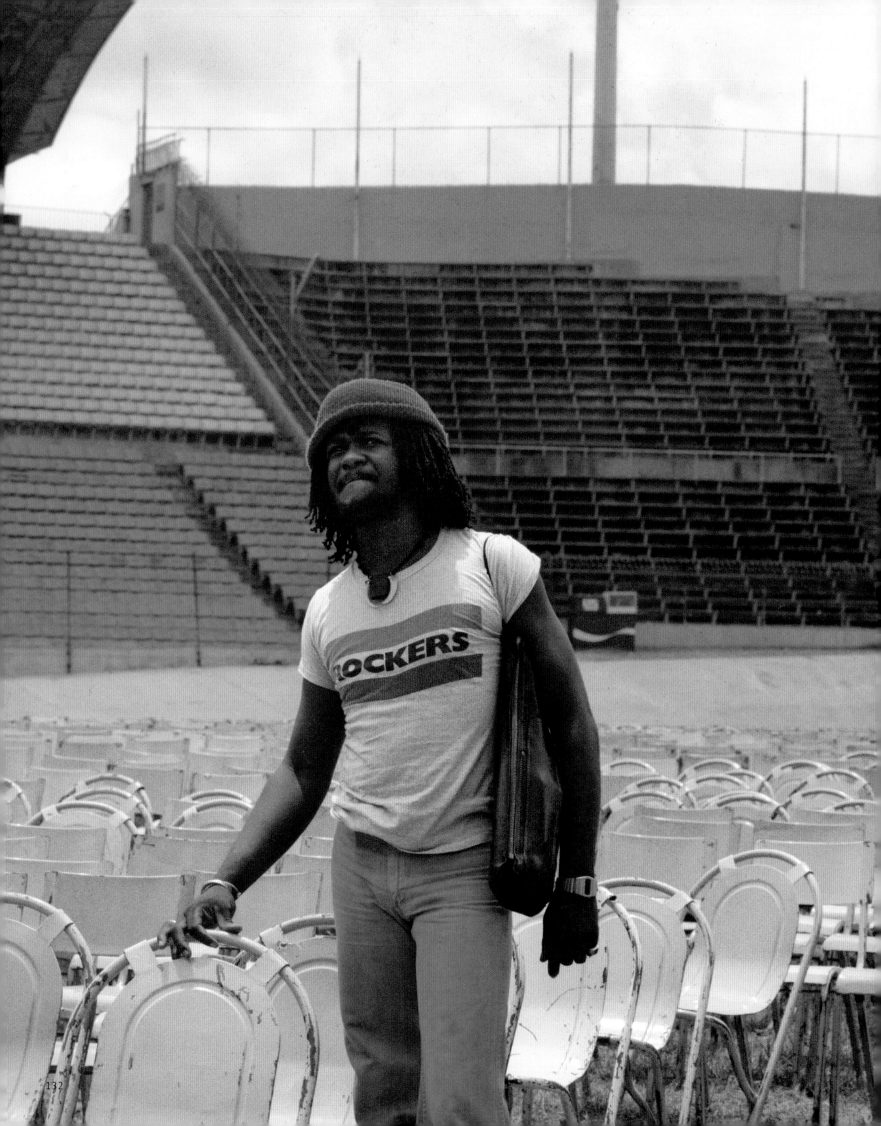

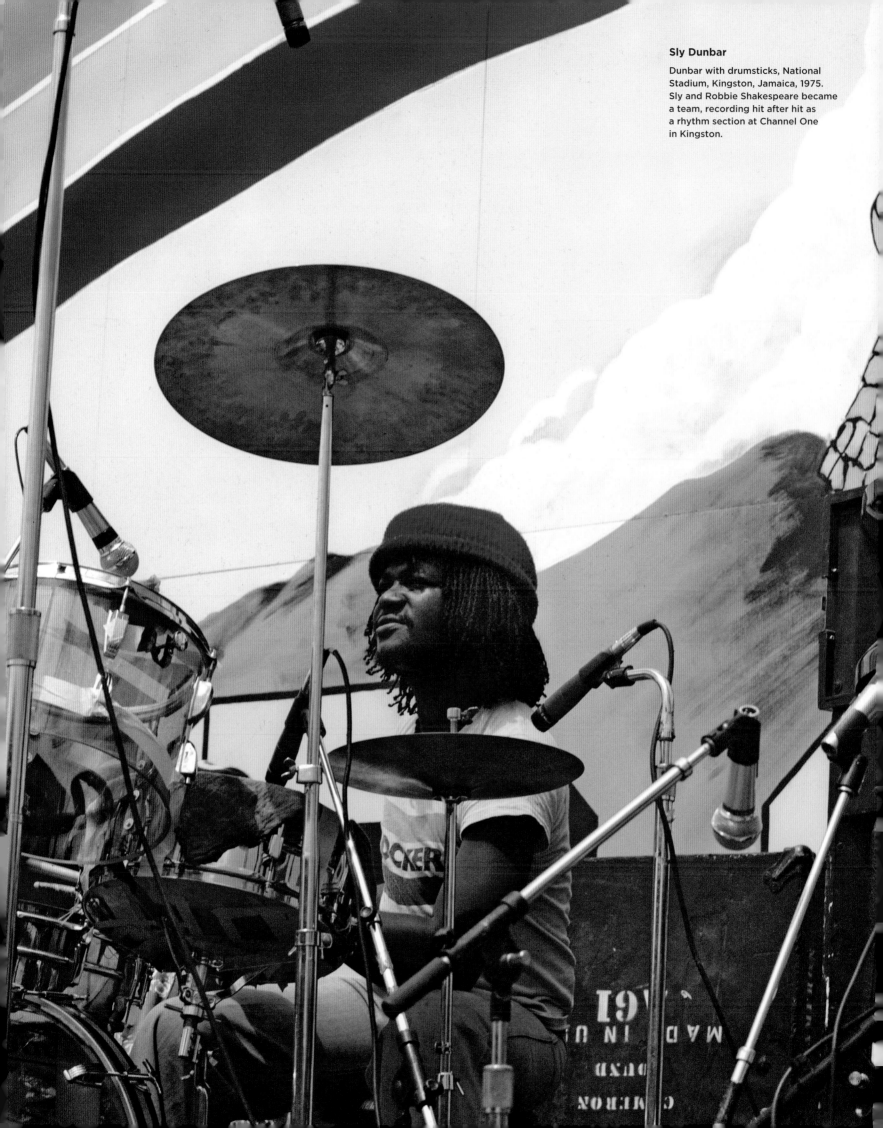

Sly Dunbar

Dunbar with drumsticks, National Stadium, Kingston, Jamaica, 1975. Sly and Robbie Shakespeare became a team, recording hit after hit as a rhythm section at Channel One in Kingston.

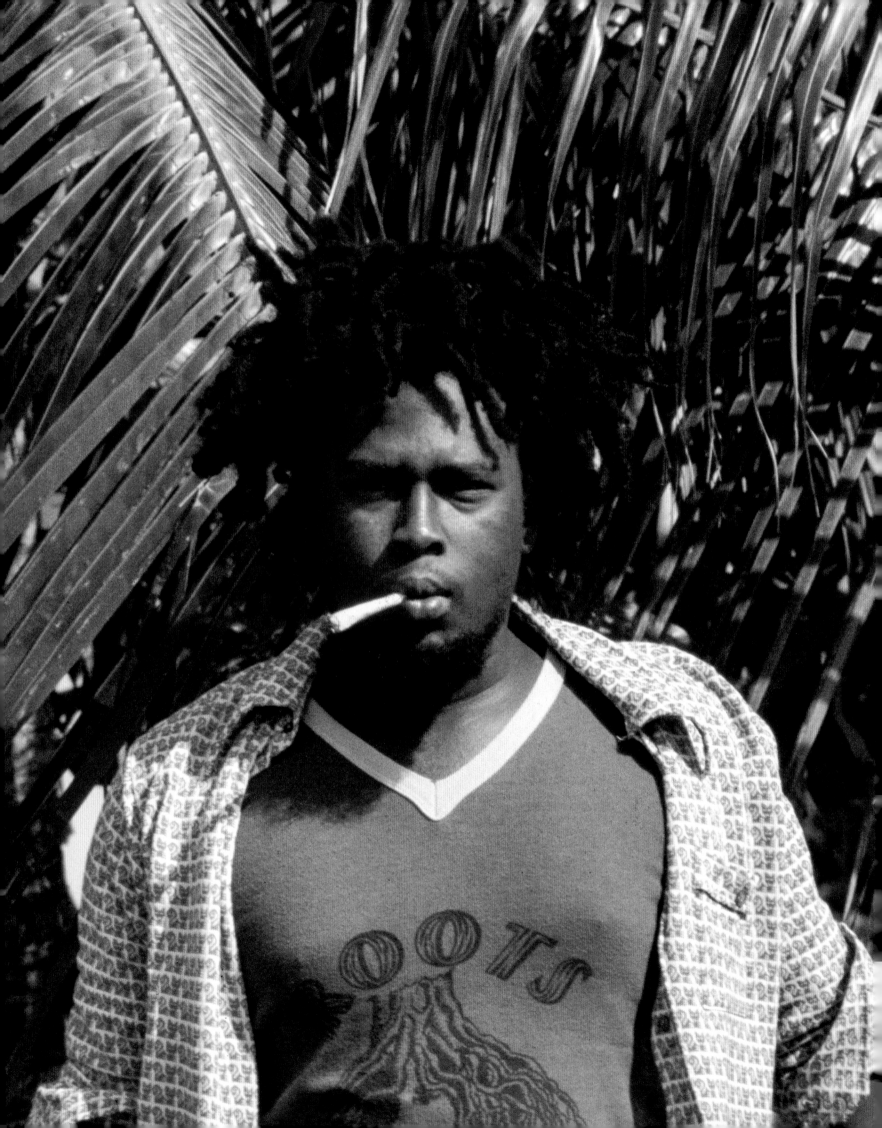

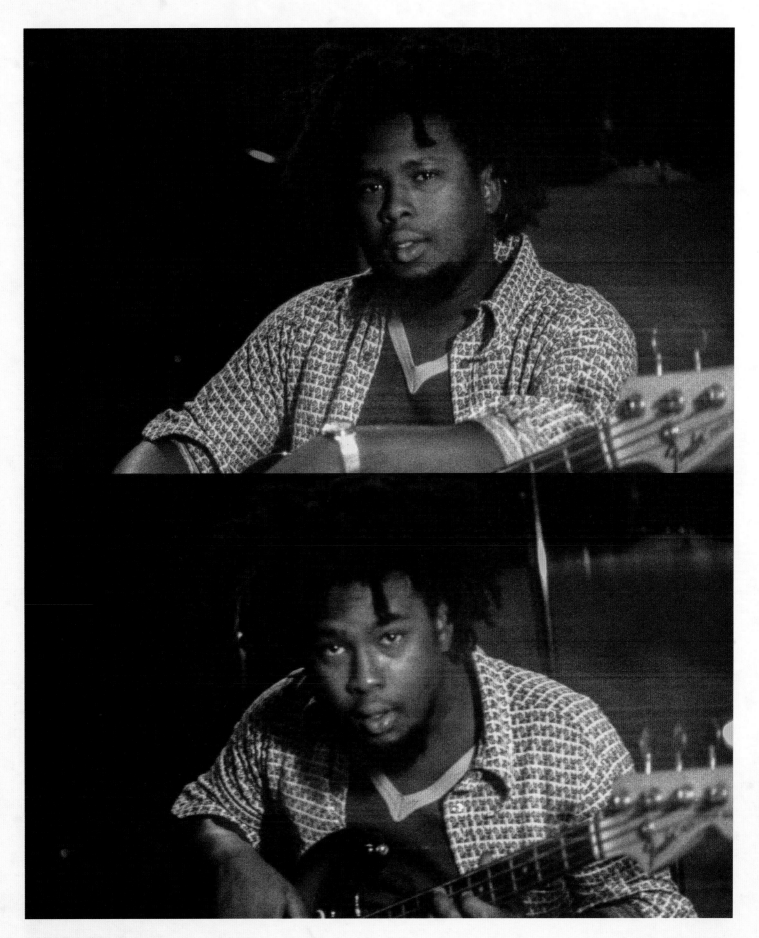

Robbie Shakespeare

At Channel One Recording Studio, 29 Maxfield Ave.,
Kingston, Jamaica.

Aston "Familyman" Barrett

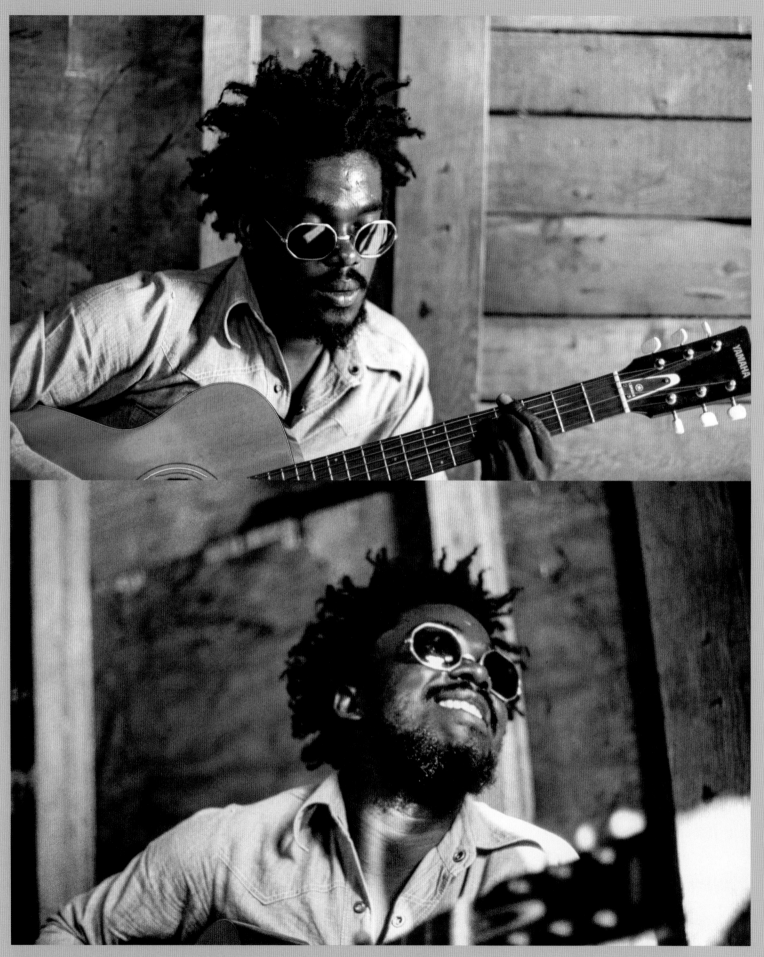

Aston "Familyman" Barrett

Affectionately known as "Fams," came to prominence along with his drumming brother Carlton "Carlie" Barrett as the rhythm section for Lee "Scratch" Perry's house band, the Upsetters. They played on the Scratch productions of the Wailers' albums, *Soul Rebels* and *Soul Revolution* (circa 1971), and when the original Wailers were signed to Island Records in 1972, Familyman and Carlie became permanent and integral members of the band. Familyman's rhythms have influenced countless musicians around the world.

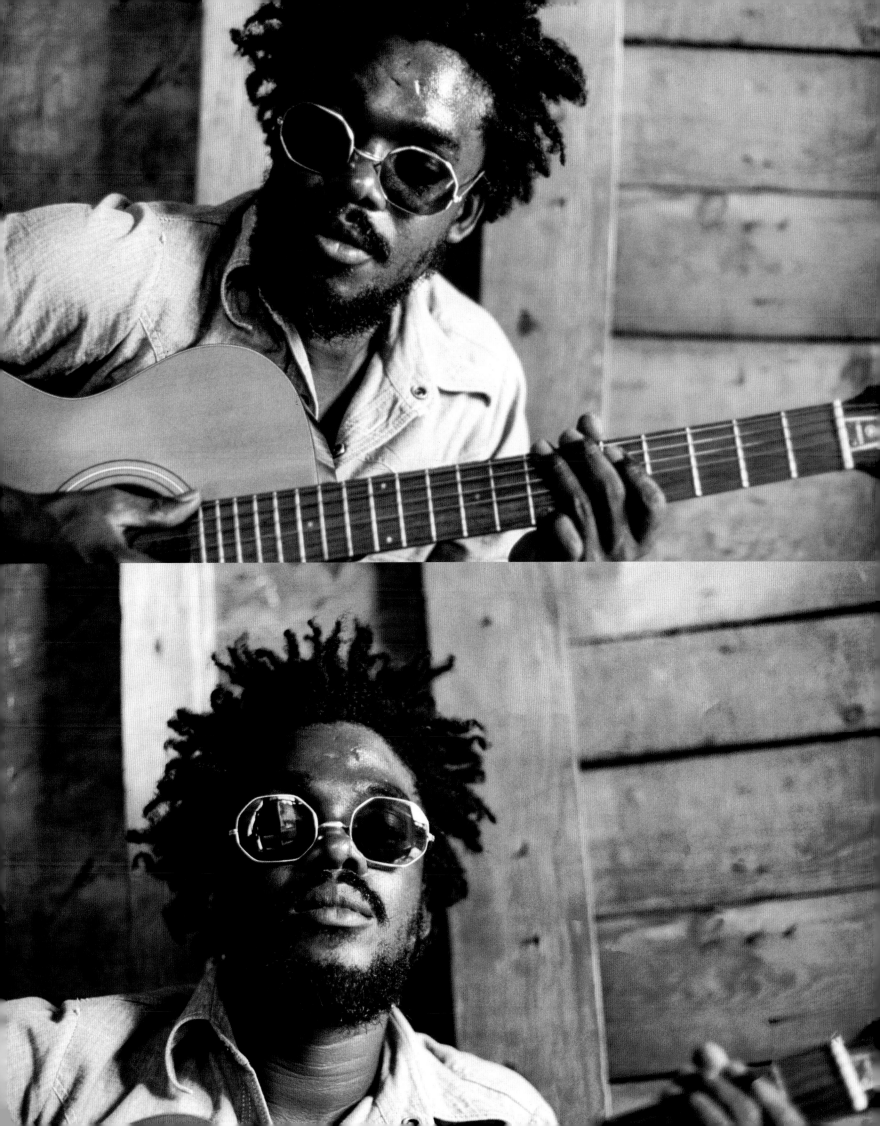

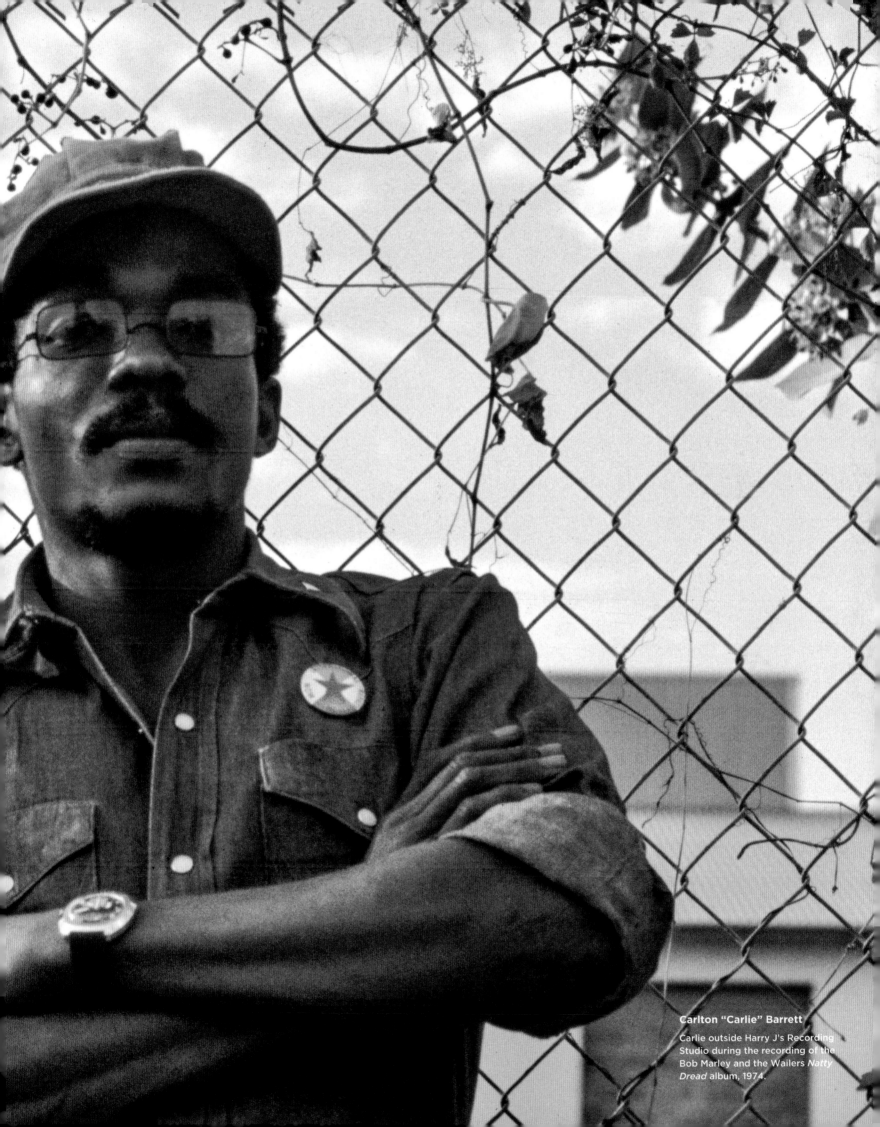

Carlton "Carlie" Barrett

Carlie outside Harry J's Recording Studio during the recording of the Bob Marley and the Wailers *Natty Dread* album, 1974.

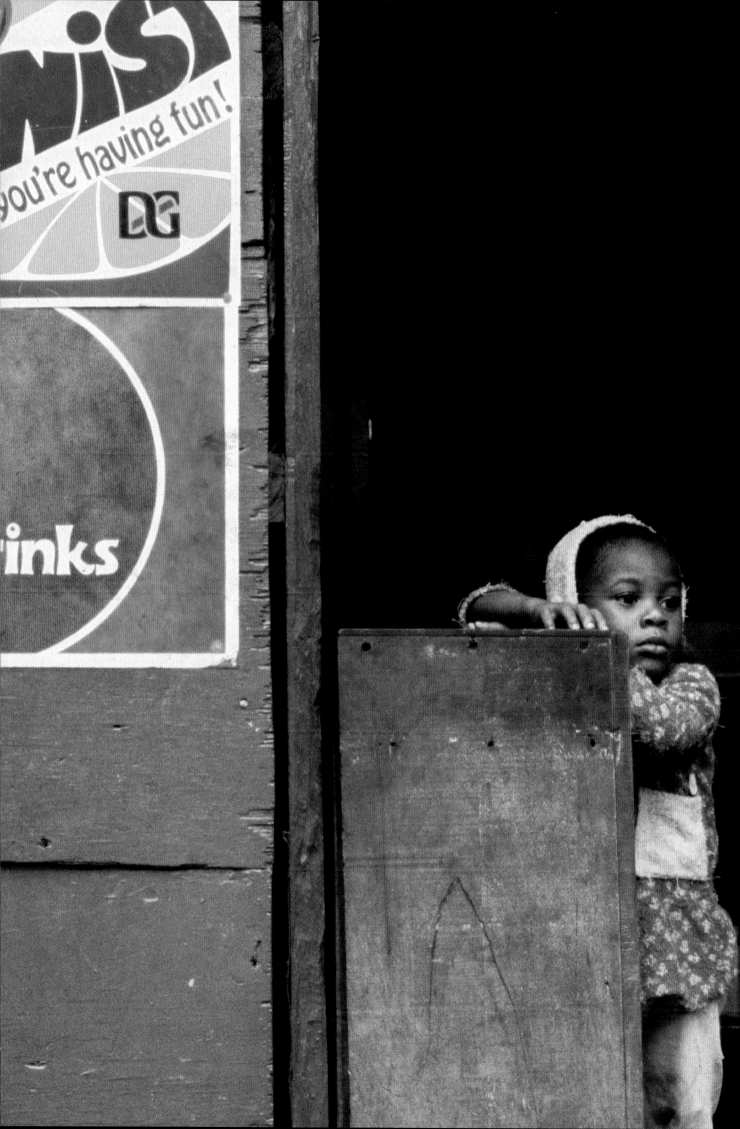

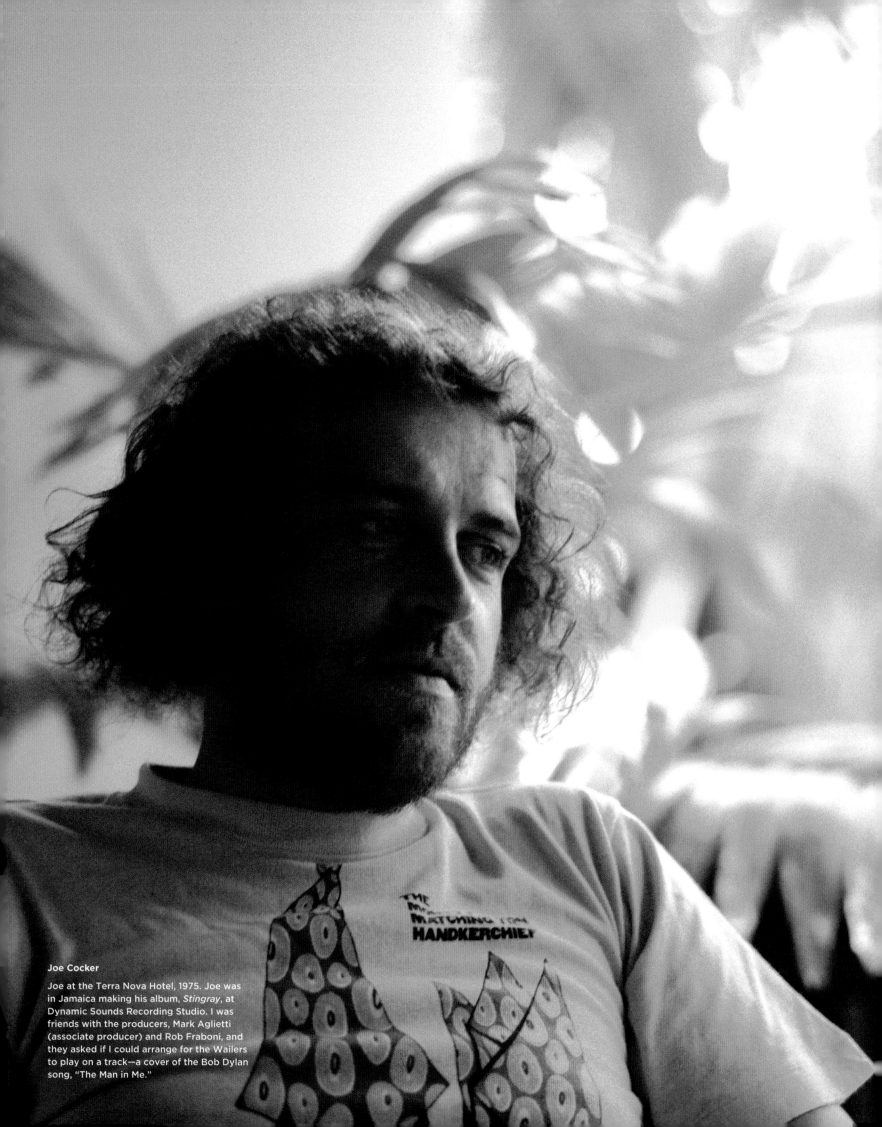

Joe Cocker

Joe at the Terra Nova Hotel, 1975. Joe was in Jamaica making his album, *Stingray*, at Dynamic Sounds Recording Studio. I was friends with the producers, Mark Aglietti (associate producer) and Rob Fraboni, and they asked if I could arrange for the Wailers to play on a track—a cover of the Bob Dylan song, "The Man in Me."

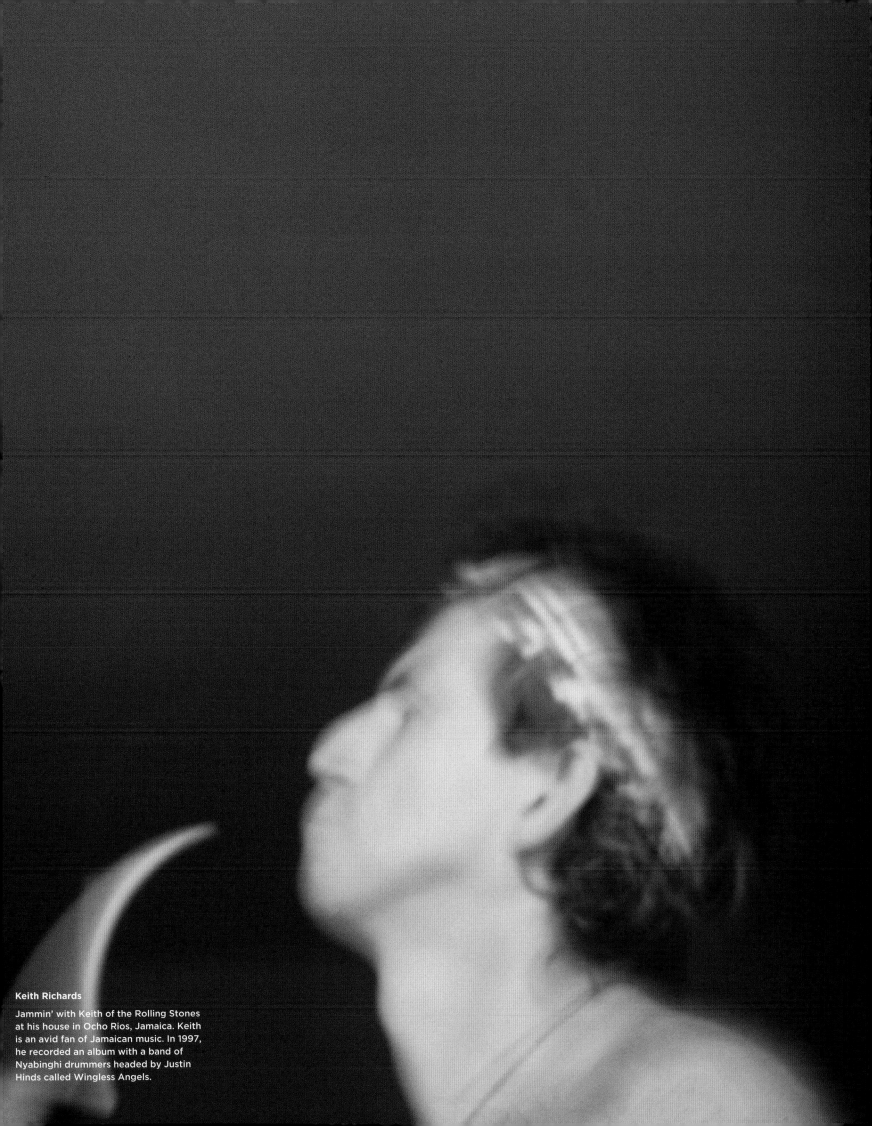

Keith Richards

Jammin' with Keith of the Rolling Stones
at his house in Ocho Rios, Jamaica. Keith
is an avid fan of Jamaican music. In 1997,
he recorded an album with a band of
Nyabinghi drummers headed by Justin
Hinds called Wingless Angels.

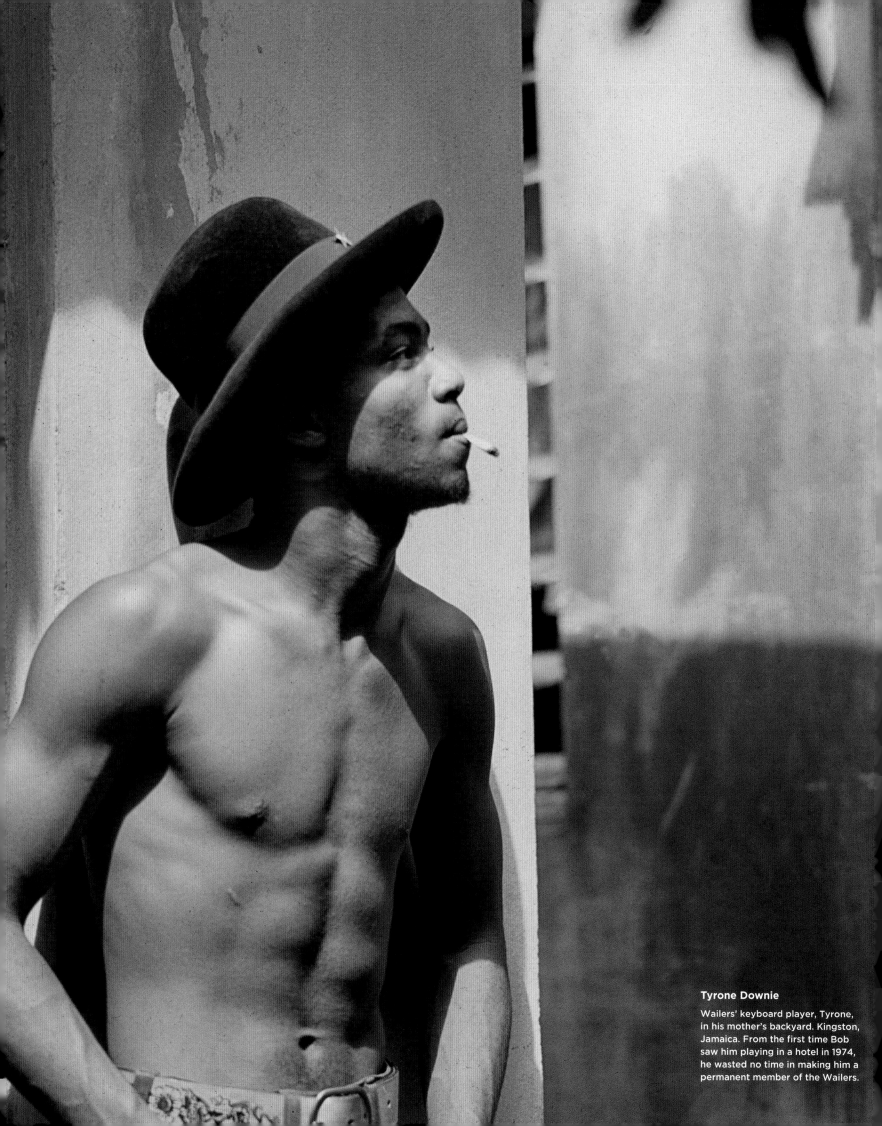

Tyrone Downie

Wailers' keyboard player, Tyrone, in his mother's backyard. Kingston, Jamaica. From the first time Bob saw him playing in a hotel in 1974, he wasted no time in making him a permanent member of the Wailers.

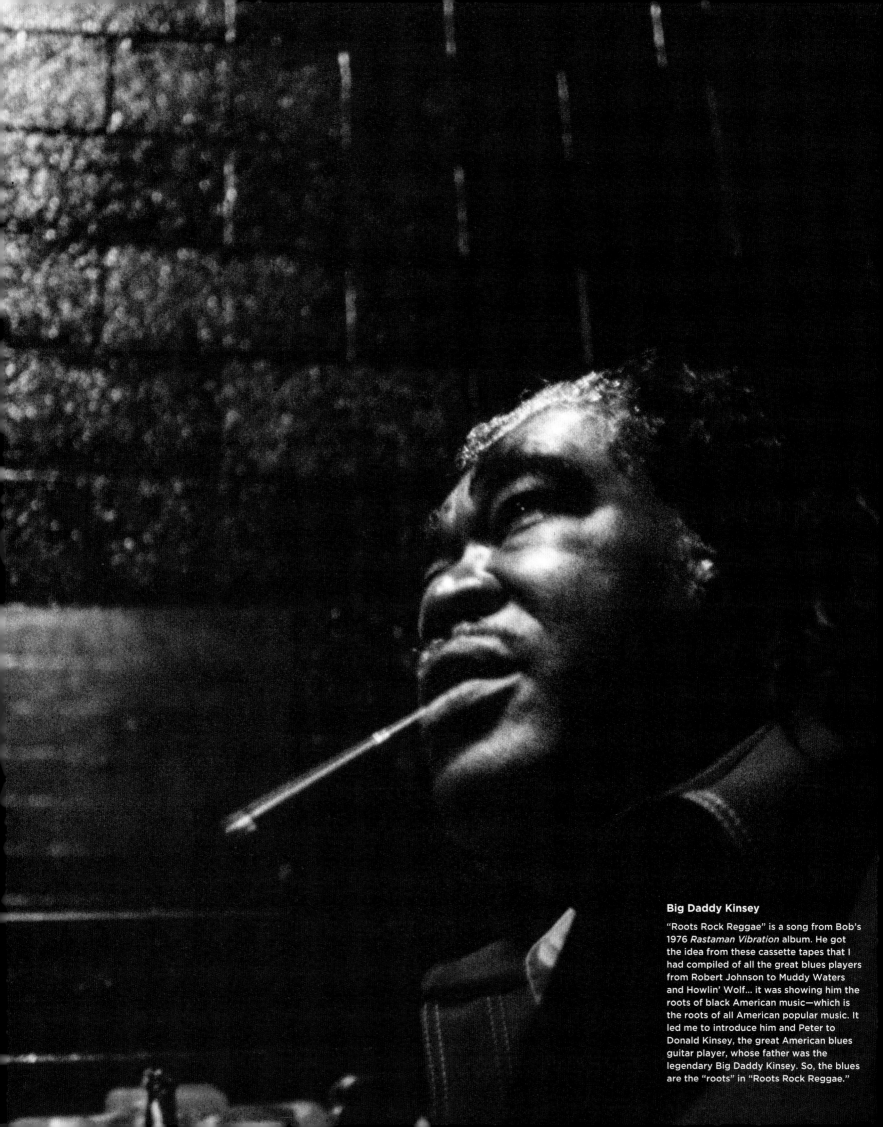

Big Daddy Kinsey

"Roots Rock Reggae" is a song from Bob's 1976 *Rastaman Vibration* album. He got the idea from these cassette tapes that I had compiled of all the great blues players from Robert Johnson to Muddy Waters and Howlin' Wolf... it was showing him the roots of black American music—which is the roots of all American popular music. It led me to introduce him and Peter to Donald Kinsey, the great American blues guitar player, whose father was the legendary Big Daddy Kinsey. So, the blues are the "roots" in "Roots Rock Reggae."

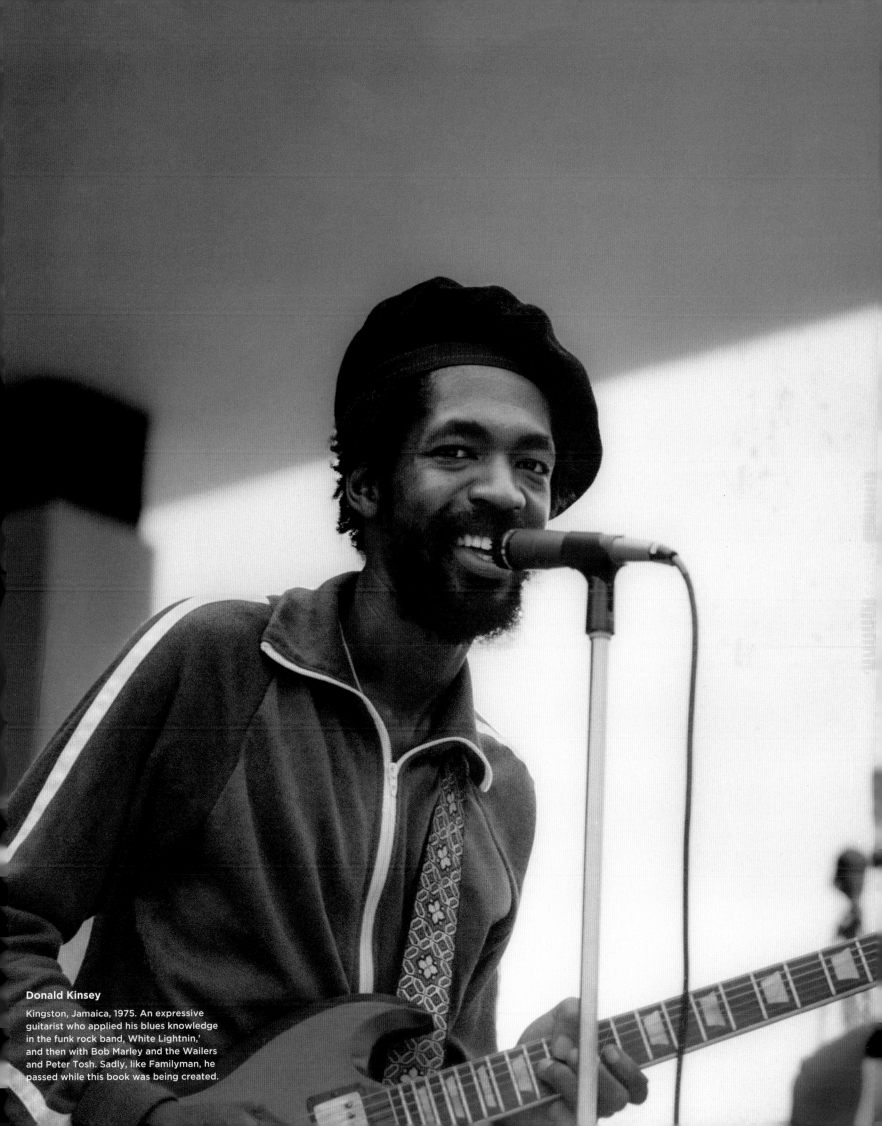

Donald Kinsey

Kingston, Jamaica, 1975. An expressive guitarist who applied his blues knowledge in the funk rock band, White Lightnin,' and then with Bob Marley and the Wailers and Peter Tosh. Sadly, like Familyman, he passed while this book was being created.

Donald Kinsey

Kingston, Jamaica, 1975. Kinsey drew heavily on his
extensive blues vocabulary in his recorded and live
performances with Marley and Tosh.

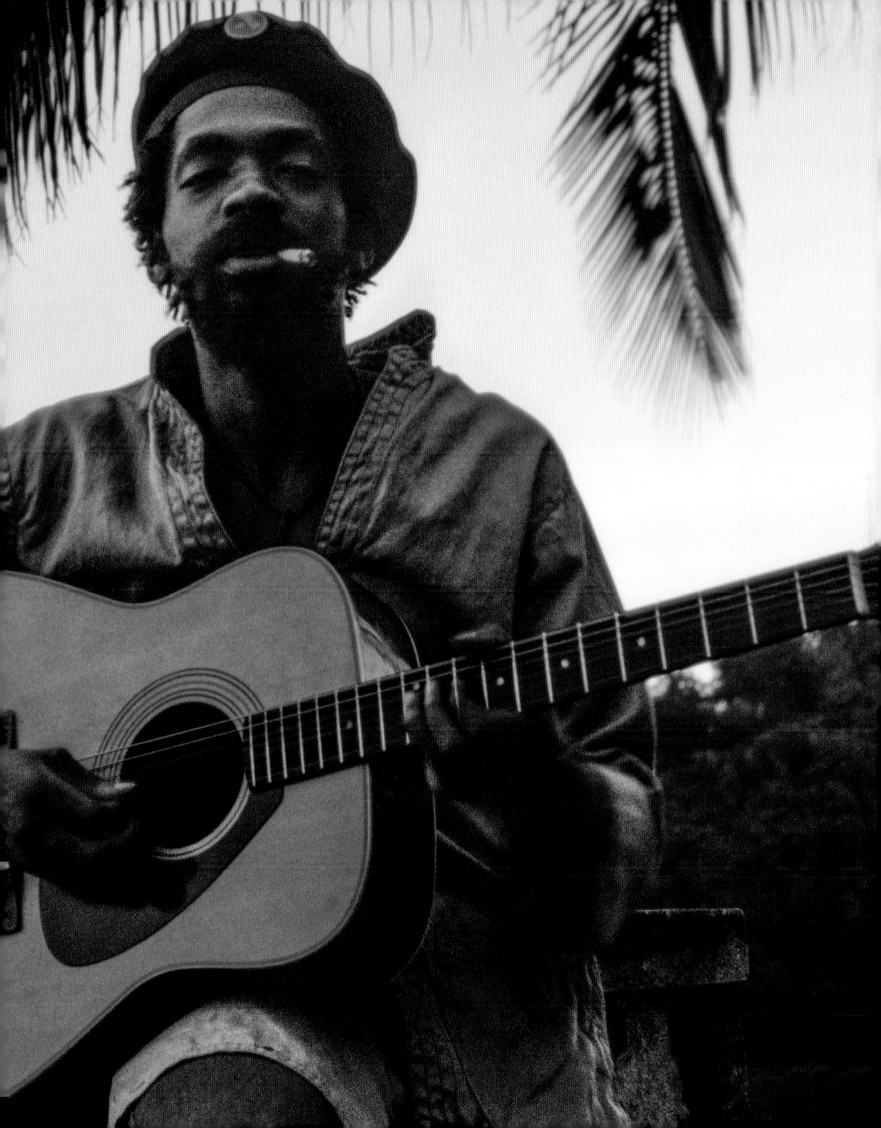

Jamaican alarm clock.

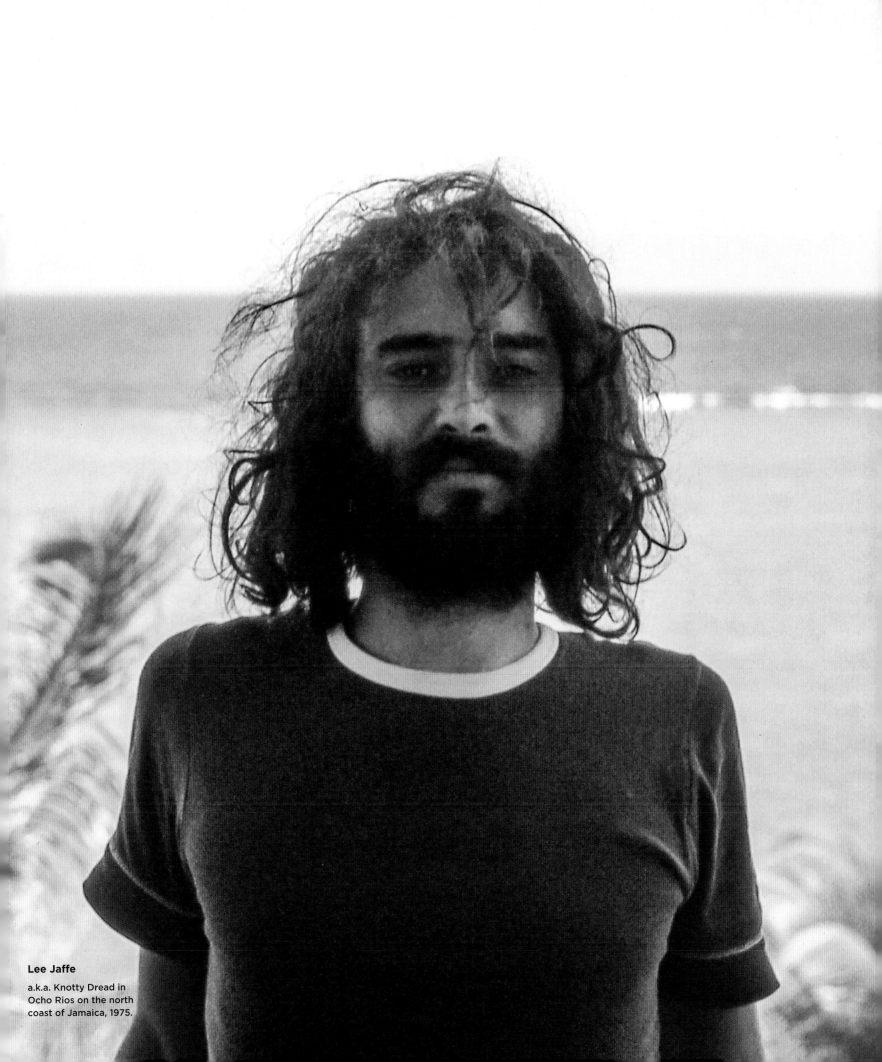

Lee Jaffe

a.k.a. Knotty Dread in Ocho Rios on the north coast of Jamaica, 1975.

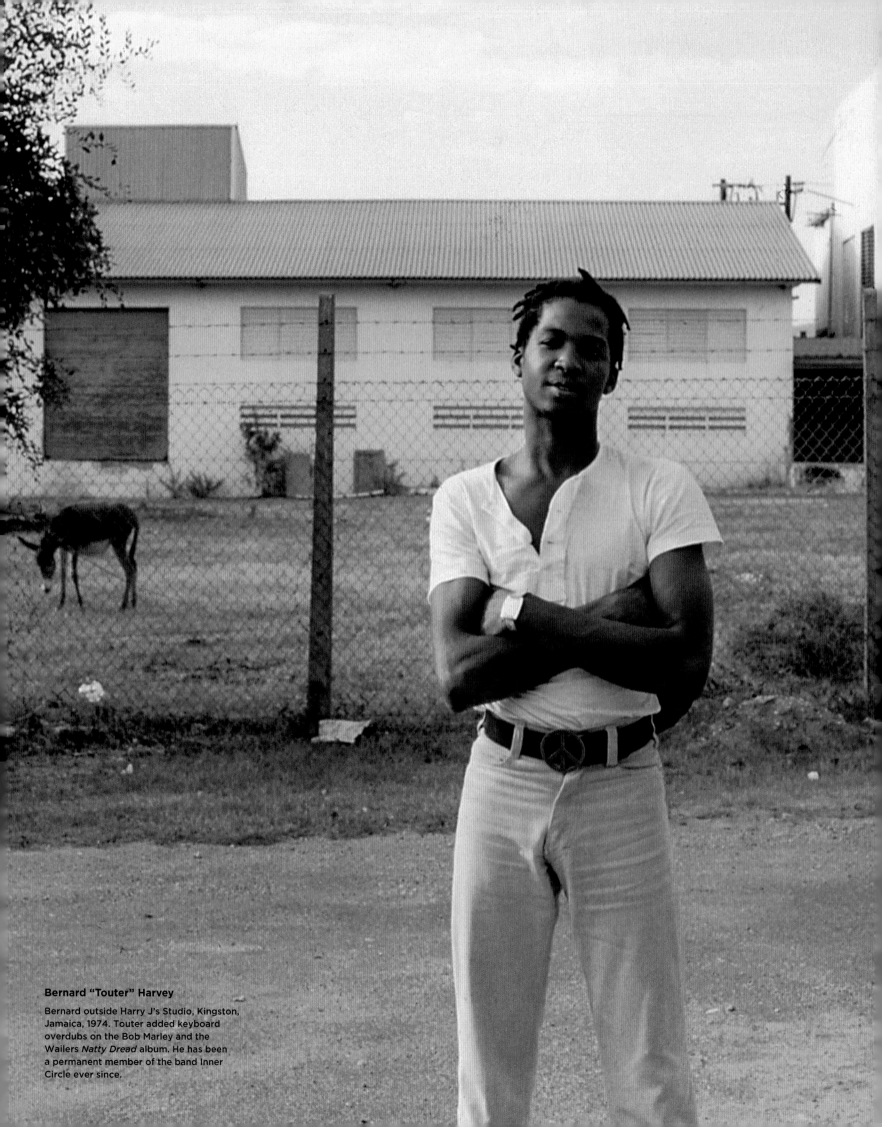

Bernard "Touter" Harvey

Bernard outside Harry J's Studio, Kingston,
Jamaica, 1974. Touter added keyboard
overdubs on the Bob Marley and the
Wailers *Natty Dread* album. He has been
a permanent member of the band Inner
Circle ever since.

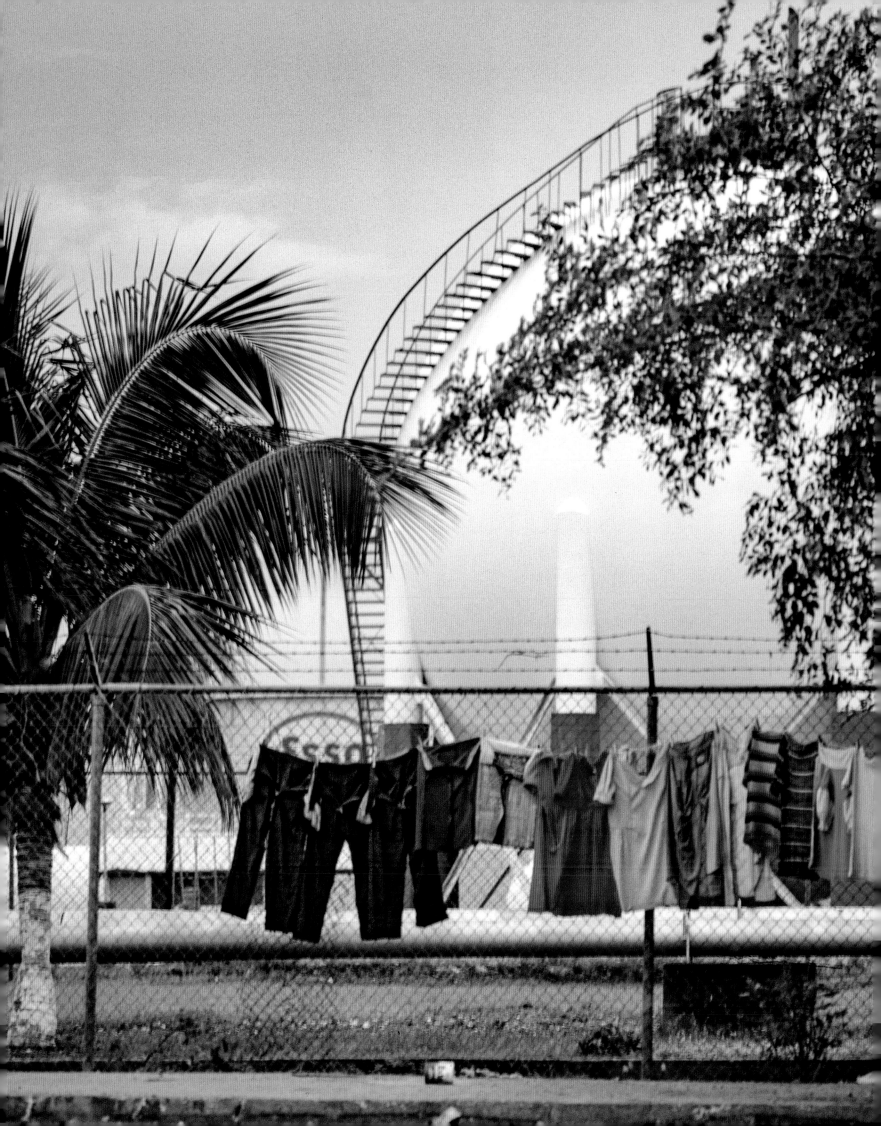

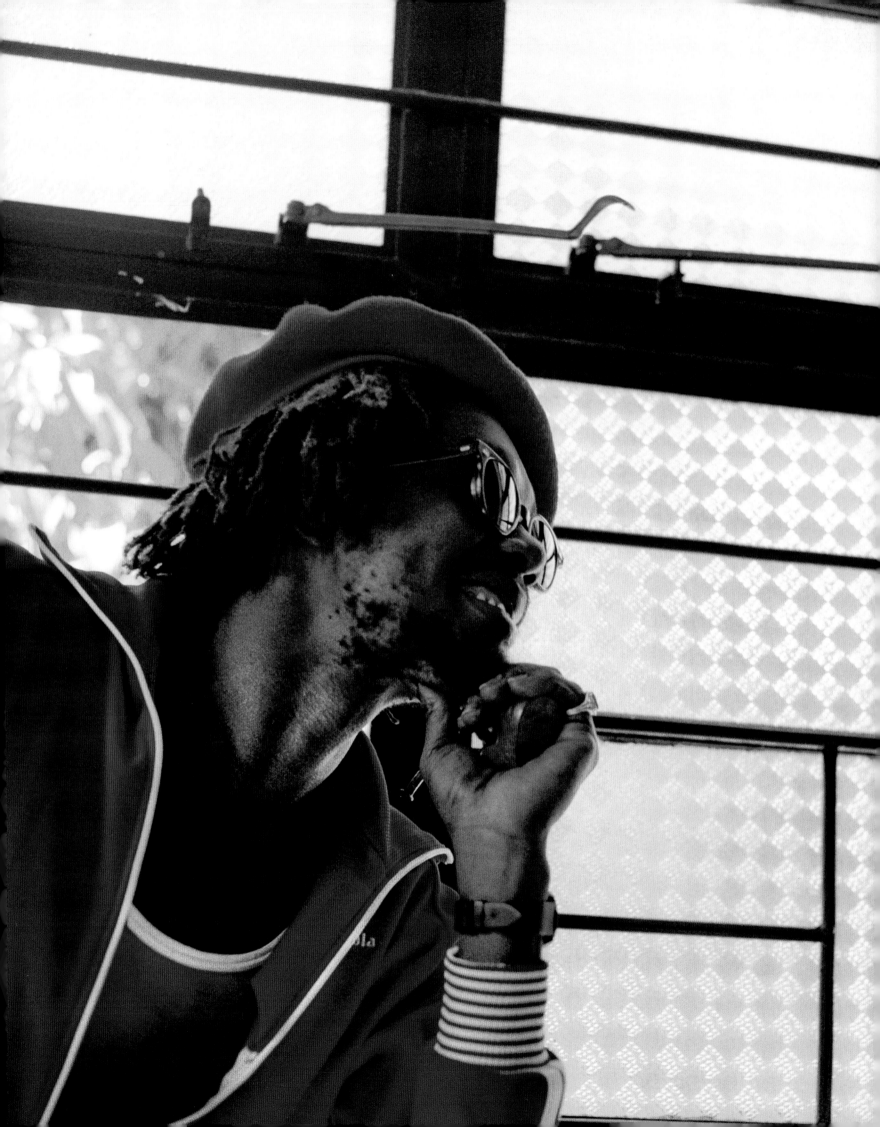

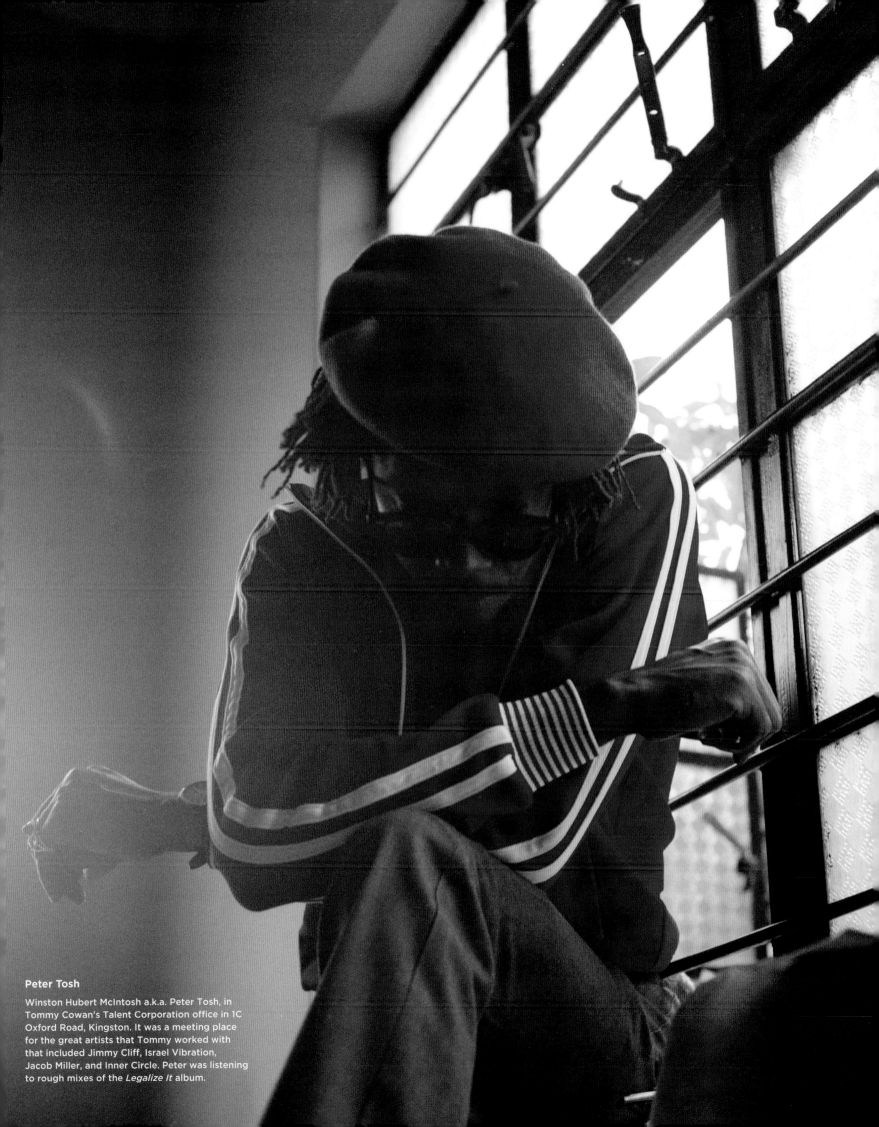

Peter Tosh

Winston Hubert McIntosh a.k.a. Peter Tosh, in
Tommy Cowan's Talent Corporation office in 1C
Oxford Road, Kingston. It was a meeting place
for the great artists that Tommy worked with
that included Jimmy Cliff, Israel Vibration,
Jacob Miller, and Inner Circle. Peter was listening
to rough mixes of the *Legalize It* album.

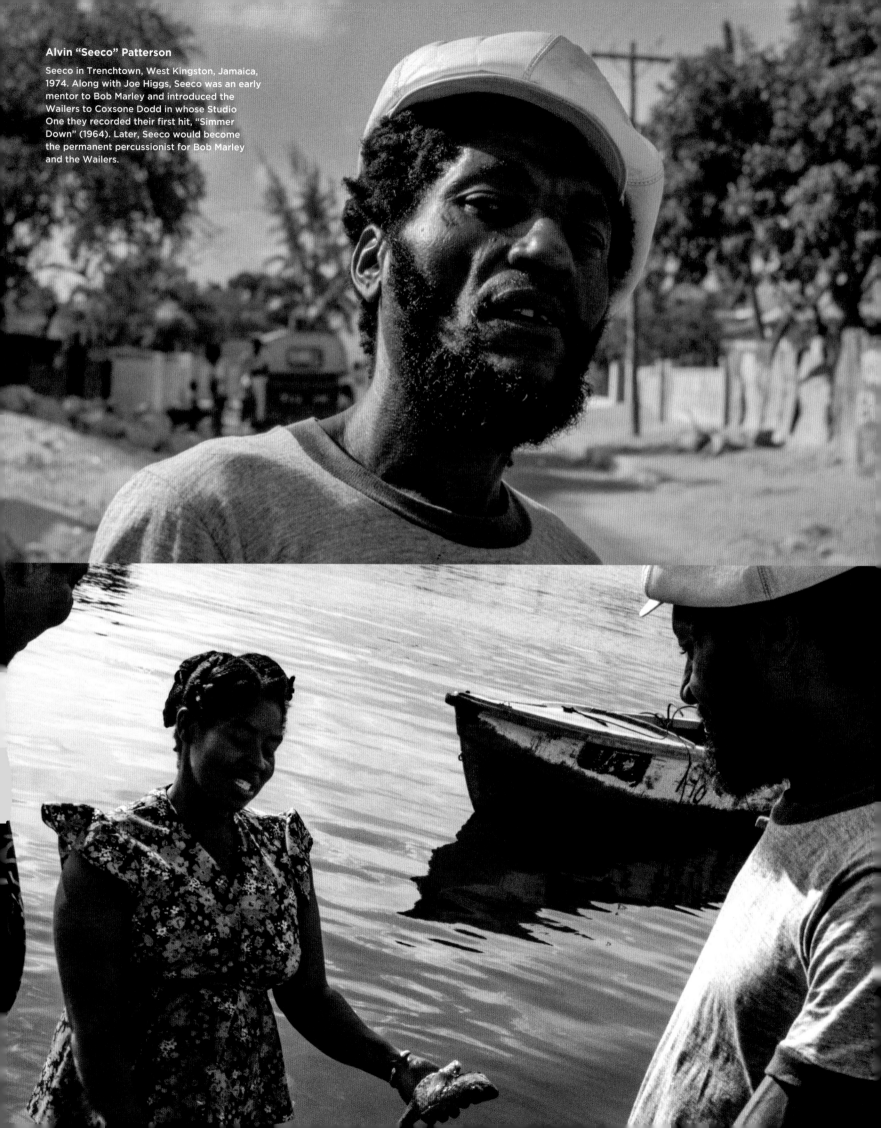

Alvin "Seeco" Patterson

Seeco in Trenchtown, West Kingston, Jamaica, 1974. Along with Joe Higgs, Seeco was an early mentor to Bob Marley and introduced the Wailers to Coxsone Dodd in whose Studio One they recorded their first hit, "Simmer Down" (1964). Later, Seeco would become the permanent percussionist for Bob Marley and the Wailers.

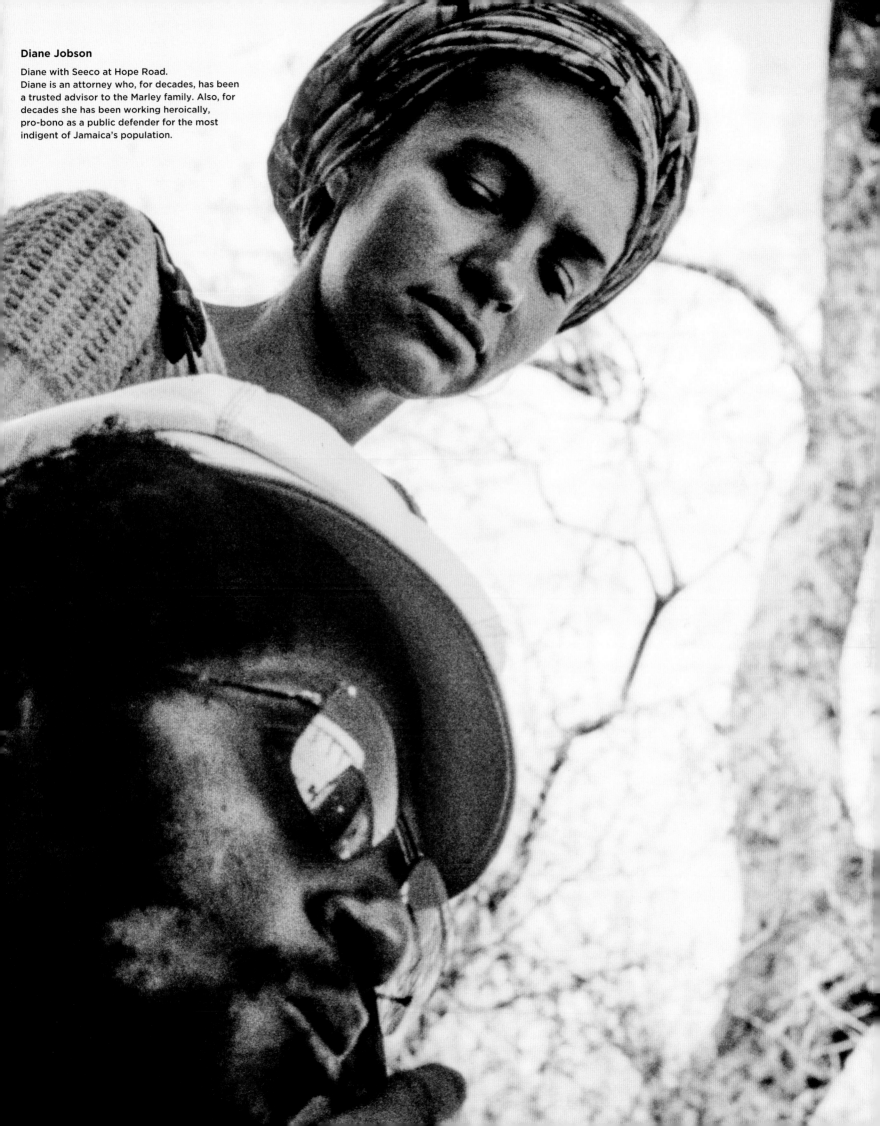

Diane Jobson

Diane with Seeco at Hope Road.
Diane is an attorney who, for decades, has been
a trusted advisor to the Marley family. Also, for
decades she has been working heroically,
pro-bono as a public defender for the most
indigent of Jamaica's population.

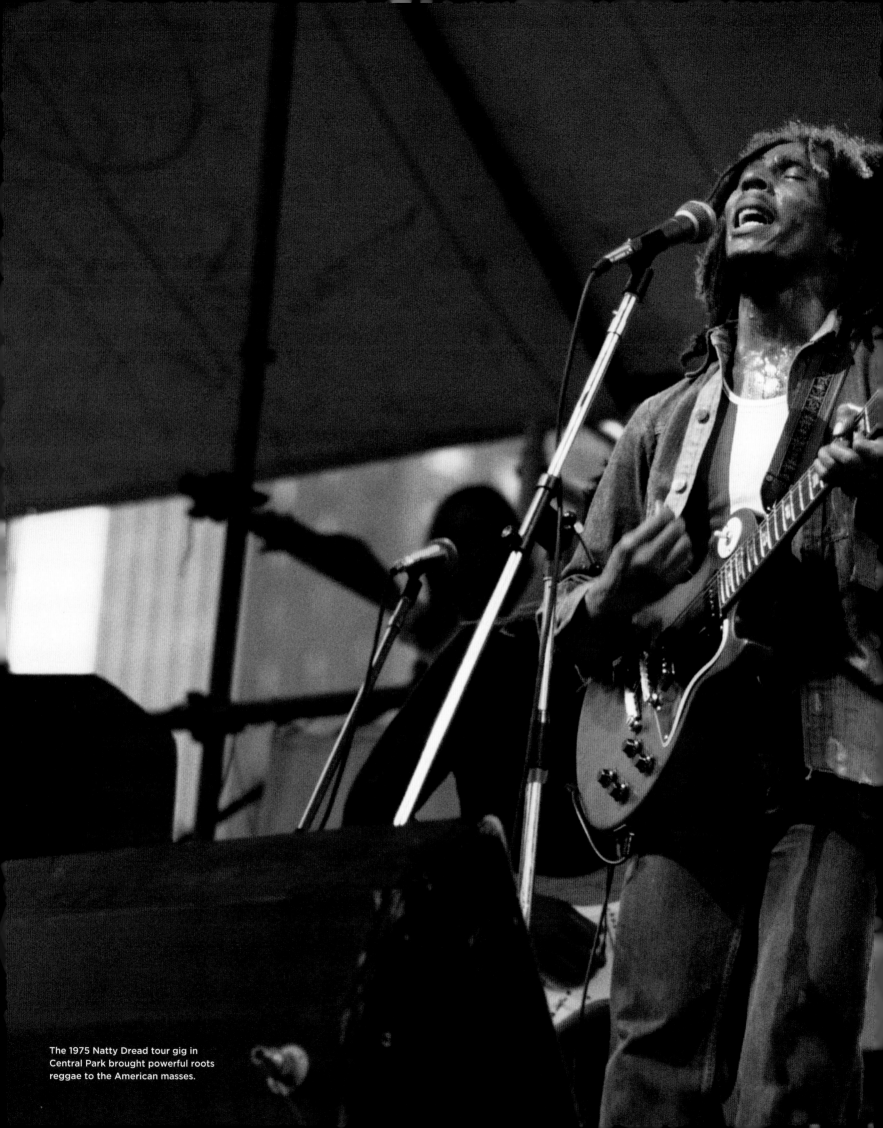

The 1975 Natty Dread tour gig in Central Park brought powerful roots reggae to the American masses.

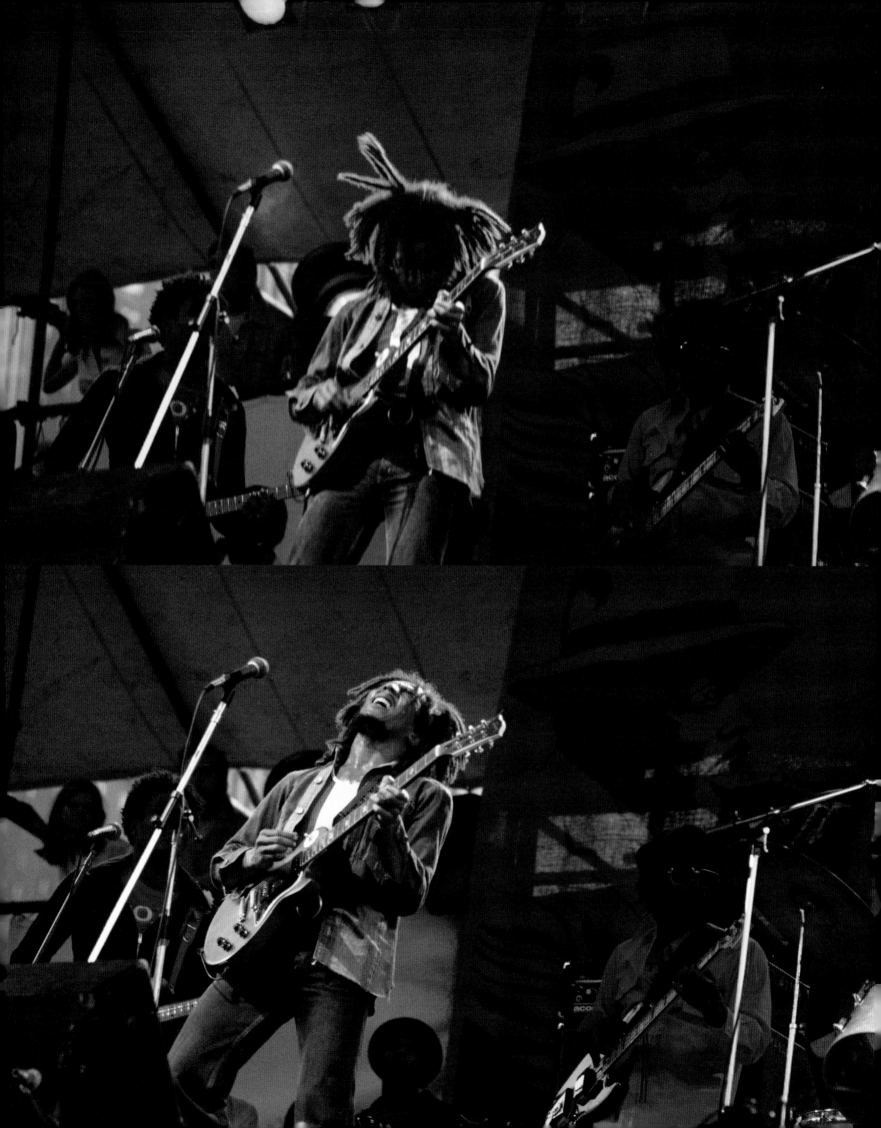

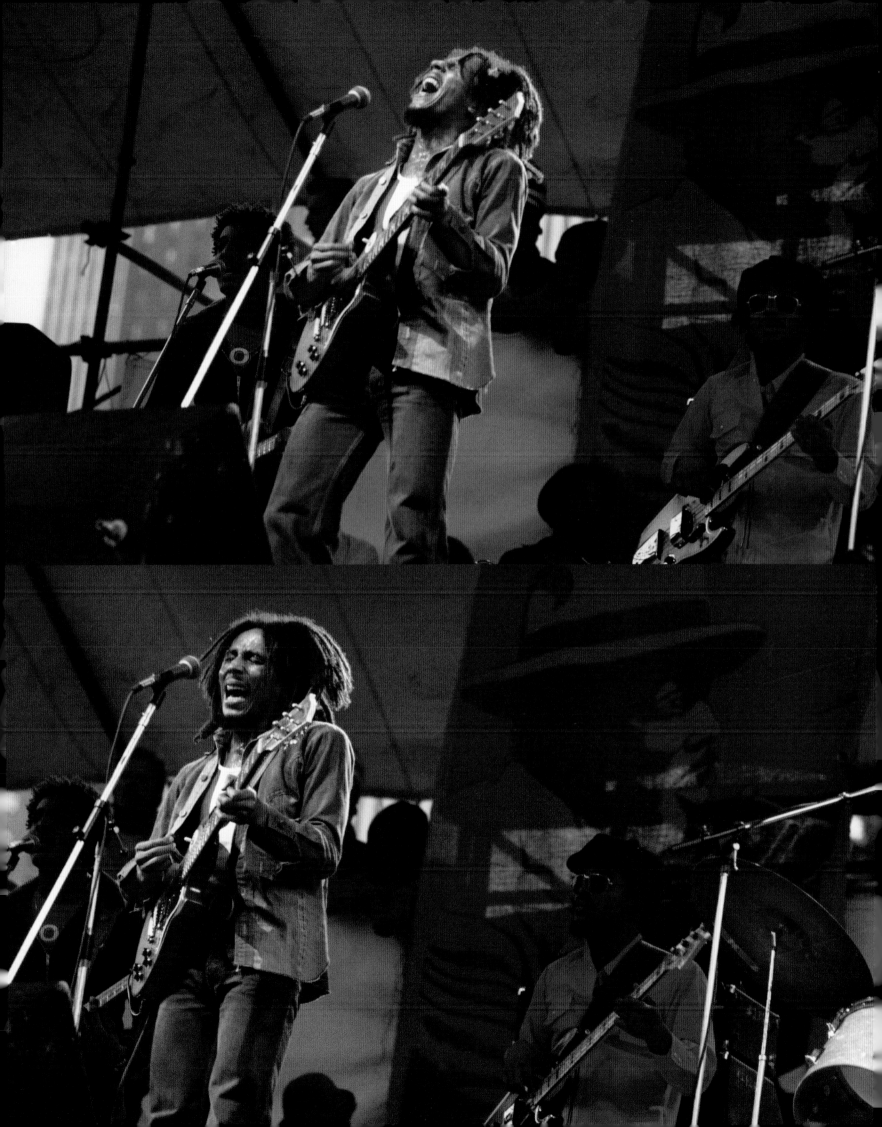

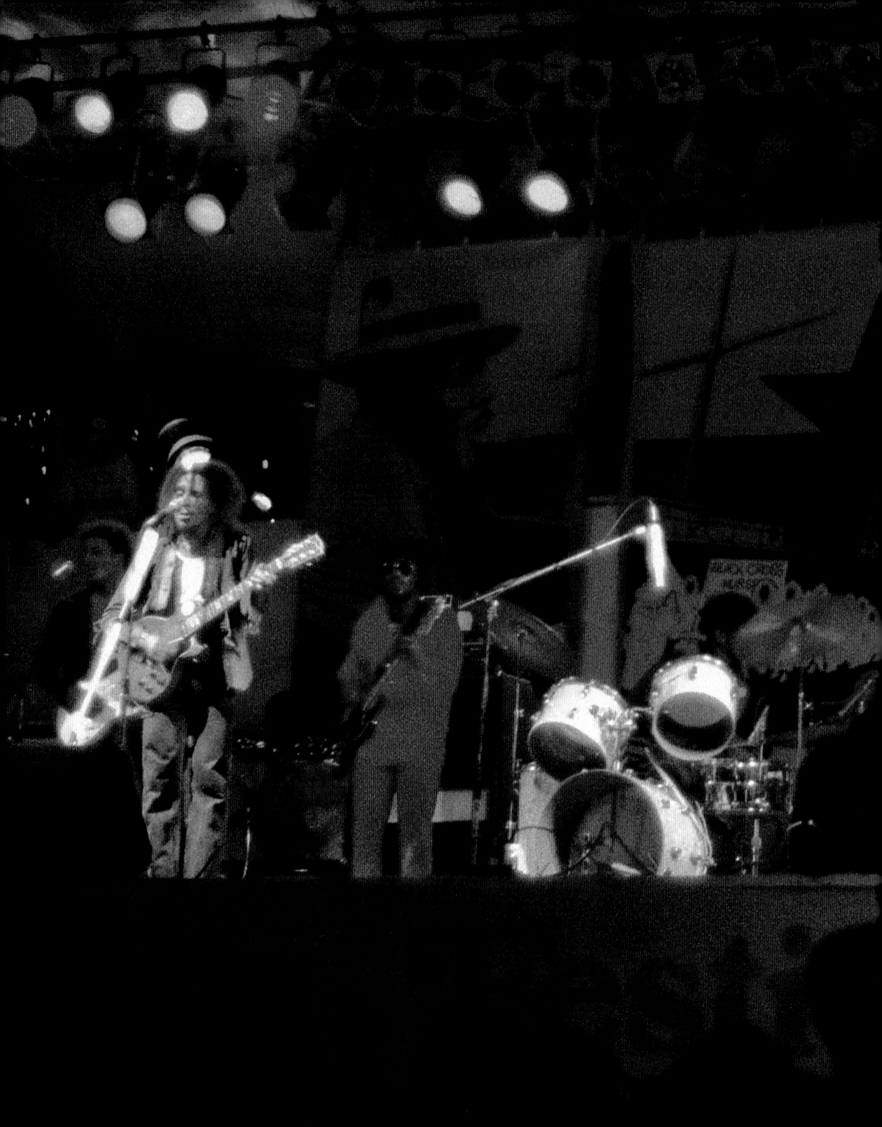

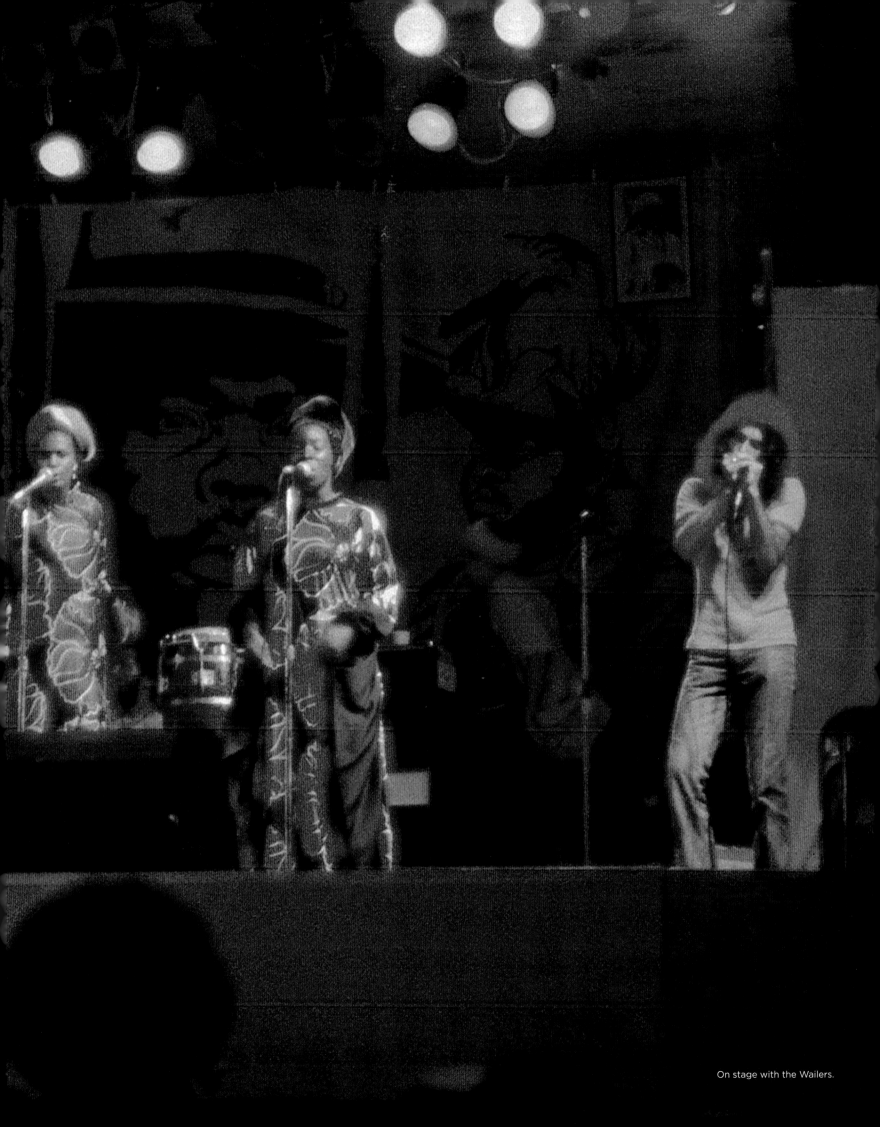

On stage with the Wailers.

Central Park
Natty Dread & Maddy

On June 18th, 1975, the Natty Dread tour came to New York City's Central Park. With the sun beginning to set, Bob Marley and the Wailers took the stage in front of more than 15,000 people—by far the largest crowd we had ever played for. And what was so amazing was the diversity of skin tones, blending as one shared community loving the music in the warm seventy-five-degree twilight descending graciously over the park. What a thrill for me, in front of my hometown family and friends, to realize the fruits of all the tough work on the previous two North American tours, playing in tiny clubs and driving around the country with musicians and instruments cramped into rented station wagons. This was a major turning point for Bob, and for reggae music.

I moved from the side of the stage as "No Woman, No Cry" was fading, and took up the mic from the stand next to Judy Mowatt and Rita, anxious with anticipation. It was my time. The band lit into the intro to "Road Block" (a.k.a. "Rebel Music"). I was due to come in after the first few bars, and when I blew into my Hohner D mouth organ, I panicked when I heard nothing. My mind flashed that I would be up there playing with no one hearing me. But when I blew again, I was loud and clear and upfront in the mix for the rest of the song. Bob's song list called for the encore to be "Talkin' Blues," and with the raucous applause unending, I took the stage again with Bob and the rest of the band. As I looked out over the cheering crowd with thousands of eyes transfixed on the stage, I felt like my body was floating. A warm wave of joy and satisfaction ran through my veins, and I felt an enormous sense of accomplishment. I had brought dreadlocks to North America.

After the concert, I went with the Wailers' guitarist Al Anderson and my friend Brew to a saloon on the Upper East Side on 2nd Ave near 73rd Street, called Doctor Generosity's. It was a funky place with maybe twenty tables and a long bar with sawdust on the floor, and on Sunday afternoons they held poetry readings. At night, you couldn't get in. Former members of the Beatles would hang out there as well as the hippest movie stars

like Warren Beatty, but Brew—as he had the best herb in New York—was friends with the owner Jimmy Pulis, and was tight with Benji, the 350 pound, six-foot, six-inch-tall Trinidadian bouncer who guarded the door. As we ordered beers at the bar, I noticed—seated at a table opposite us—a stunningly exquisite girl, who very well might be Jamaican, staring at us. After a few sips of beer, I caught her staring again. Obviously, she had been to the Central Park gig that afternoon. I turned to Al and said, "This incredibly gorgeous girl can't stop looking at you. You better go over there." Al went over and sat down with her and her two friends, and I thought how lucky Al was to have a friend like me to look out for him.

A few minutes later Al walked back and I was shocked. "What?" I said. Al looked at me: "No man. She wasn't checking for me. She was checking for you." I felt like I had just won the lottery. Jah was rewarding me for all my hard work. Brew leant me the keys to the stash house apartment on 85th Street and said, "There's clean sheets and blankets in the closet."

And yes, Madeline Scott was Jamaican, 21 years old, and had just graduated from Hunter College. Her parents were divorced—her father was a barrister and had been the Solicitor General of Jamaica—and her mother, Gloria Scott, was an esteemed economist and author, heading a commission at the World Bank that was advocating for women's rights.

Her parents had purchased Blue Harbor/Firefly Estate a few years before. It was an amazing property in St. Mary Parish overlooking Port Maria, with an unobstructed view east, down the coast toward Port Antonio. It had been owned by Noel Coward until his recent death, and with its three guest houses and ocean water pool, was a vacation spot for his rich and famous friends of "café society." Maddy and I became inseparable, and later when we were struggling to get the finances to finish producing Peter Tosh's first solo album, *Legalize It*, Blue Harbor became a perfect place to store the herb we were buying from the many various small farmers, collecting over many weeks the near thousand pounds to fly off to "foreign."

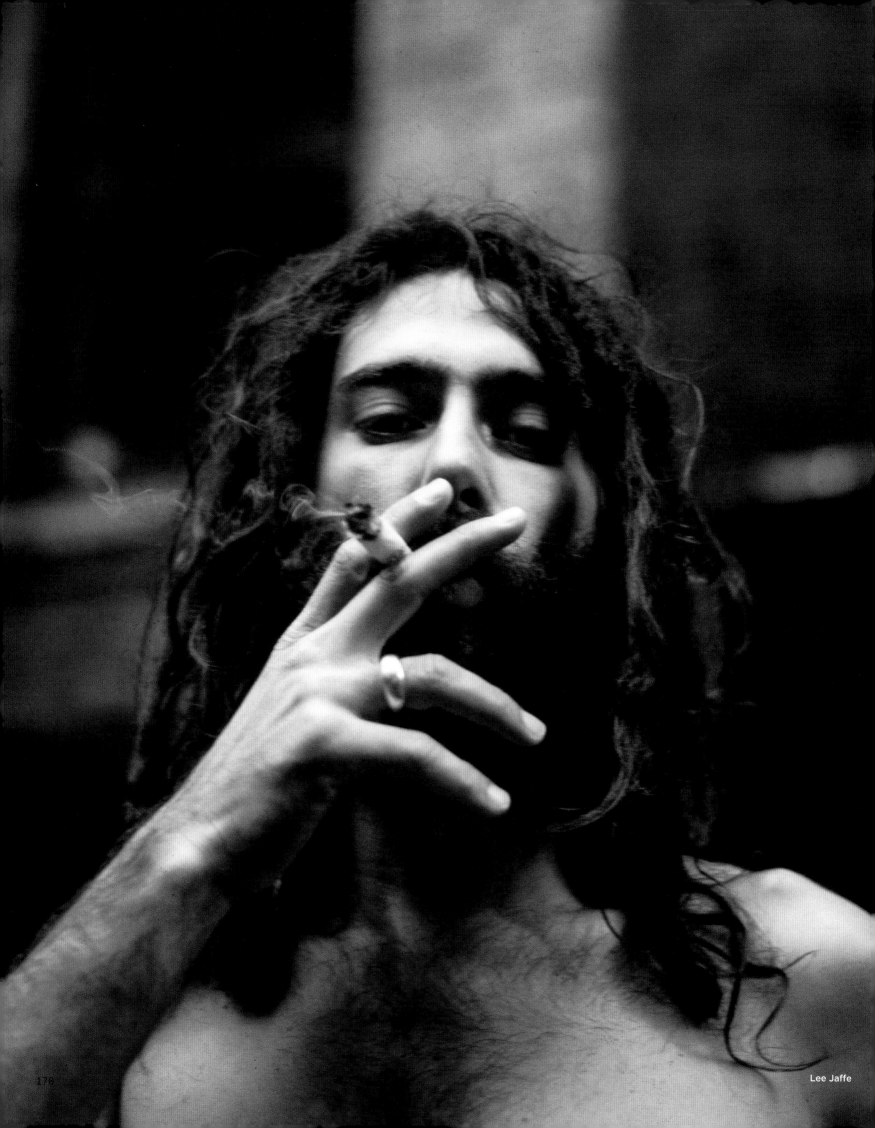

Lee Jaffe

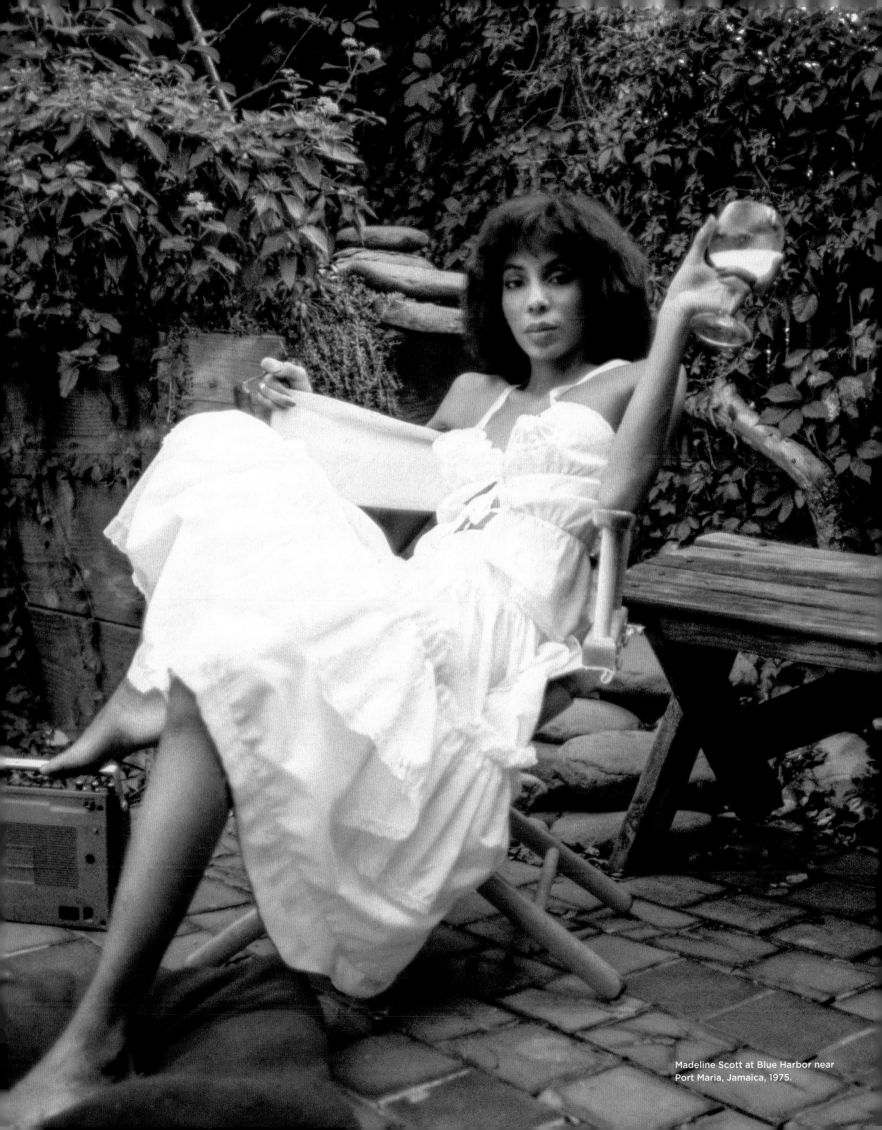

Madeline Scott at Blue Harbor near
Port Maria, Jamaica, 1975.

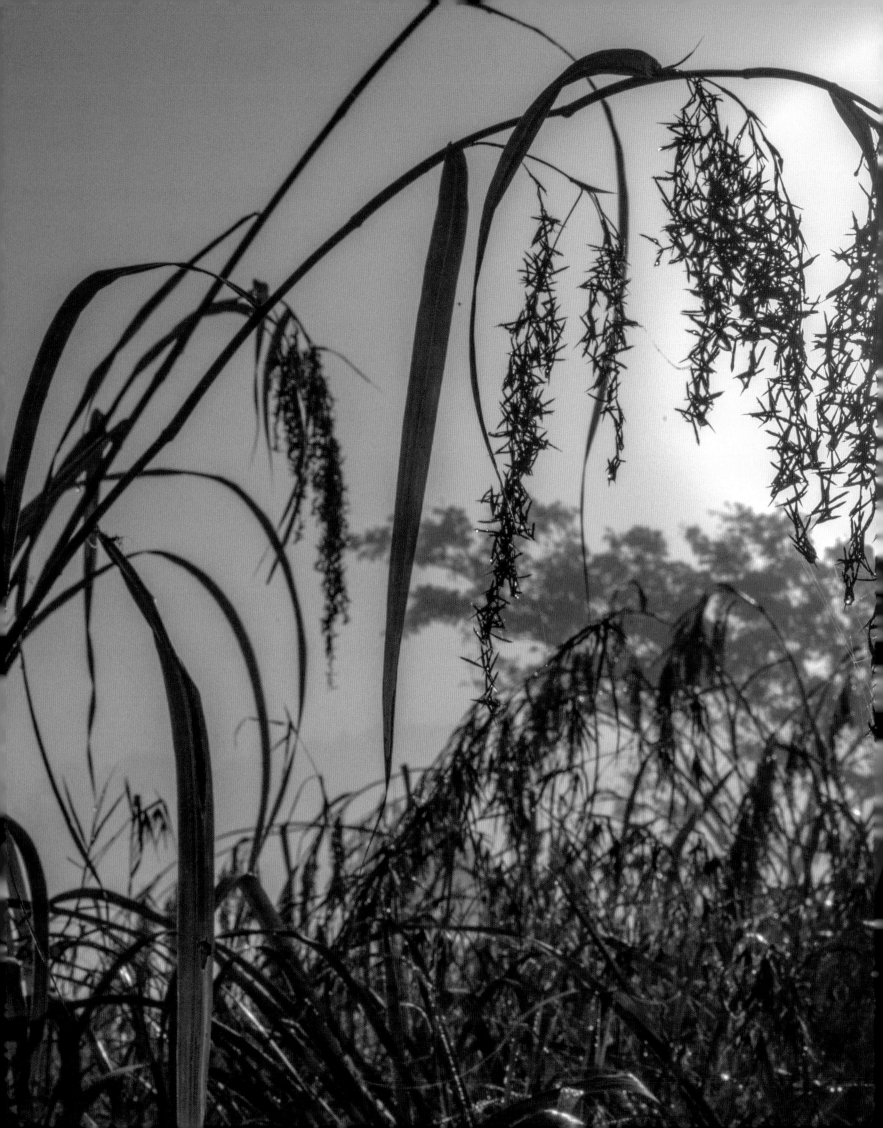

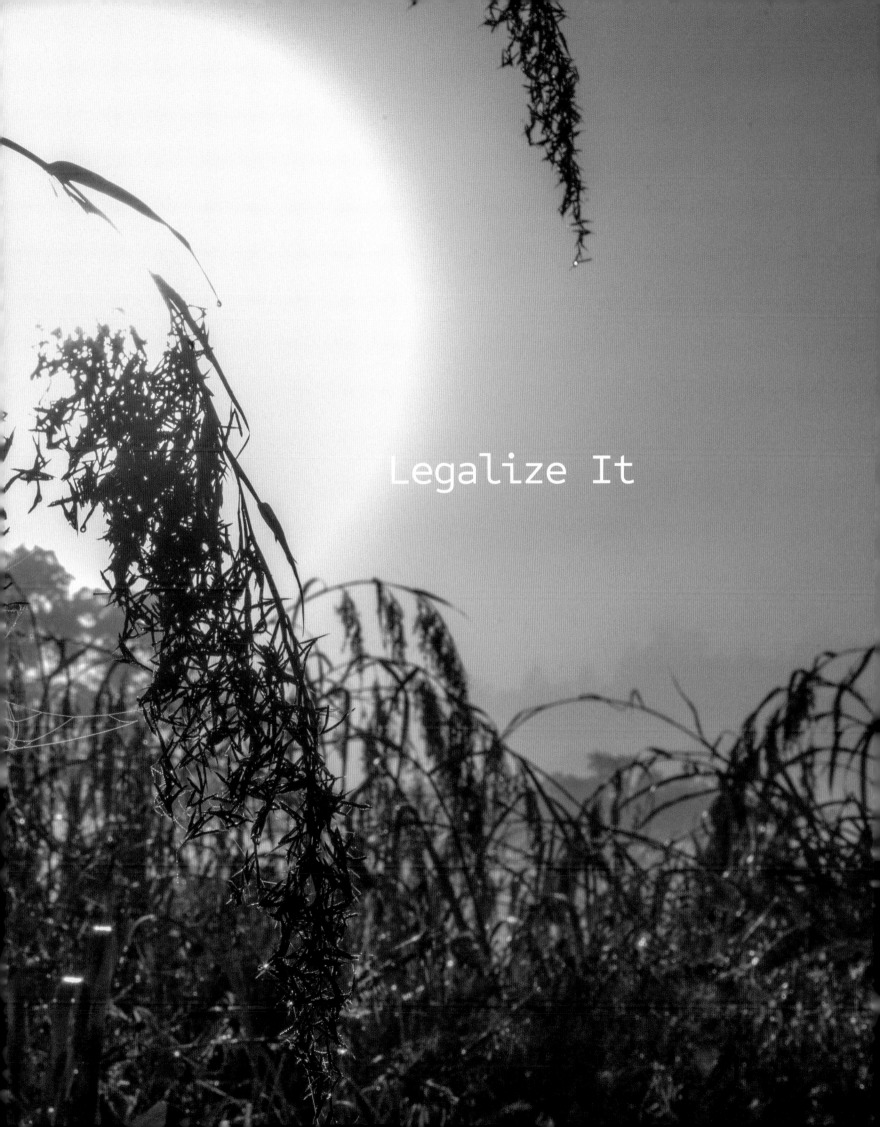

Legalize It

Bush Doctor

After *Natty Dread* became a commercial breakthrough for Bob Marley and the Wailers, I received a call from Peter Tosh who was now solo after leaving the group in late 1973. He wanted me to listen to some songs he had written. Arriving from New York, I rented a car at the airport in Kingston and drove out towards Spanish Town near where Peter was living with his partner, Yvonne Whittingham. Spanish Town was originally inhabited by the indigenous Taino. The Spanish colonized the town in 1534, enslaved the peaceful Taino, and virtually eliminated the population in less than fifty years. Only a few who fled to the mountains survived. Its grim history actually made Spanish Town an ideal base for Peter whose music fearlessly attacked colonialism. I drove with the windows down in the early afternoon scorching sun past Harbor View and a crumbling cement factory; past downtown and the shacks of Denham Town, Trenchtown and Back-a-Wall; past the vast smoldering garbage dump and the steamy stench of the burning ghosts of slaves subjugated first by Spanish and then English colonizers. I had been with Peter through the first North American Wailers tours when there was no money playing in small clubs, driving around from city to city, crowded into station wagons. Now, with Bob breaking through commercially, Peter had something to prove. Thus—with all I had learned from being there through the recordings of *Burnin'* and *Natty Dread*—I felt that there was still more that I could contribute. Peter performed again with Bob and Bunny in 1975 at their National Stadium concert with Stevie Wonder, but they needed to move in different directions. When I arrived, Yvonne and Peter—who were inseparable—greeted me with a glass of soursop and Irish moss blended with nutmeg and a dash of honey; I knew I was in Jahmaica. Peter had two ital corn-trash spliffs rolled. He handed me one, lighting it with a smile, then turned serious as he lit his own. He picked up his acoustic guitar, and without stopping, played 30 songs—almost all never recorded—and I was mesmerized. It was then that I realized—after having just 3 songs, plus the co-written "Get Up, Stand Up" on the first two Island albums—why Peter needed to leave Bob. These songs needed to be recorded and the world needed to hear them. He was offering me the opportunity to work with him to produce what would be his first solo record, and I was thrilled to collaborate.

I went to see Bob at Hope Road. I wanted him to know first that I would be taking on the project with his longtime partner. Without asking anything, he handed me $1,500. Peter rounded up the Wailers and we recorded basic tracks for four songs—one of which was "Legalize It"—at Duke Reid's Treasure Isle Recording Studio. With the help of Tommy Cowan—a seminal figure in the history of Jamaican music—and his company, Talent Corporation, Peter released "Legalize It" as a single for the local market in early 1975. Extolling the benefits of cannabis, it was a sensation even though radio censored it. It was an anthem, and I was certain that it would have a global impact. However, I knew we would need a lot more money to complete an album with the production values needed to compete internationally.

My college friend Brew and his brother, "The Fox," had graduated from distributors to major herb smugglers, flying planes from Colombia. Along with another college friend, Robbie Yuckman, they helped us finance and organize a trip from Jamaica. They introduced me to a pilot that they worked with and invested the cash to rent a plane and make down-payments to Jamaican farmers. Champs, who we met through Jack Ruby, and Bob's cousin Sledger, travelled with Peter and me to hidden mountain farms in St. Ann and at the far end of the island in Westmoreland to help find the better-quality flowers. If the visionary Peter was alive today, he'd be laughing at the mad international scramble to make cannabis mainstream!

The album cover was appropriately shot in the middle of an herb field in Westmoreland. It confirmed that Peter was literally putting his money (and herb) where his mouth was (as was I!), and that his herbal advocacy was real. The cover choice might have been different if Columbia Records in the U.S. hadn't "lost" the first six suggested frames that I shot. They didn't want a photograph of their newly signed artist surrounded by "marijuana" trees, but I urged Peter to insist and I sent them the film that finally, in 1976, became the cover of the iconic *Legalize It*. The record represented an important moment for Peter, for reggae, and the world—it marked a significant milestone of the ongoing movement to legalize cannabis. For anyone who wasn't somehow already clued into the culture, it placed herb up front and center as part of Peter Tosh's musical statement as a solo artist.

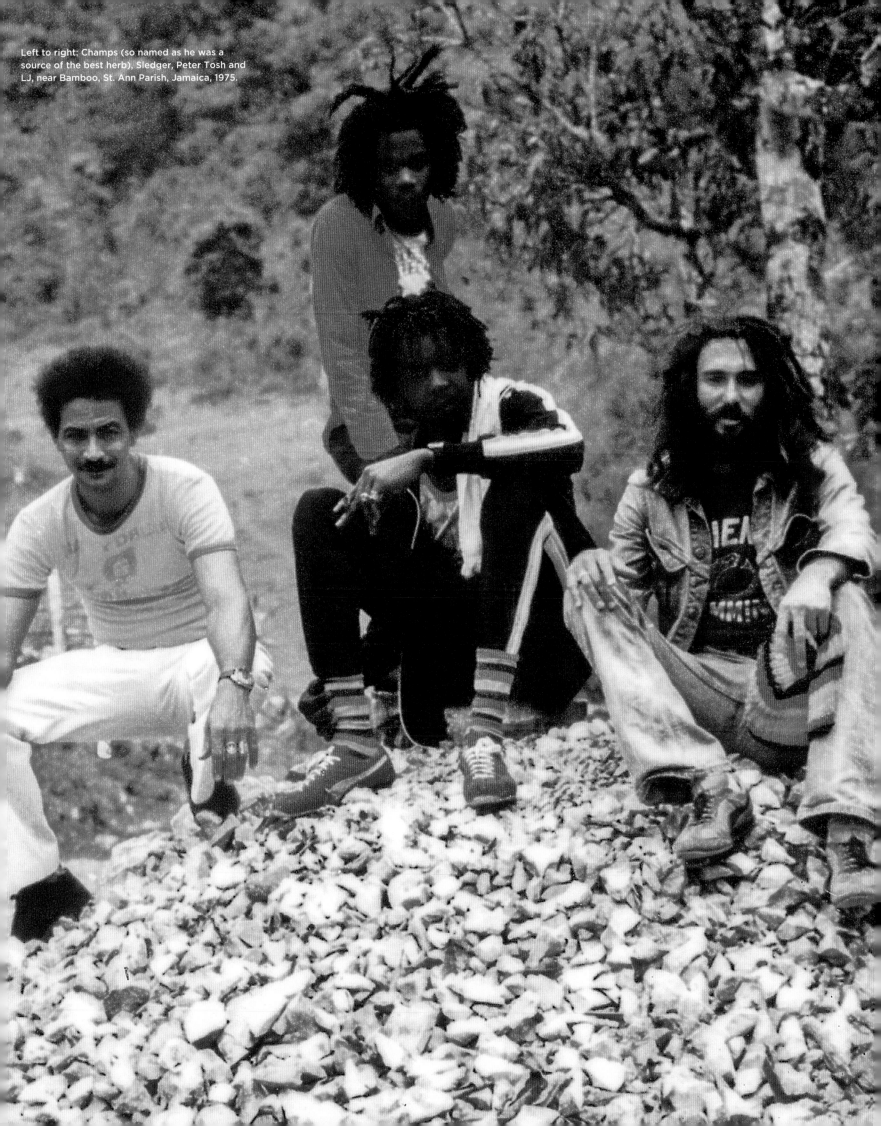

Left to right: Champs (so named as he was a
source of the best herb), Sledger, Peter Tosh and
LJ, near Bamboo, St. Ann Parish, Jamaica, 1975.

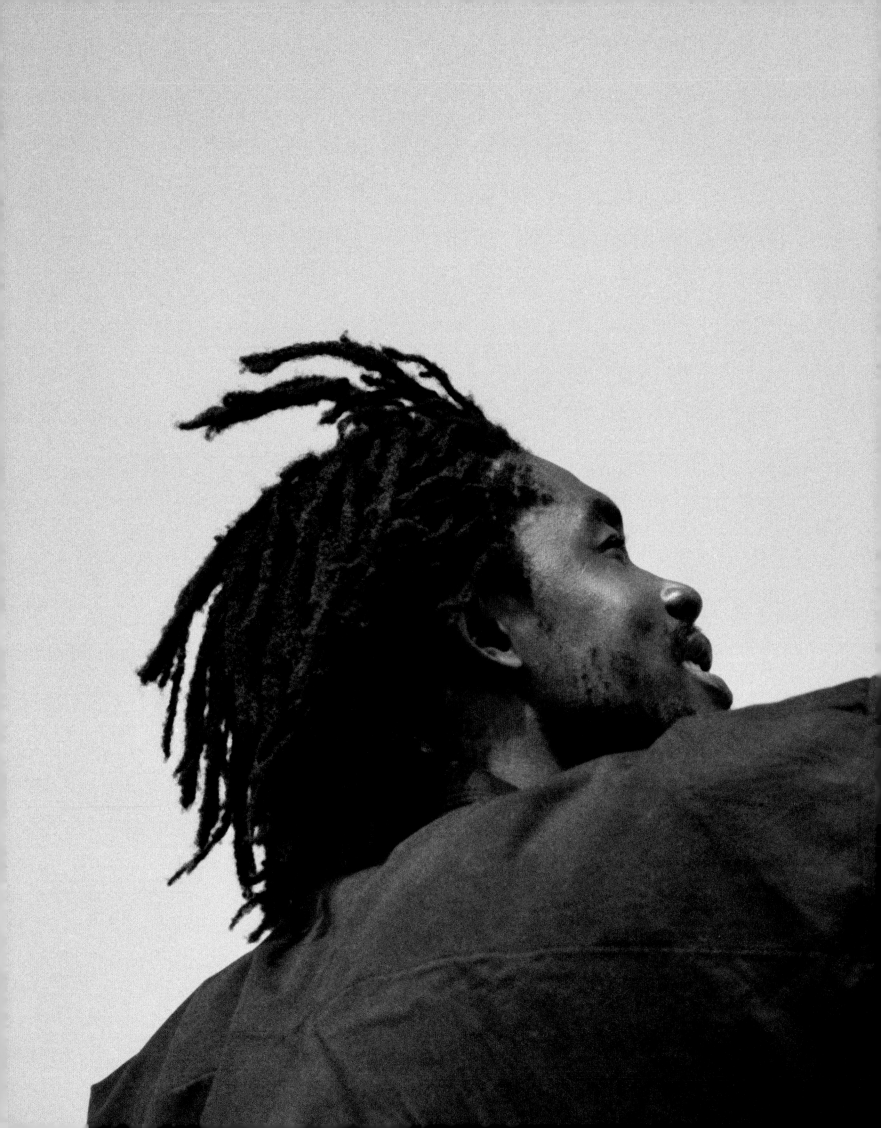

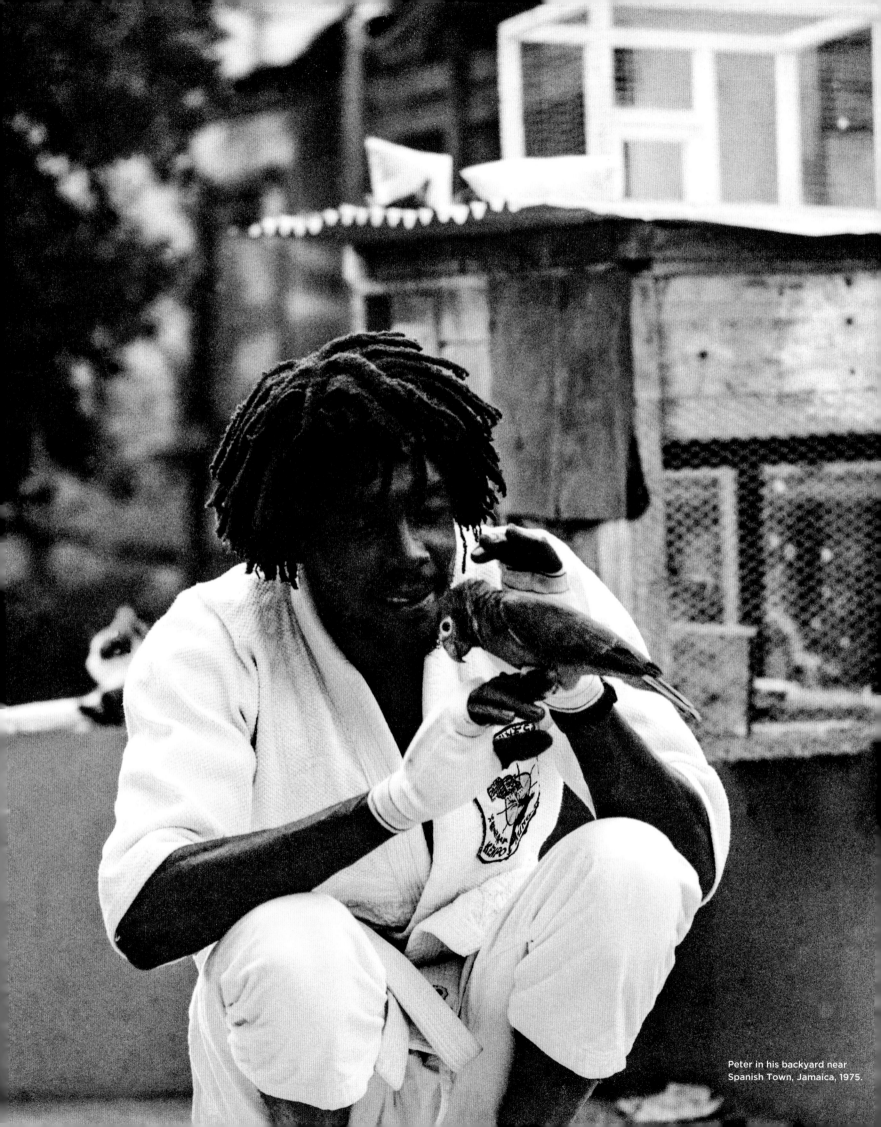

Peter in his backyard near
Spanish Town, Jamaica, 1975.

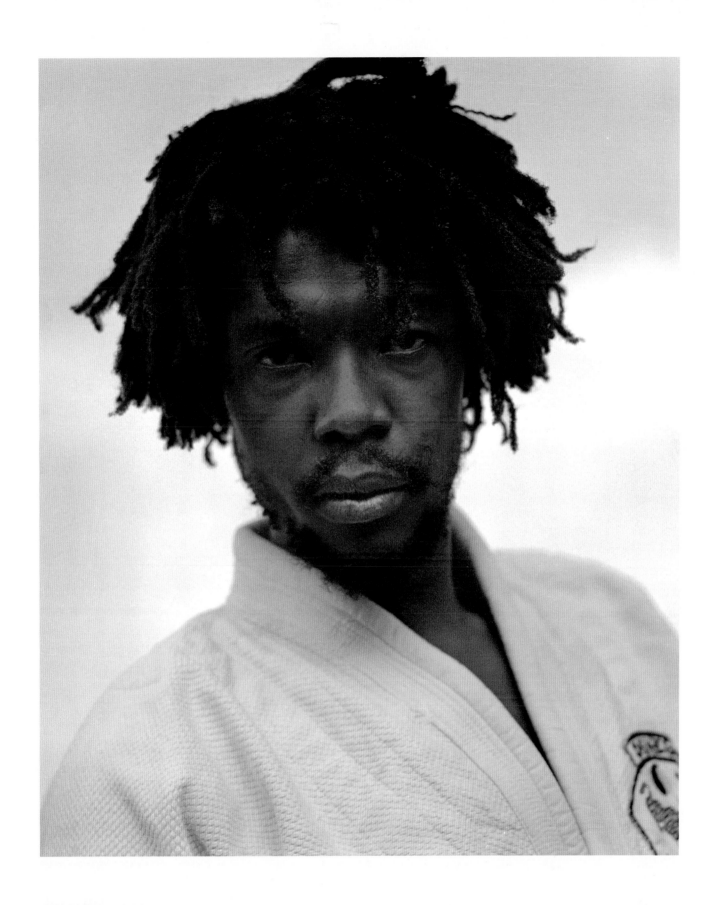

Legalize it

Don't criticize it

Legalize it

And I will advertise it.

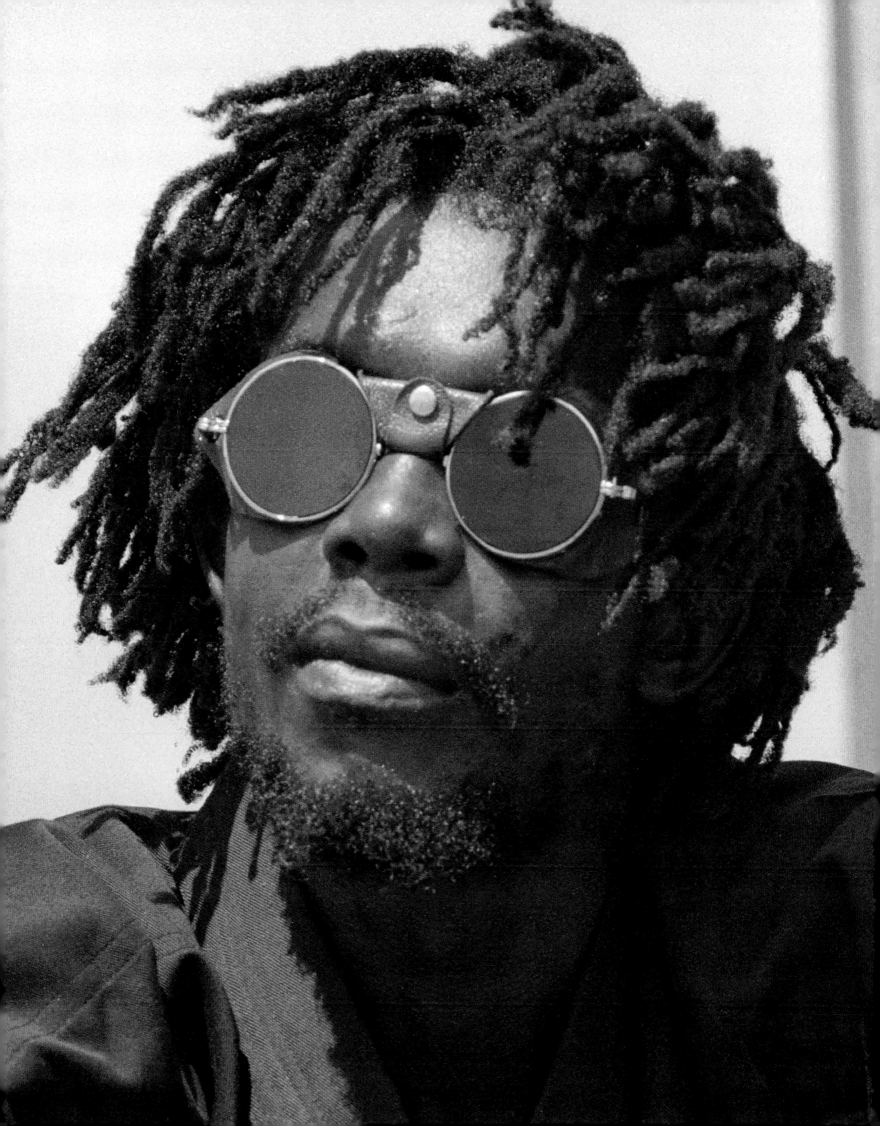

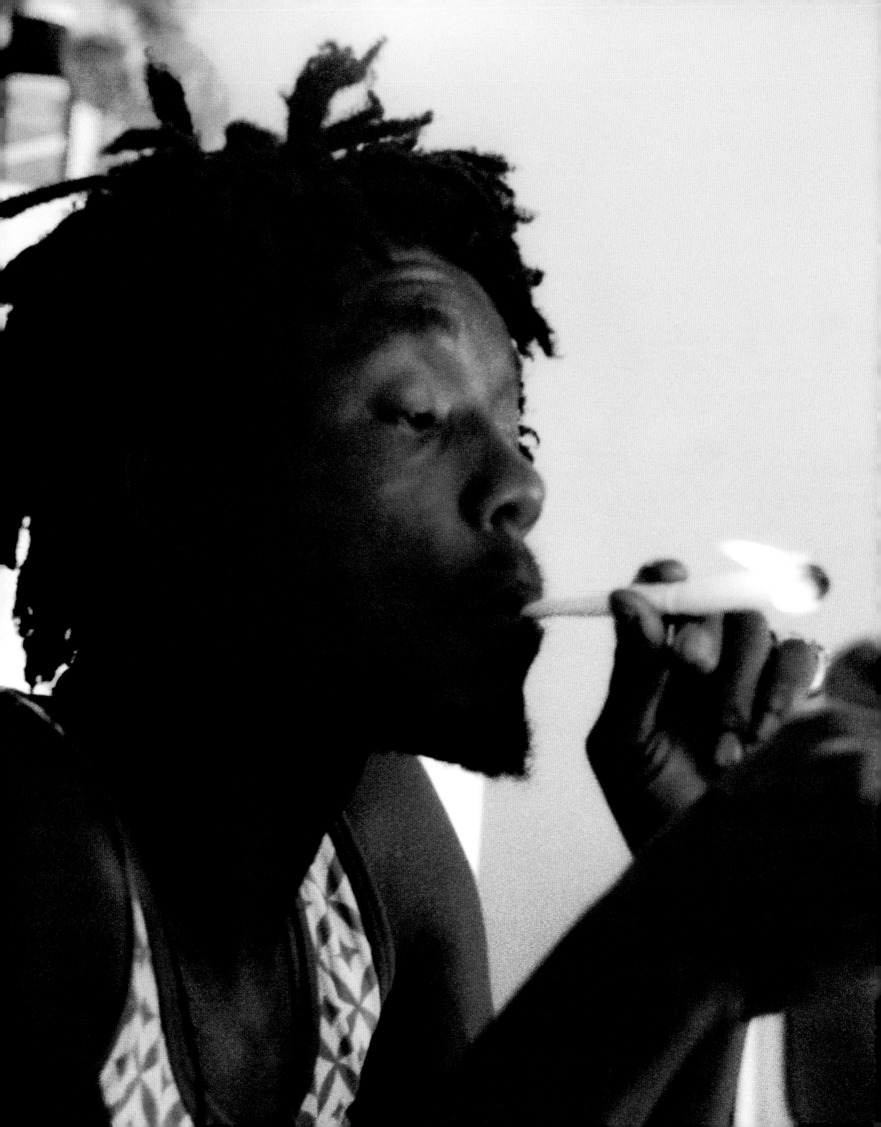

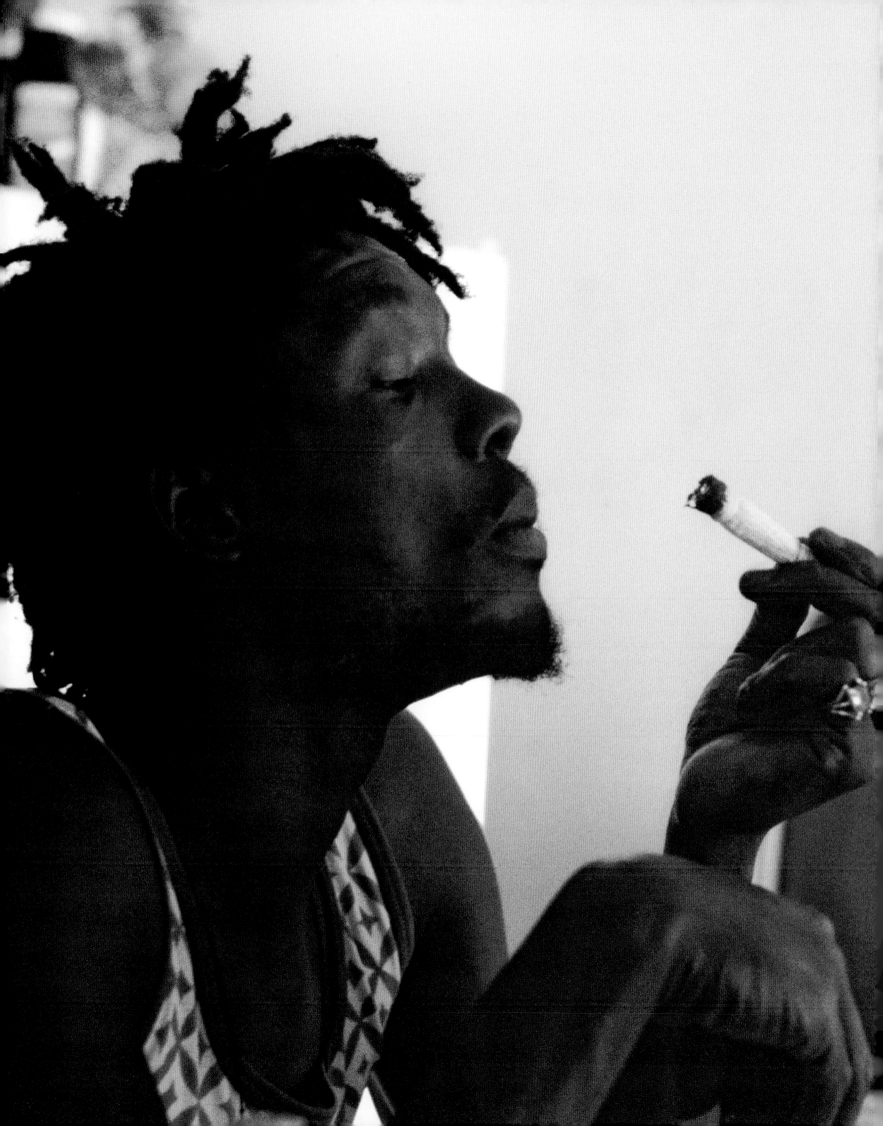

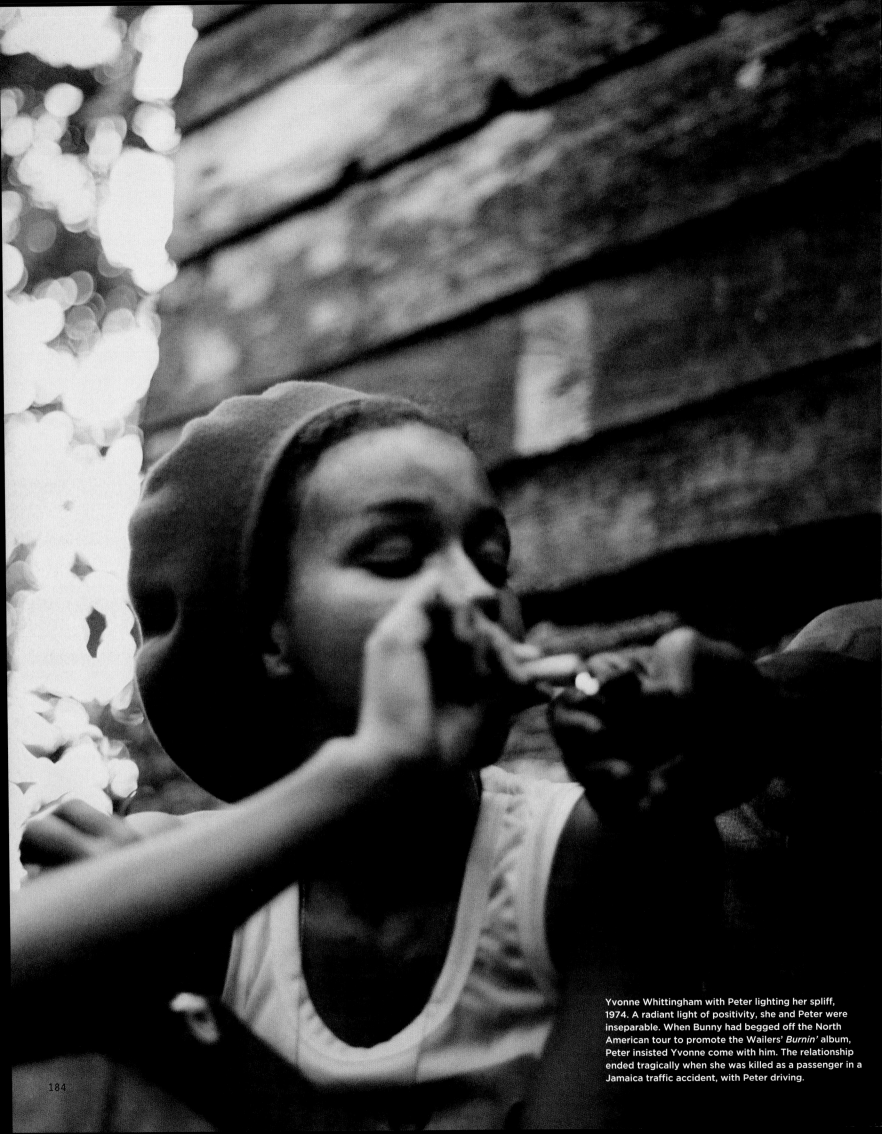

Yvonne Whittingham with Peter lighting her spliff, 1974. A radiant light of positivity, she and Peter were inseparable. When Bunny had begged off the North American tour to promote the Wailers' *Burnin'* album, Peter insisted Yvonne come with him. The relationship ended tragically when she was killed as a passenger in a Jamaica traffic accident, with Peter driving.

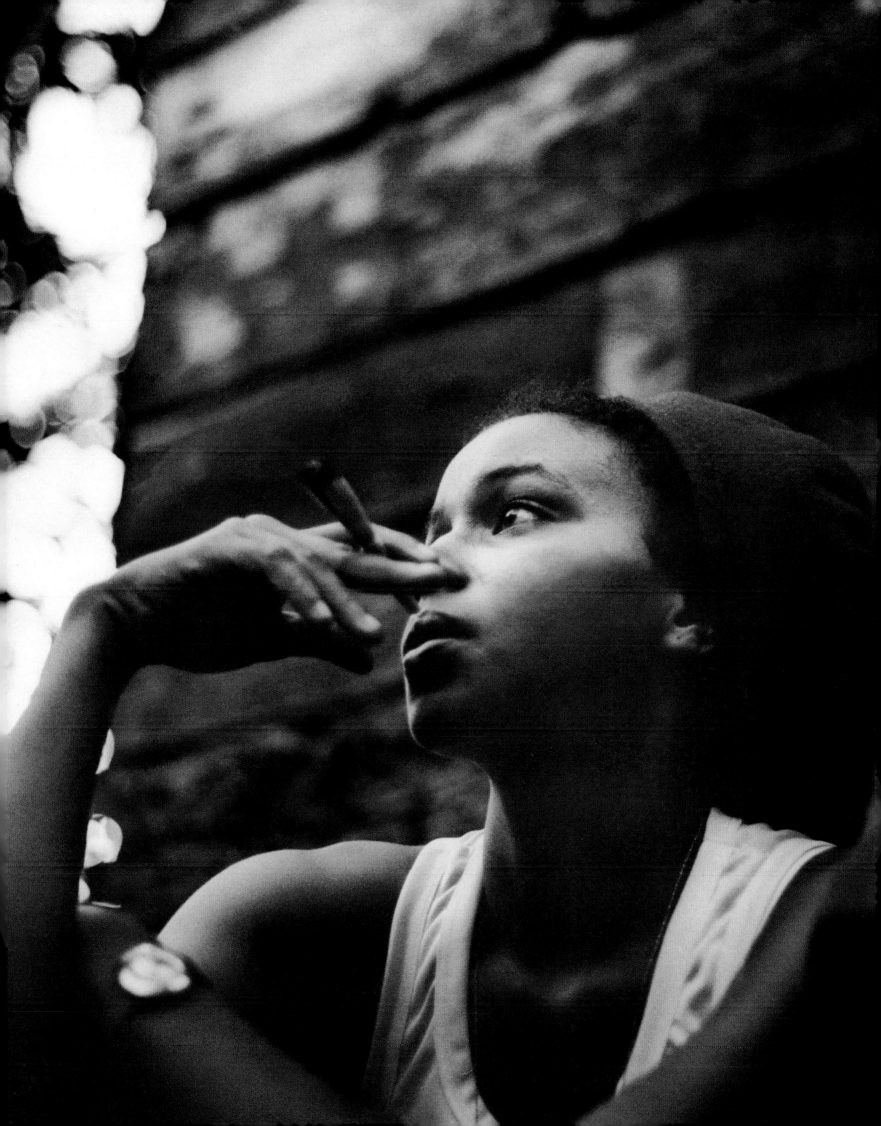

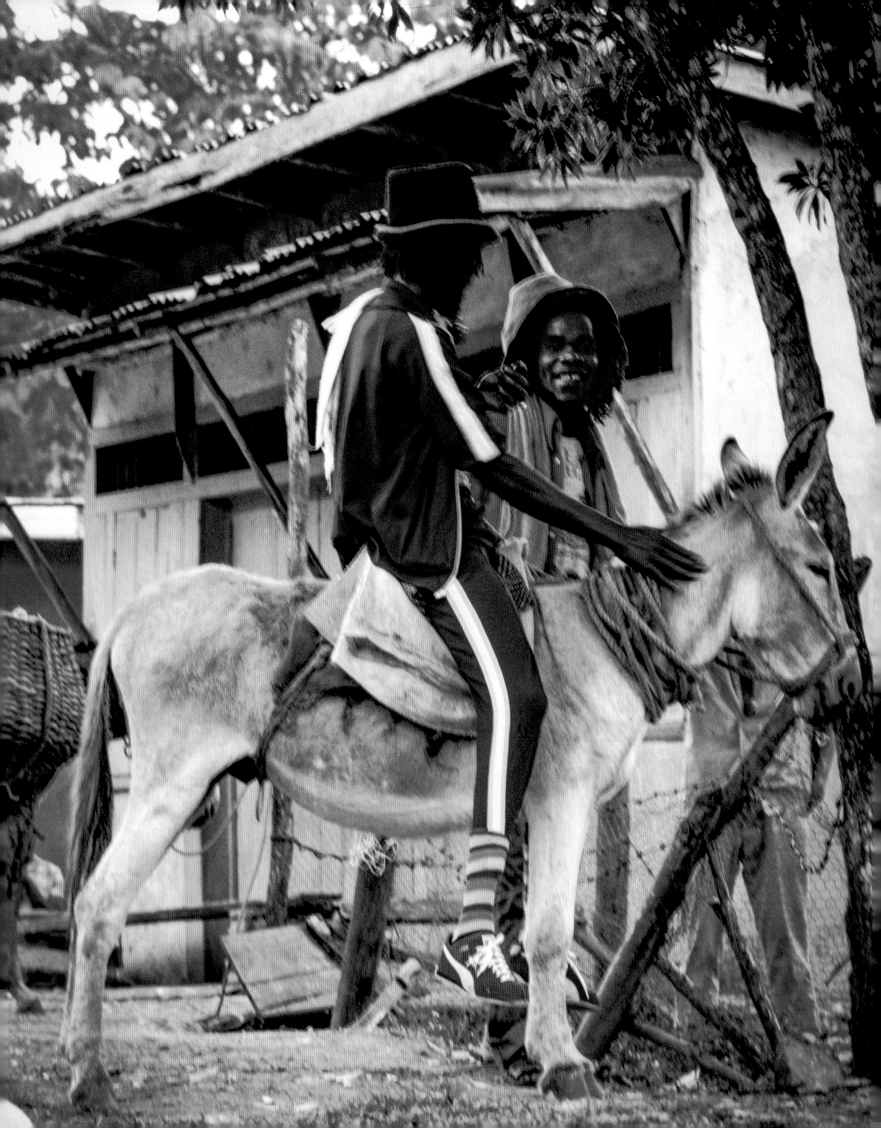

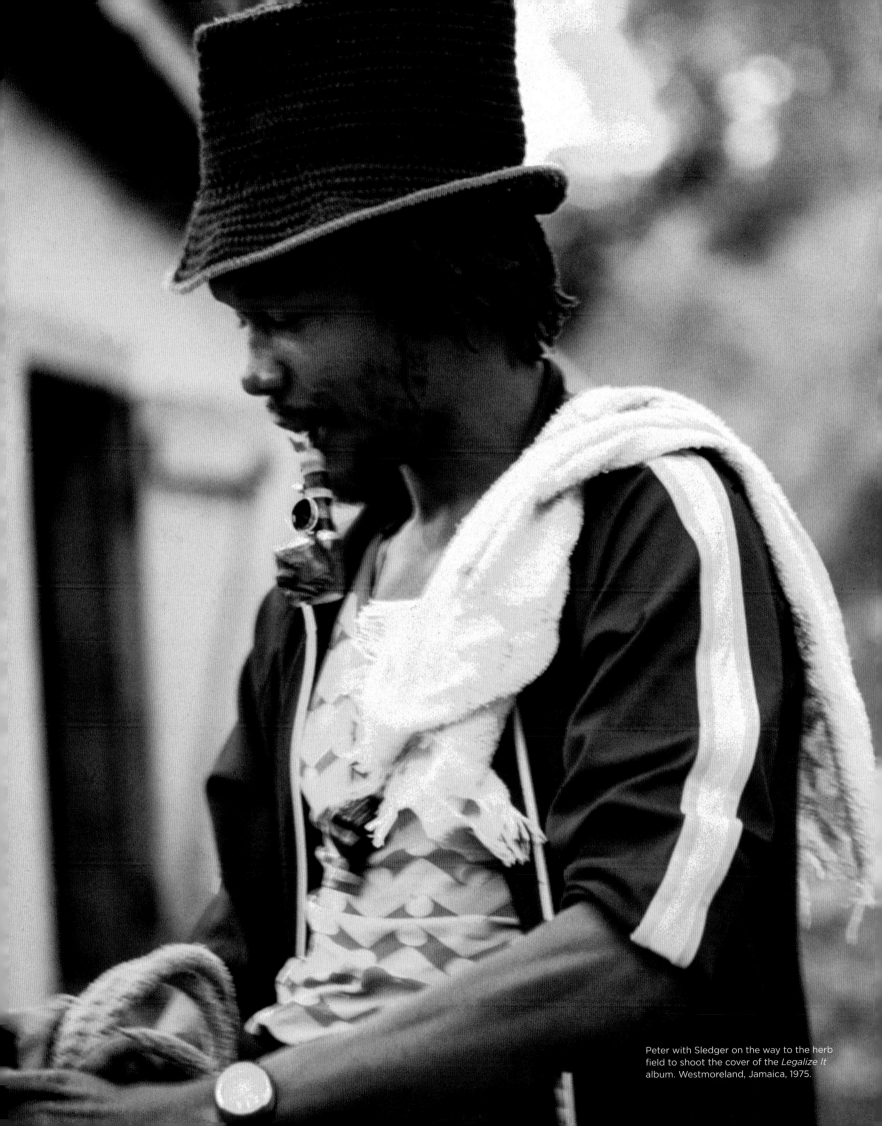

Peter with Sledger on the way to the herb field to shoot the cover of the *Legalize It* album. Westmoreland, Jamaica, 1975.

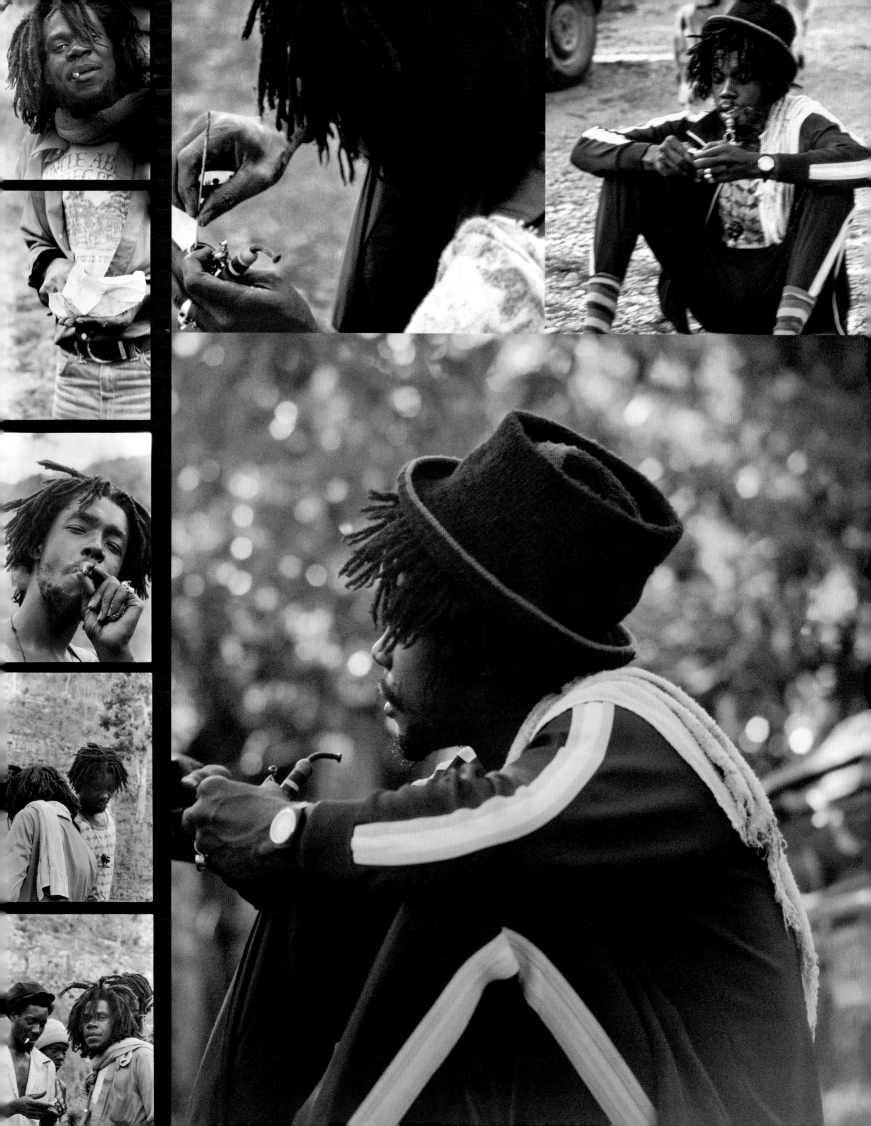

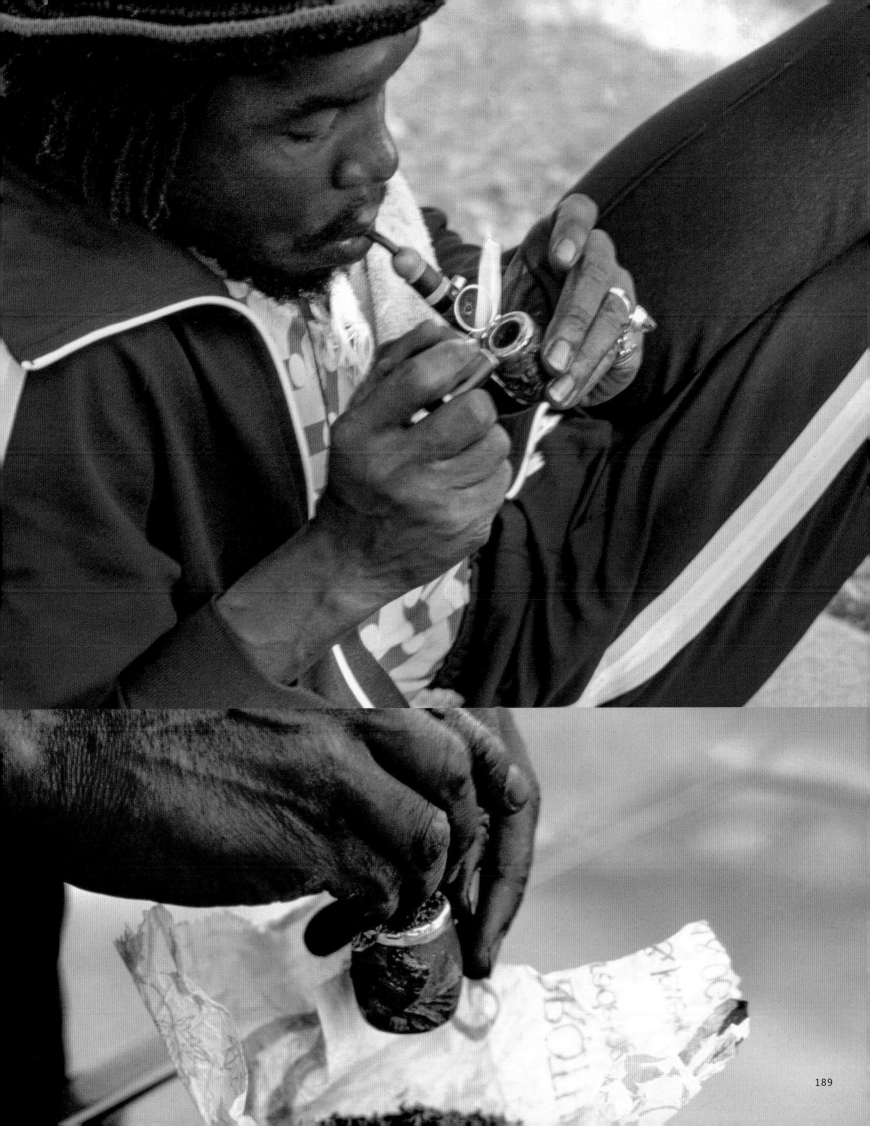

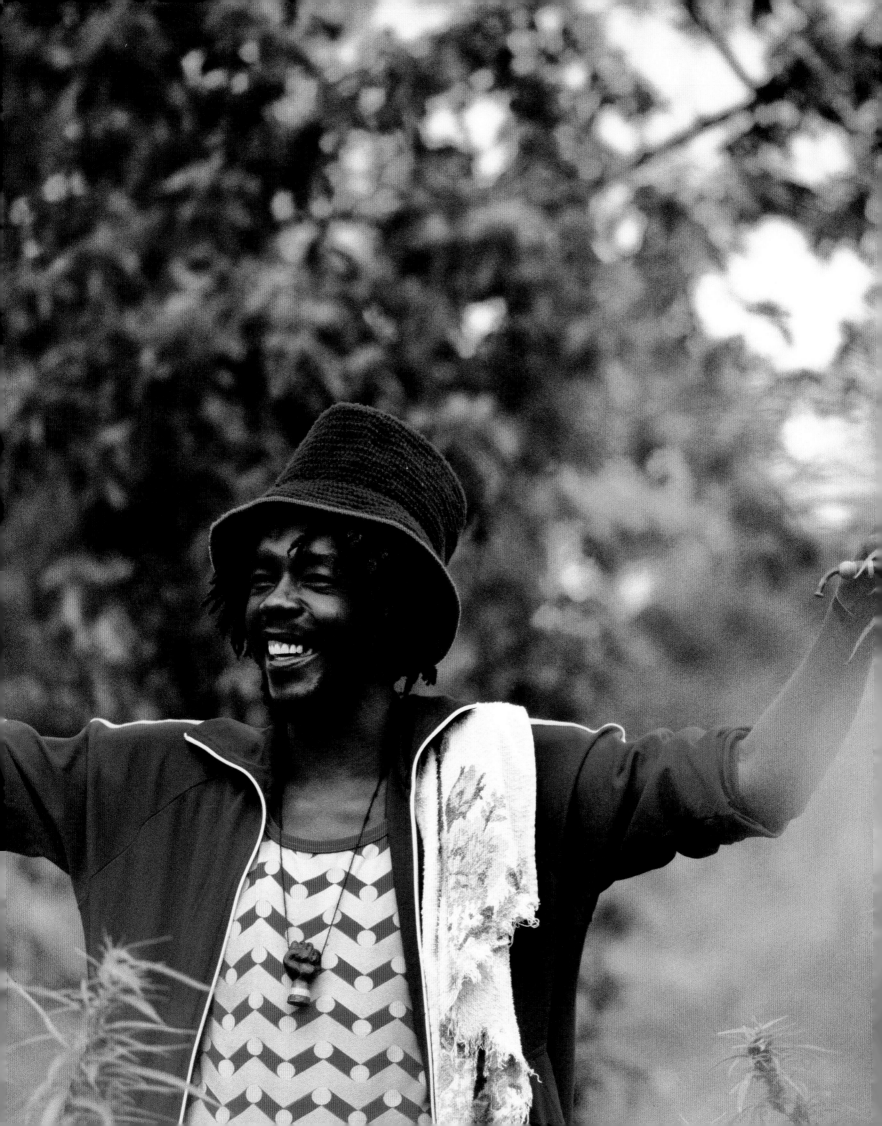

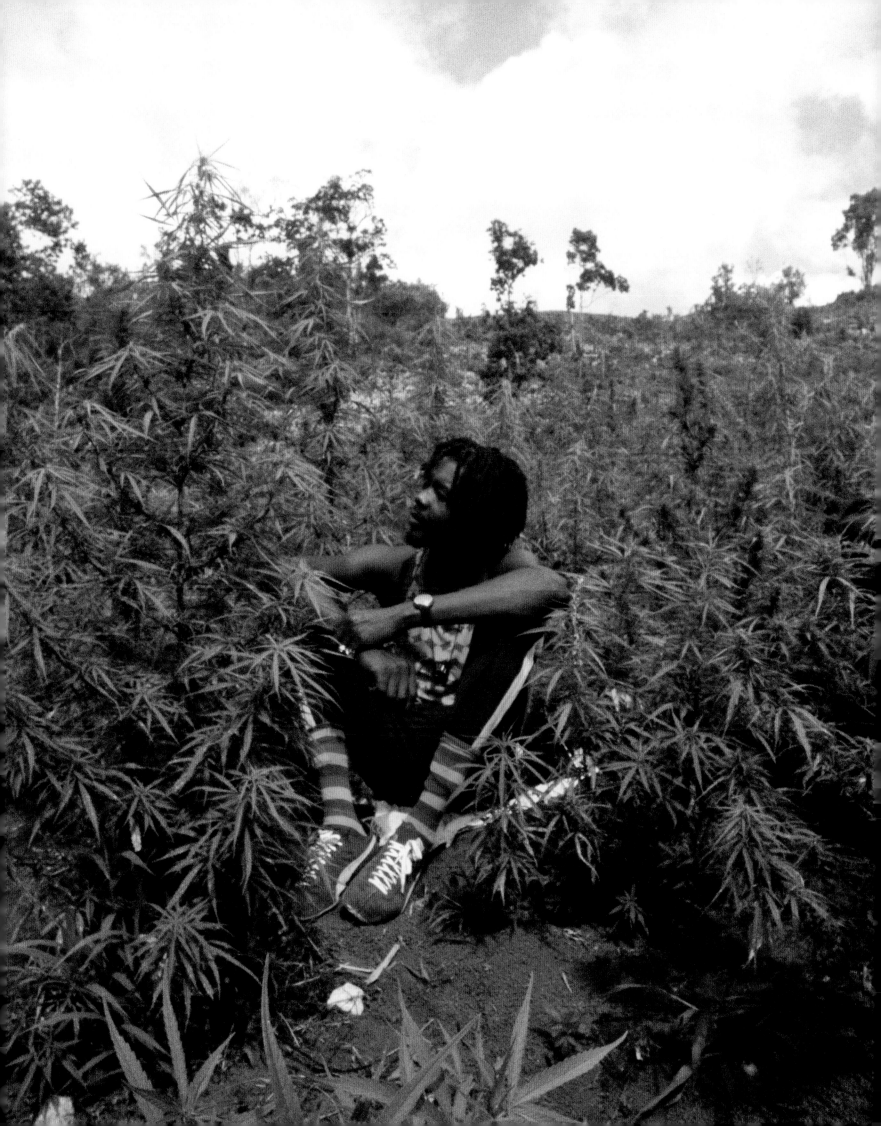

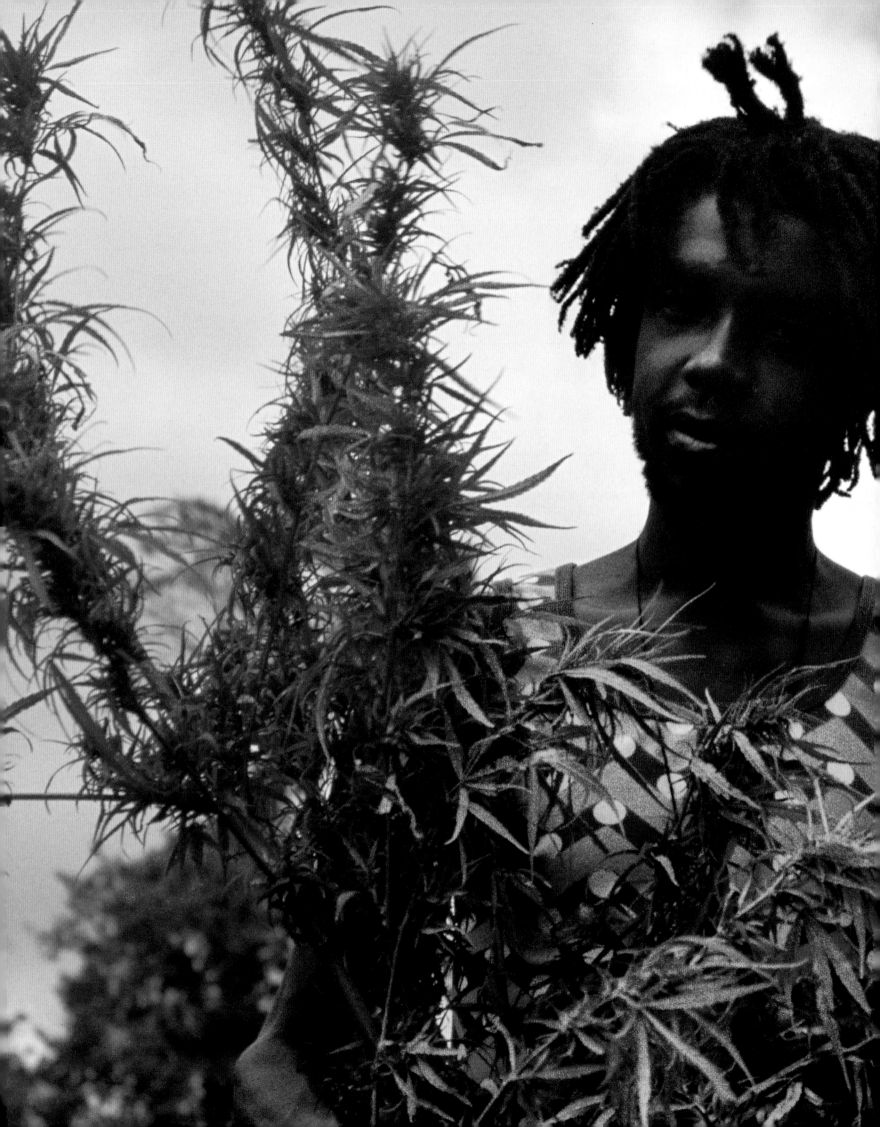

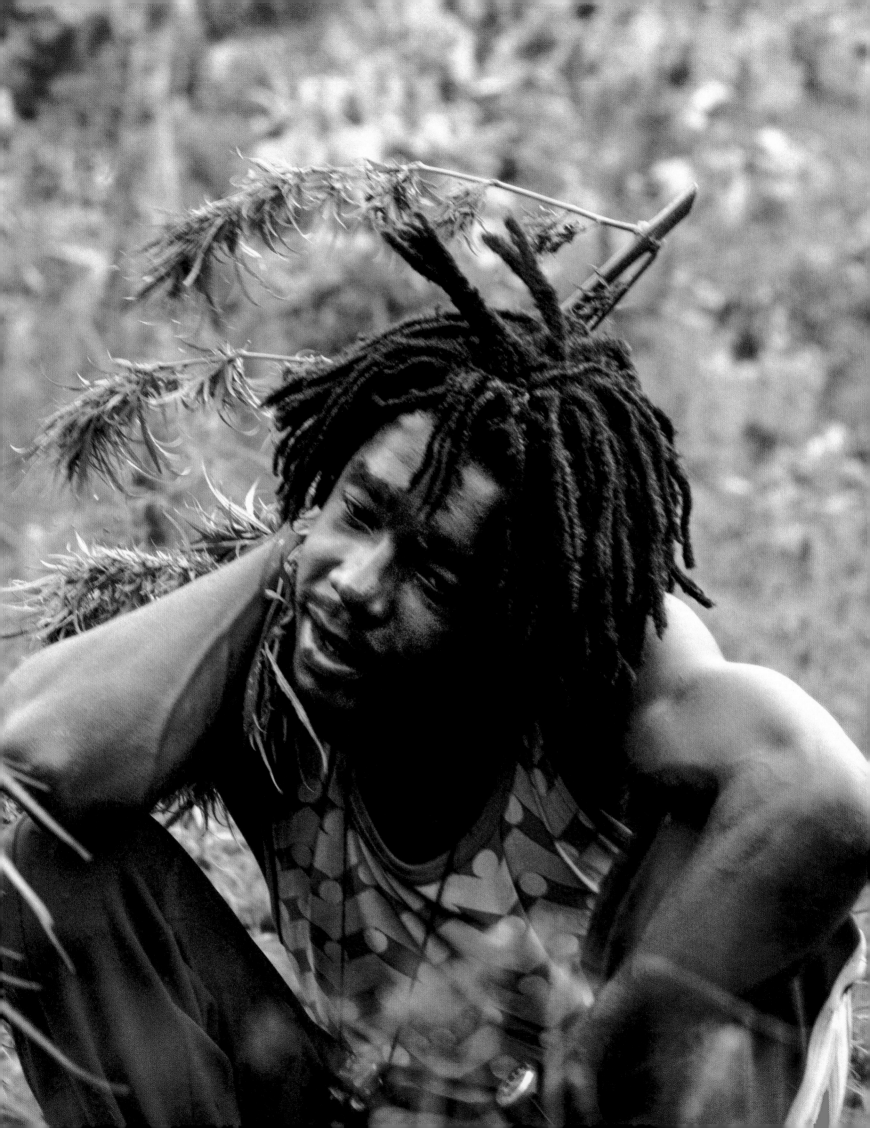

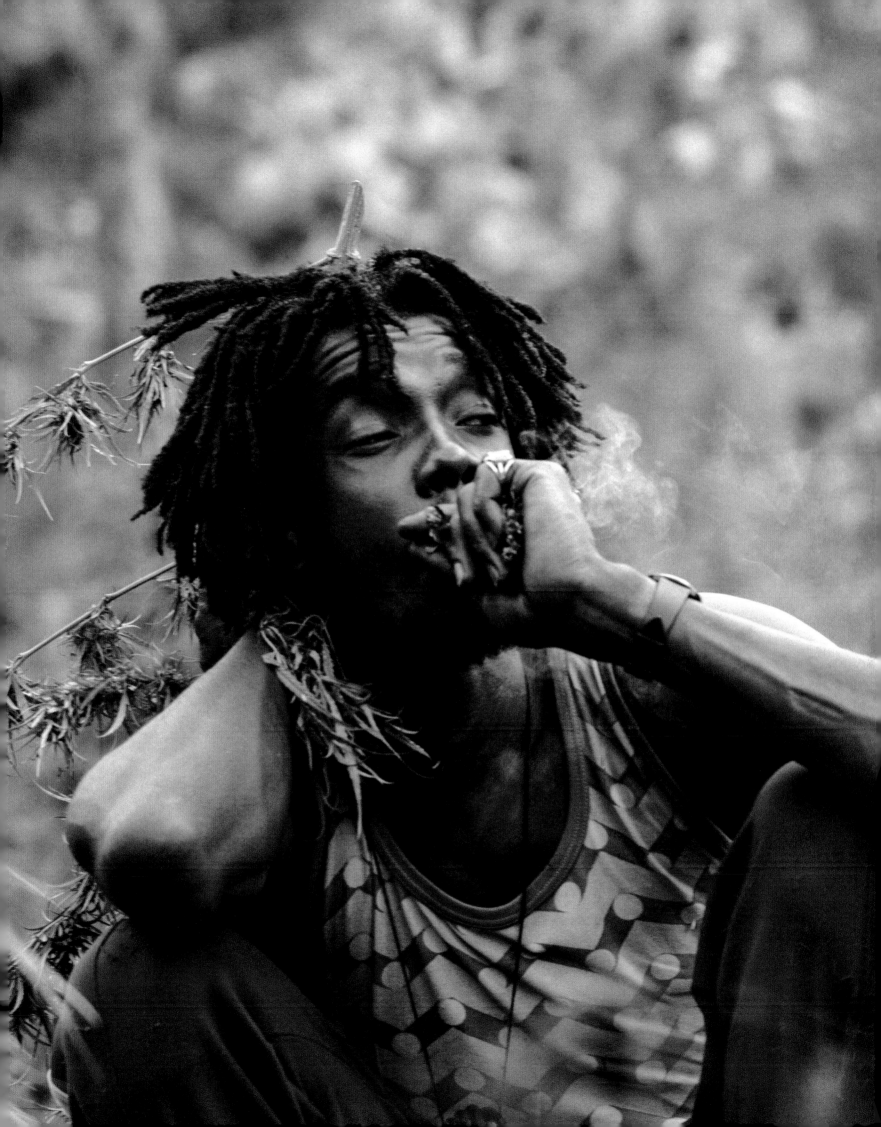

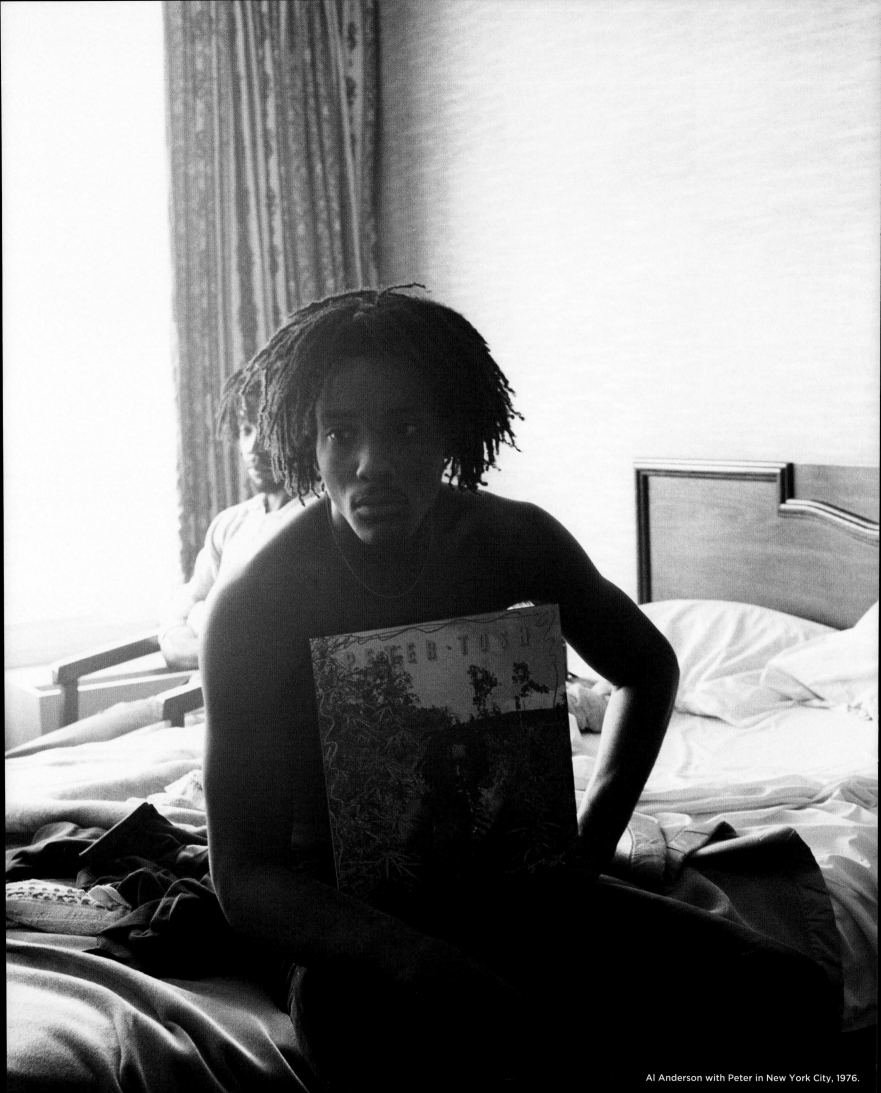

Al Anderson with Peter in New York City, 1976.

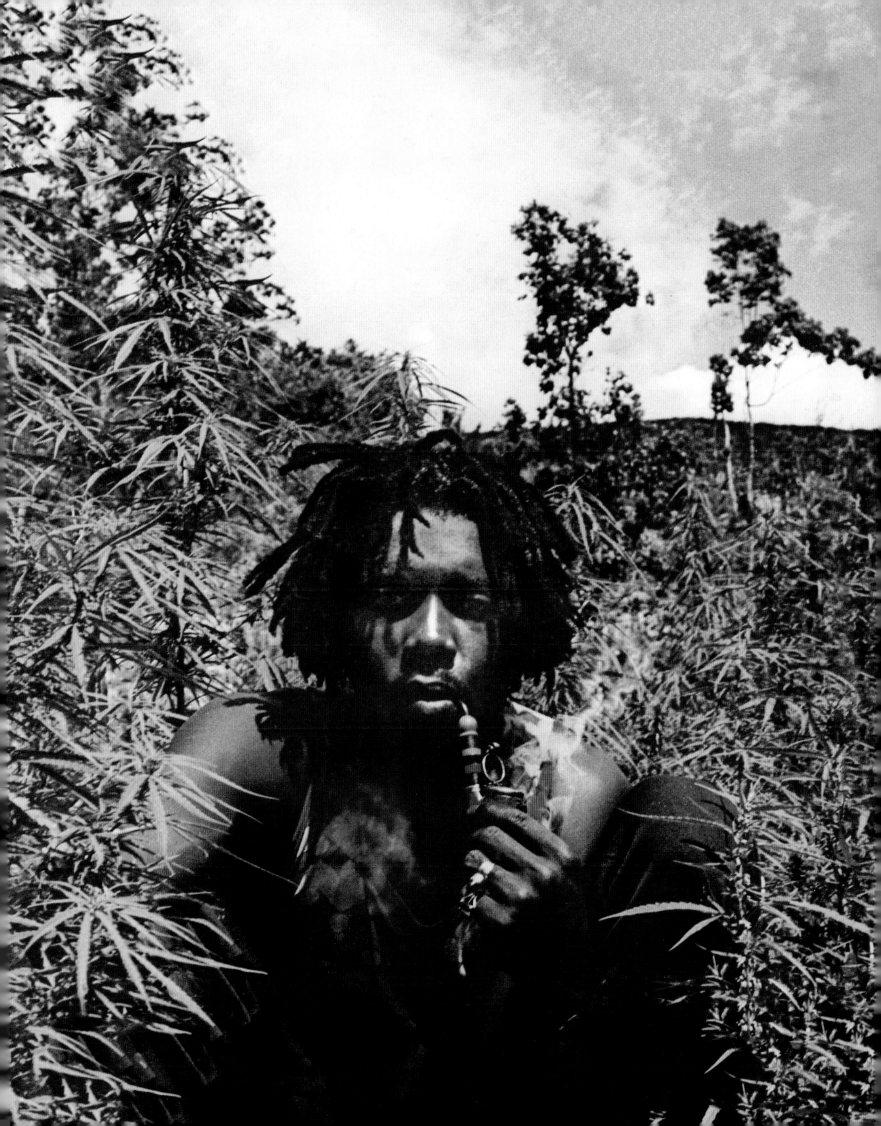

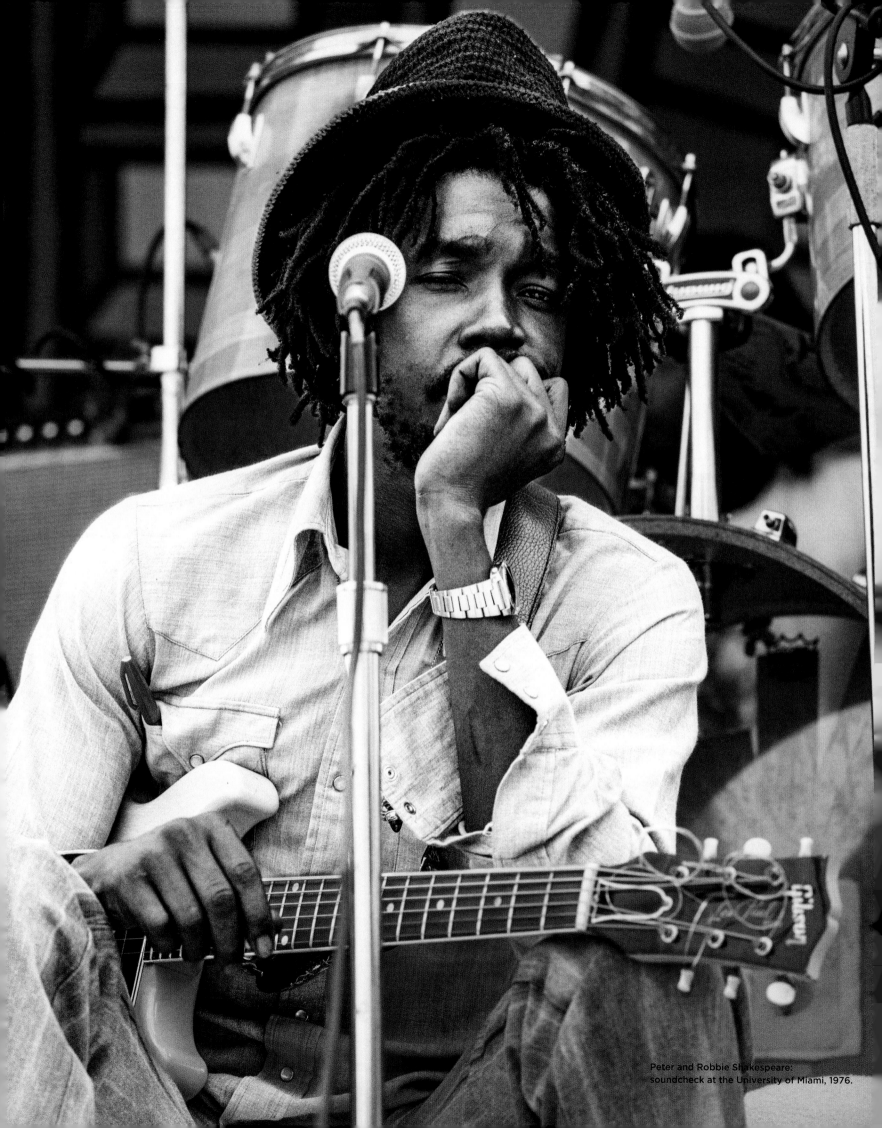

Peter and Robbie Shakespeare: soundcheck at the University of Miami, 1976.

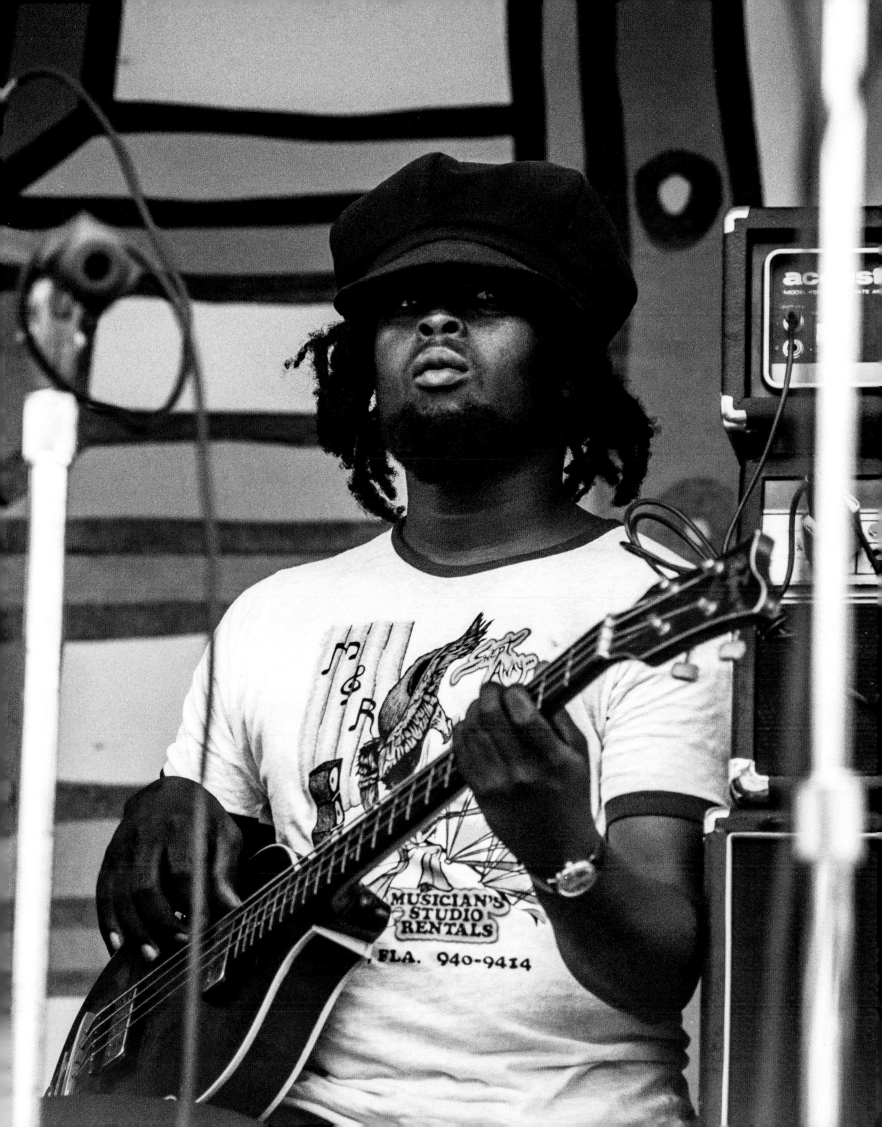

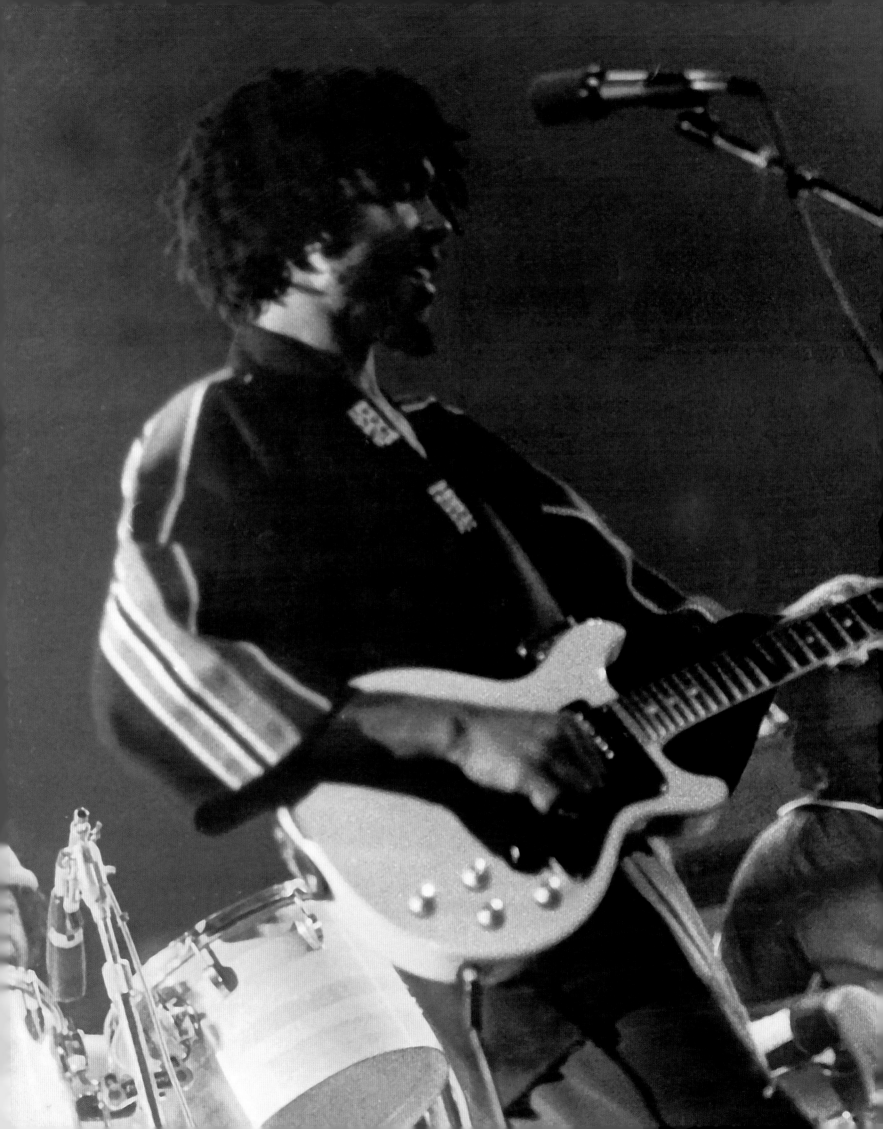

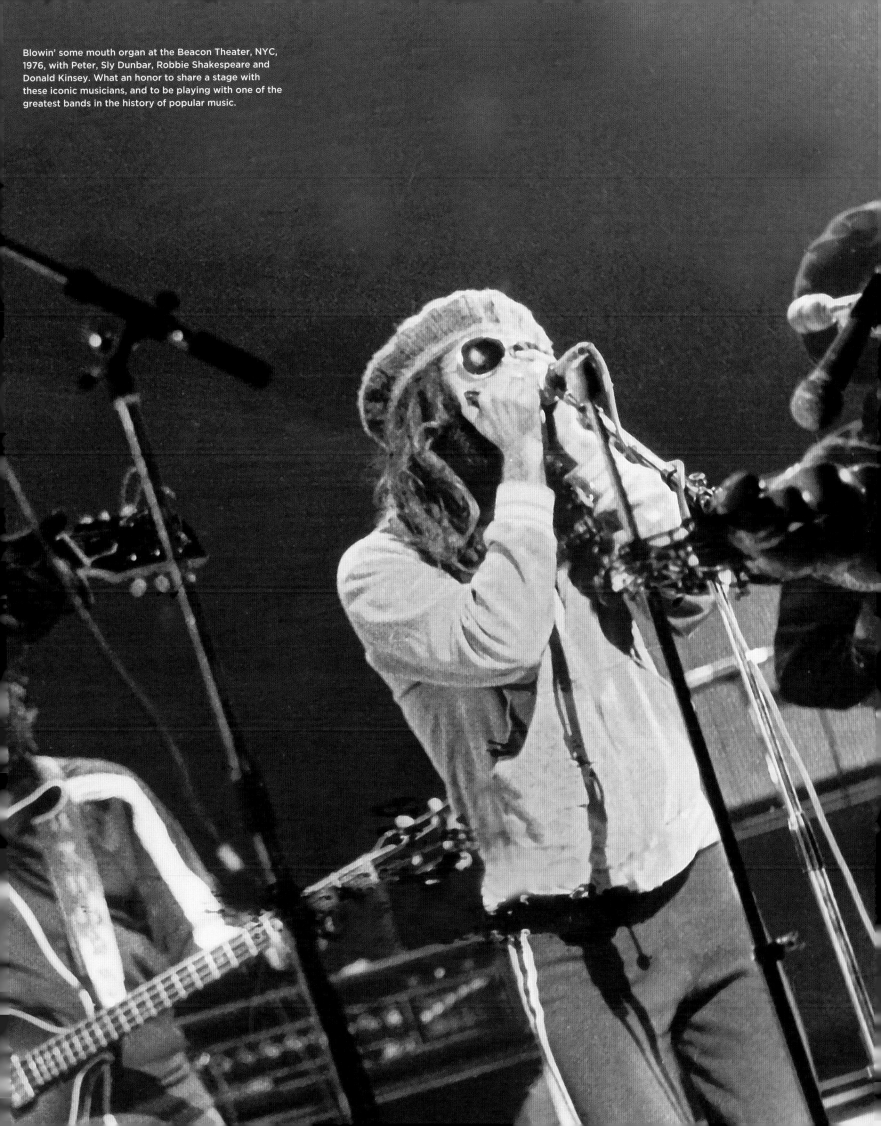

Blowin' some mouth organ at the Beacon Theater, NYC, 1976, with Peter, Sly Dunbar, Robbie Shakespeare and Donald Kinsey. What an honor to share a stage with these iconic musicians, and to be playing with one of the greatest bands in the history of popular music.

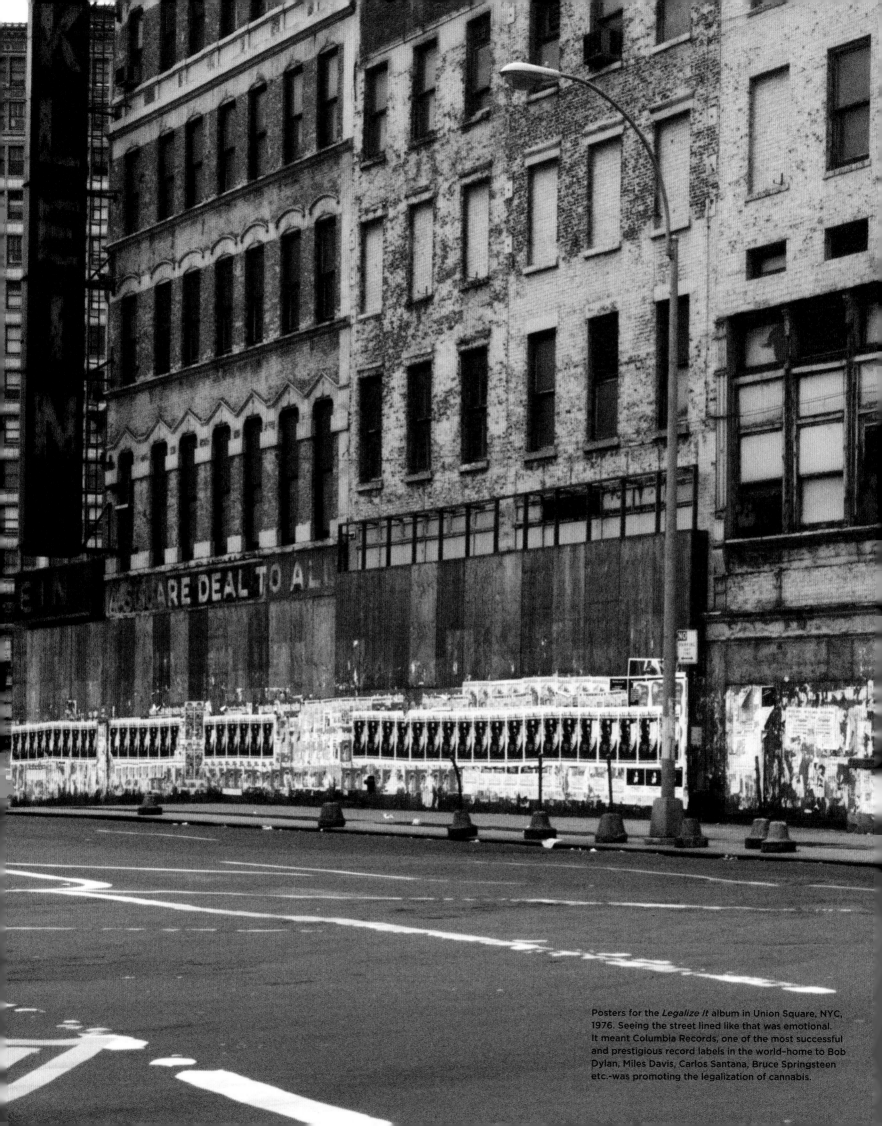

Posters for the *Legalize It* album in Union Square, NYC, 1976. Seeing the street lined like that was emotional. It meant Columbia Records, one of the most successful and prestigious record labels in the world—home to Bob Dylan, Miles Davis, Carlos Santana, Bruce Springsteen etc.-was promoting the legalization of cannabis.

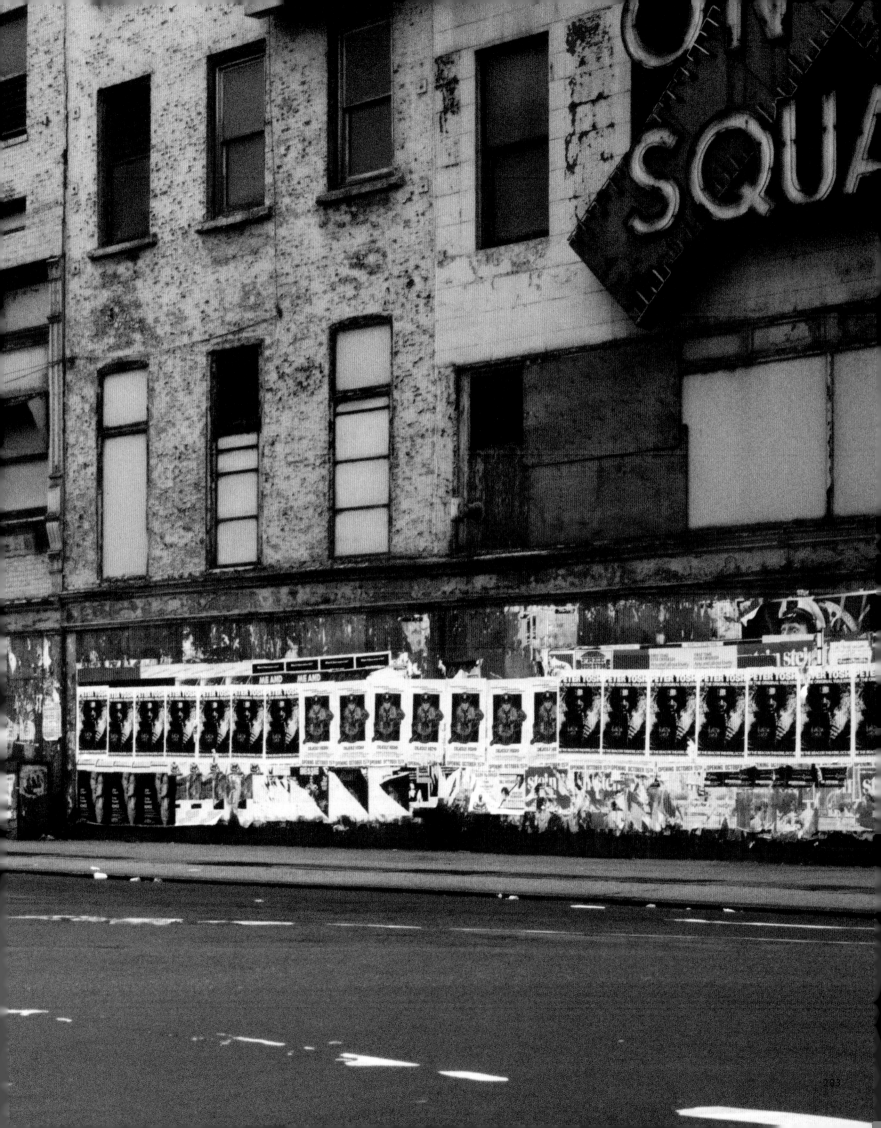

Dream Concert with Stevie Wonder

On October 4, 1975, the *Wonder Dream Concert* took place. Bob Marley & the Wailers performed at the National Stadium in Kingston, Jamaica, with American superstar Stevie Wonder as the headline act. This would be the last joint performance of Bob Marley, Peter Tosh, and Bunny Wailer.

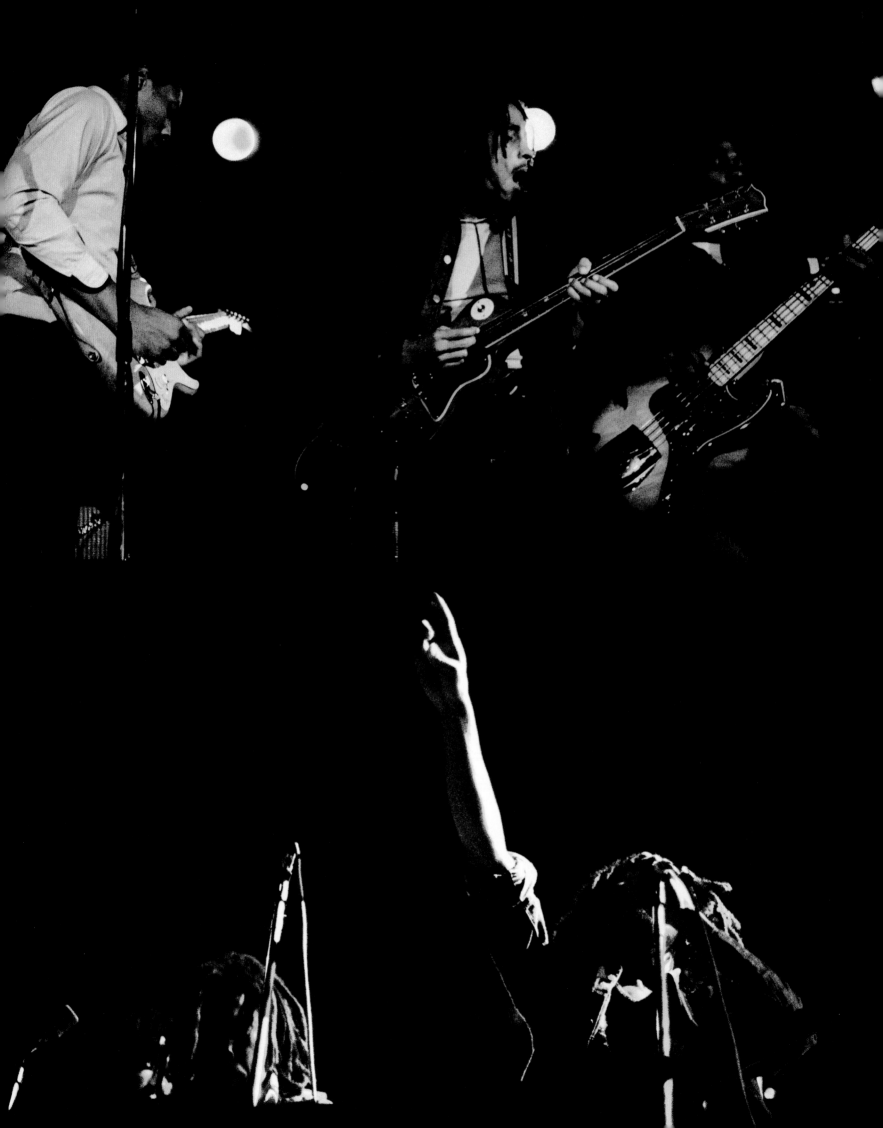

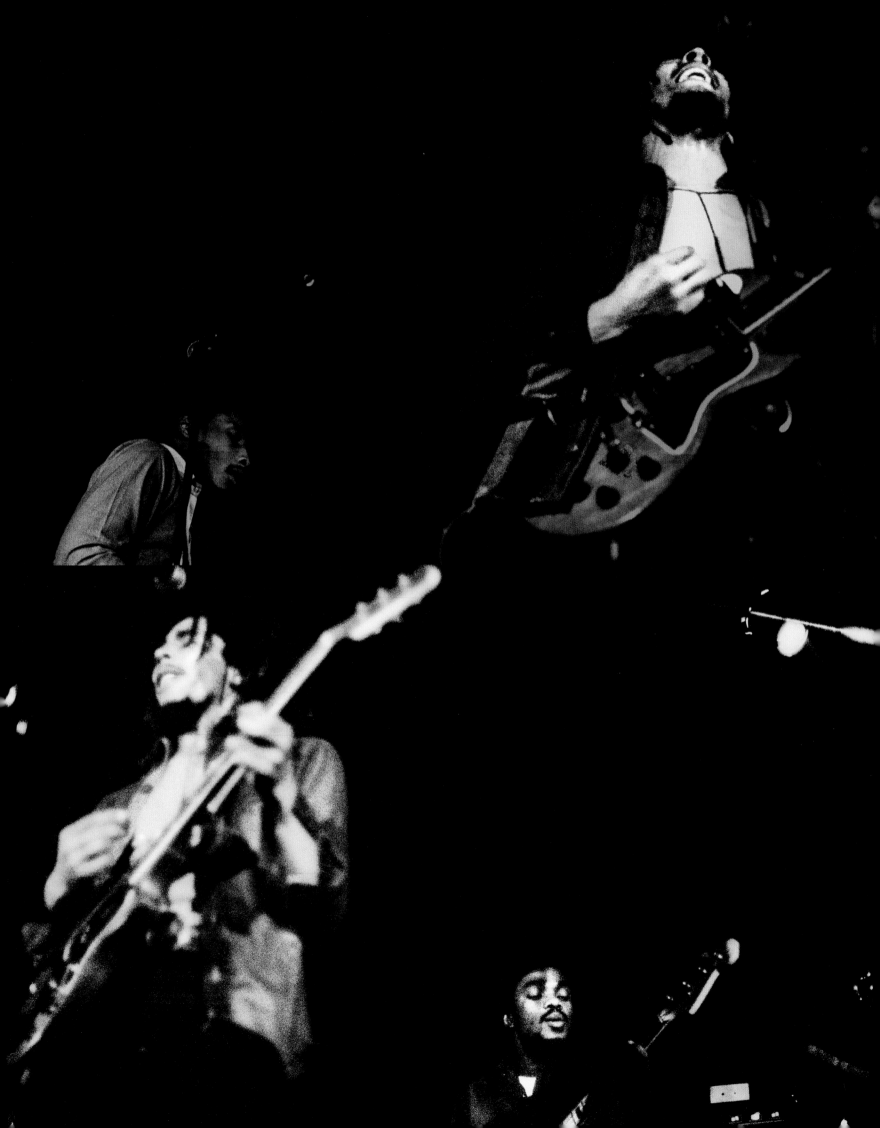

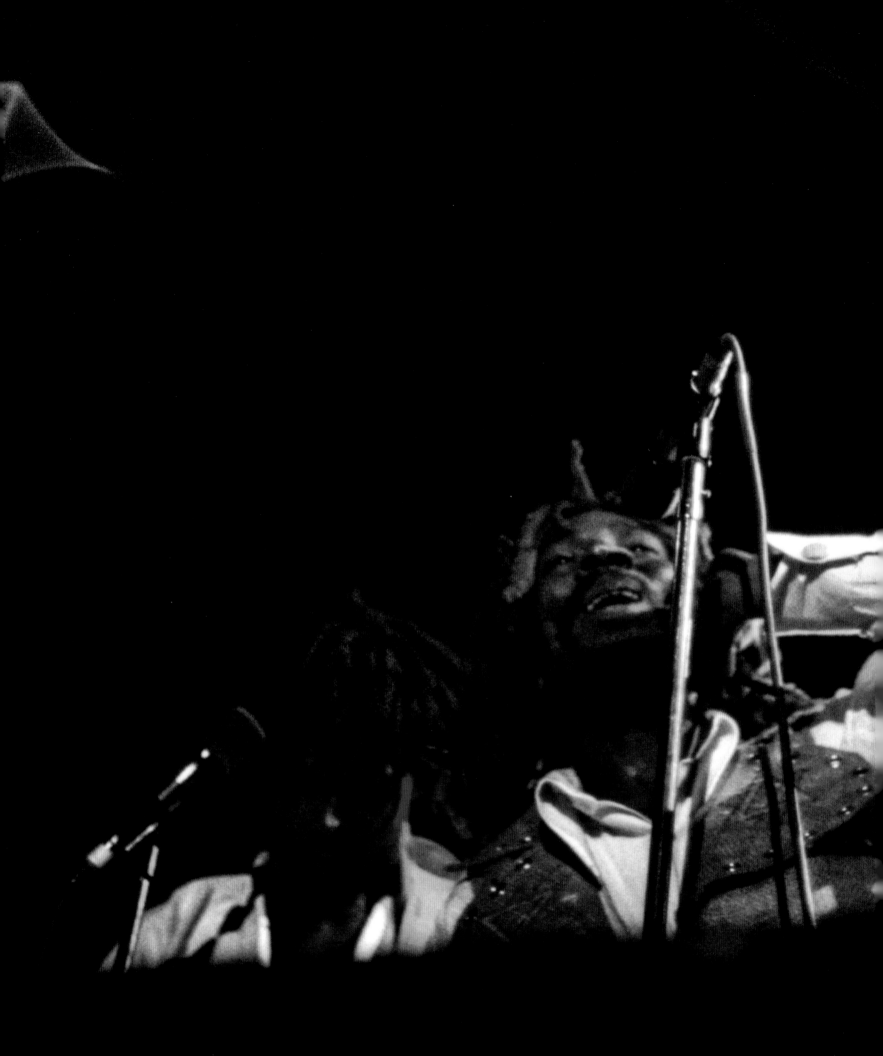

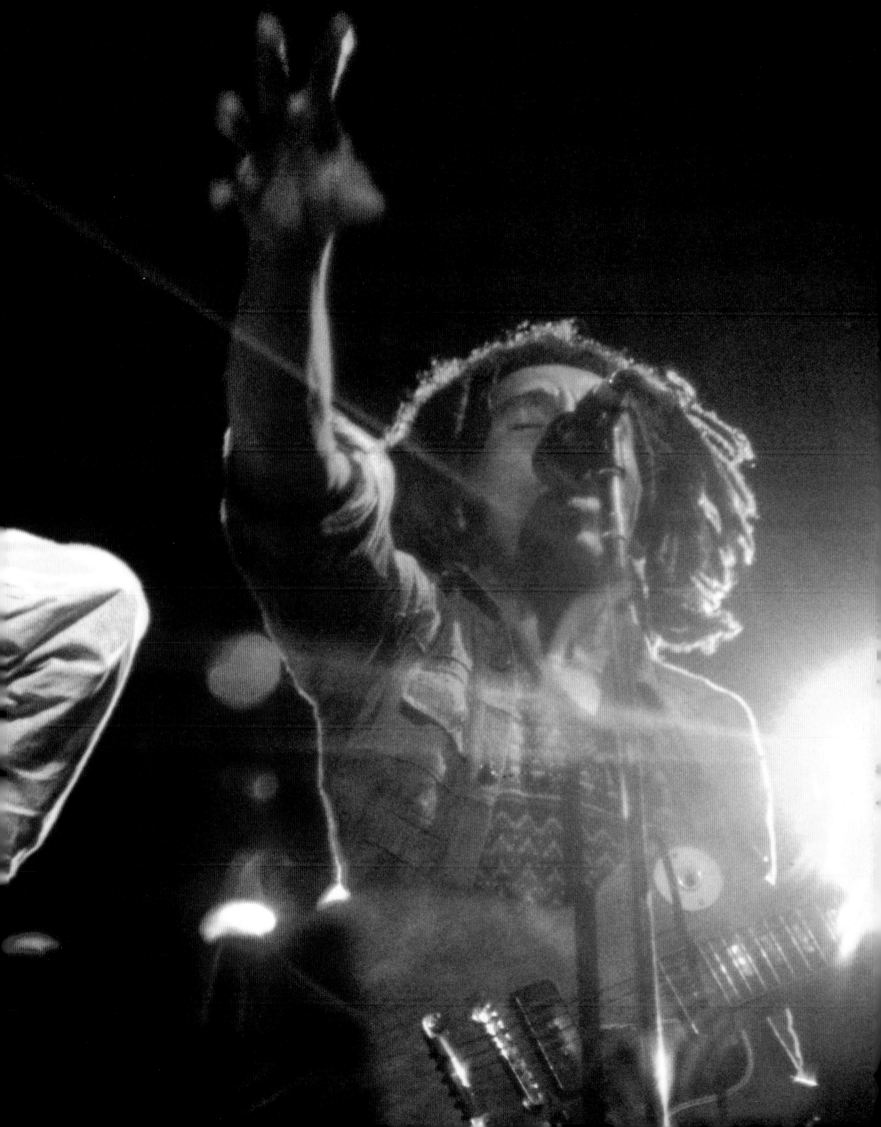

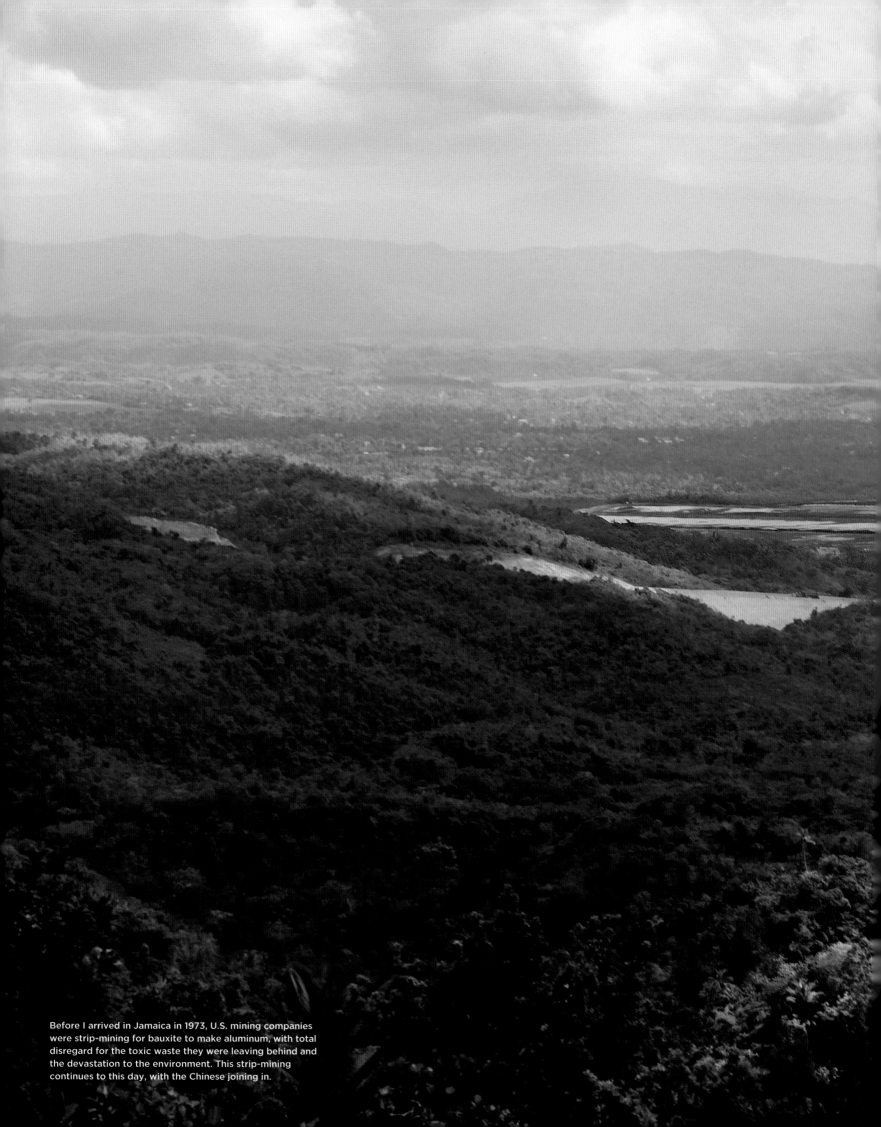

Before I arrived in Jamaica in 1973, U.S. mining companies were strip-mining for bauxite to make aluminum, with total disregard for the toxic waste they were leaving behind and the devastation to the environment. This strip-mining continues to this day, with the Chinese joining in.

Eternal

No Woman No Cry

Good friends we have,
Oh, good friends we have lost
Along the way,
In this great future,
You can't forget your past,
So dry your tears, I say.

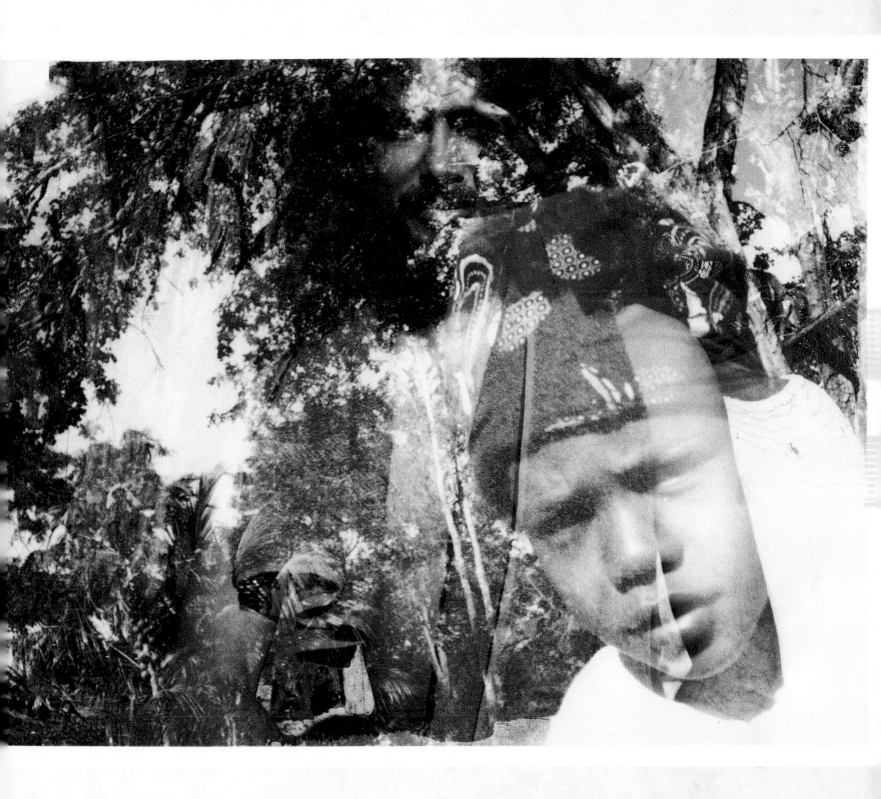

Joe Higgs

Joe Higgs with Lee Jaffe, Venice, California.

Joe Higgs (d. 1999) was a mentor to Bob Marley, Peter Tosh, and Bunny Wailer when the three had just come together, originally meeting in Joe's yard in the West Kingston neighborhood of Trenchtown. He taught them to sing harmonies and would prepare them for stage appearances by bringing them to a graveyard at midnight to rehearse—the idea being that if they could overcome the fear of "duppies," they could handle performing in front of the notoriously critical Jamaican audiences. Joe had some success as part of the duo, Higgs and Wilson, and his huge heart and generous personality was a magnet for younger artists. Joe introduced the Wailers to Coxsone Dodd who first recorded them at his legendary Studio One set-up in Kingston, where they produced their first hit, the 1964 ska classic, "Simmer Down." Joe became known as the "Godfather of Reggae" and "Teacher" by artists such as Pipe and Bread of the Wailing Souls, and Jimmy Cliff, who would later become his band leader. When I first moved to Jamaica in 1973, Joe was record-ing what would be his first album and I contributed a few lyrics to the title track, "Life of Contradictions," issued by the Jamaican label, Micron Music, in 1975. The record has been described as "a seminally sophisticated work combining reggae, jazz, and rhythm and blues influences to create a new texture that would have a profound effect on the best Jamaican music to follow." He was at Hope Road almost daily, and I was privileged to sit and jam with him on acoustic guitar and myself on harmonica. When I was organizing the Wailers North American tour to support their second Island Records re-

lease, *Burnin'* (1973), Bunny had decided he wouldn't go, and I suggested to Bob that Joe take his place. It was always a thrill seeing him perform with Bob and Peter. In Joe's own words:

"Music is a matter of struggle… Reggae is a confrontation of sound. Reggae has to have that basic vibrant sound that is to be heard in the ghetto. It's like playing the drum and bass very loud. Those are the basic sounds… Freedom, that's what it's asking for; acceptance, that's what it needs, and understanding, that's what reggae's saying."

In the 1980s, when I moved back to the U.S. to resume a visual arts career—first to New York and then to Los Angeles in 1986—I was happily surprised to discover that Joe was living in L.A. I had friends, Edgy Lee and Joe Vittarelli, who owned a recording studio, and they agreed to help produce an album with Joe which became *Family* and was released on Shanachie Records in 1988—a wonderful indie label that had begun by releasing Irish revolutionary records and had expanded into reggae (so it made perfect sense).

Robert Christgau, known as the "Dean of American Rock Critics," had written reviews of *Triumph*, and the follow-up Higgs album, *Family*. *Triumph* was produced by a seminal figure of Jamaican music, guitarist Earl "Chinna" Smith, who to this day keeps roots and reggae alive, recording at his home studio, Inna da Yard. Here are Christgau's review comments on *Triumph* (Alligator, 1985): The ska pioneer and fourth Wailer is one of reggae's most respected writers of songs and singers of

harmonies. He's been around too long to have much use for millenarian cant, and he's too honest to play the romantic stud—he sings about love because he needs it, soul and body in the ghetto where he figures to spend the rest of his days, and at forty-five he feels like he's got a lot of days ahead of him. His weathered voice and reassuringly deep and unpredictable backup also articulate the way he understands the world. I know of no Jamaican whose sensibility is more accessible to ordinary American music lovers of a certain age.

And certainly I would agree with Robert Christgau that Earl "Chinna" Smith's production of *Triumph* is among the greatest achievements in popular music of any genre. In reviewing *Family* (Shanachie, 1988), Christgau commented: In a chronically undifferentiated music, subtlety can be a curse, and though I've gotten to know every song here and have no trouble admiring most, I wish Higgs had rehired the musicians who backed Triumph three years ago. It's my guess—and with subtlety you have to guess some— that the likes of Chinna Smith, Wire Lindo and Augustus Pablo made the difference between an acknowledged classic and an obscure near thing.

After the release of *Family*, I began to look for a studio to create large-scale paintings and a multimedia installation for what would be my first major museum exhibition, scheduled for early 1992 at Moderna Museet in Stockholm, Sweden. A realtor showed me a small two-bedroom bungalow in Venice that had a huge studio space with a thirty-foot ceiling at the end of the backyard, built by a sculptor who was the previous owner. The present owners were Lisa Bonet and her husband, singer/ songwriter Lenny Kravitz. They wanted to move to New York, and I agreed to sublet them my New York loft on Broome Street in exchange for their place.

We became good friends, and our exchange of places became a creative boom for both of us. My exhibition in Stockholm wound up traveling to the U.K., Amsterdam, and to the Irish Museum of Modern Art in Dublin. Lenny wrote the songs and recorded his first album, *Let Love Rule*, while he and Lisa were living in my place.

On a trip to New York, I stayed with them and Lenny brought me to the New Jersey studio where he was recording, and I did some of my best playing on a song co-written by Lisa—"Rosemary"—which wound up on the album. Lenny's talent was enormous—he was playing all the instruments on the album, including drums.

I was not at all surprised when those recordings garnered a record deal with Virgin Records (with the album released in 1989) and when the label threw a star-studded release party at the Roxy in L.A., Lenny brought me on stage for an acoustic encore of "Rosemary." I had brought Joe to meet him. Lenny was not at all impressed with celebrity—after all his mother was Roxie

Roker, star of the ground-breaker sitcom, *The Jeffersons* (the first TV show to have an "interracial" couple), and his wife Lisa was a star on *The Cosby Show*. But he was thrilled to meet Joe as he viewed him as one of the most influential figures in the history of popular music. A&M Records had just started a label to release World Music and had hired a DJ from the public radio station KCRW, with Tom Schnabel to be the head. I asked the dreadlocked Lenny if he would be interested in producing an album with Joe, and he was keen. It would be a labor of love. He would carve out a few weeks after his upcoming "Let Love Rule" tour—which I was convinced would be a huge success—and I pitched Schnabel the idea to sign Joe. Lawyers were carving out a deal, and I was excited that Lenny and Joe would have a great musical collaboration, and that Lenny's involvement would help to bring Joe the international recognition he deserved.

It was not to be. Without an explanation from A&M or Schnabel—he wouldn't even take my calls—they dropped the deal. It was heartbreaking to inform Joe, as I knew that Virgin Records would soon fill up Lenny's schedule as to not slow the momentum of breaking a new star.

I carried on. Lenny was very disappointed at the turn of events, as he really loved Joe. I reached out again to Richard Nevins and Dan Collins, Shanachie Records founders and their head of A&R, Randall Grass, and they agreed to provide a budget to do another album. The Wailers Band, which was headed by original bassist Aston "Familyman" Barrett, and keyboardist Tyrone Downie, recorded the basic tracks with Joe in New York, and we did overdubs and Joe's final vocals in L.A. Joe had met Frank Gironda, who worked at Lookout Management for Elliot Roberts who managed Joni Mitchell, Neil Young, and Bob Dylan, and he connected us with the brilliant David Briggs who had produced twenty-three albums with Neil, to mix the record. David was friends with Richard Kaplan who owned Indigo Ranch Studio, situated on a sixty acre property in Solstice Canyon in Malibu overlooking the ocean.

David drove his pristine navy blue '61 Mercedes 220SE down from his home in the Bay Area. He picked me up in Venice and we went to collect Joe at his mid-L.A. apartment. Joe lived in a dingy four-story apartment complex. His tiny one room studio with kitchenette was always immaculately clean and in meticulous order and, like his yard in Trenchtown, had become a meeting place for singers and players of instruments—a center for the SoCal reggae community of musicians who reveled in the opportunity to hang with the Maestro. I became one of them and would pass through to spend an hour or two a few times a week to jam with him and with whoever happened to be there. It seemed he was never alone, but always surrounded by admirers.

215

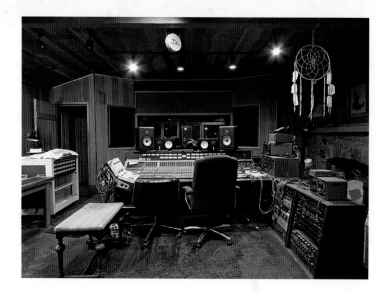

Indigo Ranch Recording Studio, Malibu, outside and within.

We drove out to Pacific Coast Highway on this balmy L.A. afternoon, windows down, ocean wind blowing in my face in the back seat. Dave and Joe—who immediately hit it off—were talking and laughing non-stop, and though I couldn't decipher a word they were saying, I knew this was good. We drove past Topanga Canyon Blvd. and took the next right onto Los Flores Canyon Road, winding our way up the mountain hooking around onto Los Flores Mesa and then onto a dirt road, Eagle Pass Drive, that dead ended at Indigo Ranch. We bounded out of the Benz, looking down the mountains from what seemed like heaven to an unobstructed view of an endless gleaming blue Pacific Ocean.

A short, round, jocular figure came to greet us, Cheshire cat smile beaming. He was balding with a thick drooping mustache, and my eyes widened, mistaking it was David Crosby; but it was his doppelganger, Richard Kaplan—owner of what had become a legendary recording studio. Kaplan was an avid gear collector and had assembled an incredible array of vintage equipment, including dozens of classic microphones he had acquired from Abbey Road Studios in London. As I sat next to David in the control room during the coming weeks, I was constantly wowed as he recorded Joe's powerful immaculate vocals using what had been Paul McCartney's favorite AKG C12 tube mic.

David and I became close friends during the time he was working on Joe's record, and he would spend long hours with me during breaks from mixing in Malibu at my artist studio in Venice while I was working towards my Stockholm exhibition.

When the album was completed, he brought it to Frank and Elliot Roberts and they played it for Dylan. They were in the midst of negotiating a joint-venture label deal for Bob with Columbia Records and as David was enthusiastically committed to producing a next album for Joe, Bob wanted it to be the first release on his new label. I had visions of Joe writing a song with Neil, and Bob playing harmonica on one of the tracks and"getting ahead of myself—envisioning Joe as an opening act tour-ing with Neil and/or Bob. It would finally bring Joe his long-deserved international recognition.

Shanachie released the album, *Blackman Know Yourself*, and it received stellar reviews. David had returned to Marin County where he lived, but we were in touch by phone several times a week.

Then to more bad news. Dylan's label deal with Columbia fell through, never to happen. Yet David and I continued to discuss. We made a plan to go with Joe to Jamaica, and I was arranging with Sly Dunbar and Robbie Shakespeare, who by then had become a terrific producing team, to record the basic tracks with them at Mixing Lab Studio in Kingston. Then we would go to the Bay Area to do some overdubs with some musicians Dave had been working with for years with Neil, and then return to Malibu to mix the record at Indigo.

Then a couple of weeks passed with David not answering the phone. I couldn't understand what was up. Eventually he called and told me he had begun to suffer from excruciating back pain, and apologized for not being in touch. Then another couple of weeks passed, and I got a call from Bettina, David's wife who was also his production coordinator; "Lee, I'm arranging with Neil a celebratory Irish wake for David. It would be great if

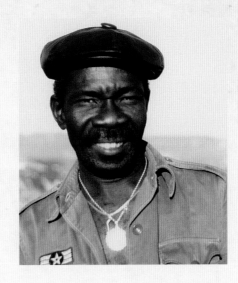

you could come."

Neil would later write in his autobiography, *Waging Heavy Piece: A Hippie Dream*, much of which is dedicated to David: "Briggs and I made my best records—the transcendent ones… We somehow knew the way." And he refers to Briggs in the lyrics for the song, "No Hidden Path":

And the leaves on the ground
Make a rustling sound
In the wind now blowing in my face
It's that cool wind again
And I feel my missing friend
Whose counsel I can never replace.

A few months later, Joe called. He said he had a gig coming up the next night in Santa Barbara, and asked if I would come and sit in on a few songs; I gladly agreed. He gave me the address: 4025 Foothill Rd, Santa Barbara. It was a cold, wet stormy January night. I made my way through thick fog north on the 101 past Ventura, Faria Beach, and Carpentaria. Through the mist, I could barely make out the paradise palms and eucalyptus that lined the highway being whipped violently by the wind. I exited at Calle Real and pulled off to the side of the road to check the directions I had written on a crumpled-up scrap of paper. The torrential rain had subsided to a steady drizzle, and I drove cautiously, taking a right on San Marcos Pass to Foothill, surprised to find that the address led me to a herculean parking lot made to seem even larger than it was by being nearly deserted—less than a dozen parked cars. Due to the weather, what would have been a ninety-minute drive had

taken almost three hours, and I shuddered thinking I had gotten the address wrong from Joe. There were no cell phones. GPS was not yet widely available.

There was a long, one-story building, completely dark except for a sign that said "La Colina Junior High School." Next to it, a separate building with a high roof and lights on—the school's gym. I shuffled my way through the thick damp night. There was Joe, with his wonderful, forever dedicated revering musicians: guitarist Glen Jones, keyboardist Jawge Hughes, drummer Rock Deadrick, and saxophonist Jimmy Roberts, who, as a member of Rod Stewart's band, was used to playing in sold-out arenas and stadiums. They were finishing setting up their equipment below one of the backboards of the basketball court—no stage—just placing their gear on the hardwood floor. There was an audience of maybe eight or nine people mulling around, and when the band finished tuning up, the diminutive, barely five-foot-six-inch thin framed Mighty Joe Higgs stepped up to the makeshift microphone stand, and they lit into a rousing rendition of "Family," then "Steppin Razor" ("don't watch my size, I'm dangerous…"), "Blackman Know Yourself," "Caution," "Small Axe," and without pause, Joe motioned for me to come up and join him on "Mother Radio." They played a fourteen-song set without pauses between, ending with "There's a Reward for Me." I stood along with the small group who had shunned the nasty weather, totally mesmerized.

It was one of the greatest performances I had ever witnessed, and when it was over, I could barely hold back the tears that were welling up inside me.

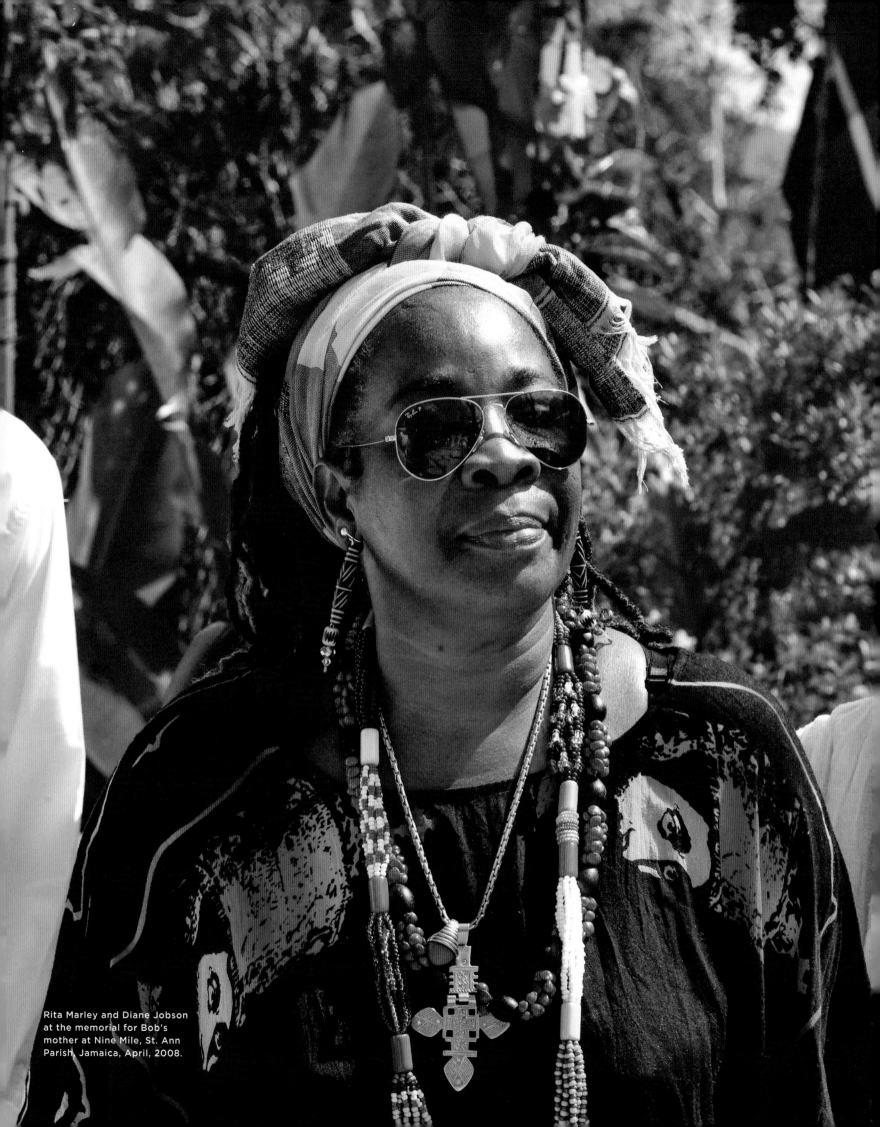

Rita Marley and Diane Jobson at the memorial for Bob's mother at Nine Mile, St. Ann Parish, Jamaica, April, 2008.

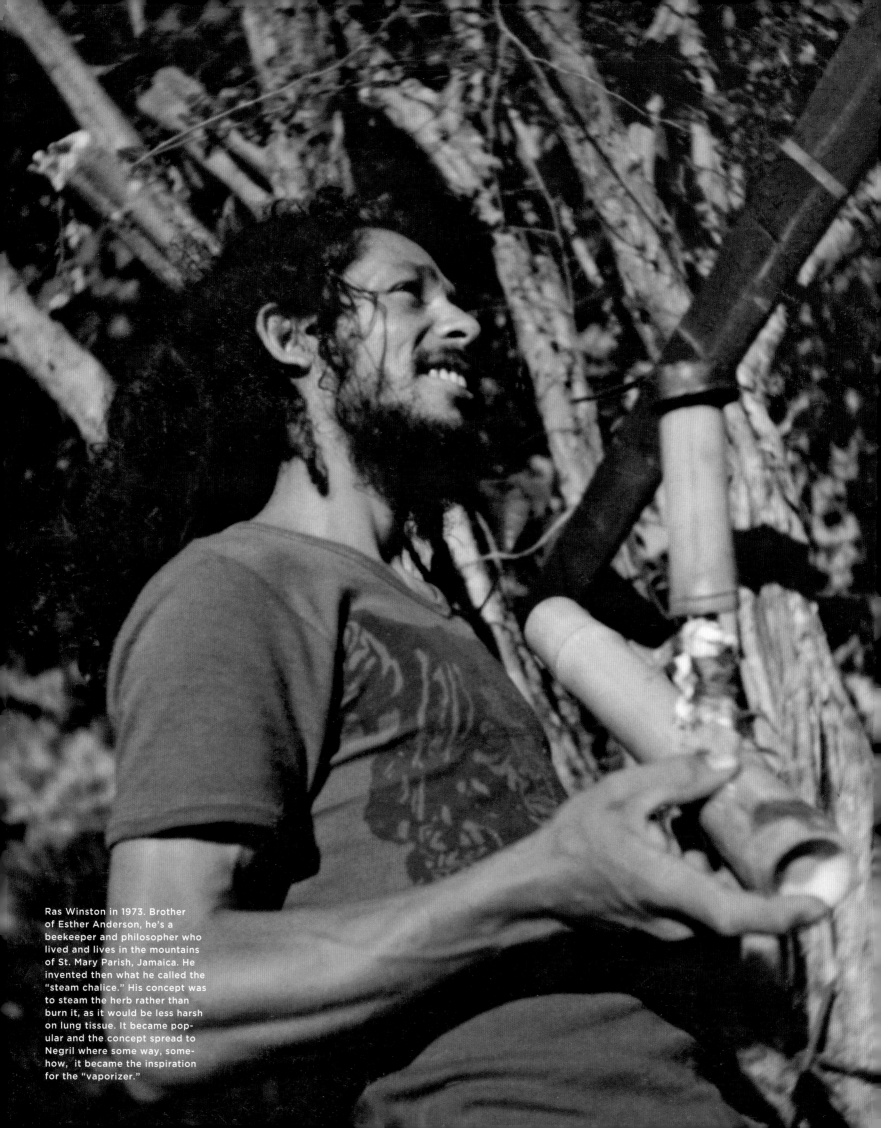

Ras Winston in 1973. Brother of Esther Anderson, he's a beekeeper and philosopher who lived and lives in the mountains of St. Mary Parish, Jamaica. He invented then what he called the "steam chalice." His concept was to steam the herb rather than burn it, as it would be less harsh on lung tissue. It became popular and the concept spread to Negril where some way, somehow, it became the inspiration for the "vaporizer."

Winston
and the First Vaporizer

Recently, I was back in Jamaica looking for a friend I hadn't seen in nearly forty years. Sometime in 1974, when I was living at 56 Hope Road and the pressures of life in Kingston were getting overwhelming, I managed to get to the country, to St. Mary Parish. Winston Anderson, a Jamaican Rastaman of East Indian and Scottish ancestry with a crown of thick, shiny, light brown dreads, had built a small, immaculate stilted house on a hillside overlooking Port Maria. It was made from indigenous woods, both hard and soft—mahoe, mahogany, and cedar. At Hope Road, often upon waking, I'd hear the morning news reports from Frowser and Take Life—two notorious ghetto youths whose cherub like teenage faces seemed to wear permanent grins, like two teenage Richard Widmark's in *Kiss of Death*. Bwoy was I naïve… Why were they laughing "when there ain't no joke"?

Theirs was alternative news to the ones statically emanating from the small transistor radio on the floor in the corner of my bedroom, either from the JBC or BBC. Bob had assigned them to be my bodyguards, and they had assumed the roles as if auditioning for a still untitled movie. Of their chatter—even though I had been living in Jamaica for almost two years—I could only comprehend half of all they went on about. Maybe I just didn't want to hear all the details. They would report on all the mayhem and gang violence they had witnessed and/or participated in the night before, in the sweltering west-end slums of the city.

Although I didn't take the notion of needing bodyguards seriously, and always assumed that these detailed recountings of the previous night's goings-on to be exaggerations (like two young screen writers going over scenes for a spaghetti western), I had begun to be worn down by them and to wonder if there were not bits of truth ingrained in their dissilient diatribes.

I had helped the Wailers to get on tour in the U.S. to promote the *Catch a Fire* and *Burnin'* albums, and although a love affair was born with the press, the records had failed to sell or garner any substantial airplay. There was uncertainty amongst Bob, Peter and Bunny to the point of not knowing if they would continue to exist as a group, and economic pressures weighed heavy. Tension was palpable.

I grabbed a bus at Half Way Tree at the bottom of Hope Road, and endured the overcrowded seasick ride over the mountains to Port Maria. From there, I begged for a ride a few miles down a windy road, close enough to walk through the bush to where Winston lived. He had his genius invention—a "steam chalice" alight—a pipe of bamboo that, instead of burning the herb, steamed it.

In fact, this was the first vaporizer!

He heard me call his name and, without looking up from his pipe, reached for an envelope and handed it to me. He smoked some more and then offered me the pipe. "You need to go to the place where you were born. You need to re-charge mon. You need to gain some perspective. Take what's in the envelope and buy a ticket. Spend some weeks a foreign and then come forward again. Then I have much important works fa do." Then he handed me a blue soft cover booklet of about twenty pages. The author was anonymous—was it Winston? "You can read this on the plane Iya." The book was really a kind of spiritual manual. It was about intention and explained that when one has been given a task that comes from some higher place, that it is best to refrain from speaking about it, as that would only serve to disperse the energy needed to be successful in completing it.

Thirty-five years later, and I was looking for Winston… Cicadas screamed in the dwindling remnants of twilight. The thick air of the summer tropics had begun to thin and a soft breeze lilted round my neck. I could make out about twenty meters in front of me. Along the jungle path was a small hut and, as I approached, my body tingled with anticipation. Time is something not always comprehensible to me, but the decades that separated Winston and me were now tangibly dissolving. My breath quickened as I stepped up the three stairs to the doorless abode. He was there, sitting on a soft rug on the floor with his steam chalice in hand, the oil lamp and candlelight mingling in an aromatic haze. His dreadlocks, decades long, were tied and wound in thick circular knots above the crown of his head. "Winston," I said, trying to avoid revealing all the emotion welling inside me. He did not look up to see who it was as he continued to stir the hot coals atop his pipe that served to steam the herb. "Yes Lee mon, come tru. I man did just meditate upon di I jus de other day. Me did wonder wha happen ta Lee mon. Come mon I did jus light di chalice." Finally, he raised his head to see me.

I could see the four decades of life carved in his face. Winston smiled, and time stood still. "Ya may not remember me mon, but ya remember me pipe."

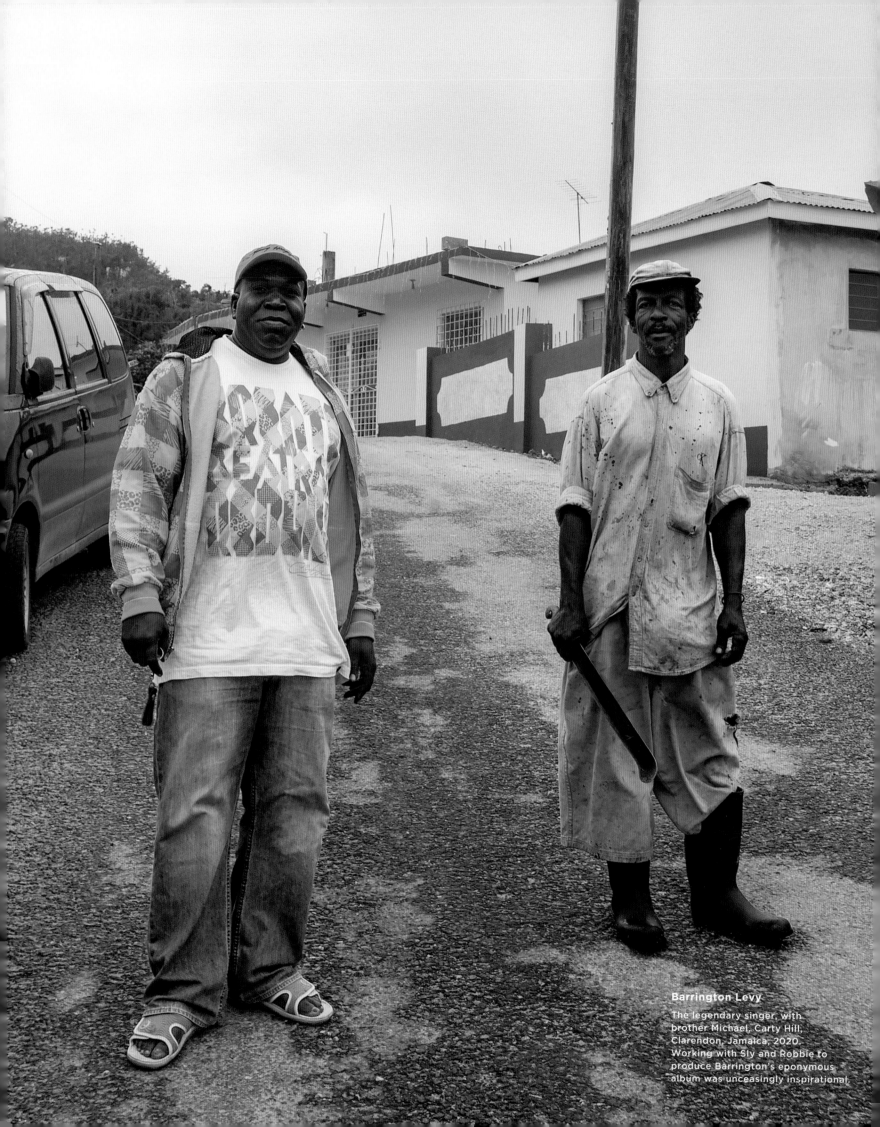

Barrington Levy

The legendary singer, with brother Michael, Carty Hill, Clarendon, Jamaica, 2020. Working with Sly and Robbie to produce Barrington's eponymous album was unceasingly inspirational.

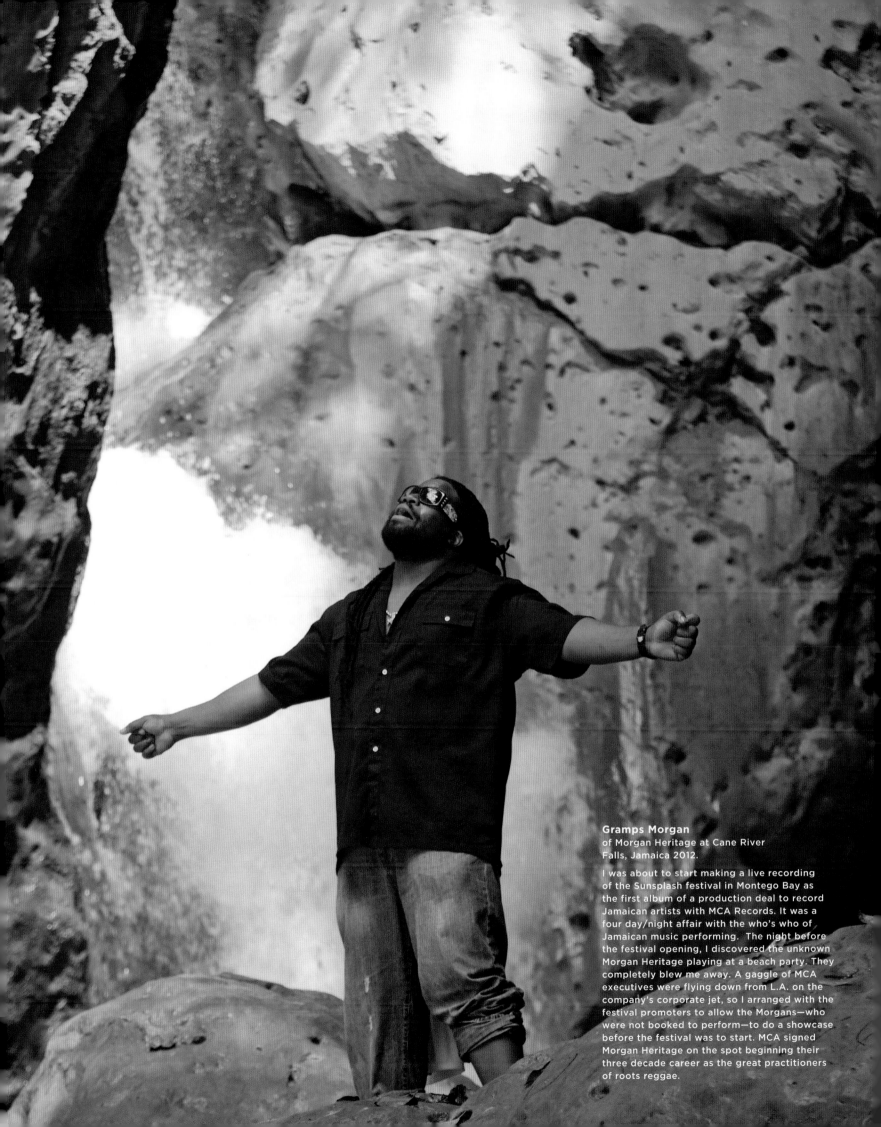

Gramps Morgan
of Morgan Heritage at Cane River
Falls, Jamaica 2012.

I was about to start making a live recording
of the Sunsplash festival in Montego Bay as
the first album of a production deal to record
Jamaican artists with MCA Records. It was a
four day/night affair with the who's who of
Jamaican music performing. The night before
the festival opening, I discovered the unknown
Morgan Heritage playing at a beach party. They
completely blew me away. A gaggle of MCA
executives were flying down from L.A. on the
company's corporate jet, so I arranged with the
festival promoters to allow the Morgans—who
were not booked to perform—to do a showcase
before the festival was to start. MCA signed
Morgan Heritage on the spot beginning their
three decade career as the great practitioners
of roots reggae.

Lee Scratch Perry

It's no hyperbole to describe Lee "Scratch" Perry as a legend. As one of the most influential producers in the history of recorded music, his importance is reflected not only in the hundreds of millions of listeners that have been touched by the music he has created—in his roles of producer, writer, vocalist and live performer—but also by the incredible range of artists that have been profoundly inspired by his body of work extending through five decades. Beginning in the early 1960s, he collaborated with legendary Jamaican artists of the ska and rock steady eras—the Skatalites, Alton Ellis, Tommy McCook, and Prince Buster. In the late 1960s and early 1970s, he was a foundational creator of reggae and was a profound influence on the careers of the Wailers. He united what was then a vocal trio (Bob Marley, Peter Tosh and Bunny Livingston) and brought them together with his studio rhythm section known as the Upsetters. In so doing, he lifted them out of the age of ska and rock steady and into the realm of a new music whose profound global impact continues to this day. Perry produced hits with dozens of singers including seminal tracks like "One Step Forward" with Max Romeo (1975), "Cherry Oh Baby" with Eric Donaldson (1971)—later covered by the Rolling Stones (1976) and UB40 (1984)—and "Police and Thieves" with Junior Murvin (1976). He is one of the inventors of dub, which combined radical experiments in electronic music—panoramic delay, extensive use of echo and inventive collaging techniques—deconstructing and reconstructing current popular recordings.

In 1973, he produced *Blackboard Jungle Dub*, one of the first entire dub albums. His dub experiments coincided with his work with toasters U-Roy, Prince Jazzbo, Big Youth and others—creating some of the first recordings of people talking on top of music, foreshadowing the birth of rap and hip-hop in New York nearly a decade later.

As his legend grew, international artists gravitated towards him, utilizing his magical creative skills. The list of collaborators crosses genres and geographical boundaries, ranging from George Clinton to the Slits, Keith Richards, the Orb, Dub Syndicate, Bill Laswell, the Vienna-based Dubblestandart, and Subatomic Sound System. Scratch produced The Clash's "Complete Control," widely acknowledged as one of punk rock's greatest singles. It's a fiery diatribe against corporate control of the music business. As an artist, *Rolling Stone Magazine* has rated him the #100th Greatest Artist of All Time.

-

Scratch's bold personality and talent are well documented. The genre he helped invent—dub—has gone on to rule dance floors everywhere, filtered through sounds like grime and EDM. But for me, his greatest triumph will always be the sonic kick of hearing Bob Marley's voice of liberation on "Duppy Conqueror," proudly riding a radical rhythm that could only have been produced by "The Upsetter," Lee "Scratch" Perry (d. 2021).

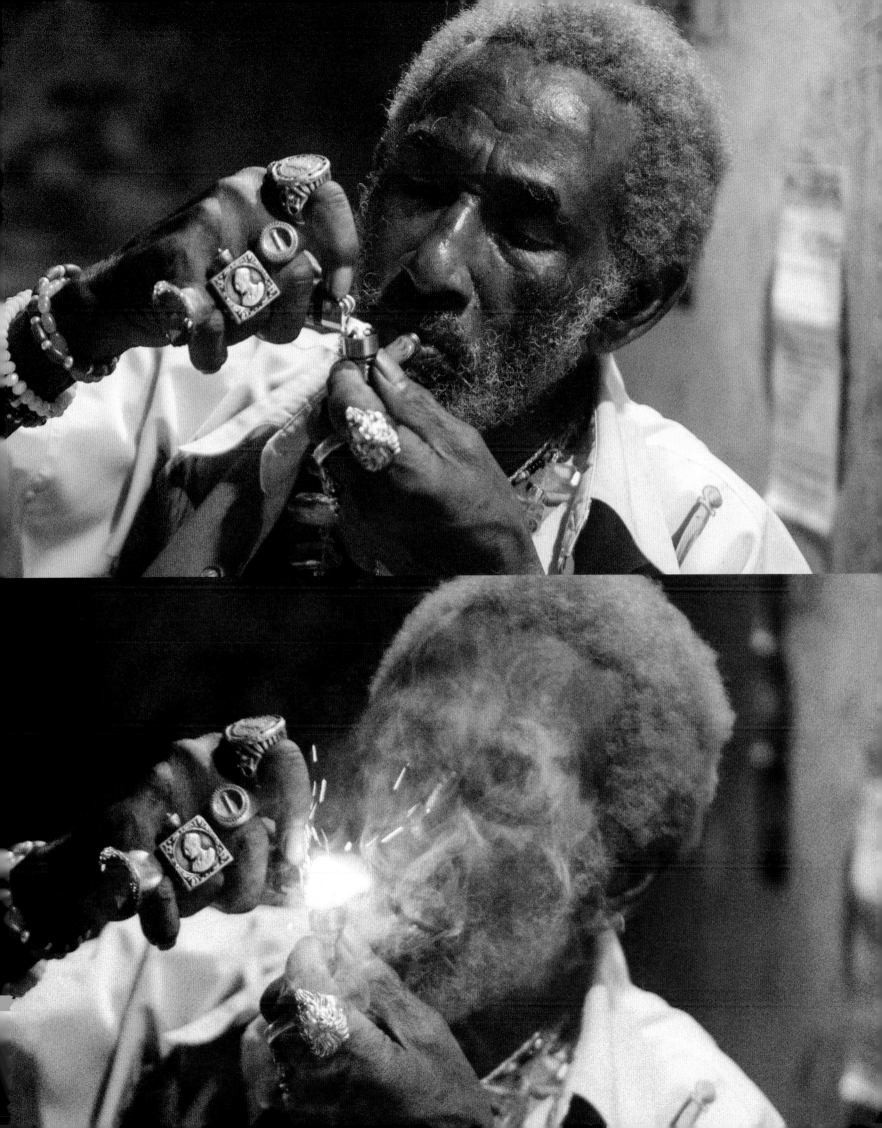

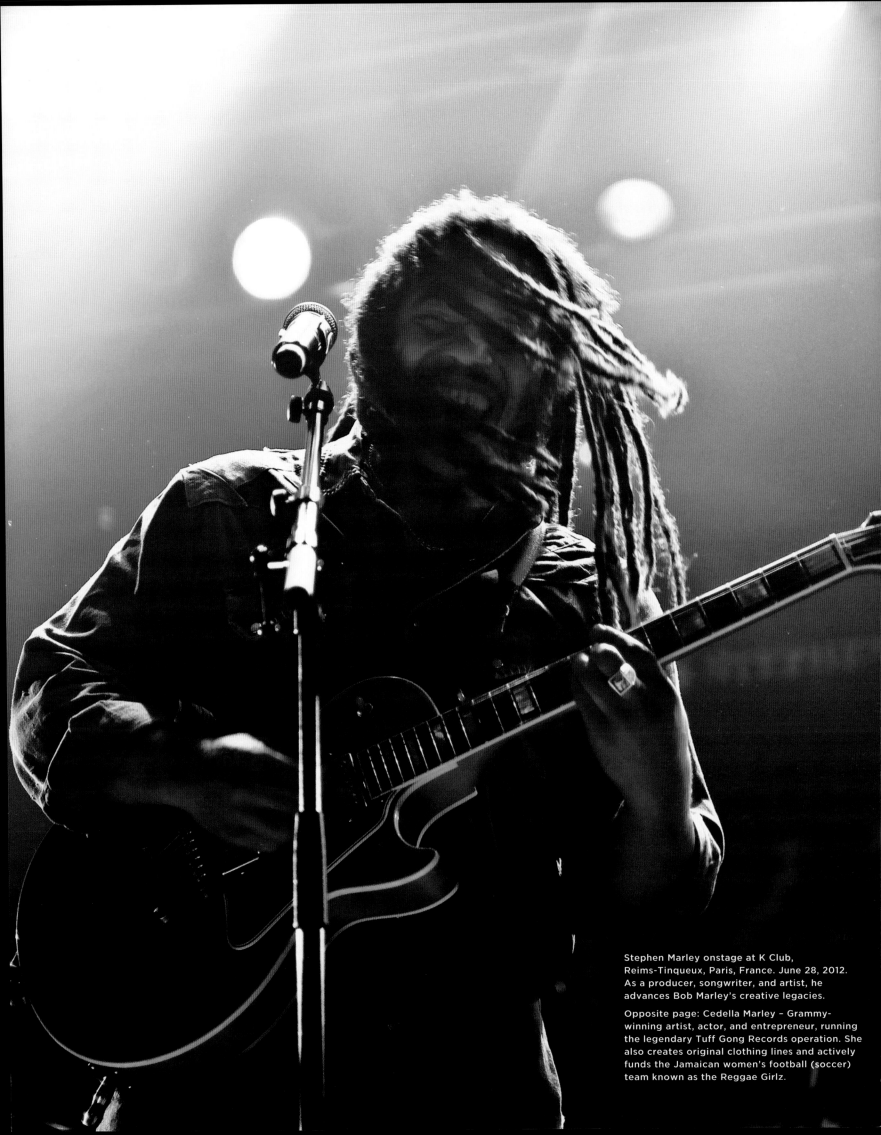

Stephen Marley onstage at K Club, Reims-Tinqueux, Paris, France. June 28, 2012. As a producer, songwriter, and artist, he advances Bob Marley's creative legacies.

Opposite page: Cedella Marley – Grammy-winning artist, actor, and entrepreneur, running the legendary Tuff Gong Records operation. She also creates original clothing lines and actively funds the Jamaican women's football (soccer) team known as the Reggae Girlz.

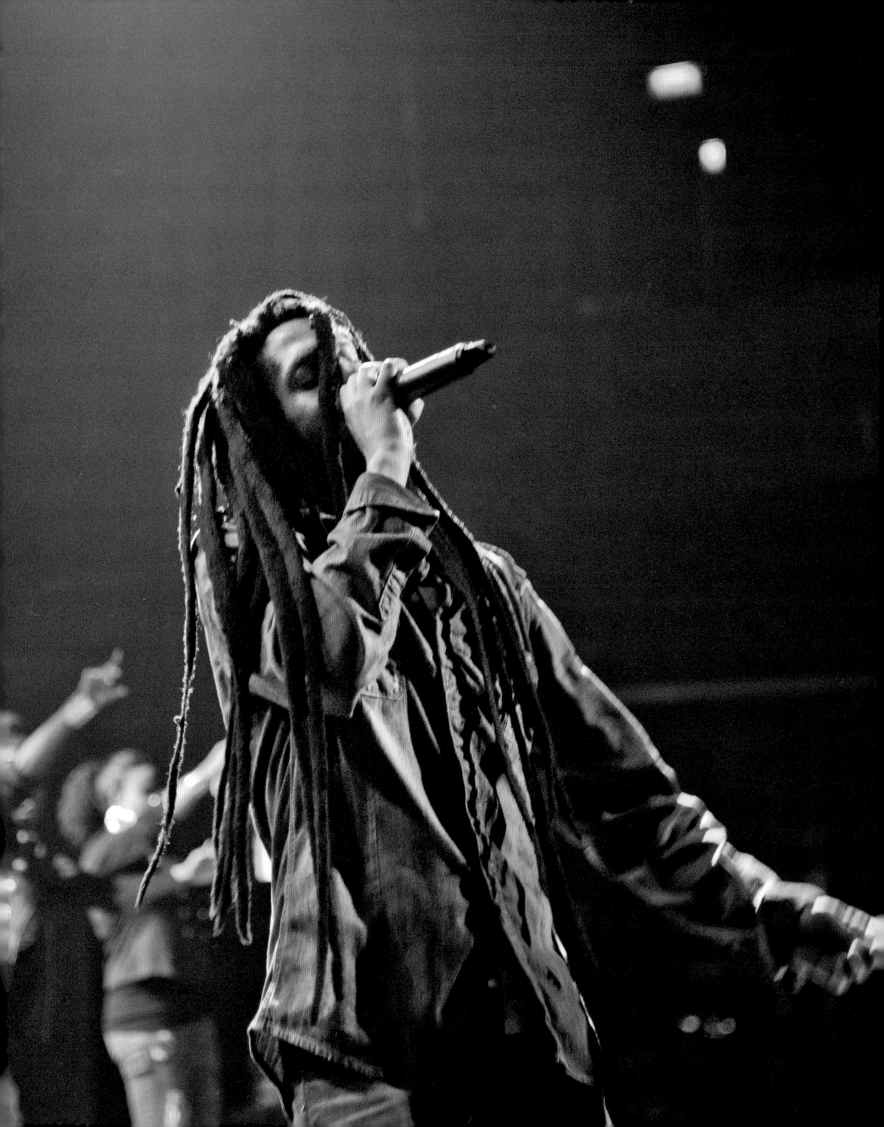

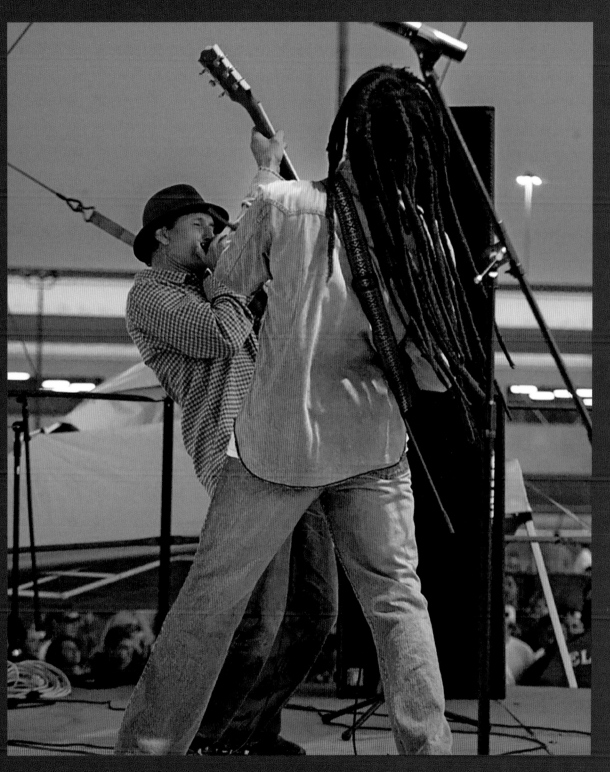

Left: Julian "JuJu" Marley, performing with his brothers Stephen Marley and Damian Marley. London, England July, 27th , 2012.

Above: Jammin' with JuJu: Del Mar, California.

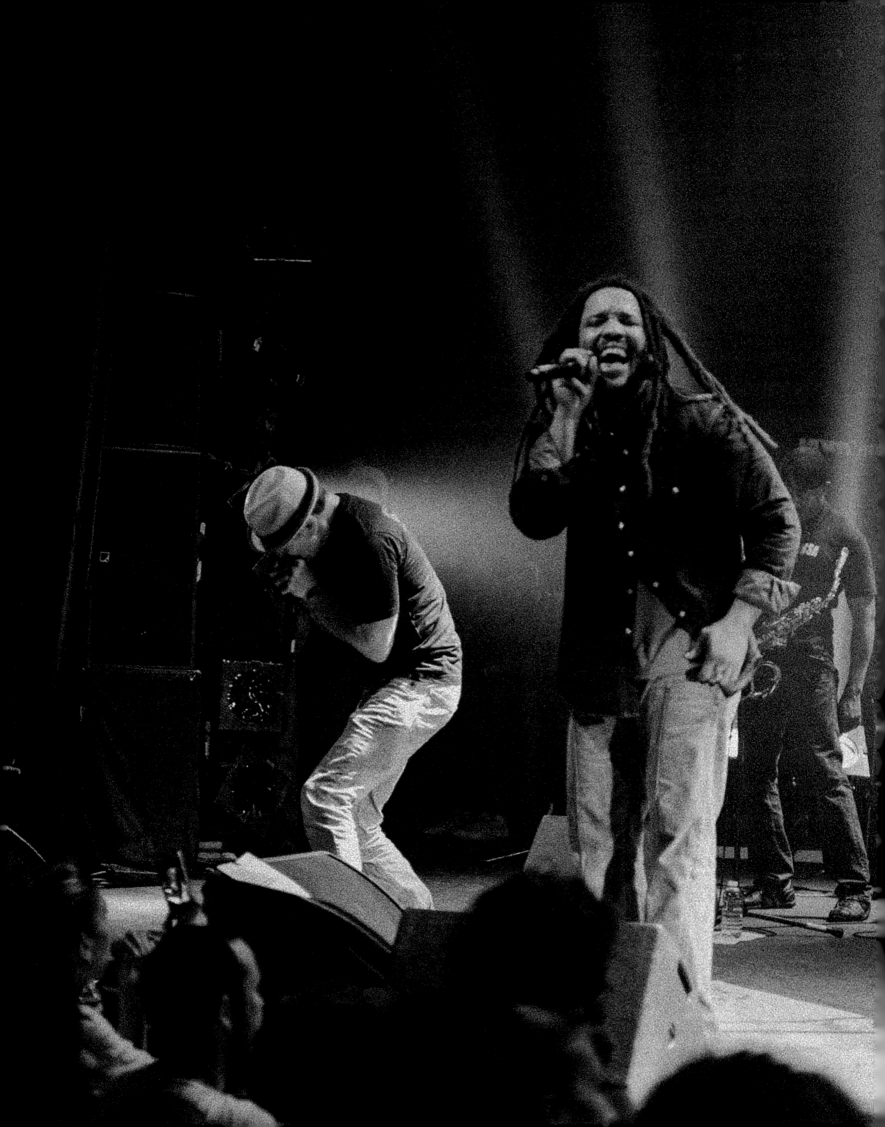

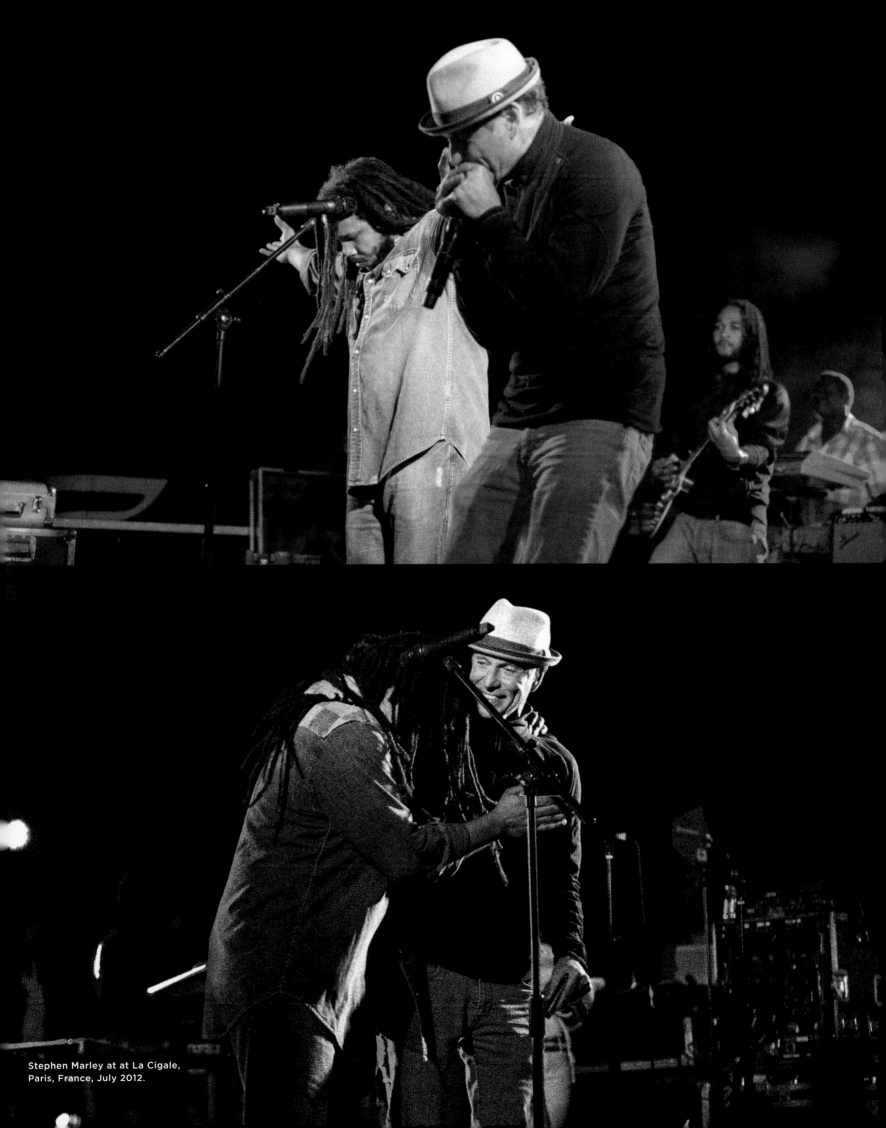

Stephen Marley at at La Cigale,
Paris, France, July 2012.

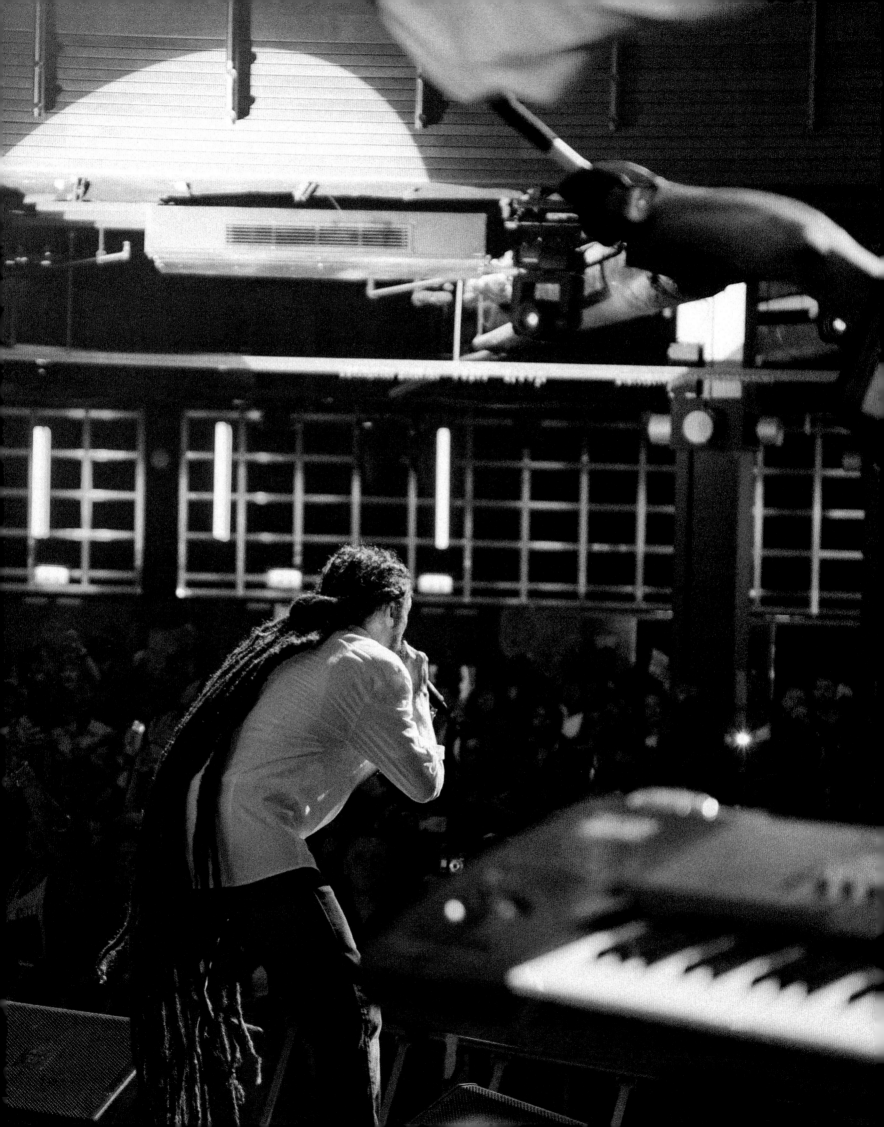

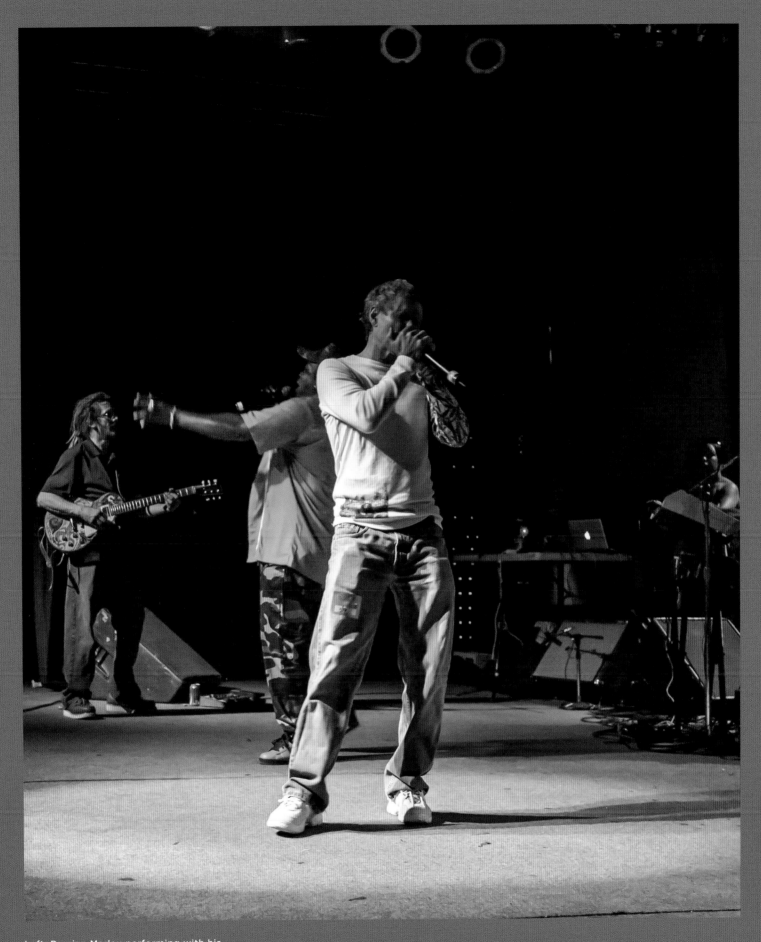

Left: Damian Marley performing with his brothers, Stephen and Julian July, 28th, 2012, London, England.

Above: Performing with Barrington Levy: San Diego, California.

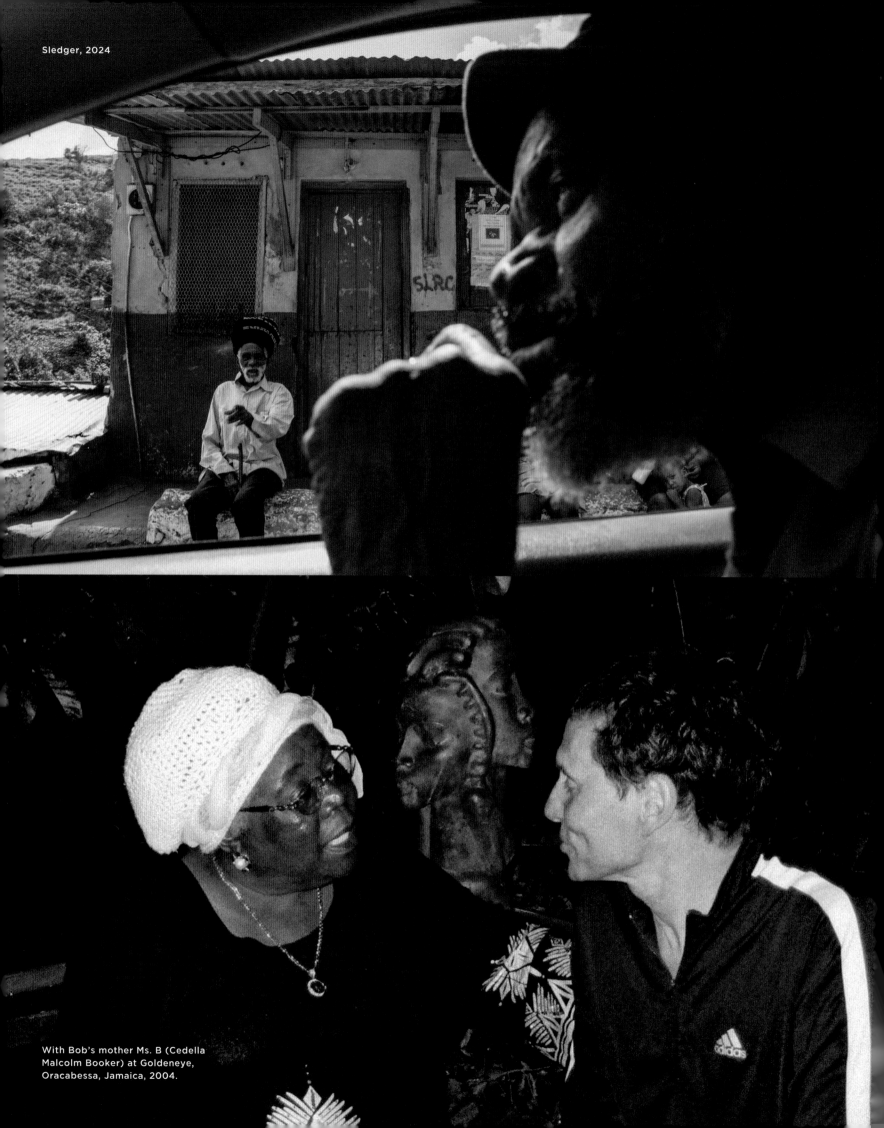

Sledger, 2024

With Bob's mother Ms. B (Cedella Malcolm Booker) at Goldeneye, Oracabessa, Jamaica, 2004.

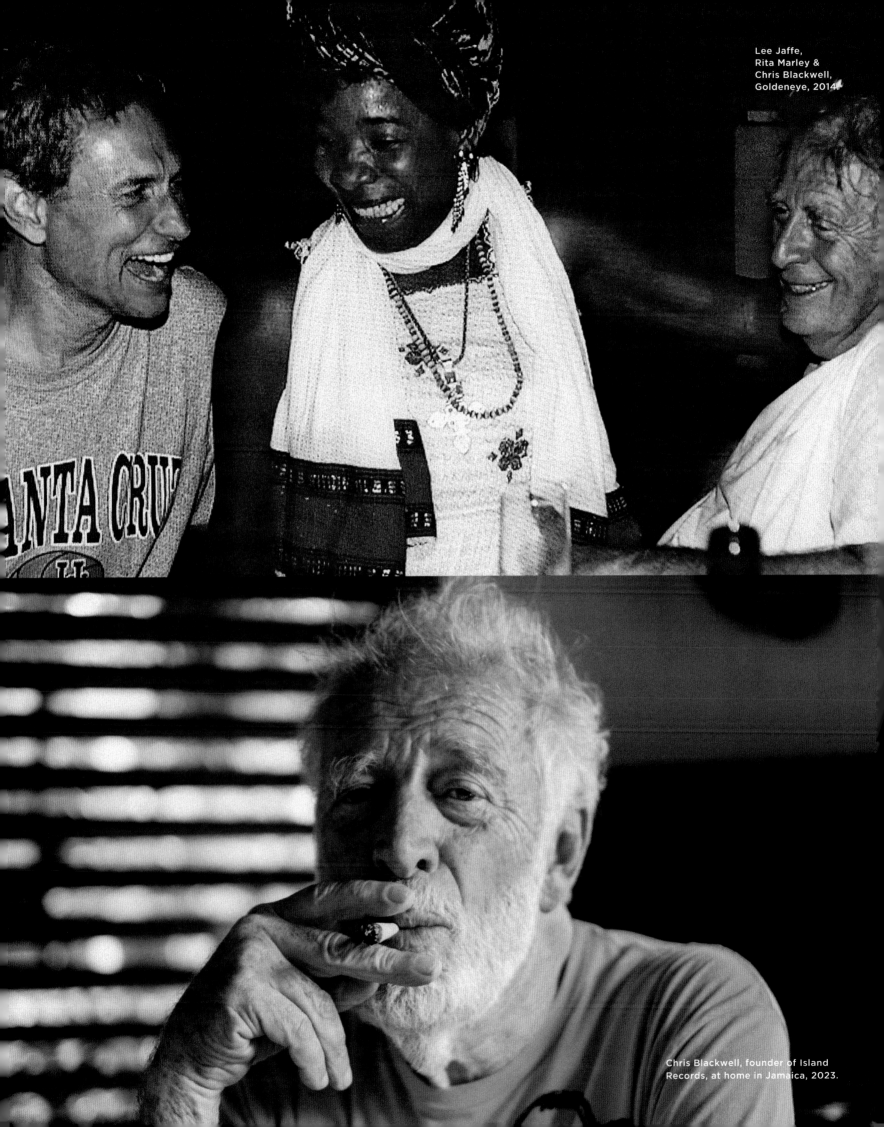

Lee Jaffe,
Rita Marley &
Chris Blackwell,
Goldeneye, 2014.

Chris Blackwell, founder of Island
Records, at home in Jamaica, 2023.

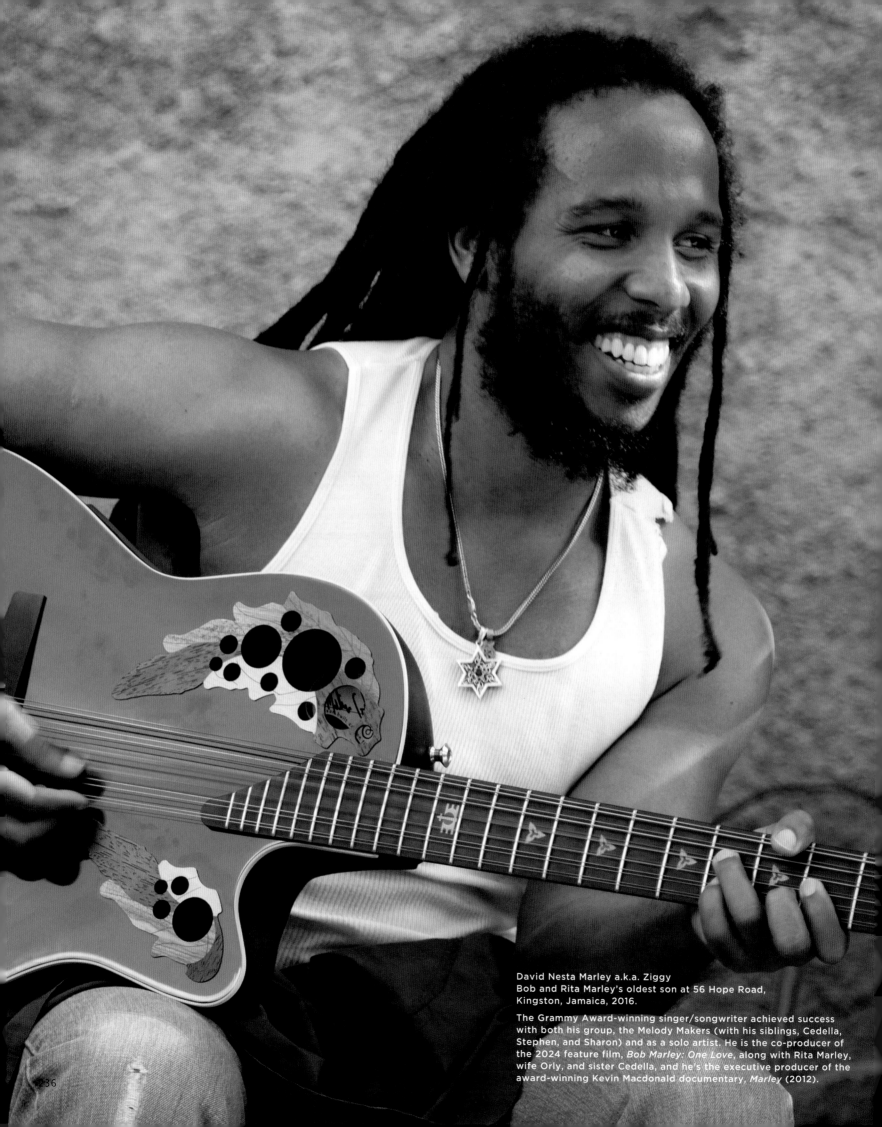

David Nesta Marley a.k.a. Ziggy
Bob and Rita Marley's oldest son at 56 Hope Road,
Kingston, Jamaica, 2016.

The Grammy Award-winning singer/songwriter achieved success
with both his group, the Melody Makers (with his siblings, Cedella,
Stephen, and Sharon) and as a solo artist. He is the co-producer of
the 2024 feature film, *Bob Marley: One Love*, along with Rita Marley,
wife Orly, and sister Cedella, and he's the executive producer of the
award-winning Kevin Macdonald documentary, *Marley* (2012).

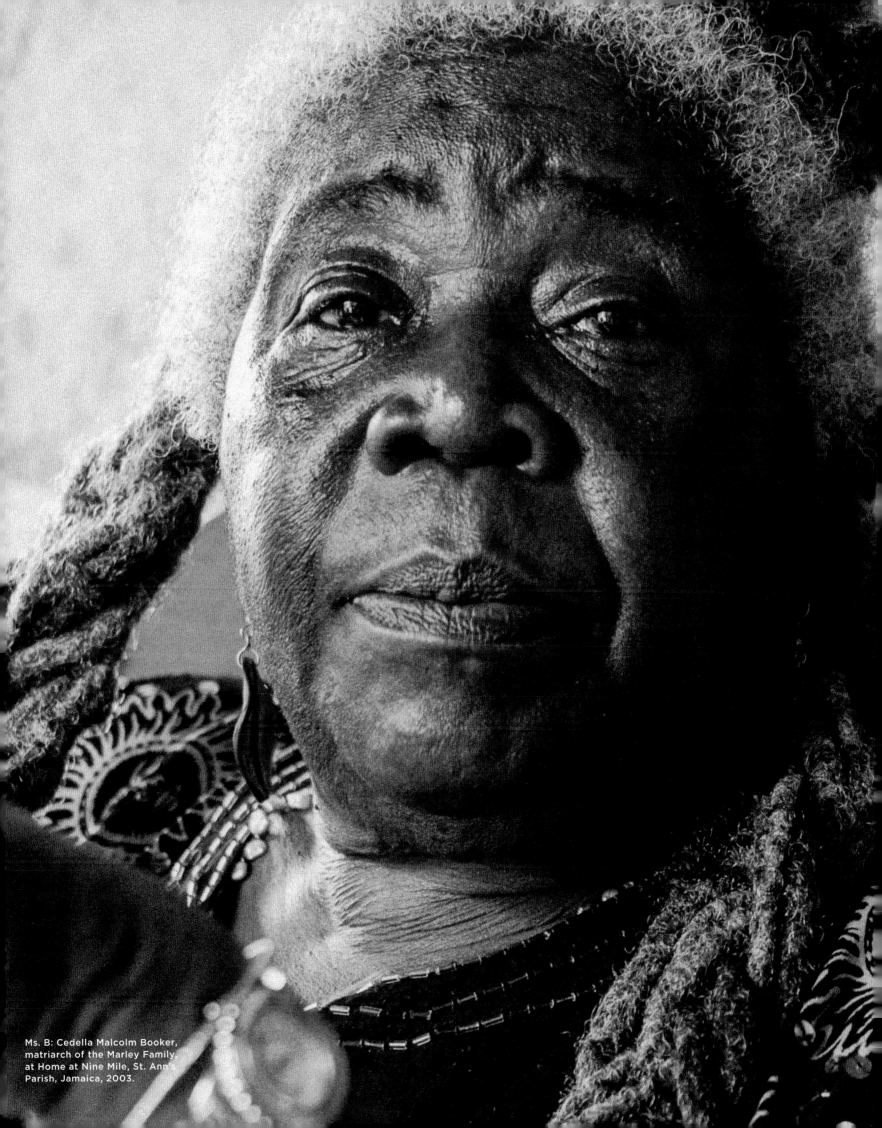

Ms. B: Cedella Malcolm Booker,
matriarch of the Marley Family,
at Home at Nine Mile, St. Ann's
Parish, Jamaica, 2003.

Acknowledgments

**Special Thanks to family
and the brilliant collaborators
I've been blessed to work with.**

Kweku Mandela
Anthony Petrillose
Charles Miers
Sam Sohaili
Marc Beckman
Prof. Mike Alleyne

Artistic Allies
Marley Family
Chris Blackwell
Peter Tosh
Hugh "Sledger" Peart
Madeline Seltzer
The Wailers and all the musicians
Sly Dunbar and Robbie Shakespeare
Donald Kinsey
Barrington Levy
Morgan Heritage
Barrington Levy
Wailing Souls
Lenny Kravitz
Handel Tucker

Family
Harriette, Morris, Aishlinn,
Max, Julianne, Gregg, Rachel,
Maria Gladys, Mia, Grace An

Friends & Collaborators
Vito Acconci
Staffan Ahrenberg
Neville D'Almeida
Ashley Barker
Jean-Michel Basquiat
Noah Becker
Miguel Rio Branco
Kerry Chen
Rae Dawn Chong
Maria Magdalena Campos-Pons

Lynne Cooke
Cesar Oiticica Filho
Lee Gause
Charlies Griffen
Peter Goulds
Mary Heilman
Sophia Heriveaux
Family Kacev
Jeremie Kroubo
Sanford Kwinter
Dicky Landry
Stan Lathan
Kevin Macdonald
Elizabeth Ann Macgregor
Walter de Maria
Gordon Matta-Clark
Rebecca Meek
Danielle Myer
Declan McGonagle
Monica Nichols
Helio Oiticica
Annie Paul
Massimo Pantano
Luca Di Salvo
Italo Scanga
Oberon Sinclair
Franklin Sirmans
Nancy Spero
Björn Springfeldt
Roger Steffens
James Thomas Stevens
Betsy Sussler
Simon Tatum
The Engine for Art,
 Democracy and Justice
Tricky
Nari Ward
Mary Weatherford
Selene Wendt

Photo Credits

All Photos by **Lee Jaffe**, exceptions:
Page 14: Illustration by **CCS Associates**
Page 16: Photo by **Dennis Hallinan**/Getty Images
Page 46: Photo by **Bob Gruen**
Pages 58 & 60: Photos by **Chuck Krall**
Page 80: Photo by **Colin Jone**

Lee Jaffe's photos of Bob Marley,
courtesy of Bob Marley Images
© Fifty-Six Hope Road Music, Ltd.

Accompanying short films by Lee Jaffe
Video Editor **Madeleine Davis**

Hope Road

Let Him Go

HOUSE OF MANDELA

We are the proud progeny of the
Royal House of Mandela; an African
family dedicated to the preservation
of our history, culture, and family.
Our history, culture, and values
are losely linked with the life
and times of Africa, her people,
resilience, compassion, and courage.
We strongly believe in a sense
of humility, integrity, and a
common notion that our problems
can be solved more effectively
when we open our hearts, our minds,
and come together.

Bee Totem
The Bee is the Mandela family's
totem symbol and represents the
House of Mandela. It is the
literal translation of the family
patriarch's name, Rolihlahla Nelson
Mandela, colloquially meaning,
"One who is brave enough
to challenge the status quo."

A joint venture between House of
Mandela and DMA United, Mandela
Media sheds light on consequential
historical and contemporary events and
personalities; with the aim of
creating substantive discourse +
action toward social justice.

First published in the United States of America in 2024 by
Rizzoli International Publications, Inc.
300 Park Avenue South, New York, NY 10010
www.rizzoliusa.com

Copyright © 2024 Lee Jaffe
Foreword: Chris Blackwell
Introduction: Cedella Marley
Creative Direction and Design: **Sam Sohaili**, DMA United
Art Director: **Eduardo Vallejo**, DMA United
Project Coordinator & Text Editor: **Prof. Mike Alleyne**
Additional Editing: **Madeline Seltzer**

Publisher: **Charles Miers**
Associate Publisher: **Anthony Petrillose**
Editors: **Gisela Aguilar, Lucie Bisbee**
Production Manager: **Colin Hough Trapp**
Managing Editor: **Lynn Scrabis**
Design Coordinator: **Tim Biddick**

Printed in Hong Kong

2024 2025 2026 2027 2028 / 10 9 8 7 6 5 4 3 2 1
ISBN: 9780847835126
Library of Congress Control Number: 2024933822

Visit us online:
Facebook.com/RizzoliNewYork
X: @Rizzoli_Books
Instagram.com/RizzoliBooks
Pinterest.com/RizzoliBooks
Youtube.com/user/RizzoliNY
Issuu.com/Rizzoli

MIX
Paper | Supporting
responsible forestry
FSC™ C023053

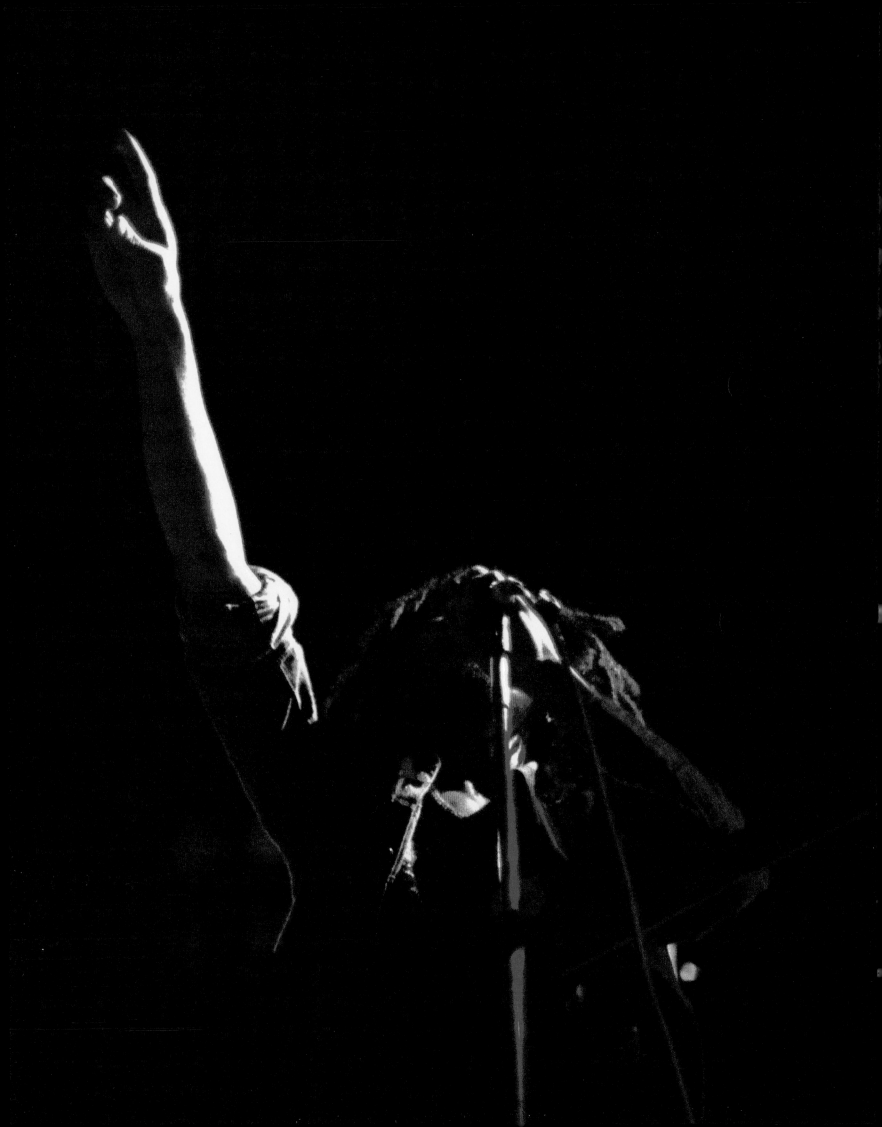